'This beautifully paced book, a history of the painting and all the people who've owned it, reads like a thriller. So much money is at stake it makes your head spin. Not for the first time the unabashed greed and corruption of the art market is laid bare, but I'm not sure I have ever read a volume of art history so quickly and with such pleasure' *Daily Mail*

'Lewis's portrait of the artist-engineer … as a "dreamer, a doodler, and a dawdler" is refreshingly compelling … Lively and ultimately sinister sketches from over the centuries amount to the *Salvator Mundi*'s provenance … A deliciously detailed, satisfying book, that is simultaneously a call for change' *Irish Times*

'Ben Lewis writes about the painting's twisty, contentious road to the auction block and beyond' *New York Times*

'A story as unbelievable as any fiction … Lewis has served as investigator-journalist-historian in telling this backstory to a painting that still can't deliver concrete answers. Half historical fiction with Agatha Christie-style quality' *New York Journal of Books*

'As Lewis chronicles the quest to attribute the painting to da Vinci, he uncovers an astoundingly dysfunctional world of museums, galleries, auction houses, collectors – a Russian oligarch and a Saudi prince among them … Art, greed and stealth make for a lively tale of intrigue' *Kirkus*

THE
LAST LEONARDO

A MASTERPIECE, A MYSTERY AND
THE DIRTY WORLD OF ART

BEN LEWIS

WILLIAM
COLLINS

William Collins
An imprint of HarperCollins*Publishers*
1 London Bridge Street
London SE1 9GF

WilliamCollinsBooks.com

First published in Great Britain in 2019 by William Collins
This William Collins paperback edition published in 2020

1

A catalogue record for this book is
available from the British Library

ISBN 978-0-00-831344-9

Set in Bembo Std
Printed and bound in Great Britain by
CPI Group (UK) Ltd, Croydon

MIX
Paper from
responsible sources
FSC™ C007454

This book is produced from independently certified FSC™ paper
to ensure responsible forest management.

For more information visit: www.harpercollins.co.uk/green

To Niamh and Lorcan

CONTENTS

PART III

ILLUSTRATIONS

Salvator Mundi, free copy after Boltraffio (1467–1516) *(Cook Collection, Richmond. Photograph by William E. Gray c.1908–12. Witt Library, Courtauld Institute of Art, London)*

Girolamo Alibrandi (?) (c.1470–1524), *Salvator Mundi. (Getty Images/ KONTROLAB)*

Leonardo's studio, *Salvator Mundi. (Private collection)*

Gian Giacomo Caprotti, known as Salai (1480–1524), *Head of Christ. (Pinacoteca Ambrosiana, Milan © Veneranda Biblioteca Ambrosiana/Gianni Cigolini/Mondadori Portfolio/Bridgeman Images)*

Giampietrino (active c.1495–1540), *Salvator Mundi. (Pushkin Museum, Moscow, Russia/Bridgeman Images)*

Marco d'Oggiono (c.1467–1524), *Salvator Mundi. (De Agostini Picture Library/Bridgeman Images)*

Salvator Mundi. (Detroit Institute of Arts, USA/Gift of James E. Scripps/ Bridgeman Images)

Follower of Leonardo da Vinci (sixteenth century), Painting. *(Biblioteca Berenson, Fototeca, Villa I Tatti – The Harvard University Center for Italian Renaissance Studies. Photograph by A.C. Cooper Photographers Ltd, London)*

Salvator Mundi, Wilanów Palace. *(Photo: Wojciech Holnicki-Szulc/ Museum of King Jan III's Palace at Wilanów)*

Robert Simon at the National Gallery's Leonardo exhibition, November 2011. *(The Times/News Licensing)*

Heraclitus, thought to be a portrait of Leonardo, detail, *Heraclitus and Democritus*, Bramante, c.1487. *(Pinacoteca di Brera, Milan, Italy/ Mondadori Portfolio/Archivio Magliani/Mauro Magliani & Barbara Piovan/Bridgeman Images)*

Alex Parish. *(Courtesy Alex Parish)*

Martin Kemp. *(Photo: John Baxter)*

Margaret Dalivalle. *(Courtesy Margaret Dalivalle)*

Dianne Modestini. *(Courtesy of Dianne Modestini)*

Charles I and Henrietta Maria, engraved by Robert van Voerst, 1634, after Anthony van Dyck. *(Royal Collection Trust © Her Majesty Queen Elizabeth II, 2019/Bridgeman Images)*

James Hamilton, third Marquess of Hamilton, *c.*1640, by Anthony van Dyck. *(Scala Art Resource LT00719 2019. Liechtenstein, The Princely Collections, Vaduz-Vienna/SCALA, Florence)*

Sir John Charles Robinson, by John James Napier. *(© National Portrait Gallery, London)*

Sir Francis Cook. *(© Robin Briault, courtesy of the Department of Image Collections, National Gallery of Art Library, Washington, DC)*

Herbert Cook. *(Courtesy of Richard Cook)*

Yves Bouvier. *(Public domain)*

Mohammed bin Salman. *(Fethi Belaid/AFP/Getty Images)*

Dmitry Rybolovlev. *(Agence Nice Presse/Icon Sport via Getty Images)*

Doughty House, London, home of the *Salvator Mundi* during the first half of the twentieth century. *(Courtesy of the Department of Image Collections, National Gallery of Art Library, Washington, DC)*

Sale of paintings from the Cook Collection, Sotheby's, 1958. *(© Illustrated London News/Mary Evans)*

'A peice of Christ done by Leonard': item 49, Commonwealth Inventory, 1649–51. *(Commonwealth Inventory of King Charles I's goods, English School (17th century)/British Library, London, UK/© British Library Board. All Rights Reserved/Bridgeman Images)*

'A Lord halfe figure by Leonardo': item 123, Commonwealth Inventory 1649–51. *(Commonwealth Inventory of King Charles I's goods, English School (17th century)/British Library, London, UK/© British Library Board. All Rights Reserved/Bridgeman Images)*

The St Charles Gallery, New Orleans, sale catalogue of April 2005. *(Courtesy of the author)*

Opening of the Global Center for Combating Extremist Ideology, Riyadh, during President Trump's state visit to Saudi Arabia, 21 May 2017. *(White House Photo/Alamy Stock Photo)*

Christie's auction of the *Salvator Mundi*, 15 November 2017.
　(Timothy A. Clary/AFP/Getty Images)

Having wandered some distance among gloomy rocks, I came to the entrance of a great cavern, the likes of which I had never seen. I stood for some time in front of it in astonishment. I bent over, resting my left hand on my knee, while shading my eyes with my right. I squinted, shifting first one way and then the other, to see whether I could ascertain anything inside, but this was hindered by the deep darkness within. After having remained there some time, two contrary emotions arose in me: fear and desire — fear of the threatening dark cavern, desire to see whether there were any marvellous thing within it.

LEONARDO DA VINCI

The politics of Leonardo scholarship are like any other politics except that so far no blood is shed.

SIR KENNETH CLARK

Signs form a language, but not the one you think you know.

ITALO CALVINO

It ain't where ya from, it's where ya at

ERIC B. & RAKIM

THE LEGEND OF LEONARDO

Centuries ago, in an age when the world was still ruled by monarchs and dukes and countesses dressed in velvet and golden brocade, there lived a man of illegitimate birth, as warm-hearted in his disposition as he was boundless in his curiosity, fierce in his intellect and skilful with his hands. This man was engineer, architect, designer, scientist and painter – the greatest painter, say many, who had ever lived. A genius, say others, who had brought the modern world into being. His pictures were both real and ideal, more beautiful than anything ever seen before. He studied the natural world in its tiniest details, from the leaves on trees to the paws of bears, and in its hidden rules, such as the proportions of the human face and body. He looked far and peered close, sketching the pale horizons of mountains and peeling back men's skin so he could see the muscles and arteries that lay beneath.

But this artist was also an enigma. When he died, he left riddles and tricks for those who wished to cherish his memory and preserve his legacy. Sometimes his masterpieces were painted with colours that faded or crumbled even before he had finished the work; others were sealed with varnishes that made them darker and darker with the

passing of decades. Like many great men, he seemingly cared little for the gift God had given him, painting little and slowly, and instead burying himself in the notebooks that he filled with scribbles of magnificent ideas, which he had neither the patience nor the technology to build. He made fewer paintings than any other great artist in history, and even fewer have survived: at most only nineteen.

In the centuries that followed his death, people yearned to possess more of his work than they had; there were never enough pictures by this artist to satisfy the world's craving for his images. Myths and theories proliferated about the pictures that had been lost, hidden or painted over. In the institutes of learning devoted to the arts, there was no higher calling than the study of this artist's work; and among those scholars who studied his art, there was no greater glory than discovering a lost or forgotten painting, drawing or sculpture by his hand.

The stakes were high – and, if you fell on them, sharp. The artist never signed or dated his work. He had many pupils, whom he taught to paint as skilfully as himself, in exact imitation of his style, and they produced hundreds of copies of his works. Occasionally, a contemporary recorded, he would add the final touches himself – a fact which further confused posterity. Knowing the risks, the wisest scholars sought to resist the temptation to identify a lost work of art, preferring to explore an overlooked fragment or a half-finished sentence in the artist's notebooks. But, eventually, many succumbed to the allure of buried treasure. The corridors of art history libraries were full of the wailing ghosts of professors whose life's work had been destroyed by the chimera of a 'new' Leonardo they believed they had found; the headlines, news reports and celebrations that greeted their discovery were replaced within years, if not months, by academic derision for what was now revealed to be a forgery or copy, betrayed by paint that had been applied too loosely, or colours pronounced too dominant, or in which there was a trim in the costume that belonged to an incongruous era.

This artist, Leonardo da Vinci, was just like the sun. He was the brightest planet in the art history cosmos. Scholars who flew too close to him found their books suddenly aflame and themselves engulfed in the fire of ambition. Yet still their attempts continued ...

PART I

PART 1

FLIGHT TO LONDON

Robert Simon had plenty of legroom on his flight to London in May 2008. He was flying first class, an unusual luxury for this comfortably successful but unostentatious Old Masters dealer, president of the invitation-only American Private Art Dealers Association. During moments of transatlantic turbulence he cast a glance down the aisle at one of the first class cabin's cupboards, where he had been given permission to stow a slim but oversized case.

It contained a Renaissance painting, 66cm high and 45cm across, of a 'half-figure', to use the old-fashioned art historical term, of Christ. The portrait composition showed the face, chest and arms, with one hand raised in blessing and the other holding a transparent orb. One reason Simon was worried about the painting was because he had not been able to afford the insurance premium he had been quoted for it. He had bought it three years earlier for around $10,000 – or so he had told the media – but it was now thought to be worth between one and two hundred million dollars.

Far from being the life of luxury many people imagine, dealing in art can be a precarious existence even at the highest levels, because selling expensive paintings is, well, very expensive. Top-end galleries

have vertiginous overheads. Walls have to be repainted for each show, catalogues printed, wealthy collectors wined and dined. Simon had spent tens of thousands of dollars restoring the boxed painting, and had not yet seen a penny return.

Solidly built, medium height, Jewish, fifty-something, soft-spoken, polite, Robert Simon is the kind of person who believes that modesty and understatement are rewarded by the higher forces which direct our lives. He projects a pleasant, but slightly brittle calm. 'Loose lips sink ships,' he likes to say, repurposing a slogan emblazoned on American propaganda posters in the Second World War to the business of art.

Simon leant backwards in his seat. He was overcome by that mood men fall into when they know the die has been cast, the pieces arranged on the board, and there is nothing more they can do except perform a sequence of now predetermined actions. There could be no more organising, influencing, persuading. It was all done, to the best of his abilities. The confinement of the long pod of the aircraft cabin and the sensation of forward motion provided by the thrust of four jet engines combined into a physical metaphor for this moment in his life.

Alongside the submarine, the parachute and the machine gun, the aeroplane was the most famous invention anticipated by the artist who had consumed Simon's life for the previous five years. Leonardo da Vinci was not the first human who had designed flying machines, and it is likely he never built one himself, but he had studied the subject for longer, written more, and drawn designs of greater sophistication than anyone before him. His ideas for human flight were based on years of watching and analysing the airborne movements of birds, bats and flying insects, and recording his observations in notes and drawings. As Simon felt air currents lifting up the plane, he recalled how Leonardo was the first to recognise that the movement of air was as important to a bird's flight as the movement of its wings.

On 15 April 1505 Leonardo completed a draft treatise *On the Flight of Birds*, also known as the *Turin Codex*. It was only about forty pages long, filled with unusually neat lines of text, written in black ink in his trademark mirrored handwriting, right to left, interspersed with geometric diagrams, and the margins sometimes decorated with tiny, beautiful sketches of birds in flight. Leonardo's early *ornithopters*, or 'birdcraft', had wings shaped like a bat's, because, as he wrote, a bat's wing has 'a permeable membrane' and could be more lightly constructed than 'the wings of feathered birds', which had to be 'more powerful in bone and tendon'. Leonardo positioned his pilot horizontally in a frame underneath the two wings, where he was to use his arms and legs to push a system of rods and levers to make them flap. Historians say Leonardo soon came to realise that the human body was too heavy, and its muscles too weak, to provide enough power for flight, so his later designs had fixed wings and were more like gliders. He imagined launching one, appropriately, from a mountain 'named after a great bird', referring to Monte Ceceri, or 'Mount Swan', in Tuscany. Relishing the avian metaphors, Leonardo wrote that his 'great bird will take its first flight on the back of the great swan, filling the universe with amazement, filling all writings with its renown and bringing glory to the nest in which it was born'. Nothing he designed ever flew. The contraptions were almost daft, but there was prophetic genius in his perception of the natural phenomena and laws of nature which gave rise to his machines.

Robert Simon knew that, whatever the outcome of this trip – and that really could be everything or nothing – it marked the pinnacle of his career to date in the art world. If everything went well, he would probably earn a place in the art history books. If not, he would remain respected but unexceptional. This flight also represented the apogee of something more personal. In common with most art dealers, there was a motivation behind his career which had nothing to do with money or success, and which had shaped his life for some-

what longer: an unconditional, unrelenting love for art; not modern and contemporary art with its splodges, squiggles and splats, but the great art of the past, especially the Renaissance, in which the eternal stories of the Bible and of Ancient Greece and Rome were brought to life by the melodramatic gestures of bearded men and golden-haired women, amidst thick gleaming crumples of silk and satin cloth, set against a classical backdrop of esplanades and porticos, temples and fortresses.

When he was fifteen, Simon went on a school trip to Italy. He remembers the winding roads of the hills around Florence, the low sun flashing through the cypress trees as the bus drove towards the town of Vinci, the birthplace of Leonardo *da* Vinci, *from* Vinci. (By coincidence, my parents would take me on a similar trip in my own teenage years.) 'Leonardo has been my deity for most of my life – and I am not alone,' Simon told me. 'He's my idea of the greatest person that civilisation has produced.' Over the decades Simon had seen every major Leonardo exhibition that had been staged, and every Leonardo painting, and 'as many drawings as I could'. His professional life, which now revolved around Leonardo, had taken him once before into the artist's sphere, in 1993, when he was asked to examine the *Leicester Codex*, one of Leonardo's revered manuscripts, for its owners. It is now owned by Bill Gates, but then belonged to the oil magnate Armand Hammer's foundation.

Simon's family were well-to-do but had not been deeply involved in art. His father was a salesman of eyeglasses. Simon was sent to an exclusive, academically orientated high school, Horace Mann School, in the New York suburb of Riverdale. Afterwards he specialised in medieval and Renaissance studies, and then art history, at Columbia University. He wrote his PhD on a newly discovered painting by the sixteenth-century Italian Mannerist painter Agnolo Bronzino, held in a private collection. A portrait of the Florentine Medici ruler Cosimo I in gleaming armour, it was known from the many copies, around

twenty-five of them, which hung in museums and homes, or sat in storerooms around the world. Art historians had long considered that the original work was the one in the Uffizi, Florence's famous museum. However, in a story with uncanny parallels to that of the painting that he was now taking to London, the young Simon had argued that he had identified an earlier original of this painting, the owners of which wished to remain anonymous. He published an article about it in the esteemed journal of connoisseurship and painting, the *Burlington Magazine*.[1] The painting now hangs in an Australian museum, as a Bronzino, although some experts still believe it was painted by the artist's assistants.

Simon climbed the ladder of the art business slowly. He was a research fellow at the Metropolitan Museum in New York. He taught briefly. He considered entering the academic side of the art world. 'The basic truth is I could not find an academic position in a place I liked,' he says.

He contributed reviews and articles to the *Burlington Magazine*, wrote catalogue essays about Italian Renaissance artists for Sotheby's and minor museum exhibitions from Kansas to Milan. In the 1990s he also wrote catalogues for selling exhibitions at New York's Berry-Hill Galleries, which collapsed under multiple lawsuits in the mid-2000s.

Simon found employment as an appraiser, one of the more discreet jobs in the Old Masters art market. The appraiser is invited by a collector to assess the quality and value of a work of art, usually with an eye to a sale or purchase, also for divorce settlements and for gifting or loaning to museums, for which there are lucrative tax breaks which American collectors wisely take advantage of. Just as often, the appraiser answers a call from a family that has inherited artworks. 'Often one is called in to value the estate of someone who has recently passed away, so it's not exactly a pleasant situation. Maybe two months after a person's died, you're in an apartment and the

place has not been touched and there are paintings still on the wall, often things that have been there for years and haven't been cleaned. You're looking at these paintings in poor light and poor conditions, and there's a certain treasure-hunting feel to it, but it's also compromised by the situation.' Years of experience had taught Simon to peer through the gloom of dark rooms, and the dirt of unrestored and unloved paintings, to perceive a glimmer of quality and art history.

Appraising is a job that embodies one of the great conundrums of the art world – the source of much suspicion and conspiracy theory – which is the interwovenness of scholarship and the market. As Simon says of his work as an appraiser, 'It's usually about the financial component, but often enough one has to do a fair amount of research to figure out what it is exactly that one is dealing with before one gets to the value stage.' The appraiser needs to be as familiar with the development of an artist's style as he or she is with archives of auctions and inventories, through which a painting's history may be traced. And the appraiser needs to understand the parabolas of the rise or fall of an artist's prices, as collated in subscription-only databases. This work, and indeed every kind of dealing in Old Masters, requires a capacious visual and factual memory. You need to be able to recall thousands of works of art, often in their smallest details.

Robert Simon began working as a dealer in 1986, and set up his own gallery in the house he bought in Tuxedo Park, New York state, in the early 1990s. He specialised in European Renaissance and Baroque art, and also took an interest in colonial Latin American art. He followed up his discovery of the Bronzino portrait with a handful of other Renaissance finds: a Parmigianino here, a Pinturicchio there. Over the years he has sold a handful of paintings and sculptures to American museums in Los Angeles, Washington, Detroit, Yale and so on. Curators appeared to respond favourably to his low-key, insistently academic manner. But whatever his past successes, he is the first to admit that he had never sold a work of art as exceptional, or as

expensive, as the one he had walked on board this aircraft with, carrying it in a custom-made aluminium and leather case supported by a long strap over his shoulder.

Inside the elegant case was a painting depicting Salvator Mundi, Christ as Saviour of the World, which Simon now believed to be by Leonardo da Vinci. He had only heard informally who would be looking at his picture in London. A few months earlier in New York he had shown it to the director of Britain's National Gallery, Nicholas Penny. Penny was impressed, thought it could be a Leonardo, and had sent one of his curators, Luke Syson, across the Atlantic to examine it. Syson had begun work on an ambitious Leonardo exhibition that would open several years later, and he saw potential in the painting too. Simon's trip to London was Penny and Syson's idea. It would be highly irregular, if not unprecedented, to include a recently discovered but unconfirmed work by such a famous artist, and one which was also currently on the market, in an exhibition at a museum of the international standing of London's National Gallery. Syson and Penny decided to discreetly convene a panel of the greatest Leonardo scholars in the world to judge the painting behind closed doors, before taking a decision on whether to include it in their exhibition.

Simon knew the odds would be stacked against him and his painting. There was a small army of Leonardists, as they were known, traversing the world, each with a long-lost and newly discovered Leonardo under their arm, trying to build an array of opinions favourable to their cause from museums and universities. Different art historians were allied to different paintings, and, such is the nature of academia today, all were competing with each other. There was the so-called *Isleworth Mona Lisa*, originally from a collection in a British country house but now owned by a consortium of investors who had set up a front organisation called the Mona Lisa Foundation. Western museums never showed it, but the *Isleworth Mona Lisa* had been exhibited in a luxury shopping centre in Shanghai. There was a

Leonardo self-portrait, known as the *Lucan Panel*, discovered in southern Italy by an art historian who was also a member of a society linked to the Order of the Knights Templar, founded in the twelfth century, to which, legend has it, Leonardo himself had once belonged. That painting had been on show at a Czech castle, but was turned down by the University of Malta. The Victoria and Albert Museum in London had the *Virgin with the Laughing Child*, a small terracotta which it had long attributed to the Renaissance artist Rossellino, but which this or that art historian periodically tried to reclassify as Leonardo's only known surviving sculpture. There was even another *Salvator Mundi* supposedly by Leonardo, known as the *Ganay*, named after its last known owner, the French resistance hero Jean Louis, Marquis de Ganay. The last time a painting's reattribution to Leonardo had been widely accepted was ninety-nine years ago: the *Benois Madonna*, which today hangs in St Petersburg's Hermitage Museum.

When Old Master dealers are not selling established masterpieces on behalf of an important client – the easy side of the business – they spend their time finding lost, overlooked or simply underrated works of art, dusting them off, identifying their author and then attempting to sell them as something bigger and better than what they had originally bought them as. The game is to exercise 'connoisseurship', using *the eye*, as it is known, to spot undervalued works. 'I liken this ability to recognise an artist from what he paints to knowing your best friend's voice when he calls on the phone,' Simon told me. 'He doesn't need to be identified, you just *know*, from a combination of the intonation of the voice, the timbre of it, the pattern of speech, the language that he or she might use. There are these elements that when put together amount to fairly distinctive patterns that you, as someone who knows this person, would recognise. That's really the essence of connoisseurship. There are many in the art community and the art historical community who dismiss it as some sort of voodoo process, but it's both very rational and at the same time is based on a

subjective understanding of things certain people have a knack for, or have studied …' It is not easy to find the right words to define this elusive process. No wonder Simon was nervous.

It's worth mentioning that the painting inside his case was a connoisseur's worst nightmare. It had once been as damaged as any Renaissance painting could be. It had a great slash down the middle; the paint had been scraped away to the wood on parts of the most important part of any portrait, the face; it had broken into five pieces and was held together by a ramshackle combination of wooden batons on the back, known as a 'cradle'. There was no contemporary documentation: not a contract, not an eyewitness account from the time, not a note in a margin about this painting, not one scintilla of evidence that dated from the lifetime of the artist, aside from the odd drawing of an arm or a torso, which bore only a partial resemblance to the finished picture. The painting had vanished from sight for a total of 184 of its estimated five hundred years of existence – 137 years between 1763 and 1900, and another forty-seven years between 1958 and 2005. When the great British art historian Ellis Waterhouse saw it at an auction in London in 1958, he scribbled one word in his catalogue: 'wreck'.

Robert Simon was on a high-risk mission. He hadn't even been able to afford the insurance premium for the full worth of his hand luggage. The auction house Sotheby's had helped him in the end by kindly writing a low valuation of the painting at only $50 million. His piece was fragile. He wasn't sure it would survive the plane trip, let alone make it onto the walls of a world-class museum or into the saleroom of a famous auction house. The panel on which the paint-ing had been executed had been pieced back together and beautifully restored, but under its freshly varnished surface lay a hidden flaw: a huge knot in the lower centre. When it was studied by technical panel specialists in Florence, they said it was the worst piece of wood they had ever seen.

THE WALNUT KNOT

The countryside north of Milan sweeps slowly up towards the still blue lakes and then the jagged outline of the Alps. Before the land rises to alpine heights there are foothills and farmland that were once dotted with walnut trees, whose thick canopies of smooth-edged leaves shuffled in breezes and shook in winds. Their dense webs of branches broke up the hot sunlight, and farmyard cats scratched their backs on the trees' distinctive, deeply furrowed dark bark. The trees grew quickly, developing thick trunks – up to two metres in diameter – and lived up to two hundred years. They are mentioned in medieval Italian legends about female shamans who summoned the spirit world by dancing around them. Millennia earlier, according to Roman myth, Jupiter, the most powerful of all the gods, subsisted on walnuts when he walked among men.

In his notebooks, Leonardo studied the structure of the walnut and other trees in the same way he studied so many other phenomena of the natural world. He observed how the colouring of the leaves was a product of four things: direct light, lustre (reflected light), shadow and transparency. He went on to analyse more complicated principles governing the structure of trees. He discovered one of the basic

mathematical laws of their growth, that the combined size of a tree's branches is equal to the width of its trunk, and the smaller branches that spring from larger ones follow the same proportional rule. At the heart of Leonardo's life work was this pairing of the minutely detailed observation of nature with an understanding of the principles governing the appearance and behaviour of things, which today we call empiricism. For Leonardo, something had to be understood before it could be drawn. In a note dated April 1490 in his largest set of notes, the *Codex Atlanticus*, he wrote: 'The painter who merely copies by practice and judgement of the eye, without reason, is like the mirror, which imitates within itself all the things placed before it without cognition of their existence.' In Leonardo's paintings, the detail can be overwhelming. Each leaf, each fold of cloth, each curl of hair can be different from the one beside it, yet each may share the same formal structure.

Leonardo's mind was poised between the medieval and the modern eras,* which is one of the reasons he is such an iconic and mysterious character today. His notebooks give the thrilling sensation that the modern idea of knowledge is being invented on their pages. The *Codex Atlanticus* contains, amid the drawings of machines, aeroplanes, weaponry and human anatomy on its 1,119 pages, enigmatic prophecies that double as riddles for court entertainment, a literary genre dating back to the Middle Ages.[1] For example: 'There shall appear huge figures in human shape, and the nearer to you they approach, the more will their immense size diminish' (shadows), and 'You shall behold the bones of the dead, which by their rapid movement direct the fortunes of their mover' (dice). He also predicted that 'There will be many who will be moving one against the other, holding in their hands the sharp cutting iron. These will not do each other any hurt

* Historians see the 'modern' period as beginning around 1500. Often they refer to the sixteenth and seventeenth centuries as 'early modern'.

other than that caused by fatigue, for as one leans forward, the other draws back an equal space; but woe to him who intervenes between them, for in the end he will be left cut in pieces' (a saw). The humble walnut tree, too, receives a mention here: 'Within walnut trees, and other trees and plants, there shall be found very great hidden treasures.' The walnut tree from which the single plank of wood was hewn on which the *Salvator Mundi* was painted was not concealing treasure, but it – or at least the section used for our painting – did hold its own secret: a deformity dangerous for artists.

For many years the tree from which the *Salvator Mundi* sprang would have performed its duty providing nuts for culinary and medicinal purposes. Its annual harvest would have enriched Renaissance pasta dishes such as spiced walnut linguine, or fig and walnut ravioli, or would have been combined with the tops of the bitter rue plant in concoctions to ward off the plague. Then one day the decision would have been made to sell the wood of the tree. It would have been dug up with spades rather than felled with an axe, since the best wood is near the base. Some of the timber would have been used to make ornate carved tables, chairs and caskets for the homes of noblemen. Other blocks would be reverentially carved into statuettes of saints and placed on the ends of choir stalls, or in the niches of altars. The finest parts would be used for the intricate Renaissance craft of *intarsia*, or wood inlay: different types of wood, each a different shade, were cut into delicately shaped strips to build sepia pictures of landscapes or religious scenes, which were set into cabinets and desks. This walnut tree was cut into planks for all these purposes, and a single plank, 45cm wide and 66cm high, would become our painting.

The walnut timber of the *Salvator Mundi* was brought on a cart to Milan, a city with a population of between 150,000 and 300,000 people. Three times the size of Florence, Milan was evolving in concentric rings, its population spilling out beyond the city walls into

new suburbs. The nobles lived in high-walled palaces, with thick
rusticated façades, behind which lay inner courtyards with trees and
fountains and sculptures on pedestals, cut off from the noise of the
street. The city skyline was dominated by the Duomo, the cathedral,
in the centre, and in the north-west by the Castello Sforzesco, the
palace of Milan's ruler, Duke Ludovico Sforza. There were shipyards,
taverns, bakeries, a debtors' prison, cloth and shoe shops. There were
quarters specialising in different trades: one full of mills producing
cloth and paper, or sawmills for cutting wood; another grouping arti-
sans working with wool; another with metalworkers. There were 237
churches, thirty-six monasteries, 126 schools and over a hundred
practising artists. Milan was, in Leonardo's own sharp words, a 'great
congregation of people' who were 'packed like goats one behind the
other, filling every place with fetid smells and sowing seeds of pesti-
lence and death'. There were periodic outbreaks of bubonic plague,
which would one day kill several of Leonardo's assistants. Leonardo,
who was (at least in his own mind) an urban planner as well as an
artist and scientist, concocted plans to redesign the city, but they
never left the drawing board.

Somewhere in the narrow streets of Milan was the carpenter or
panel-maker who supplied the wood for the *Salvator Mundi*. This
kind of artisan was the first of several craftsmen involved in the
execution of a Renaissance work of art such as the *Salvator*. They
were often required to construct large and intricate surfaces for
paintings, building up a flat surface from planks of wood connected
with animal glues and grooved joints, and combining panels of differ-
ent shapes into elaborate altarpieces with wings on hinges. But the
creation of the walnut panel for the *Salvator Mundi* was a relatively
mundane task, since it was cut as a single piece of wood; it is therefore
all the more strange that it was so poorly executed.

The size of the panel was standard for devotional paintings, for
which there was a large demand among wealthy Italian families.

Typical subjects were the Virgin and Child, various saints including John the Baptist, and Christ, carrying the cross, crowned with thorns or as the Saviour of the World. Such pictures were hung in the owner's bedroom or private chapel.

Wood has to be prepared for painting with various undercoats, just as canvas is usually primed. In fifteenth- and sixteenth-century Italy, this was sometimes done by the artist's assistants, but often by the panel-maker's workshop. The *Salvator Mundi*'s panel was prepared more or less as Leonardo said it should be in his notebooks:

> *The panel should be cypress, pear, service tree or walnut. You must coat it with a mixture of mastic* [also known as gum Arabic, a plant resin] *and turpentine which has been distilled twice and with white* [lead] *or, if you like, lime, and put it in a frame so that it may expand and shrink according to its moisture and dryness … Then apply boiled linseed oil in such a way as it may penetrate every part and before it is cold rub it with a dry cloth. Over this apply liquid varnish and white with a stick …*

Florentine artists had their wood panels prepared with gesso, a chalky substance, but Leonardo, in common with Milanese painters, preferred a mixture of wood oil and white lead as the ground. He had his 'sized' with a first layer of animal glue. Then two layers of undercoat were applied, one made of a recipe of lead white pigment, with little grains of soda-lime glass and a binding agent of walnut oil; the second of more white paint, mixed with some lead tin yellow and some finer glass. The result was a surface with an off-white colouring. The addition of glass was a familiar trick used by artists at the time to lift the brightness of their pictures and accelerate the drying of the paint. Light on a painting does not reflect only off the top surface of paint. If the layers are thin enough and partly transparent it can pierce through layers of pigment and be bounced back by fine granules of

glass, creating an effect of translucence. For the final process of the preparation – I confess I do not know if this was applied in the case of the *Salvator Mundi* – Leonardo advised 'then wash it with urine when it is dry, and dry it again'.

But the panel-maker had done an exceptionally poor job. Deep within the prepared panel, unbeknown to the artist who was about to receive it, behind the preparatory layers of oil, gesso and urine lay a hidden problem. Unlike the walnut panels on which Leonardo painted other famous portraits such as *La Belle Ferronnière* and *Lady with an Ermine*, the *Salvator*'s panel contained a large knot in the lower half, right in the centre. Such knots were usually filled in with vegetable fibres, wood filings or fabric, as the Florentine artist Cennino Cennini advised in his fifteenth-century painter's manual. But, in a second oversight, difficult to reconcile with the expertise of Renaissance woodworkers, who well knew the properties of their materials, that was not done to this piece of wood.[2] It seems that either the panel-maker or an assistant in Leonardo's workshop to whom the task had been delegated was careless with the selection and preparation of the wooden panel, and the defect was then hidden under layers of primer.

Even so, Leonardo would surely have taken a look at the back of the panel and seen the knot. The likelihood of that raises a second puzzle. Leonardo is known to have been interested in the technical aspects of making a painting. It seems out of character for him to accept such a flawed surface to paint on, especially if the work was destined for an important client. In humid and dry conditions a knot like this expands and contracts at different speeds from the rest of the wood, so that if the panel, looking far ahead into its future, became dried out, or wet, it would push and pull, perhaps taking the panel to breaking point, and creating splits and cracks. Alternatively, a knot is a weak point, so that if the picture was one day to be knocked or dropped, it could split around the knot. The knot in the walnut panel

on which the *Salvator Mundi* was painted was a gnarled, ticking time bomb.

BURIED TREASURE

Squinting at a computer screen one day in his home office, Alex Parish discovered the *Salvator Mundi*. It was listed for sale in an online catalogue of an obscure auction house in New Orleans, the St Charles Gallery. This was in 2005, three years and a few months before Robert Simon would board his flight to London carrying the painting under his arm. Parish thought the picture looked promising, and the price was so low that it was worth taking a small risk. He remembers: 'I had a recollection of a similar thing that had come up with Sotheby's a few years before. I bought the picture because I know this is just the sort of thing other people like to speculate on.' He contacted Simon, who had himself also spotted the picture, as he subscribed to the gallery's mailing list and received a hard-copy catalogue by post. Parish suggested they buy it together, fifty-fifty, the same way they had jointly bought many works before. Simon agreed.

Until he discovered the *Salvator Mundi*, Parish was a small-time Old Masters dealer whose career in the art world had been full of false starts, along with the treadmill of low-value backroom sales.

The art world has a glamorous image as a global nomadic court presided over by latterday kings and queens – the blue-chip gallerists

(gallery owners), artists whose work fetches million-dollar-plus auction prices, and multi-millionaire collectors, around whom swarm smaller galleries and dealers and emerging artists. In the second half of each year the entourage moves en masse from art fair to art fair: Basel, the FIAC in Paris, TEFAF in Maastricht, Frieze London, the Armory and Frieze New York, Hong Kong, Miami, taking in auctions in London and New York on the way, in a blaze of parties and packing cases.

And yet, this is only the sparkling surface. Behind the scenes are many other people who are not born into riches, who do not have a large designer wardrobe or a taste for high society, and who are drawn into the art business not so much by a love of art, which everyone gives as their primary motivation, but by their hunger for an experience much more exciting, akin to gambling or hunting for buried treasure. For them, the attraction is the exhilaration of buying a painting from the first show of an unknown graduate artist, in the hope that five years later he or she will be part of a group show in a public institution. Or, as is the case in our story, coming across, after years of searching, an old painting ascribed to a third-rate provincial school but which, they believe, might be by an artist of great renown.

Such successes are far from guaranteed. Like any other industry to which people are drawn by the glow of fame and fortune emanating from those at the top, the art world has a very narrow peak of achievement and a wide base of footsoldiers, bottom-feeders and also-rans. One of those at the base of the hierarchy was Alex Parish. As he himself says, 'I've been down to a suitcase more than once in my life.' Born in 1954 into a lower-middle-class American family, he majored in art history at Ohio Wesleyan University and then moved to New York, where he worked in the gift shop of the Museum of Modern Art. He left after two years and tried unsuccessfully to set himself up as a dealer, but 'through a combination of zero training, zero initiative, a certain amount of youthful lack of discipline, etc., I ground to a halt

after a few years'. He went to London in the early 1980s and took a one-year course in the art market, not at a prestigious establishment like Sotheby's Institute of Art, but at a private school, the New Academy for Art Studies, run by art historians Lucy Knox and Roger Bevan. When he returned to New York, he worked for a while in another gift shop, this time at the Metropolitan Museum of Art, and then 'begged to get the shittiest job at the shittiest auction house in New York City, and managed to do it. I worked there for two years and ended up writing their catalogue.' While he was there he succeeded in identifying an interesting-looking undervalued painting that had been consigned to auction, the kind of painting known in the trade as a sleeper. The *Salvator Mundi* can well lay claim to being the greatest sleeper ever discovered.

The painting Parish spotted was a seventeenth-century Dutch pastoral scene, which he brought to the attention of the renowned Old Masters gallery Colnaghi. It was a gesture that displayed an appropriate combination of knowledge and ambition. Colnaghi took him on, and he worked for them in New York for two years, from 1980 to 1982, but not in a high-profile position. It was not an easy business in those days, he recalls. 'No one was selling old Italian pictures or English pictures, or anything like that, in New York at the time.' After a couple of years he went to work for Christie's. It was another low-paid job, but he was becoming increasingly fluent in the lingo of art market insiders: 'I was essentially the guy on the floor, taking the pictures into the back room, black-lighting them [putting them under an ultraviolet light to show up how much over-painting had been done], turping them down [cleaning them with turpentine], showing them to all the trade [that is, not to private collectors but to dealers and gallerists, who usually get the first look at new arrivals].' He had one further invidious task: 'I was the one who always got sent down to the front counter to tell people that their van Dyck was really not what they thought it was, and thank you for coming.'

At Christie's, Parish found once again that he had a talent for spotting sleepers. 'I was working late one night in 1985,' he remembers. 'I was the only person around from my department, and a picture came in. I got a call from a girl downstairs, "Please come take a look at this painting before you leave." I went down and there was an enormous picture, four feet by six feet, with a couple of mirrors, just dropped off by some picker.' A 'picker' is a dealer-middleman who buys from myriad regional auctions, from the estate sales of deceased collectors and from antique shops across the United States, and then takes the works to New York and consigns them for sale, hopefully for a higher price. 'I looked at it, and I was like, "Oh my God, this could be by Dosso Dossi."' You need a thorough knowledge of sixteenth-century Italian painting to know a Dosso Dossi when you see one. He is one of those few artists, like El Greco or Gustave Moreau, who seem to exist outside history. His mysterious paintings of obscure allegories and mythological scenes, featuring magicians, pygmies and unicorns alongside the more conventional array of saints and madonnas, all bathed in the gentle, golden evening light of Venice, reach forward from the Renaissance to the Primitivism and Surrealism of the twentieth century.

'So I told the girl, "Don't tell anyone about this. It could be worth $100,000,"' Parish told me. 'And I called my boss, who was still over at the main building, and I said, "I think there's a Dosso in the warehouse." And he was totally dismissive. "Shut up. Get back to work." End of story. What was I to say? *I'm* just a flump. He was an expert. So I totally forgot about it. About two weeks later, I'm in a meeting with someone, and I get a call from him and he says, "Oh my God, there's a Dosso in the warehouse." And I'm like, "Yes."' Parish's deadpan indicates a life full of rejections because he didn't come from the right social strata for the art world.

Experiences like these led Parish to an epiphany. 'The pickers and runners would arrive at Christie's with a truckload of paintings, and

I would value each picture. I'd look at what they had and it was like, "No, that's $4,000. That's $2,000. We don't want that, we don't want that, we want this."' He could see that most of the runners did not know enough about art history to know what they were buying. 'I saw a gap in this supply chain for someone who had the knowledge to go out and look in the backwaters of America.'

So he set himself up once again as an independent dealer, specialising in Italian painting. Once again, it didn't work out. It was still difficult to find buyers for the Italian pictures he unearthed. In the meantime, his wife gave birth to triplets and he moved out of New York to a larger house. He now had a large family and a small income. It was a hand-to-mouth existence, buying old paintings and then 'shovelling' them through the auction houses. It was around this time that he became a born-again Christian, a highly unusual commitment for someone in the art world.

Help came around 1996 in the form of a phone call from the largest Old Master dealership in the world, founded by Richard Green. Green has galleries on Bond Street in London, but was looking for someone to find paintings for him in the United States. 'In their heyday, they were flipping,' says Parish – using another art market term, this time referring to fast-turnaround buying and selling – 'something along the lines of six hundred pictures a year – two hundred at fairs, two hundred through their galleries and two hundred through auctions.' Parish worked for Green's son Jonathan, who told him, 'Go and look for pictures for us.'

Jonathan Green sent Parish into the hinterlands of America to scour auction houses, estate sales and remote regional galleries for promising works of art. 'I needed to be trained at first, because I didn't know anything about the breadth of merchandise they bought, but it turned out to be a happy marriage because I didn't hugely affect the bottom line there,' Parish told me, indicating that his salary was modest. Meanwhile, his contract permitted him to buy and sell

works of art for himself on the side, although a gentleman's agreement meant his employer got first refusal. In addition to travelling, he subscribed to trade newspapers and catalogues, going through them and asking for Polaroids of any pictures that looked promising. But, he says knowingly, 'Within a few years the digital revolution totally reinvented this business.'

At the time, the United States was awash with paintings whose value their owners did not have a clue about. From the late nineteenth into the middle of the twentieth century, American collectors had 'vacuumed up' European Old Master paintings, usually buying from impoverished European aristocrats whose wealth had been eroded by the recessions of the late nineteenth century and the 1930s, and by the two World Wars. 'All the Americans were desperate for class, and all the Europeans were desperate for money,' says Parish. This was the era in which the precursors of today's billionaire art collectors, robber barons like J.P. Morgan, Andrew Mellon and John Rockefeller, amassed peerless collections which later formed the foundations of the country's great museums. But less prominent middle-class families also collected. The paintings they bought were often unsigned and in poor condition. Over the years they had been damaged, become the victims of misguided restoration, and been passed down from generation to generation until they reached the hands of people who weren't interested in art. 'These pictures were finally starting to bubble up into the market.'

Thus was born a perfect storm of lightning-fast information technology, surging supply and deep demand. Parish was a like a meteorologist who tracked the new commercial climate. 'There was this frontier in terms of Old Masters, where all these pictures were coming up and no one knew what they were being sold, and I was looking at that frontier.'

Parish acquired from a colleague a database of five thousand auction houses across America. He whittled the list down to about a

thousand that sold paintings. If the auction houses didn't upload online or send out hard-copy catalogues, Parish got on their electronic mailing lists and asked for jpegs of anything that looked interesting. 'I was in a tiny office, surrounded by books, and I spent – I'm not kidding you – fourteen hours a day going through this thing. Hunting, hunting, hunting. I mean, literally: click, click, click, click. I was not going to let a picture sell in this country that I didn't know about.'

Soon Parish was buying a painting a week for Green, using this database. Green requested 'sporters and nautical' (that is, paintings of sporting scenes and sailing ships) or 'Victorian and silks and satins' (eighteenth- and nineteenth-century portraits of noblemen and ladies dressed in expensive fabrics). The art market had embraced the online database, and Parish was poised to show what a powerful tool it could be.

Parish often turned to other dealers he trusted, like Robert Simon, to share the financial risk of buying works in which Green wasn't interested.* At his peak Parish was holding stakes in up to seventy pictures over the course of a single year, taking 50 per cent, 33 per cent, and occasionally 25 per cent shares in the purchases. It was a very hit-and-miss business. 'If I had a picture for $1,500 and it

* Jonathan Green recounts a story of how he found himself in a taxi with Parish in London in the mid-2000s. Parish pulled out his mobile phone and showed Green a detail of a blessing hand. It was from the *Salvator Mundi*, but Green didn't know that. 'What do you think of this?' he asked nonchalantly. Green nodded appreciatively. Green says Parish never offered him the painting, and told me, with magnanimity, 'I don't hold anything against him.' Parish has a different version of the story. 'I had bought the *Salvator Mundi* at least a year or two prior to leaving Green, and I'd mentioned it to them a couple of times, but they were so contemptuous of me in some respects. You know, "Just, shut up. Go get us coffee." That kind of tone of voice. So, OK. Okie dokie …' Parish drew out the last two words with his excellent drawl, and never finished the sentence.

brought $15,000 at auction, then that to me would be like, "Hallelujah!" I had a couple of years in a row where I would land one picture, be it for $500 or $5,000, and it would come back at about $100,000. It was really great. I think I did that three or four times in a row.' But there were also times when pictures Parish bought and consigned to auction did not sell. 'It's difficult, particularly when you're buying from the internet and you're buying from small photographs, which is what the trade had evolved into. You have to "spec" from photos. And it is speculation. A certain percentage of them, when you see them in the flesh, are stinkers. They come back to punch you in the nose. I was selling those things off at whatever price I could get, 99 per cent of them at a loss, just to get some seed capital back.'

And then one day Parish was clicking away as usual when he spotted the listing for the *Salvator Mundi* in an online catalogue from the St Charles Gallery in New Orleans. It was Item 664. 'After Leonardo da Vinci (Italian, 1452–1519)' it began, and then, '*Christ Salvador Mundi*, oil on cradled panel, 26 inches by 18½ inches.' Was the misspelling of the Latin 'Salvator' perhaps due to a Spanish-speaking typist? 'Presented in a fine antique gilt and gesso exhibition frame.' The estimate – an auction house always states the price it thinks the lot may achieve – was just $1,200 to $1,800. The painting was illustrated in the hard-copy catalogue that Robert Simon saw at the same time, with a very low-resolution black-and-white photograph. Christ's clothes had become a gloomy grey, his cheekbones and forehead glimmered oddly out of the murky darkness, and the fingers of his blessing hand seemed illuminated by pale candlelight. 'It looked kinda interesting. School of Leonardo is always interesting, and the price was very good,' Parish told me with a grin.

Parish asked the St Charles Gallery down in New Orleans to send him a photograph. 'When it arrived, I pulled it out, I held the picture, and in an instant I could see, like any Old Master dealer can, this part

is totally repainted, this part is pretty much untouched, and this part, which included the hand, was like, "Oh my God, that's period! That's period." You know what that means? Period means it's of the era it's trying to be. You see seventeenth-century rehashes of Renaissance pictures, nineteenth-century rehashes of Renaissance pictures. This was clearly of the era it purported to be from. And it was pretty good quality. I'm looking at the hand and I'm looking at the drapery and I can clearly see this is not simply one of numerous copies. This is an extremely good, high-quality copy.'

He and Simon decided to buy it. The rest, as they say, is art history.

Nothing in the known universe, no item, object or quantity of material, has ever appreciated in value as fast as the *Salvator Mundi* attributed to Leonardo da Vinci. It was sold in May 2005 to Simon and Parish for $1,175 – a sum considerably less than the figure of 'around $10,000' the pair later quoted to the media. In 2013 they sold it for $80 million, then four years later, in 2017 – a mere twelve years and six months after it was sold for not much more than $1,000 – it was auctioned by Christie's New York for $450 million.

CHAPTER 4

PAPER, CHALK, LAPIS

Leonardo was the most prolific draftsman of his age, with approximately four thousand surviving drawings attributed to him, four times the number left by his most active contemporaries.[1] He drew diagrams, emblems, allegories, architecture, anatomy, maps, landscapes, biblical figure groups, nude studies and portraits from life. He was an expert in silverpoint, using a hard-edged metal stylus to draw lines into paper covered with a mixture of pulverised bone and mineral colours. He liked ink and quill pens plucked from the wings of domestic geese. After the turn of the sixteenth century he preferred chalks: red, black and white. He often touched up his drawings with white highlights in yet another medium, gouache. Some of Leonardo's early paintings, *St Jerome* and *Adoration of the Magi* among them, progressed little beyond the full-size drawing stage.

As a draftsman, Leonardo was a revolutionary. To him we owe the world's first dated landscape sketch, the world's first 'exploded' diagram of machine parts, and the world's first freeform compositional sketches, in which he plans – or perhaps rather finds – a composition out of a rapid-fire maelstrom of spontaneous, half-automatic lines, scribbled in ink and chalk. One of his most famous

and most reproduced works is a diagrammatic drawing, *Vitruvian Man*, in which a man's body with extended limbs forms a square and a circle. According to the sixteenth-century Italian writer Giambattista Giraldi Cinzio, citing the reminiscences of his father, who had observed Leonardo first-hand, the artist rarely left his studio without a sketchbook hanging from his belt. In his notes for his treatise, Leonardo issued the first known exhortation about drawing from real life:

> As you go about town, be always alert when out walking, to observe and consider the actions of men while they are talking, thinking, laughing or fighting together, what actions are within them, and what actions the onlookers are doing ... and make brief notes of these forms in your small notebook, which you must always carry with you, and it should be of tinted paper, so that it cannot be erased, and must be kept diligently, because the positions and actions are many, and the memory is unable to remember them all.

The surviving studies for the *Salvator Mundi*, however, which are drawn in red chalk on red tinted paper, were executed in the studio, because they were sketches of clothing – or drapery, to use the art historian's terminology – and they were almost certainly based on draped mannequins, not live models. Today these drawings can be found in the Royal Collection at Windsor Castle.

'Leonardo sometimes made clay models,' wrote Giorgio Vasari, the great sixteenth-century Florentine art historian of the Renaissance, 'draping the figures with rags dipped in plaster, and then drawing them painstakingly on fine Rheims cloth or prepared linen.' Drapery was one of the essential components of Renaissance painting, and acted as a form of messaging in itself. The classical robes in which the saintly starring cast of Renaissance paintings were dressed elevated biblical stories to the level of the Antique, fusing the two great sources

of wisdom of the age, the Bible and classical civilisation. Their sheen, dips and pleats were bravura exercises in realism, which advertised the illusionistic skill of the artist. There is a series of sixteen drapery studies drawn on linen, usually dated to the early 1470s, some attributed to Leonardo at the tender age of nineteen. The young artist shows the texture and characteristics of the fabric depicted as well as indicating the body underneath, the cloth flowing with curving arabesques and hard-edged angles, receding in pockets of shadow, and gleaming where it catches the light.

Leonardo usually planned his paintings with three stages of drawings. First, there were the studies of body parts, gestures, faces, drapery, anatomy and landscapes, drawn from life or sometimes from models or classical statues. In a second stage, he made sketches of combinations of figures or laid out the entire composition. Last came full-scale cartoons, which were traced onto the panel on which the final painting would be executed. There must have once been many preparatory drawings for the *Salvator Mundi* – for Christ's face, the blessing hand and the orb, and perhaps for the entire composition – but only two pages of sketches survive. On one sheet there are two drawings – one of a man's torso clothed with an episcopal garment known as a stole, and the other a smaller depiction of a forearm emerging from a rich crumple of sleeve, drawn in red chalk and then overdrawn in white. On the second sheet is a forearm with a sleeve finishing in a cuff, with drapery around it.

These sketches provide a host of intriguing clues about the *Salvator Mundi*. The fabric covering the chest is drawn in obsessive detail, one of the characteristics of Leonardo's style, with thin rivulets of cloth, each one differentiated, running down from the band of embroidery around the neck, which has bunched up the fabric in tiny pleats. Looking at the painting, on the left side of the chest, just above a diagonal band, the garment's fabric has become curiously scrunched. The artist seems to take particular care in showing how untidy this

part of the clothing is. The shape and position of this crumple is momentous. At exactly the spot where the Holy Spear pierced Christ's body on the cross, the wound of the Passion, it forms the Greek letter omega, a symbol of the divine. Novelists and historians of varying academic qualifications have written numerous outlandish interpretations of hidden symbols they have discerned by carefully squinting at Leonardo's paintings, such as the *Virgin of the Rocks* and the *Mona Lisa*, but here in the *Salvator Mundi* there is a real one.

Other aspects of these sketches muddy the artistic waters of attribution. The forearm on this same page seems to have been drawn not by Leonardo but by another artist entirely, surely one of Leonardo's assistants. In the 1930s, the great Leonardist Kenneth Clark catalogued the collection of Leonardo's drawings owned by the British royal family, which included both of these sketches. He observed that the draftsmanship of the forearm is heavy-handed compared to the chest, and that, furthermore, the hatching runs left to right, while Leonardo's always runs right to left, as one would expect of a left-handed artist.

The second drawing holds a puzzle too. The sleeved limb emerges from two loose loops of fabric, which closely resemble the drapery around Christ's arm held up in blessing in the painting. But in the drawing the forearm is sleeved with a cuff at the end; in the painting it is bare. As a preparatory study it bears a surprisingly loose relationship to the finished painting.

We can vaguely date both drawings to the first decade of the sixteenth century, because of the evolution of Leonardo's style and technique. He spent most of his early career sketching in pen and ink or silverpoint. In the mid-1490s he began using red chalk for studies for the apostles in *The Last Supper*. In the first decade of the sixteenth century, chalk became Leonardo's primary drawing medium. The material was better suited to the style he was developing. Chalk's softness allowed him to intensify his *sfumato*, the most gradual light-

to-dark transitions which became the hallmark of his painting.[2] It is in this later drawing style that the preparatory sketches are executed.

Drawing is the common denominator between all of Leonardo's diverse activities as engineer, scientist and artist. And yet Leonardo had criticisms of drawing. One of the fundamental aspects of his thinking, which set him apart from his contemporaries, was his radical attitude to line. 'Lines are not part of any quantity of an object's surface, nor are they part of the air which surrounds this surface,' he wrote. 'The line has in itself neither matter nor substance and may rather be called an imaginary idea than a real object ... Your shadows and lights should be blended without lines or borders in the manner of smoke losing itself in the air ... O painter, do not surround your bodies with lines!' There were no lines in the real world, he said, so don't paint them.

In the cool and pungent backstreets of Milan, in the dark shops of the apothecaries, majolica vases lined the shelves, full of herbs, medicines, chemicals and pigments – the raw material for colouring the world. These were roughly chopped preparations of minerals, insects, animal remains and plants, waiting to be finely ground into powder, mixed with egg yolk or oils to make paint, and with water for dyes. The customers came and went – dyers, glassmakers, tailors, the manufacturers of ceramics and furniture, manuscript illuminators and painters.

Behind every Leonardo painting lay a global network of anonymous collaborators, with professions far removed from the creative arts. The minerals for pigments came in ships from distant Central Asian cities that few Europeans had seen, often via Syrian merchants. Some were manufactured in Venetian or Florentine laboratories run by religious orders. There was ultramarine powder ground from blue-veined chunks of lapis lazuli by the Jesuits of the Florentine Convent

of Santo Giusto alle Mure; the semi-precious rock was imported from what is now Afghanistan and Uzbekistan, via Damascus. A more sensibly priced version of the same colour, from the same convent, was made of azurite acquired from Austrian and Balkan mines and manufactured with copper oxide. The chromatic reputation of these priests was so high that the Florentine contract commissioning the *Adoration* specified that Leonardo had to buy his colours from them. A red pigment came from the dried bodies of kermes lice from the eastern Mediterranean, mixed with water, alum and soda. Another came from boiled brazilwood, which Spanish and Portuguese merchants imported from the Latin American colonies. A third red, 'dragon's blood', was a resin derived from various plants, and was used both as a medicine and a varnish. Cochineal was a scarlet named after the insects from which it came, and was imported to Italy via Antwerp. Rubies, which could be ground down into an expensive colour, were available too. White, ochre, and yet another red came from different treatments of lead. A dark 'bone black' came from a distillation of carcasses. Verdigris, a green familiar to us as the patina on old copper, was obtained by exposing copper plates to vinegar. Gold leaf was made from old coins, the thin sheets carefully placed between sheaves of paper in books. Saffron was used to make an intense yellow colour when mixed with alum and egg yolk. Thus, science and trade formed a basis for art.

Leonardo would probably have sent one of his teenage apprentices to buy the pigments, a shopping list in his hand. The artist's notebooks contain to-do lists, often compiled before a long journey, which give an indication of the errands his 'boys' had to run. One, from 1490, reminds the apprentice to get hold of 'a book that treats of Milan and its churches, which is to be had at the stationers on the way to Cordusio [a piazza in the centre of the city]'. Another, from the years 1508 to 1510, quite possibly the time when Leonardo began to work on the *Salvator Mundi*, lists 'boots, stockings, comb, towel, shoelaces, penknife, pens, gloves, wrapping paper, charcoal, spectacles

with case, firestick, fork, boards, sheets of paper, chalk, wax, forceps …' This list may refer to items he had already bought from Milan's shopkeepers and kept in his studio, but Leonardo does add a note about one thing that he clearly didn't have: 'Get hold of a skull.'

For the *Salvator Mundi*, the apprentice would have had only a small number of pigments on his list, because this painting was made with remarkably few colours: lead white, lapis lazuli, lead tin yellow, vermilion, red iron oxide, carbon and charcoal black, bone black and umber. Back in the studio, the assistants would then have to grind the colours to create a fine powder. However, on this occasion, as later restoration showed, they didn't do a very thorough job: the brilliant blue grains of the lapis lazuli were rather coarse compared to those in Leonardo's other paintings.

There was probably a cartoon by Leonardo for the entire composition of the *Salvator*. This would have been pricked with tiny holes, or *spolveri*. The cartoon was laid on top of the panel, dusted with fine powder and then removed. An outline of the composition, traced by the dark dust seeping through the pinpricks, remained. Microscopic photographs of the *Salvator Mundi* have revealed a handful of tiny black dots, but only enough to raise the possibility, not the certainty, of a cartoon. The artist definitely used a pair of compasses to make the circle of the orb, because there is a hole where the compass point went in. Then another layer of underpainting was added in thin, semi-transparent washes of browns and blacks, some derived from charred wood, others from charred bones.

Leonardo was a member of the Arte dei Medici, Speziali e Mercai – the Guild of Doctors, Apothecaries and Mercers. He had his own recipes for making colours, and he listed many of them in his notebooks. That was unusual for a Renaissance painter, but it fits our knowledge of Leonardo the artist-scientist. The master of light and shade was particularly interested in the variety of ways he could mix colour for shadows: 'Take green [i.e. malachite] and mix it with bitu-

men, and this will make the shadows darker. And for lighter shades mix green with yellow ochre, and for even lighter green with yellow, and for the highlights pure yellow. Then take green and turmeric together and glaze everything with it … to make a beautiful red take cinnabar or red chalk or burnt ochre for the dark shadows, and for the lighter ones red chalk and vermilion, and for the highlights pure vermilion, and then glaze with fine lake.'

We don't know how the artist of the *Salvator Mundi* prepared his palette, but there is a description by Vasari of the way another artist, who was taught in the same studio as Leonardo, did. Lorenzo di Credi and Leonardo were both trained by the Florentine master Andrea Verrocchio, and sometimes worked on the same pictures together. Di Credi, says Vasari, 'made on his palettes a great number of colour mixtures, so that they went gradually from the lightest tint to the darkest, with exaggerated and truly excessive regularity, so that sometimes he had twenty-five or thirty on his palette, and for each of them, he kept a separate brush'. Such preparation would also have been necessary for the delicate, painstaking and time-consuming manner in which the *Salvator Mundi* was painted.

Now Leonardo could pick up his brush and begin to paint – should he have had the inclination, of which we cannot be certain. Unlike every other picture Leonardo is widely recognised to have executed after his fame was established, there is no documentary evidence that his hand ever painted the *Salvator*. That is not in itself an unusual problem for a Renaissance painting. Thousands of artworks before 1700 were unsigned and undated, leaving art historians with thousands of picture-puzzles to solve. The tool of connoisseurship was developed two centuries ago specifically to tackle this problem. But it is a process which art dealers such as Robert Simon and Alex Parish cannot undertake on their own, since however gifted they might be as connoisseurs, they are potentially compromised by commercial motivations. Thus, it was time to call in the experts.

CHAPTER 5

ZING!

Martin Kemp is a powerful academic, who positions himself a streetwise scholar, resistant to the elitism of the art world, not afraid to defend his corner. When he speaks, the sentences are elegantly formed and the insights – usually about Leonardo – are admirably precise, but the delivery is stern, as if to ward off anyone who might disagree.

Despite all his decades of scholarly study, he tells journalists modestly that he is just in 'the Leonardo business', although he has written an autobiographical account of his adventures in it, *Living with Leonardo*. He professes to be understanding of, even apologetic towards, people who have misunderstood the artist to whom he has dedicated his academic career: 'It is worth remembering that many of those who have developed untenable Leonardo theories have invested a large amount of time and emotional commitment in their researches,' he once wrote sympathetically. 'I have endeavoured to respond in an understanding manner, although I fear I may have been overly abrupt on occasion.'[1]

Kemp first studied the sciences at Cambridge University before switching to history of art – an early change of course which some

of his academic rivals have used against him, but which placed him in a well-nigh perfect position for the study of the ultimate artist-scientist. He taught at various art history departments in Britain and North America before becoming a professor at Oxford in the 1990s. In 1981 his masterwork was published, *Leonardo da Vinci: The Marvellous Works of Nature and Man*. It slotted seamlessly into over a century of Leonardo historiography by bringing together Leonardo's scientific studies and his artistic career.

From Giorgio Vasari, the sixteenth-century Florentine author of *Lives of the Artists*, until the nineteenth-century essayist, novelist, literary theorist and art critic Walter Pater, Leonardo scholars had focused almost entirely on the paintings. That changed in 1883, when the reclusive German Leonardist Jean Paul Richter published meticulous transcriptions of Leonardo's papers organised according to themes, such as his writings on art, mechanics, anatomy and water, as well as his letters. Richter's apposite choice of title was *The Literary Works of Leonardo da Vinci*. In the 1930s Kenneth Clark contributed a useful catalogue of the Leonardo drawings held in the British Royal Collection and a biography, but that was a sideshow compared to the monumental post-war work of Carlo Pedretti, the Italian professor of Leonardo studies at UCLA who taught himself to read Leonardo's handwriting as a teenager, and who at the height of his fame would arrive for lectures in a helicopter. In *Leonardo: A Study in Chronology and Style*, published in 1973, Pedretti arranged around seven thousand surviving pages of Leonardo's twenty-five extant notebooks in a convincing chronological order.

Kemp picked up the baton from Pedretti. He analysed the notebooks and paintings and evolved a coherent and impressively simple model – 'a common core', he called it – for Leonardo's thinking and a narrative for how it developed. For Kemp, Leonardo's creativity combined observation, intellect, invention (fantasia) and propriety (decorum). Leonardo, said Kemp, set out with the purpose

of understanding the mathematical and scientific principles that underlay the natural world, anticipating that there must be a common set of laws that applied to all phenomena:

> *Those authors who have written that Leonardo began by studying things as an artist but increasingly investigated things for their own sakes have missed the point entirely. What should be said is that he increasingly investigated each thing for each other's sake, for the sake of the whole and for the sake of the inner unity, which he perceived both intuitively and consciously. In moving from church architecture to anatomy, from harmonic proportions to mechanics, he was not leaping erratically from one separate branch to another, like a frenzied squirrel, but climbing up different branches of the same tree.*[2]

Then, at the end of his life, Kemp argued, Leonardo changed his tune. He became convinced that nature was too diverse and mysterious to be grasped, and this was reflected in his stunningly dynamic series of late drawings of floods and tempests.

In the almost four decades since *Marvellous Works*, Kemp has published a profusion of scholarly articles and catalogue essays about the intersection of science and art in the work of Leonardo and in the broader Renaissance culture. He has also been active in the less austere world of exhibitions and television documentaries, often involving the reconstruction of a working model based on one of Leonardo's designs. In the year of the quincentenary of Leonardo's death, he collaborated with a British choral group on a concert tour and CD of music loosely related to Leonardo, while he worked on a new scholarly edition of one of Leonardo's scientific notebooks, the *Leicester Codex*, owned by Bill Gates. He is Mr Leonardo. The intellectual has become in part impresario, and scholarship has merged with showmanship, a trend that can be observed across the entire art historical and museological community in recent times.

Martin Kemp had long been an outspoken critic of the methodology of connoisseurship and attributions in art history. In a lecture in The Hague he said, 'The state of methods and protocols used in attribution is a professional disgrace. Different kinds of evidence, documentation, provenance, surrounding circumstances of contexts of varied kinds, scientific analysis, and judgement by eye are used and ignored opportunistically in ways that suit each advocate (who too frequently has undeclared interests).'[3] He has warned that commercial incentives and professional networks often trump scholarly reserve: 'In extreme cases, curators of exhibitions might fix catalogue entries in the service of loans; museum directors and boards might bend their own rules.'[4] To his credit, Kemp has long refused to accept a fee, or even expenses, if he inspects a work of art (although some might point out that there are many other incentives, besides direct financial gain, to discover a long-lost work by the world's most famous artist). 'As soon as you get entangled with any financial interest or advantage, there is a taint, like a tobacco company paying an expert to say cigarettes are not dangerous,' he told the *New Yorker* magazine.[5]

Like many other Leonardists, Martin Kemp has been receiving scores of emails for years, 'sometimes more than one a week',[6] he says, from individuals who think they own an unrecognised Leonardo. Some of these works are by Leonardo's pupils, others are incompetent copies, and many have nothing to do with the artist. Most of the time he rejects the invitations to view the works; sometimes he can see from the images he is sent that the work is not a Leonardo. He knows that attributions are a murky business, and he has kept his distance. He says that he does not attribute works of art – he researches them. Back in *Marvellous Works* he wrote that 'The speculative attribution of unknown or relatively unknown works to major masters is a graveyard for historians' reputations.'[7]

But, as often as Professor Kemp has warned of the dangers of attribution, he is as human as any other Leonardist. For all his caveats

about connoisseurship, he still finds it useful to deploy the mysterious and instantaneous power of *the eye* of the art historian: 'The actual physical presence of a work of art is always very different from even the best photographic images … The first moments are always edgy. If a certain *zing* does not occur, the encounter is going to be hard going.' Sooner or later, all the great Leonardo experts have been lured into the vortexes of authentication. That may be because no mortal, whether scholar or not, can hold out forever against the allure of beauty, money and fame. Or it may be because, over a long and distinguished career, it is impossible to avoid every patch of academic quicksand.

In March 2008, Kemp received an email with a jpeg file of a small drawing on parchment, 23 x 33cm. It was of a pretty young woman in profile, with piercing green–brown eyes and a delicate upturned nose. Her hair was swept back into an elaborate hairpiece, and there was a knotwork pattern on the sleeve of her garment, which was curiously plain and cheap. The picture had been bought at auction in 1998 for under $20,000 as a nineteenth-century work by a German artist, one of a circle which had been reviving and imitating Italian Renaissance painters.

Kemp thought it 'zinged decisively'. He authenticated it as a Leonardo and named it *La Bella Principessa*, although there was no evidence that it was of a princess. Eventually he published a book about the painting, which he said depicted a bride, Bianca Sforza from the ruling family of Milan, for whom Leonardo worked, and that it came from a late-fifteenth-century bound vellum book in a Warsaw library which commemorated the wedding. He observed Leonardo's hand in the left-handed cross-hatching, the glassy pupils and traces of fingerprints. 'Leonardo has evoked the sitter's living presence with an uncanny sense of vitality,' he said.[8] However, aside from some mono-chrome illustrations of geometric forms for a book about mathematics, Leonardo had never done a drawing on vellum; nor is there any

document naming the sitter. The only scrap of supporting evidence Kemp could find for the choice of medium was a note Leonardo had once written asking a French court painter about this technique:

> Get from Jean de Paris the method of dry colouring and the method of white salt, and how to make coated sheets; single and many doubles; and his box of colours.

Kemp observed that there were tiny holes in the side of the drawing which showed that it had once been bound into the Warsaw book. But the holes were in the wrong places, there weren't enough of them, and the type of vellum was not the same as that in the book. In addition to that, the *Bella Principessa* was wearing a costume that was too dowdy for a wedding, and a strange slit in her sleeve was inexplicable.* To add to the case against, the drawing's owner claimed to the *Sunday Times* that he had found the picture in a drawer at a friend's house in Switzerland.[9] The Italian art historian Mina Gregori agreed with Kemp about the attribution, but most other Renaissance art historians reacted with doubt, or worse, derision. Kemp and the painting's private owner, Peter Silverman, wanted it to be exhibited in a major public institution, and allowed the Albertina Museum and Academy of Fine Arts in Vienna to examine the painting in its labs,

* The Polish art historian Katarzyna Krzyżagórska-Pisarek wrote an analysis of the drawing: 'There is no real evidence that *La Bella Principessa* shows Bianca Giovanna Sforza, or that the vellum leaf comes from the Warsaw Sforziad ... The vellum of the Warsaw Sforziad is of different quality/texture (white and smooth) than the support of *La Bella Principessa* (yellow and rough, with follicles) and its size is different too (by 0.8 cm). The drawing was also made on the inferior, hairside of the vellum, unlike Birago's illuminations [contained in the Warsaw volume] ... the "archaic", formal and highly finished style of *La Bella Principessa* combined with the complex mixed media technique are unusual for Leonardo, and there is no evidence that he ever drew a full female profile (face and body), especially in coloured chalks on vellum ...'

with a view to showing it, but the museum director reported back that he didn't think the work was genuine.[10]

Despite his relative isolation, Kemp has stuck to his guns, and has become, like many connoisseurs in such a position, increasingly vociferous towards his critics and increasingly defensive in his opinion. In the course of his research into the *Bella Principessa*, the great Oxford Leonardist ended up working with a highly controversial collaborator. Peter Paul Biro is a Canadian forensic art expert who has made a name for himself authenticating works of art by discovering the hidden fingerprints of artists on them, through the use of a multi-spectral-imaging camera with impressive powers of magnification which he designed himself. He claimed to have authenticated pictures by Turner, Picasso and Jackson Pollock with his fingerprint cameras. Kemp invited Biro to examine the *Bella Principessa* and Biro analysed a fingerprint on the picture which, he said, was 'highly comparable' to another on Leonardo's *St Jerome*. But in 2010 an article in the *New Yorker* by David Grann alleged that Biro had found Pollock's fingerprints on paintings supposedly by Pollock but which, experts said, contained acrylic paint that had not been previously documented in his drip paintings.[11]

Kemp blamed the failure of *La Bella Principessa* on its over-hasty exposure to the media by Silverman. 'I call it premature ejaculation,' he told *The Art Newspaper*. 'There were things that came out before they were thought through. I would have much preferred to produce all the evidence when we had it, in one go.'[12] Kemp said he had learned from the *Bella Principessa* debacle: 'Above all, the public debut of a major item should be accompanied or preceded by the full historical and technical evidence being made available in the way scholars regard as proper.'[13]

And yet, when Robert Simon invited Martin Kemp to see the *Salvator Mundi*, the Oxford art historian seemingly forgot all his own advice.

CHAPTER 6

THE BLUE CLUE

Mystery is the defining quality of Leonardo's art. A seductive glance is thrown, we know not to whom. The Virgin and child take shelter with saints and angels in a twilight grotto, which has no address in the Bible. A smile, whose cause can only be imagined, begins to cross a woman's face, if indeed it is a woman's face, if indeed it is a smile. Around these strange incidents and encounters hover a few ambiguous facts open to a multitude of interpretations. Our understanding of Leonardo's life and work rarely becomes more than a pool of theories, surrounded by a tangle of conjecture, suspended from a geometry of clues. Amidst this network of possibilities, the *Salvator* presents the most fundamental mystery of them all. In some respects, it appears to be the most compressed embodiment of the essence of Leonardo's art; in other ways it is a stark anomaly. While other of Leonardo's paintings ask questions like, *Am I smiling?* or *What am I feeling?* or even *Who is winning?*, the *Salvator* asks *Am I a Leonardo?*

* * *

Leonardo's paintings have left a trail of documents behind them –
contracts for commissions, legal filings from irate clients, eyewitness
statements from admirers, oral histories recorded by the children of
men who knew him, and even notes in the margins of books on
completely different subjects. Such documents are a mine of
information.

There are legal agreements for many of Leonardo's commissions,
each of which contains its own set of illuminating details about
Leonardo's profession and character. The one for his first major work,
the *Adoration of the Magi*, offered him a piece of land as payment,
which he couldn't sell for three years, while he had to pay for all the
paints and gold leaf himself. He was soon behind schedule, and the
monks wrote to him telling him to hurry up. Within a year they had
given up, writing off the small sum they had already advanced
Leonardo so he could buy wheat and wine. Leonardo was a genius,
but also temperamental and, by turns, a self-critical perfectionist: he
worked slowly and left many works unfinished, much to the exasper-
ation of his clients. A trail of lawsuits followed him wherever he went.

In 1500 another set of angry monks, this time Milanese, from the
Confraternity of Immaculate Conception, refused to pay for the
Virgin of the Rocks, now in the National Gallery in London, saying it
hadn't been finished. Leonardo countersued, arguing that the previ-
ously agreed fee was too low for the quality of work he was provid-
ing. The dispute lasted years. In 1506 a judge ruled in favour of the
monks, arguing that there was not enough of Leonardo's hand in the
picture, and that he had to return to Florence and finish it. He went
back reluctantly, but it is not known what additional work he carried
out on the painting.

Another important client, the Council of Florence, was disap-
pointed the same year, when the artist departed for Milan leaving
behind him the unfinished *Battle of Anghiari*, now lost. Leonardo had
'taken a goodly sum of money and provided a small beginning of a

great work, which he should have made', complained the *Gonfaloniere*, one of the city's leaders.

Where there are no surviving contracts, we often read of Leonardo's paintings in the letters and memoirs of awestruck fans, who recorded for posterity the moment they met the great artist. Secretaries and agents of cardinals and countesses left entries in their diaries marvelling at the paintings and notebooks they had seen when they visited his studio, such as Antonio de Beatis who saw the *St John*, the *Mona Lisa* and the *Virgin and Child with St Anne* in Leonardo's studio in 1517. Leonardo's unusual working practices were often a talking point. The Italian author Matteo Bandello recorded watching him working on *The Last Supper* in 1497:

> *He would arrive early, climb up on to the scaffolding, and set to work. Sometimes he stayed there from dawn to sunset, never once laying down his brush, forgetting to eat and drink, painting without pause. At other times he would go for two, three or four days without touching his brush, but spending several hours a day in front of the work, his arms folded, examining and criticising the figures to himself. I also saw him, driven by some sudden urge, at midday, when the sun was at its height, leaving the Corte Vecchia, where he was working on his marvellous clay horse, to come straight to Santa Maria delle Grazie, without seeking shade, and clamber up on to the scaffolding, pick up a brush, put in one or two strokes, and then go away again.*

Proof of Leonardo's authorship of paintings can come from the most obscure and unpredictable sources. The identity of the *Mona Lisa* and the date when Leonardo started painting it were both subject to dispute until 2005, when a German scholar came across a note in the margin of a Renaissance volume of letters by the Roman orator Cicero. The marginalia came from Agostino Vespucci, a Florentine civil servant who worked for Machiavelli. A line from Cicero, about

how the fabled Roman painter Apelles left parts of his paintings unfinished, reminded Vespucci of Leonardo. Cicero commented, 'Apelles perfected the head and bust of his Venus with the most elaborate art, but left the rest of her body roughly rendered ...'Vespucci jotted next to the text:

> ... *This is how Leonardo da Vinci does all his paintings, for example the head of Lisa del Giocondo and of Anne, the mother of the Virgin. We will see what he is going to do in the hall of the Great Council, for which he has just reached an agreement with the Gonfaloniere. October 1503*

From such a recent, chance discovery, art historians could confirm that Leonardo was painting a version of the *Mona Lisa* by 1503, earlier than many had previously thought, and that her identity was definitely the Florentine noblewoman Lisa del Giocondo.

Leonardo's works were the subject of public spectacle as well as private reflection. By 1500 he was a celebrity, whose every move was watched and gossiped about. It was a major event when a new Leonardo was finished and unveiled to the general public, akin to the opening weekend of a blockbuster film today. Vasari wrote that when a new cartoon of St Anne was put on display in Florence for two days in 1501 (incidentally the first show of a single drawing in the history of Western art), 'it attracted to the room where it was exhibited a crowd of men and women, young and old, who flocked there as if they were attending a great festival, to gaze in amazement at the marvels he had created'.

There are only two Leonardos that were undocumented in his lifetime: the *Portrait of a Musician* in the Ambrosiana in Milan, which art historians tend to think is by Leonardo's assistant Giovanni Antonio Boltraffio, and the *St Jerome*, whose authenticity has never been questioned and for which certain probable references can be

found. Both of these paintings were made relatively early in Leonardo's career. There is no Leonardo painting executed after 1496 which is not remarked in contemporary sources – except, perhaps, one now.

No records from the artist's lifetime, or for a further hundred years after it, mention Leonardo painting a *Salvator Mundi*. This is all the more surprising because of the significance of the subject matter. The Christ which Leonardo painted in his *Last Supper* is the subject of a long anecdote in Vasari's *Lives of the Artists*. He relates how Leonardo went to see his client, the Duke of Milan, and provided a progress report on *The Last Supper*, explaining that he had still not yet painted Christ's head because 'he was unwilling to seek a model on earth and unable to presume that his imagination could conceive of the beauty and celestial grace required of divinity incarnate'.

If the greatest artist of his times was painting the greatest subject in Christian art, a Salvator Mundi, one would expect to find it recorded in a note in a monk's chronicle or a secretary's letters, at the very least. The absence of such documentation is the first great mystery of the *Salvator Mundi*. It compels art historians to rely on their 'superpower', 'the eye', alone. The name of the artist and the date of execution of this painting can only be determined by analysis of the style, technique and motifs of the work, but the result of such a process will always lack the certainty of proof.

Leonardo never dated any of his paintings, but on stylistic and technical grounds, the *Salvator Mundi* can be placed in the second half of his career, beginning after 1500 and ending with his death in 1519. The preparatory drawings must have been made in the early years of the sixteenth century because they are executed in Leonardo's softer red chalk style. They are usually dated 1502–10. The painting itself has the intense *sfumato* shading of the second phase of Leonardo's

work, beginning in the sixteenth century. The walnut wood used for the panel points to a date after 1506, when Leonardo returned to Milan. Walnut was a relatively unusual choice in Renaissance Florence, but was widely used by Milanese painters. It is difficult to be more precise, because Leonardo worked on many of his pictures for a long time, painting them slowly, sometimes on and off over a decade or more, occasionally returning to them after an intermission, often never finishing them. The scientific means of dating a panel painting by analysing the rings in the wood, dendrochronology, cannot be used with walnut, because the rings are too widely spaced to give more than the vaguest indication of epoch.

Whatever the day was when the first brushstrokes were applied to the *Salvator Mundi*, Leonardo had by then become one of the most celebrated living artists of the Italian Renaissance, alongside Botticelli, Piero della Francesca, Raphael, Michelangelo, Giovanni Bellini, Andrea Mantegna and a dozen others. He had progressed from artistic child prodigy to gifted studio assistant, then a master painter with his own practice in Florence, and later official court artist, the grandest position a Renaissance artist could rise to in Milan, where he also worked as a sculptor, engineer, set designer and architect. But his career had also had challenging periods when work and money were in short supply.

Born in 1452 in Vinci, a village on the outskirts of Florence, Leonardo was the illegitimate son of a notary, Ser Piero, and a local farmer's daughter, Caterina di Meo Lippi. His early life was both privileged and disadvantaged. Ser Piero was well-to-do, with a number of properties including a farm in Vinci. By the time Leonardo was in his late teens his father also had offices in the Bargello in Florence, where he offered his legal services to clients from important monasteries and Florentine businesses. But having been born out of wedlock, Leonardo seems not to have received the classical education that a family of Piero's standing would normally have given their son.

He grew up not having learned Latin or Greek, and occasionally referred to that lack in his notebooks. He called himself an 'unlettered man', and once signed himself 'Leonardo da Vinci, disciple of *sperentia*', which means both experience and experiment, Renaissance Italian for the 'school of life'. For the introduction of his planned treatise on painting, which he never published himself, he drafted this opening paragraph:

> *I am fully aware that my not being a man of letters may cause certain presumptuous people to think that they may with reason blame me, alleging that I am a man without learning. Foolish folk! … They strut about puffed up and pompous, decked out and adorned not with their own labours, but by those of others … They will say that because I have no book learning I cannot properly express what I desire to describe – but they do not know that my subjects require experience rather than the word of others.*

Leonardo had the Renaissance version of a chip on his shoulder. He turned this weakness into a strength by approaching his subjects without preconceptions or precepts, making the blank page the starting point for enquiry and creativity.

Fifty kilometres east of Vinci lay the ochre and red assemblage of roofs, domes, towers and crenellations of Florence, where the Renaissance was under construction. The dome of Florence cathedral, designed by Brunelleschi, built without scaffolding out of four million bricks, still the largest masonry dome in the world, was nearing completion; Leonardo was to be involved in its finishing touch, a gleaming bronze ball placed atop the lantern in 1472. Luca della Robbia was filling lunettes and decorating sarcophagi with his ceramic reliefs of pretty Madonnas and characterful saints, smoothly glazed in bright green, blue, white and yellow. In the evenings the low sunlight caught Ghiberti's *Gates of Paradise*, a door with ten

scenes from the Old Testament, cast in bronze but looking like burnished gold, completed in 1424 and given its popular name by an admiring Michelangelo. It was a beacon to the future of art, with its energetic crowd scenes full of billowing robes and flailing limbs, set within the arches and atria of monumental classical backdrops.

The basic laws of perspective, the representation of three-dimensional space on two dimensions, mostly forgotten since Antiquity, had been revived in frescos decorating chapels by artists Masolino and Masaccio, and in diagrams and text by the architect and humanist Leon Battista Alberti. All these developments were so remarkable that, a century later, they prompted the first ever art history book, Vasari's *Lives of the most Excellent Painters, Sculptors and Architects*, to give it its full title. This account of Italian art from the fourteenth to the sixteenth century distinguished between three phases in Renaissance art – early, middle and high – categories which are still widely accepted today. Vasari placed Leonardo at the start of 'the third manner which we will agree to call the modern'.* Today this period is known as the High Renaissance.

Leonardo's father was a friend of one of the busiest artists in Florence, Andrea Verrocchio. He ran a large workshop in premises previously occupied by the greatest Florentine Renaissance sculptor from the preceding generation, Donatello, showing how the baton of the Renaissance was handed down from one leading artist to the next. A team of assistants helped Verrocchio execute a mixture of large-scale commissions, statues, jewellery and small workshop paintings, which could be bought by customers coming in off the street. Leonardo had shown early ability with drawing, and his father took

* Vasari explained why he thought Leonardo belonged to the third phase of the Renaissance: 'In addition to the power and boldness of his drawing, not to mention the precision with which he copied the most minute details of nature exactly as they are, he displayed perfect rule, improved order, correct proportion, just design, and a most divine grace.'

him into Florence to see Verrocchio. He was taken on as an apprentice in his mid-teens, around 1469.

Already by his early twenties, Leonardo's style was so distinctive that art historians argue over which parts of Verrocchio's paintings might be by the master and which by his precocious pupil. There is a deliciously shiny fish and an alert, fluffy dog in Verrocchio's *Tobias and the Angel* (1470–75) which are sometimes attributed to Leonardo. The angel on the far left of Verrocchio's *Baptism of Christ*, with his demure and elliptical expression, that tiny knowing smile and hint of gender fluidity, is said to be by Leonardo. In the background, a vast panorama of rolling hills, lakes and steep mountains unfolds, strikingly different from Verrocchio's well-tended lawns, gentle slopes and neatly pruned trees. Another tell-tale sign is that this background is painted in oil. Leonardo liked to use the new medium of oil paint, which had arrived recently from the Netherlands, while Verrocchio used the old medium of tempera, based on egg yolk, so parts of his paintings finely executed in oils are generally thought to be by Leonardo.

In 1478 Leonardo left Verrocchio's workshop and set up his own practice in Florence. His first major commission, from an order of Augustinian monks, the *Adoration of the Magi*, now hangs in the Uffizi. It was a breathtakingly inventive work for its time in how it set aside the conventional, flat depiction of this scene and instead offered a sweeping arabesque of a procession, which curves from the distance to the foreground, suggesting the passage of time and a distance travelled. The wise kings and their entourage gather in a semi-circle around the Madonna and child, evoking a deep foreground space. The recently restored *Adoration* shows the artist's underdrawing, a dense web of constantly altered figures, gestures and details, which point to yet another distinctive characteristic of Leonardo: a striving imagination which altered his compositions with a freedom unknown to his contemporaries. The painting was never finished.

In Florence, Leonardo painted a dynamic and beautifully propor-
tioned *Annunciation*, in which one finds his obsession with naturalis-
tic detail in the flowery lawn and marble table. Close-up photographic
study of the painting has also revealed the artist's fingerprints, another
distinguishing feature of his work. Leonardo had, it seems, an idio-
syncratic way of occasionally using his fingers and palms to work the
paint. At this time he also painted his first known portrait, of *Ginevra
de' Benci*. The painting's realism, its glossy oil-painted sheen and austere
atmosphere of introspection, show the huge impact on Leonardo of
northern European Renaissance painters, whose fame had spread to
Italy. In the *St Jerome*, which never went beyond the design stage,
Leonardo conveys the suffering of the saint in the wilderness by his
meticulous depiction of an undernourished anatomy. Leonardo's
drawings were as epoch-making as his paintings. On 5 August 1473
he drew in pen and ink what Martin Kemp has described as 'simply
the first dated landscape study in the history of Western art'[1] – a view
of the Arno valley showing Montelupo Castle, just outside Florence.

Around 1482, Leonardo left Florence to begin the second phase
of his professional life in Milan, not for the last time reneging on his
contractual obligations to finish paintings when he saw the opportu-
nity for a step up the professional ladder. The new Milanese ruler,
Duke Ludovico Sforza, had consolidated his power after defeating the
French army and poisoning his nephew. Now, like many a newly
established despot before and since, he turned to culture as a tool of
statecraft (today this is called 'art washing'). Sforza wished to make
Milan a northern city to rival Florence, but Leonardo appears not to
have been aware of the duke's new priorities. There is a draft of a
letter to him in the notebooks in which Leonardo – a man on the
make as well as a genius – seeks to reinvent himself as a military
engineer. He pitches hard that he could make 'all kinds of mortars,
most convenient and easy to carry, and with these I can fling small
stones almost resembling a storm'. He could dig tunnels under rivers,

make 'safe and invincible' chariots, 'big guns' and catapults, and lastly – change of subject – 'I can carry out sculpture in marble, bronze, or clay, and also I can do in painting whatever may be done.' It was these last two talents that the duke would principally avail himself of.

At the time, Milan was a cultural backwater. The most popular local painters, Vincenzo Foppa, Bernardo Zenale and Ambrogio Bergognone, had barely left the Middle Ages, stylistically speaking. Their workshops were busy but the output uninventive. Thick halos of gold leaf encircled the heads of their saints, who stood stiffly in their heavy robes. Their complexions were pallid and their facial expressions dour and portentous. A wonky perspective in the depiction of a throne, canopy or manger in the foreground usually jarred with that of the architecture or landscape behind. By comparison, Leonardo was the avant-garde with his anatomical and botanical precision, his developing subtle tonality (aka *sfumato*) and his grip on storytelling.

Leonardo's first commission in Milan was the most enigmatic painting of his entire oeuvre, the *Virgin of the Rocks* which now hangs in the Louvre (the National Gallery in London has a second, later version of the painting). Once again the traditional format for such paintings, in which the Virgin and child are seated on a throne on a podium, with saints on either side, has been unceremoniously discarded. Instead, the mother and child appear to have taken refuge in a mountain cave, along with a baby St John, who prays to Jesus, though the Bible never suggests that they met at this age. The group are perched on the edge of a rocky chasm which falls away in front of us, creating a gulf between the viewer and subject. The bizarre landscape of rocky pillars brings to mind the Surrealist paintings of Max Ernst four and a half centuries later. The painting is the epitome of the sophisticated but indecipherable symbology which Leonardo inserted into his compositions. The lake in the background on the left may symbolise the purity of the Virgin, and so may the foreground, since Mary is referred to in the Song of Songs as 'the cave in

the mountain'. Alternatively, the inhospitable terrain could refer to medieval biographies of St John the Baptist or St Francis, while the manner in which the entire rocky backdrop echoes the arrangement of holy figures could embody the belief, widespread in the Middle Ages and shared by Leonardo, that the earth with its land and water functioned much like the human body with its flesh and blood. Art historians have discussed the meaning of this painting for centuries, without reaching any degree of certainty or agreement.

In Milan, Leonardo introduced emotional transitions, suggested movement and implicit narratives into the static genre of portrait painting. The faces of his sitters show shifting and elusive emotions – *moti mentali*, as he described them – of acquiescence and resistance, of pleasure and fear. There is a strange atmosphere of serenity and intimacy in these portraits, whose subjects have the faintest of smiles, anticipating the *Mona Lisa*. The *Lady with an Ermine* is the most dramatic of them all. A young woman, not yet twenty, turns her head as if taken by surprise – perhaps even feigning surprise – as she hears someone approaching her from behind. She looks shy but inquisitive, demure but also coquettish. The painting was commissioned by the sitter's lover, the Duke of Milan, Ludovico Sforza. The opposing directions of movement of her head and body belong to the already established Renaissance language of *contrapposto*, counterpoise, a way of articulating the body to create drama and volume, to which Leonardo has added a narrative purpose.

When Leonardo turned to *The Last Supper*, a commission for the dining hall of a Milanese convent, he was dealing with an established biblical narrative, in which gestures and facial expressions had long conveyed story and drama. However, he ratcheted up the excitement and action to new levels. He depicted the moment of greatest antagonism, when Christ tells his disciples, 'One of you will betray me.' Their reactions create an undulating wave of emotions on either side of Christ – postures and faces showing surprise, shock, denial (from

Judas, clutching a bag of money), shame, anxiety, argument, and even fainting. 'The painter who wants to have honour in his work,' wrote Leonardo, 'must always find the imprint of his work in the natural, spontaneous acts of men, born from the strong and sudden revelation of feelings, and from those make brief sketches in his notebook, and then use them for his purpose.'

In the 1490s Leonardo began to write and draw entries in his notebooks, of which only a quarter are estimated to have survived. These codices and manuscripts constitute one of the most important historical archives of all time, a cross-section of the European intellect and imagination at the doorstep of a new world of discovery and experiment, and proof that Leonardo possessed one of the most active and analytical minds of all time, 'undoubtedly the most curious man who ever lived', as Kenneth Clark called him.

Across the notebooks' pages a dazzling array of thoughts unfold about the natural world and the sciences. The art historian Ernst Gombrich remarked how 'Posterity had to struggle with that awe-inspiring legacy of notes, jottings, drafts, excerpts, and memoranda in which personal trivia alternate with observations on optics, geology, anatomy, the behaviour of wind and water, the mechanics of pulleys and the geometry of intersecting circles, the growth of plants or the statics of buildings, all jostling each other on sheets that may contain sublime drawings, absent-minded doodles, coarse fables, and subtle prose poems.'[2] To be sure, Leonardo was as idiosyncratic as he was intelligent: all the text was written in right-to-left mirrored hand-writing, which suggests to our imagination a desire to withhold secrets from all but the most dedicated students, but which may also be a sign of Leonardo's 'unlettered' if not obdurate pragmatism. It was easier for the left-handed artist to write backwards because there was less risk of smudging the ink.

Leonardo appears to have been a highly unconventional character. He had a distinctive taste in clothes – his early biographer Anonimo

Gaddiano wrote that he 'wore a rose-coloured cloak, which came only to his knees, although at the time long vestments were the custom'. A list of his clothing in his notebooks itemises a pink cap, two rose-coloured gowns, a purple-velvet hooded cape, and two satin coats, one crimson and one purple again.[3] One supposed portrait of him, which may hint at his character, is by his friend Bramante, who, the artist Gian Paolo Lomazzo wrote, used Leonardo's face for a fresco of the melancholic Greek philosopher Heraclitus. We see a straggly-haired forty-something man, his face running with tears, perhaps from sadness, but also possibly from drunken mirth. Leonardo appears to have been, or to have become, a vegetarian. The Florentine traveller Andrea Corsali wrote a letter to a friend in 1516 in which he mentioned that Leonardo 'lives on rice, milk and other inanimate foods'. That was a highly unusual diet for a Renaissance European.

Leonardo seems to have had a high sense of self-worth. His pictures did not come cheap by the standards of the day – *The Last Supper* cost 200 ducats. He could be short-tempered if he felt he was not being accorded the respect he was due: on one occasion he told a client's cashier haughtily, 'I am not a penny painter.' But at the same time he apparently often felt dissatisfied with his achievements, and some early biographers cite that as the reason he left so many of his paintings unfinished. Lomazzo, who spoke to Leonardo's assistant Francesco Melzi, wrote that 'He never finished any of the works he commenced because, so sublime was his idea of art, he saw faults even in the things that to others seemed miracles.'

In this first Milanese period, Leonardo was commissioned to make a monument to the Duke of Milan's father. He designed the largest equestrian statue in the world, and built a clay model three times life-size. But before he could cast it in bronze, the French crown had turned against the Milanese duke. The duke reassigned the metal that had been intended for the statue to the production of cannons, but with little effect. The French King Louis XII invaded northern Italy

and occupied Milan. The world lost a masterpiece and Sforza his dukedom. There is a touching description in the notebooks of how Leonardo hid his money in small bags around his studio as the foreign army approached. When they arrived, French archers used Leonardo's giant clay prototype for target practice and destroyed it.

Leonardo had now lost his great benefactor, and there followed several years of uncertainty, if not poverty. He travelled to Mantua and Venice, reduced on one occasion to making drawings of crystal and amethyst vases for Isabella d'Este, who was considering buying them, and on another to sketching the villa of a Florentine merchant for the Duke of Mantua, who wanted to build his own country mansion.

Leonardo moved on to Florence in 1500, and spent the next six years there. He was given a studio in the large halls of the Santa Maria Novella church. A measure of stability returned, notwithstanding a curious brief interlude in 1502–03 when the notorious warlord Cesare Borgia employed him for two years as his military architect and engineer, although, beyond drawing a map, it is not clear what work the artist actually carried out for the commander.

In Florence Leonardo began his second great phase of works, distinguished by their intense *sfumato* effects, which included the *Mona Lisa* and *Virgin and Child with St Anne*. His storytelling reached its apogee in *The Battle of Anghiari*, a prestigious commission for the Signoria, the seat of the Florence town council. He had technical problems with this fresco, as would later emerge with *The Last Supper*. Before he had finished it, his paint started slipping and flaking off the walls of the council chamber. He blamed a freak rainstorm, but the cause was more likely his technique of trying to use oil paint on plaster, to which it could not adhere. Leonardo could be slow at some times, but rushed and careless at others. He could have avoided the decay of his largest works, *The Last Supper* and *The Battle of Anghiari*, if he had first tested his technique out on a smaller scale. The original

Battle no longer survives, but there is what is thought to be an accurate copy in the form of a large drawing, which probably began life as a copy of Leonardo's cartoon, which was then reworked or retouched by the great seventeenth-century Dutch painter Rubens – an example of how complicated and how hybrid the authorship of Old Master drawings and paintings can be. The scimitars of mounted soldiers clash, while the heads of their horses butt against each other in a tight, violent circle of a composition which shows that Leonardo, for all his apparent disdain for learning, must have studied Graeco-Roman battle friezes and free-standing sculptures.

In 1506 Leonardo returned to Milan, lured there by its new French rulers, leaving the *Battle* unfinished, much to the fury of the Florentine town council. In Milan he continued to work on paintings designed or begun in Florence, the *Virgin and Child with St Anne* and the *Madonna of the Yarnwinder* among them, although the latter may have been mostly executed by assistants. Here he and his assistants probably also finished painting the second version of the *Virgin of the Rocks*.

The *Salvator Mundi* was probably begun in this period. The painting compresses into its modest format a summation of many, but not all, of the techniques, themes and passions of Leonardo's oeuvre. His Christ is not like the bright and youthful Jesuses of Raphael, or the strong athletic ones of Michelangelo. He seems a level above such mortal and physical attributes. He floats towards the onlooker like a mystical vision. He transcends time, harking back to the images of a blessing Christ that are found in early Christian catacombs and on the mosaic ceilings of Byzantine churches, but upgraded with a Renaissance makeover that is both realist and idealising. The Salvator's eyes, eroded as they undoubtedly are, seem to look straight through us, with a gaze as piercing as it is ethereal. Christ's expression hovers, in that Leonardesque way, between a range of contrasting emotions:

serene, placid, wise, resigned, resolute, or implacable and unmoved. On the almost imperceptibly upturned corners of Christ's lips, damaged as they are, is the slightest trace of a smile. The facial typology of the Son of God seems eerily modern, like those of the Nazarenes or Romantic painters, evidence of the realism and originality of Leonardo's portraiture.

All this is contained within a composition which transforms the traditional image of Christ with blessing hand and globe into a rigorous and compelling geometrical structure. The globe, hand and face of Christ occupy distinct horizontal thirds of the painting. The eye moves diagonally across from feature to feature echoing the diagonals of the embroidered crossing bands. Unlike the many other paintings of this subject, which preceded this one, Christ's hand is raised clear of the shoulder, instead of being in front of the chest, so it glows against the black background.

Leonardo is known for the intricate and precise way he painted hair, so different from the patterned and schematic rendering of his Renaissance contemporaries. In the *Salvator*, Christ's long curls glisten with highlights of varying intensity as they catch the light. Amidst the best-preserved strands on the right you will find a double helix, a shape that we find in Leonardo's drawings of coiled ropes, machines and waterfalls. In his notebooks he wrote of the similarities between the way hair fell and water flowed. There were 'two motions, of which one responds to the weight of the strands of hair and the other to the direction of the curls; thus the water makes turning eddies, which in part respond to the impetus of the principal current, while the other responds to the incidental motion of deflection'.

These curls may also be carnal. Leonardo's notebooks contain sketches of curly-haired boys, which are often said to be portraits of his teenage assistant and almost certainly his lover, Gian Giacomo Caprotti da Oreno, whom Leonardo nicknamed Salai, or 'little devil'. In April 1476, a week before his twenty-fourth birthday, Leonardo

was arrested by the zealous Florentine vice squad, which patrolled the city streets at night. The accusation was of sodomy with a male prostitute, though the artist was acquitted.

Along the upper hem of Christ's garment and in two yoke-like crossing-bands run filigree embroidery in golden thread, forming a geometric pattern of knots, sparkling like his hair with reflected light. Leonardo was fascinated by knots, in which his passions for mathematics, geometry and art intersected. He copied and owned the knot patterns of artists, and he also invented his own, far more intricate, ones. Prints of his 'Vincian knots' were sold across Europe. Vasari remarked how Leonardo would 'waste his time in drawing knots of cords, made according to an order, that from one end all the rest might follow till the other, so as to fill a round'. In fact, mathematicians from the University of California analysed Leonardo's knots a few years ago and found that they were made up of several broken strands, not a single one. Where necessary illusion trumped science in Leonardo's art.[4]

The hands and the orb provide further evidence of Leonardo's keen observation, obsession with detail and willingness to replace the tiringly conventional with the marvellously real. The orb held by the Salvator Mundi was commonly depicted in European Renaissance paintings as brass, bronze or glass, sometimes with a cross above it. Sometimes it was painted as a globe of the earth. In some northern European paintings it is transparent, and within it you may see an unforgiving biblical landscape. Leonardo painted his as a pure sphere, stripped of any metal casing or imagined scene, and minutely observed. Despite the severe damage this part of the *Salvator Mundi* has suffered, you can see tiny defects in the orb, air bubbles, each exactingly painted with a dark ring of shadow and a dab of white highlight. Leonardo has added more careful highlights around the fingertips, as if lit by 'lustre', as he called bounced light, here reflected off the crystal orb.

Meanwhile, the Salvator's other hand, raised in blessing, displays a balletic grace and solid volume. It is painted with a faultless foreshortening (a kind of perspective for objects and bodies, when seen front-on) so that it seems to project itself out of the picture towards us. Leonardo has added soft trails of lead white paint along the edges of the fingers, in the creases of the palm, and a dab at the bottom of the thumb, suggesting the softest of broken light from the upper left. Equally, veils of shadow of subtly varying darkness are painted on the parts of the hand facing away from the light, like the third knuckles of the bent fingers. The thumb curves inwards – previously rare in paintings of this type – so that the entire gesture forms an elegantly elongated pyramid, a geometric form Leonardo often used for his compositions of figures.

All these elements cohere in the *sfumato* style in which the painting is executed. While Leonardo's peers favoured bright colours and strong lines, Leonardo, a maverick within the Renaissance avant-garde, took painting in the opposite direction towards tonality, building up from dark undercoats to light highlights. Raphael, Michelangelo, Perugino, Piero della Francesca and other Renaissance masters painted scenes that were flooded with light. Their saints, temples and porticos have bright hues. They painted lighter colours on first, in general, and then modelled the figures and architecture with darker shades. But Leonardo worked the other way round. The *Salvator* is painted up from gloomy underlayers of dark vermilion and black paint. Areas of light are built up from this darkness in thin, transparent layers of very carefully graduated oil-based mixtures, known as glazes. Leonardo advised: 'Paint so that a smoky finish can be seen, rather than contours and profiles that are distinct and crude.'

However, the *sfumato* which we admire in Leonardo's paintings today is never only the work of the Renaissance master. Part of the effect derives from the decay of the art. Leonardo's fresco paintings, *The Last Supper* and *The Battle of Anghiari*, fell apart in his own life-

time because he tried to find a way to paint with oils on plaster; the paint did not stick. In other paintings, most famously the *Mona Lisa*, the colours have faded and the varnishes darkened. Restorers dare not clean the painting, lest the general public not recognise the work of art which emerges from underneath. The *St Jerome* once had the saint's head cut out, and it was only glued back in decades later. Of all Leonardo's paintings, the *Salvator* is, relative to its size and regarding the most important areas of the work, the most damaged of them all. Leonardo's paintings often carry the enhanced atmosphere of an ancient ruin, a work of genius placed slightly beyond reach by the ravages of time. The texture itself prompts a spiritual reflection on the transitory nature of material things, combined with an irresolvable yearning for something lost forever.

While we see so many of the above Leonardesque attributes in the *Salvator*, other notable aspects of the painting are not very *Leonardo*. The composition, for one thing, is uniquely flat within the artist's oeuvre. Christ has none of the movement and *contrapposto* we see in the figures in Leonardo's other paintings, despite the fact that he had written 'Always set your figures so that the side to which the head turns is not the side to which the breast faces.' Rather than reinvent the composition of this traditional subject, Leonardo seems to have produced, for the first and only time in his life, a carbon copy of the static one that scores of other early Renaissance artists used. The typology of the Salvator Christ, with its long nose and sombre expression, is remote from the delicate, androgynous charm of the Christ he painted in *The Last Supper* and of a drawing of Christ he made around 1494. In fact, the facial features don't resemble any of Leonardo's drawings of other young men. The orb presents another problem. Its realism is undermined by the absence of any notable optical distortions in the drapery behind it, and of the reflections of the surroundings which

would logically be visible in such a piece of crystal. Leonardo studied and wrote about optics at length in his notebooks; it is unlikely that he would paint such an object in such an unrealistic way.

After Martin Kemp accepted Robert Simon's invitation to examine and research the *Salvator Mundi*, the Oxford art historian embarked on years of study of the painting in all its aspects, from its style to its iconography, and from its overall effect to its smallest details. The painting merits attribution to Leonardo, Kemp has elegantly written, because of

> ... *the soft skin over the bony joints of the fingers of Christ's right hand, implying but not describing anatomical structure; the illuminated tips of the fingers of his left hand, the glistening filaments of vortex hair, above all on the right as we look at the picture; the teasing ambiguity of his facial features, the gaze assertively direct but removed from explicitness; the intricately secure geometry of the angular interlace in the neckline and cross-bands of his costume; the gleaming crystal ellipse on the pendant plaque below his neckline; the fine rivulets of gathered cloth on his chest.*[5]

The painting has, in short, 'Leonardo's magic'. Kemp finds great significance in the contrasting ways in which the face and hand were painted, the former softly, the latter crisply. Leonardo was the first artist to write about aerial perspective – the way colours and outlines fade the further away they are.* Kemp notes that the way the blessing

* Leonardo wrote: 'The nearest objects will be bounded by evident and sharp boundaries against the background, while those more distant will be highly finished but with more smoky boundaries, that is to say more blurred, or we may say less evident.'

hand comes forward in sharp focus towards the onlooker, while the face hovers in a mist of *sfumato*, is an application by the artist of his observations on the 'perspective of disappearance'.

Kemp views the painting as Leonardo's spiritual manifesto. The sign of this, he has argued, is the replacement of the conventional brass orb plus cross (the *globus cruciger*), with a transparent globe of solid rock crystal. The small circular forms apparent in the orb on the bottom and right side were read by Kemp as 'inclusions', deformations found in rock crystal. Through his adaptation of the traditional orb Leonardo was representing the cosmology of the Graeco-Roman mathematician and astronomer Ptolemy, who believed that the earth was surrounded by a transparent 'crystalline sphere of the heavens', in which the stars were situated. 'So what you've got in the *Salvator Mundi* is really a Saviour of the cosmos, and this is a very Leonardesque transformation,' Kemp has said.[6]

In regard to some of the *un-Leonardo-like* aspects of the picture, Kemp has developed explanations. The flat composition can be understood iconographically, as a representation of the Veil of Veronica, an image of Christ's face, not dissimilar to the Turin Shroud, left when the eponymous saint wiped Jesus's face with a piece of cloth. It was a serious subject, Christ as God, which demanded an austere and sombre treatment. If Leonardo's painting had been made for a client, a conservative format might well have been insisted on. This interpretation has found some support among other art historians. There was strong market demand for images of the Salvator Mundi, Veronica and Christ Pantocrator in Italy and the Netherlands in the second half of the fifteenth century. The rise of private devotion favoured small paintings of saints, hung in the chapels and bedrooms of wealthy Renaissance homes. The indulgences offered by popes for reciting the prayer associated with St Veronica in front of the 'Holy Face' inflated in this period from forty days to ten thousand days and even ten thousand years. Veronica's image was consequently

often illustrated in prayer books. It has been suggested that the dark and foggy *sfumato* of the *Salvator Mundi* may be an interpretation by the artist of the line in the Veronica prayer *Salve sancta facies* that the face of Christ could only be perceived on earth by living men and women 'in dim outline'.[7]

Leonardo studied and wrote extensively on optics – but seen through solid rock crystal, the folds of Christ's garment would normally be bent and turned upside down. The explanation for the lack of optical distortions in the orb, Kemp suggests, is that Leonardo was making an artistic decision to break a rule in the interests of the overall impact of his painting. Distortions in the orb would be distracting. The artist was exercising the Renaissance virtue of *decorum*, or propriety.

But there are shortcomings in Kemp's analysis. Regarding the orb, the arrangement of the so-called 'inclusions' around the bottom and on the right side of the orb suggest in fact that Leonardo was depicting a hollow sphere of seeded glass, containing air bubbles, which is struck by light from the upper left. Such glass spheres were manufactured at the time in Antwerp and Venice. Hollow glass also offers a simple explanation for the absence of refractions.* Most *Salvator Mundi*s by other artists from this period depict glass orbs. As for its purported symbolism, Leonardo's paintings sometimes contain signs and symbols that refer to the name of the sitter or client, but suggestions that he referenced specific philosophical ideas as he did the names and coats of arms of his aristocratic patrons remain speculative. Turning to Leonardo's depth of field, the alleged blurriness of Christ's face is contradicted by the sharpness of the curls of his hair, which are in the same plane. One excerpt from Leonardo's notebooks actu-

* The lack of optical distortions is comparable to the rendering of glasses in the copy of *The Last Supper* painted by one of Leonardo's assistants and hanging now in the Royal Academy in London.

ally tells painters that if they are painting a figure in the distance, 'do not single out some strands of hair, as the distance nullifies the shine of the hair'. It is a great mystery why a painting by an artist who studied optics, perspective and light with such intensity should contain two glaring optical inconsistencies. But that is not the greatest mystery of all.

For there is one feature of the *Salvator Mundi* about which neither Martin Kemp nor any other art historians have said anything at all. Perhaps they have dismissed it, or perhaps they haven't noticed it. This feature is so individualistic that it can neither be associated with Leonardo's painting nor disassociated from it; it belongs neither to the pictorial traditions of medieval Italy, nor to the symbology of early Christianity, nor to the classicising project of the Renaissance. The Salvator's garments are of only one colour. In almost every other Italian Renaissance depiction of Christ he wears red and blue, almost always a red tunic and a blue robe.* The Salvator wears only a blue garment, adorned with gold filigree embroidery. For the moment we have no explanation for this. Let us call it the blue clue.[8]

* I found only one example of a 'blue Christ' broadly from the era of the Italian Renaissance – a very early one, arguably more medieval than Renaissance, and perhaps significantly a Roman one. It is on the reverse of Giotto's *Stefaneschi Altarpiece*, dated around 1320, which was commissioned for the old St Peter's Basilica in Rome.

CHAPTER 7

VINCI, VINCIA, VINSETT

The word 'provenance', borrowed from French, describes a branch of art historical research the dictionary definition of which is 'a record of ownership of a work of art or an antique, used as a guide to authenticity or quality'. It means the history of the collecting of a painting after it has been painted, as it passes from collection to collection. The study of provenance serves a practical economic purpose, since the value of a painting rises according to how important its previous owners were. Kings, queens and emperors are at the top of the scale, while middle-class factory managers are close to the bottom. The role of provenance in the economy of art was already recognised at the end of the seventeenth century. It attracted the curiosity of the Anglo-Dutch philosopher Bernard de Mandeville, who, referring to a series of Raphaels at an English royal palace, remarked:

The value that is set on paintings depends not only on the name of the Master and the time of his age he drew them in, but likewise in a great measure on the scarcity of his works, and what is still more unreasonable, the quality of the persons, in whose possession they are,

as well as the lengths of time they have been in great families; and if the Cartoons now at Hampton Court were done by a less famous hand than that of Raphael, and had a private person for their owner, who would be forced to sell them, they would never yield the tenth part of the money which with all their gross faults they are now esteemed to be worth.[1]

There is also a second use for provenance studies. If the authorship of a painting is in doubt or contested, provenance can offer clues.

The inventories and archives of rich collectors often contain documents with dates and places, which allow one to trace a picture from collector to collector, in reverse chronology, to a time and place close to when and where it was made. This, in turn, can indicate who painted it. The provenance researcher may also consider whether a collector tended to buy originals or copies (sometimes difficult to tell apart connoisseurially, if the copyist is good), or if works by a particular artist were on the market in a particular place during a particular period. If the painting is genuinely a high-quality work, it is more likely to have been in the collection of a ruler or nobleman. An artist was less likely to offer a royal client a painting made by his assistants (though it did happen from time to time), and a ruler, with his team of eagle-eyed art advisers, was less likely to accept one. Often the inventories state in which room the work of art was displayed, and this detail can also become very important. If it was hung in an official hall or reception room, then it was probably an important painting; if it was placed in a corridor, on the stairs, or worse, in a storeroom, it was probably thought of as a second-rate work.

At the heart of this research are the inventories, handwritten on parchment or thick crusts of paper. These can be catalogues of collections compiled by the owner's clerks or 'keepers of pictures'. They may be itemised lists of works of art available for purchase from a hard-up merchant, or troves of freshly acquired art that are about to

be shipped out of Italy, or the valuables that a bride took with her to her new home. In an age when money was not kept in banks, you were what you owned. You didn't want your possessions, spread across your many-roomed mansions, to slip away. Largely ignored as a source of information until the late twentieth century, inventories have become the coalface of one of the most fashionable fields of art history today, rich seams of data from which deductions, speculations and occasionally conclusions can be extracted.

While inventories are vital to building a case for attribution for thousands of Renaissance paintings, the raw material is challenging. The fragmentary nature of the records means that most histories have gaps. The names of artists are spelt in many ways, and attributions can change from list to list. Descriptions of the paintings are, until the late nineteenth century, only textual, with scarcely a visual reference. That is an immense problem, because the range of subjects – especially biblical and classical – was limited, the titles are often similar, artists often made several paintings of the same subject, and the descriptions in the inventories are brief. Dimensions are rarely supplied, and sometimes there is only a title without a painter's name attached. The result is that provenance histories for works of art from before the nineteenth century are frequently assembled from a range of probabilities, which reinforce each other. Such structures can be precarious, wobbling between the likely and the hypothetical. The evidence is often circumstantial, but art history is a discipline that studies the products of the imagination; a certain flexibility is permitted, while the marvellous objects themselves have been known to inspire the most rigorous of academic minds to meld fact with fantasy.

Since the author and the date of Robert Simon's painting were unknown, he began to research its provenance within weeks of acquiring it. By his own account he spent an hour a day, every day for six years, studying the *Salvator*. Every Old Masters dealer has to present an account of the provenance of artworks they wish to sell.

Most of them subcontract this work to specialists and academics, but Simon is a particularly scholarly dealer, who enjoys the archives and takes pride in his abilities. He had done provenance research many times before the *Salvator* arrived in his gallery.

The first clue was two initials and a number on the back of the painting: 'CC 106'. Simon traced that back to the important nineteenth-century Cook Collection, belonging to a British cloth merchant. Some claim that Sir Francis Cook assembled the greatest art collection in private hands in Britain at that time, with the exception of Queen Victoria's. A three-volume catalogue of his treasures was published in 1913. There, Simon discovered his painting, listed as 'cat. number 106', on page 123 of Volume I, which was entitled 'Italian Schools'. However, it was not attributed to Leonardo but described as a poor copy, and there was no photograph of the painting in the catalogue. Simon turned to the photo archives.

It was the technology of photography that made modern art history possible. From the mid-nineteenth century specialised photo studios, most famously Alinari in Rome, methodically, accurately and beautifully photographed every notable work of art they could find, supplying an ever-growing market with perfect images, albeit in black and white. Museums and institutions built collections of thousands of photos, while art historians and connoisseurs amassed their own private stockpiles – it was a way for them to keep images of all the art they studied and loved close to them, in their homes. The previously uncontainable – a vast sea of images spread across many thousands of kilometres, too large and diverse to be committed to memory – could now be held in one's hands, spread out on a table or stored in a cupboard.

For art historians, photography was like the spear that enabled cavemen to hunt woolly mammoths. The scholars scribbled notes on the backs of their images, with dates, authorship, and what they knew of the ownership of the painting. By laying out a selection of photo-

graphs on their desks they could study, for example, the drapery folds
or facial features in a hundred anonymous Renaissance altarpieces
and group them according to stylistic traits. They could then associate
those stylistic traits with documented works by this or that artist, thus
defining his or her oeuvre and, if they had some dates, stylistic devel-
opment. They could pull out all the pictures they had on a particular
subject, like the Last Supper, or the Madonna and Child, or indeed
the Salvator Mundi, and, if they knew the dates, arrange them chron-
ologically to see how the treatment of that subject evolved over time,
which artists innovated, and which copied those innovations. Thus
was born an art history of style and symbol. Acquired over many
decades, many of these photographs have survived while the pictures
they record have been destroyed or gone missing. They are not just a
record of the art we have; they are also a record of the art we have
lost.

Robert Simon visited the Witt Library photo archive in the base-
ment of the Courtauld Institute of Art in London. There he accessed
all the folders of images marked 'Salvator Mundi'. Soon he found a
photograph of the Cook Collection's *Salvator*, where once again it
was listed as a copy. Simon was not surprised by that. Sleepers were
almost always miscatalogued, otherwise they would not have 'slept' so
long. On the bottom right of the photograph was a typed text read-
ing '(Cook Coll. Richmond)', and underneath, handwritten,
'Whereabouts unknown (1963)'. So nobody had known where this
picture was in 1963.

Parts of the Cook *Salvator* looked different from the painting
Simon had bought. In the Cook photo, Christ had a moustache and
facial hair that made him resemble a Mexican bandit in a 1950s
B-movie. That indicated that Simon's *Salvator* had been restored or
repainted in some way since the date of the photo. However the
blessing hand, embroidery, orb and other features of the Cook were
identical with Simon's painting. Now he could narrow down his

search. Before this discovery the painting could have come from any European country, but Simon now had a focus: Britain.

The second clue led back to Britain as well. Everyone in the Old Masters business knows of an etching made by the seventeenth-century print-maker Wenceslaus Hollar which bears an inscription by the artist, '*Leonardus da Vinci pinxit*', the word '*pinxit*' testifying that the print was a copy of a painting by Leonardo. It is an image of Christ as saviour of the world, orb in one hand, the other raised in blessing, with flowing curly hair remarkably similar to that in the Simon and Cook painting. The original Leonardo had long been presumed lost. Simon compared his painting to this print. It looked so similar in significant clues – its drapery and its blessing hand, even if – a significant clue in the contrary direction – Hollar's Christ had a curly beard with a central parting, and his didn't.

Simon knew where to go next. There was a particular volume on his shelf which many dealers have, and which is often a first port of call for researching the history of potentially important unknown paintings. One day in 2006 or 2007 – he can't remember which year exactly – Simon pulled out his copy of the *Walpole Society Journal*, 1972. In it, the keeper of the British royal collection, Oliver Millar, had published an inventory of King Charles I's art collection, meticulously turning a few slightly differing seventeenth-century hand-written manuscripts into a hundred-odd pages of neat type. Simon soon came across a description of a work that might match his painting: page 63, item number 49, a 'Peece [sic] of Christ done by Leonard'. Now he had found a record that Charles I had owned a painting of Christ most likely by Leonardo, and that painting was, in all probability, the one he had bought a 50 per cent stake in for the decidedly unprincely sum of $587.50.

* * *

At the recommendation of Martin Kemp, Simon contacted a young art history graduate, Margaret Dalivalle. She had been a student of Kemp's at Oxford and was writing a PhD about notions of the copy and the original in seventeenth-century painting. Simon asked whether she could, as she recalls it, 'contribute to the research into the provenance history of a newly discovered painting'.

Dalivalle was born in Ayrshire in Scotland, and showed an artistic bent from an early age, encouraged by her godmother, who worked in a gallery. She studied fine art at Glasgow School of Art, then ran her own business as an exhibition designer. After a few years she returned to study, doing a Master's degree followed by a PhD at Oxford. She now teaches at a number of Oxford colleges as a non-tenured tutor in Renaissance and early modern art history and the history of ideas.

Searching for the *Salvator* in British archives, Dalivalle thumbed through reams of rarely-consulted documents on thin, yellowed paper, written in faded brownish ink. Under the vaulted sixteenth-century timber ceiling of the Duke Humfrey reading room in the Bodleian Library in Oxford, where each panel is painted with an image of an open book, she pored through manuscripts. She ordered obscure volumes in the Rare Books department of the British Library, the quietest reading room of them all. She went to the archives of the Houses of Parliament, placing old bound volumes of their proceedings and reports between triangular wedges of grey foam so the books could not open flat, to protect their thick spines from damage. She examined bundles of documents in the archives of the royal family.

She hunted through inventories in which Leonardo da Vinci could be written as 'Leonard', 'Leonardus' or 'Lionard', and Vinci as 'Vince', 'Vincia' or 'Vinsett', and in which there was always the risk that his authorship had been mistaken for that of another Italian Renaissance artist like Raphael, Correggio or Zambelin – a strange spelling for

Giovanni Bellini. She worked on these complex materials over several years to assemble the illustrious provenance for the *Salvator Mundi*, which would lead to the auctioneer at Christie's confidently beginning his sale: 'And so now, Ladies and Gentlemen, we move to the Leonardo da Vinci, the Salvator Mundi, the masterpiece by Leonardo of Christ the Saviour. Previously in the collection of three Kings of England, King Charles I, King Charles II and King James II.'

Margaret Dalivalle declined a face-to-face meeting, but we exchanged many emails. She wore her learning a little heavily, to coin a phrase, and was defensive about what she had discovered, which, she said, would be published for the first time in a forthcoming, long-delayed peer-reviewed book. The fact is, a colleague of hers explained to me, her hopes for a permanent university post are dependent on this research, to which she has devoted the last eight years, entirely self-funded.

I learned from Dalivalle how much pride she took in the skills required for her research, and how wary she was of the layman's ability to understand the intricacy of her subject. Individual facts, she advised me, did not matter much on their own in provenance research; one had to consider the whole construction. That was good advice, which could be applied, in ways Dalivalle did not intend, to the broader framework of the *Salvator Mundi* project. Dalivalle's work on the *Salvator* cannot escape the over-arching context of its origin, which was one of commercial interest in a certain outcome. She was given her task over a decade ago by a dealer who wished to sell his painting as a Leonardo, and had been recommended by a professor of art history who had nailed his colours to this cause.

Since its beginning, the art market has always monetised scholarship. It is the scholars who appraise a work of art, and it is customary – quite rightly so – to pay them for their opinions. Museum boards have always been stuffed with wealthy patrons who privately collect works by the same artists that the museum supports. Dealers have

always hobnobbed with curators of public collections – the former relish the prestige of selling to a public institution, the latter revel in the excitement of a new discovery. The danger that scholarship can be compromised by showmanship and salesmanship has always been clear and present in the arena of art history. In the case of the *Salvator Mundi*, such familiar interrelationships were built into the project in a particularly intimate and perilous manner.

PART II

PART II

CHAPTER 8

THE KING'S PAINTING

The windows were so small, and the light in the palace so poor, that when pictures arrived they were examined by candlelight. On 30 January 1636 the papal emissary, Gregorio Panzani, and a few footmen carried the paintings down the corridors of Whitehall Palace, a higgledy-piggledy agglomeration of banqueting and reception halls, chambers, chapels, breakfast rooms and bedrooms – two thousand rooms in all – plus tennis courts, gardens and cockpits. They climbed the stairs to the private rooms, or 'closets', of Queen Henrietta Maria. Her Majesty was already in bed, perhaps because of the winter temperature in the palace rather than the lateness of the hour, and she had the pictures 'carried to her bed one by one', as Panzani wrote in his detailed account of the encounter. The art was a gift from Cardinal Antonio Barberini at the Vatican in Rome. The cunning cleric was hoping that the queen's husband, the Protestant Charles I, could be induced back to the Catholic faith, and was wooing him with Italian Renaissance paintings, which he knew the king loved. Or perhaps he could at least convince the king to moderate the oppression of Catholics in England. Of that fateful evening Panzani wrote, 'Especially pleasing to the Queen was that by Vinci, and that by

Andrea del Sarto.' However, the queen said ruefully that she would not be able to keep them for herself, because they were so good that 'the King would steal them from her'.

Meanwhile, Charles had been informed of the newly arrived masterpieces. He came hurrying down the corridors with a few of his courtiers, including the brilliant architect Inigo Jones, who shared the sovereign's enthusiasm for Italian painting. Charles and Jones then played a game. Charles removed the labels bearing the names of the artists which Panzani had attached to each picture, and Jones attempted to identify the works' creators, based on the style and technique. Thus began the discipline of connoisseurship in Britain, a parlour game for the wealthiest strata of society, but also, let us not forget, the *sine qua non* of the discipline of art history.

Inigo Jones, wrote Panzani, 'threw down his riding cloak, put on his spectacles, took hold of a candle and turned to inspect all of them minutely together with the King'. The candle flickered over the outlines of portraits of noblemen and women, lighting up the spidery lace of their collars and cuffs, the sheen of their buckles, buttons and scabbards, and flourishes in their moustaches. Jones 'accorded them extraordinary approval', then pointed to one, and – Panzani writes with a trace of the suppressed smirk that one would expect from a citizen of the birthplace of the Renaissance watching the efforts of an English novice – 'The King's architect Jones believes that the picture by Leonardo is the portrait of a certain Venetian Ginevra Benci and he concludes it from the G. and B. inscribed on her breast. As he is very conceited and boastful he often repeats this idea of his to demonstrate his great knowledge of painting.'

Jones got the artist more or less right. This was a painting attributed by everyone at the time to Leonardo, although today it is ascribed to his most sensitive pupil, Giovanni Antonio Boltraffio. But Jones got the identity and gender of the sitter wrong – perhaps understandably, given the gloom. He was in fact looking at a beautiful

and ethereal image of a young man, his hand inside his cloak covering his heart, gazing slightly askance as if lost in a daydream. The sitter was probably the Italian poet Girolamo Casio. Today the picture hangs at Chatsworth House in Derbyshire.

From Charles I's passion for art and for Leonardo da Vinci sprang the birth of the international art market, which has evolved to the business we know today. It began thirteen years earlier, in 1623, when Charles was heir to the throne. He had travelled to Madrid with the intention of returning with a bride, the Spanish Infanta Maria. He failed to win the hand of the Spanish princess, but he did return with a new love – art.

According to an account by the English author and diplomat Henry Wotton, Charles had set off for Spain with his friend the courtier George Villiers, Duke of Buckingham, who was then in his early thirties and, according to many who set eyes on him, 'the handsomest-bodied man of England; his limbs so well compacted and his conversation so pleasing and of so sweet disposition'.[1] Charles and Buckingham travelled incognito, 'with disguised beards and borrowed names of Thomas and John Smith'[2] and with only three servants. The journey was not as secret as they pretended, however. Charles's father, King James I, had sanctioned this romantic quest after having spent years trying to negotiate the marriage of his son to a Spanish princess, all in vain. Christian Europe had been split in two by the Reformation, with the Roman Catholic empires and the pope on one side, and the Protestants and an assortment of nationalist kingships and independent-minded mini-states on the other. The Catholic Spanish king was loth to marry his daughter to a Protestant prince. Charles's youthful ardour was the last card his father could play.

Charles and Buckingham's planning was slipshod. They didn't have the right small change to pay the ferry across the Thames at Gravesend

– 'for lack of silver, they were fain to give the ferryman a piece of two and twenty shillings'[3] – and this immense overpayment aroused suspicions. At Canterbury they were stopped by local officials, but made their escape after Buckingham, who was Lord Admiral of the Fleet, pulled off his beard, revealed his true identity and said he was on his way to perform a surprise inspection of the navy. In Paris the pair bought wigs and charmed their way into the French royal palace, surely with French officials winking at each other over the Englishmen's poor disguises. There they set eyes on Henrietta Maria, the daughter of the French King Henry IV, who would one day be Charles's actual bride. But she was Plan B.

Charles and his minimal retinue made their way on horseback through Spain. To the young tourists it seemed a harsh place. An English diplomat of the time, Sir Richard Wynn, observed how poor rural Spain looked compared to England: windows had no glass, meat was scarce, people used planks for tables, and there were no napkins. Spanish men dressed for all eventualities, wearing capes and carrying swords.[4] But everything changed when the royal party arrived in Madrid. Charles was put up in the towering fortress-cum-palace of Alcazar. The English king hastily upgraded his son's trip into an official mission and dispatched diplomats. Spain's King Philip IV laid out the red carpet and organised festivities. 'All the streets were adorned, in some places with rich hangings, in others with curious pictures,' wrote one contemporary.[5]

Charles rode alongside the Spanish king, under an ornate canopy, through the streets of Madrid, the capital of a freshly baked empire that stretched from North Africa to Latin America. The air reverberated with fanfares of trumpets and drums, while tapestries and carpets hung in decorative celebration from crowded balconies, wafting slowly in the spring breeze. The King of Spain temporarily relaxed the rules that limited the cost of clothing a subject might wear, and offered his nobility loans of up to 20,000 ducats so his court could

impress the visiting English prince. There was jousting and bullfighting in the city's enormous central square, the Plaza Mayor. Charles sat in a balcony neighbouring that of the Spanish princess, as close as decorum allowed, and seemed smitten. The spectacle was so expensive that locals joked that Charles had managed to sack the city without an army.

But after the festivities had subsided, Charles found himself locked in a diplomatic *pas de deux*, with the princess kept out of sight. The problem was still the prospective bride and groom's religious incompatibility. If this was to be overcome a special dispensation would be required from the pope, and concessions from the English towards their Roman Catholic subjects, neither of which were forthcoming. Spanish ministers worked to keep Charles in Madrid for as long as possible, in the hope that he would succumb to the artistic and moral superiority of the Roman Catholic faith and consider converting. They contrived for him to be present when King Philip was kissing the feet of the poor, and tipped him off about an English Jesuit who was distributing the enormous sum of £2,000 in charitable donations to hospitals and religious institutions. The Spanish king gave him paintings with unmistakable messages which laid it on with a gold-plated Catholic trowel, such as Titian's glittering *Portrait of Charles V with Hound*, painted to celebrate the pope's coronation of the then Spanish monarch as Holy Roman Emperor in 1530.

Charles, for his part, was trying to engineer a private encounter with Princess Maria. At one point he climbed over a palace wall and 'sprang down from a great height' in order to come face to face with her. But when the princess saw him she 'gave a shriek and ran back'. Her chaperone told Charles to leave at once, and he withdrew.[6]

Charles spent eight months hanging around in Madrid, waiting for a breakthrough in the marriage negotiations. He had time on his hands, and he spent it in the company of Buckingham and assorted courtiers and art advisers, visiting the magnificent palaces of the

Spanish sovereign and the mansions of his nobles, and shopping for art. In the seventeenth century Spain held much the same power over the English psyche as Paris did in the twentieth: it was the epitome of sophistication. As Ben Jonson wrote in *The Alchemist*, 'your Spanish Stoop is the best garb; your Spanish beard is the best cut; your Spanish ruffs are the best Wear; your Spanish pavin the best dance; Your Spanish titillation in a glove the best perfume …', to which he might have added, 'and your Spanish art collection is the best curated'.

By this time a small number of English aristocrats and royals, notably the Earl of Arundel and Charles's older brother Prince Henry, had built up collections, sometimes travelling to Europe to see and buy art. Charles had already ordered the purchase on his behalf of cartoons by Raphael in Italy; famous tapestries based on these would be made in London. He also had accepted gifts of pictures from Peter Paul Rubens, Europe's most famous living artist. Now the prince's experiences in Spain would supercharge his appreciation of both the beauty of art and the thrall in which it could hold men.

At the time, King Philip IV had the largest art collection in the world, consisting of about two thousand works; by the time of his death forty-two years later that figure would have doubled. A thousand of them were in his enormous palace, the Escorial, on the hills just outside Madrid. Spanish noblemen collected art too, some owning up to six hundred paintings. Their taste was overwhelmingly for Italian Renaissance artists. Titian's glamorous portraits, voluptuous mythological scenes and dramatic renditions of biblical stories, with brushwork that gave the impression of spontaneity, dexterity and speed, were the most fashionable; and he was also Charles's favourite painter. Raphael, Michelangelo, Andrea de Sarto and Leonardo da Vinci were almost as highly regarded, but slightly less flashy. The northern Europeans, comparatively dour realists like Memling, van Eyck, Dürer and others, formed a third group. Art was the educated entertainment that held this elite together.

We know much about this Spanish art world thanks to the vivid *Dialogues about Art and Painting*, written contemporaneously by the Italian-born, Spanish-resident artist, critic and courtier Vicente Carducho. Carducho's treatise takes us on an eye-opening tour of the best collections in Madrid, where he crossed paths with Prince Charles and his entourage.

> *His most serene highness King Charles Stuart was determined to acquire paintings of excellent originality. His emissaries are sparing neither effort nor expense searching for the best paintings and sculpture in all of Europe and bringing them back to the English Court … They confirm that the King is going to expand his Palace with new galleries, decorating them with these ancient and modern Paintings and with Statues of foreigners and citizens of that Kingdom, and where he cannot obtain the originals, he has sent artists to copy the Titians in the Escorial.*[7]

Charles and Buckingham were assisted by a number of art advisers. The most prominent was Balthazar Gerbier, a scheming Franco-Dutch courtier, painter and miniaturist whose Leonardesque list of side jobs included mathematician, military architect, linguist, pamphleteer, cryptographer and double agent. Charles's aide Sir Francis Cottington, a less colourful but more reliable individual, kept accounts of the money the prince was spending on art. Charles frequented estate sales, called *almonedas*, or bought from collectors, or was gifted artworks by noblemen, all to be packed and shipped back to England.

Vicente Carducho's treatise was intended primarily not to paint a picture of the Madrid art world for posterity, but to promote a new theory of art. He was determined to elevate the status of painters and sculptors from that of craftsmen to the same level as poets. He argued for the superiority of painting over sculpture owing to its more

scientific and speculative nature, and its ability to create optical illusions. These were arguments Leonardo had made in his notebooks. From Italy to Spain, Leonardo's ideas about art underpinned not just the way people made art, but the way they looked at it.

Among the houses Charles and Carducho both visited was the villa of Juan de Espina, a character later described as 'the Spanish Leonardo'. Charles would have passed through an unprepossessing door in a building in the centre of Madrid and found himself inside a high-walled villa full, as Carducho described it, of beautiful and miraculous things: artworks, rare books, musical instruments, stuffed animals, wooden automata, a telescope designed by Galileo, and historical memorabilia that included a collection of knives that had been used to execute the great and the not-so-good. Espina, a man of 'eminent and erudite wit',[8] was not himself an artist, but he was a mathematician and a virtuoso on the lyre and the *vihuela* (a kind of guitar). He threw parties that lasted until 3 a.m., at which magic tricks were performed, or mock bullfights or giant puppet shows took place. At one party in 1627, as chronicled by Don Juan himself, there was a three-hundred-course banquet at which 'fruit, china, pastries, ceramics' appeared to rise off the table and 'all flew through the window'. There were hydraulic machines, influenced by the ideas in Leonardo's notebooks, that could make music and storms. And there was a lot of art, as Espina described in his *Memorial*, written to the Spanish king:

> *When it comes to rare, curious and beautiful artwork made by the most famous masters from these and other kingdoms and nations, my house in this court can compete with all the extraordinary things worldwide, and even leave them behind, as the experts of all major disciplines have already certified in writing.*[9]

Charles must have thought Espina eccentric, for he called him 'a foolish gentleman', but as a collector he had something the future king wanted. Espina owned two notebooks, now known as the *Madrid Codices*, full of Leonardo's notes and drawings of machines, engineering and geometry. They had been brought to Spain by an Italian sculptor, Pompeo Leoni, who had acquired them from the son of Leonardo's pupil Francesco Melzi. Charles tried to buy them while he was in Spain, but Espina refused. As Carducho wrote of his visit to the collector's home:

> *There I saw two books drawn hand-written by the great Leonardo de Vinci of particular curiosity and doctrine, which Prince of Wales so loved that he wanted them more than anything when he was in this Court: but [Espina] always considered them worthy only to be inherited by the [Spanish] King, like everything else curious and exquisite that he had been able to acquire in his life.*[10]

Years later, Charles spotted another opportunity. One of his art advisers, Henry Porter, heard that Espina had been arrested by the Spanish Inquisition on the grounds that his automata were 'white magic'. Porter wrote swiftly to London: 'The owner of the book drawn by Leonardo has been taken by the Inquisition and exiled to Seville … I will try my utmost to find out about his death or when his possessions are sold.' Espina was, however, released, and later bequeathed his Leonardo notebooks to the Spanish crown. Charles and his courtiers were eventually able to buy some Leonardo drawings from Pompeo Leoni, who had inherited them before he moved to Madrid.

After nearly a year in Spain, Charles and his entourage returned to London infused with Madrid's enthusiasm for art. A year later he was king. He and his friends formed a circle of aesthetes and collectors,

known as *aficionados* – revealingly, a Spanish word – which translates as connoisseurs. Dubbed the Whitehall Group, they were determined to import the Leonardesque sophistication of Madrid's art world to London. They sent their agents to Italy, France, Germany and the Netherlands to find and buy Italian paintings and classical sculptures. They gifted each other paintings, or swapped them, and especially with the king. Art was, as the art historian Francis Haskell noted, 'the continuation of politics by other means'.

Among the artworks collected by the *aficionados* were several Leonardos. Charles's constant companion the Duke of Buckingham owned three by the time he died in 1628, including the *Virgin of the Rocks* now in the Louvre. However, the duke's efforts to persuade the King of France to part with the *Mona Lisa* while he was negotiating Charles's marriage to Henrietta Maria in 1625 failed. Charles himself owned three paintings he thought were Leonardos, though only one, the *St John the Baptist*, is now universally recognised as the genuine article.

Important visitors to Whitehall Palace, whatever their rank, were marched around on a ceremonial tour of Charles's art collection. At the palace's heart was the two-hundred-foot Long Gallery, in which the king hung around a hundred of his best Renaissance and northern European paintings, including van Dyck's *Cupid and Psyche* and Dosso Dossi's *Virgin, Child and Joseph*. The king's apartments contained another array of masterpieces by Titian, Correggio, Giorgione and others. Seventy-three smaller pictures were displayed in the intimate cabinet room, along with thirty-six statues and statuettes, as well as books, miniatures, medals and curios. By the time of his death in 1649, Charles I had collected almost three thousand paintings, drawings and sculptures. When Rubens arrived in London in 1629 he wrote:

I must admit that when it comes to fine pictures by the hands of first-class masters, I have never seen such a large number in one place as in the royal palace and in the gallery of the late Duke of Buckingham.[11]

And so it was that, thanks to the collecting of Charles and his comrades, England could now be counted among Europe's most magnificent monarchies.

It is easy to recognise the art world we know today in Stuart England; the art market emerged from the womb of the late Renaissance almost fully formed. New record prices were being set for art in seventeenth-century Europe, as established collectors from Italy and Spain sold works to new collectors like Charles's circle. Old money was profiting from new money, just as European and American dealers in our era have been able to raise prices for Russian oligarchs and Asian and Gulf billionaires. The historian Edward Chaney writes, 'The craze for the collecting of pictures grew more dramatically in the 1620s and 30s than in any other period in British history.'[12]

It was already a world of smoke and mirrors. Smooth-talking dealers were continually trying to pass off copies or studio works, executed by artists' assistants, as originals. In a series of letters dating from 1625 between an agent for Charles I in Rome and the art-dealing resident of a monastery in Perugia, the agent writes that both Charles and Arundel were unhappy about having been sold copies as originals. 'Many scandalous tricks have been played here,' he says. On another occasion, the British collector the Duke of Hamilton told his agent to watch out 'that the originals be not retained and copies given in their place'. The art market today is still bedevilled by fakes. Meanwhile, collectors had their own underhand playbook. They bought anonymously through agents who were instructed not to divulge whom they were working for, in case knowledge of their

wealthy patrons encouraged the sellers to charge higher prices. 'Had it been known that I was acting for his majesty, they would have demanded so much more,' the Venice-based art dealer Daniel Nijs wrote about securing the largest bulk purchase of Renaissance and Classical art for Charles I from the Gonzaga dukes of Mantua.

On occasion collectors formed secret anti-competitive syndicates to avoid a bidding war when they bought a collection. The richest buyers often paid late, as they do today, after their dealers had riskily financed acquisitions by borrowing in their own names – Charles took three years to finish paying Nijs for the Gonzaga purchase. But Nijs was no saint either: when he bought large collections for English clients he was known to pick off certain works for himself and try to sell them privately before forwarding the pruned consignment to London.

One marked difference between the art market of old and that of today is that in earlier times no one collected art for investment. But at least one canny adviser foresaw the rise of the art market. Balthazar Gerbier boasted prophetically to Buckingham that:

> Our pictures, if they were to be sold a century after our death, would sell for good cash, and for three times more than they cost … I wish I could only live a century, if they were sold, to be able to laugh at these facetious folk who say it is money cast away for baubles and shadows. I know they will be pictures still, when those ignorants will be lesser than shadows.[13]

The *Salvator Mundi* is said to have spent part of the seventeenth century somewhere in the court of King Charles I. But where? In 1639 Charles instructed Dutch-born Abraham van der Doort, his Keeper of the Pictures – a role we would call curator – to draw up an inventory of the royal art collection. Once completed, this was the

most detailed art catalogue yet produced in Europe. However, back in those days pictures rarely had proper titles. Thus van der Doort had to come up with his own short descriptions, such as 'the picture of an indifferent ancient gentleman'. He often mentioned where the king had acquired a work: 'Another Mantuan peece', he repeatedly wrote, referring to the scores of Renaissance paintings and classical sculptures Charles bought from the dukes of Mantua. He was careful to distinguish, where he could, between a work by an artist's own hand and one by a studio. Thus, of an 'Item above the door, a picture painted upon a board being a smiling woman with a few flowers in her left hand in a wood-coloured and gilded frame, half so big as the life', he adds: 'Said to be of Leonard de Vincia or out of his school.' Through his entries percolates the character of a methodical civil servant, struggling in a foreign language to establish a uniform system of classification for the first time, and desperate to please his royal employer. A portrait of van der Doort by the English painter William Dobson, executed in a dashing *impasto* halfway between Titian and Rubens, shows a face with muscles tensed and an anxious expression in his eyes, as if caught for a brief moment before hurrying off.

The most detailed entry in van der Doort's inventory is for a Leonardo da Vinci, but not the *Salvator Mundi*. It is a painting of John the Baptist, a marvellous but relatively simple painting, much the same size as the *Salvator*. Demonstrating his disdain for Christian propriety, and his penchant for fusing Christian and classical motifs, Leonardo had radically reimagined the iconography of his subject, depicting the saint as a puckish, quasi-Apollonian young man, smiling knowingly at the onlooker, raising one finger in a gesture that seems to beckon us to follow him as it points up to God. Van der Doort writes:

Item, A St John Baptist, with his right finger pointing upwards, and
his left hand at his breast, holding in his left arm a cane-cross; done
by Leonard da Vinci, sent from France to the King for a present, by
Monsieur de Lioncourt, being one of the King of France's
Bedchamber; the picture being so big as the life, half a figure, painted
upon board: in a black ebony frame; for which the King sent him back
two of his Majesty's pictures, the one being the picture of Erasmus
Rotterdamus, done by Holbein, being side-faced, looking downwards,
which was placed in his Majesty's cabinet room; and one other of his
Majesty's pictures, which was done by Titian; being our Lady, and
Christ, and St John, half figures, as big as the life; which was placed
in his Majesty's middle privy lodging-room …[14]

Van der Doort tells us that Charles got this Leonardo in an exchange
with the French courtier and ambassador to London Roger du Plessis
de Liancourt. So important was a Leonardo considered that the
painting was swapped not just for a Titian, the most fashionable artist
in Europe at the time, but also for a Holbein, the German painter
who had produced sharply observant portraits of Henry VIII's court.

The alluring golden *sfumato* effect, which makes St John look as if
he has stepped out of Guillermo del Toro's fantastical film *Pan's*
Labyrinth, is partly the result of Leonardo's style, but also partly of the
mishandling of the picture by its owners. In the left-hand margin van
der Doort states that it has been damaged, but not, emphatically *not*,
by him:

The arm and the hand hath been wronged by some washing – before
I came to your Majesty.

That is the longest entry by far in van der Doort's entire catalogue. It
may seem strange, then, that he makes no mention of the other
supposed Leonardo, the *Salvator Mundi*, which continues to evade the

pens of inventorists. One explanation, which Simon and Dalivalle have suggested in the past, could be that van der Doort's catalogue was not exhaustive. He concentrated on the king's collection at Whitehall Palace in central London, but overlooked parts of other palaces, including Hampton Court, the Queen's House, Greenwich, and Nonsuch Palace. It is possible that the *Salvator Mundi* may have hung in one of these locations; or maybe van der Doort just missed it. Such possible shortcomings in his work came to light after he committed suicide in the summer of 1640. Some of his biographers think he took his life out of shame, after having mislaid some of the king's miniatures. A broadsheet of the time suggested alternatively that it was because he was about to be fired for incompetence: 'It is believed he was jealous the King had designed some other man to keepe his pictures, which he had not done.' A German poet, George Rudolf Weckherlin, wrote an epigram commemorating van der Doort's death:

> Anxious to do his duty well,
> Van Dort there, conscientious elf,
> from hanging up his pictures, fell
> One day to hanging up himself.[15]

Ten years later a second inventory was made of Charles I's collection, and this one, the Commonwealth Inventory of 1649–51, does mention, for the first time, a picture that could be the *Salvator Mundi*.

At the close of the English Civil War, the defeated king was beheaded in January 1649. Two months later, Parliament, now representing a 'Commonwealth', not a 'kingdom', decided that all the late king's possessions, including his art collection, should be valued and then sold. The funds raised were to pay off the royal debts – the king owed money to hundreds of servants, tradesmen and craftsmen. The historian Hugh Trevor-Roper wrote: 'That gallery to whose forma-

tion politics had been sacrificed … was now, in turn, sacrificed to political and ideological revolution.'[16]

An inventory was produced for this sale of 'the late king's goods'. Item number 49 was a 'Peece of Christ done by Leonard'. There was only one well-known artist at the time called Leonard, or Leonardo. It is not a very precise description, but just one single-figure type of portrait painting of Christ in Leonardo's style has ever been known, and that is as the saviour of the world, or *Salvator Mundi*. The 'Peece of Christ' was valued at a mere £30.

The Commonwealth Inventory's entry for the 'Peece of Christ' introduces a new mystery to the painting, namely its price. Thirty pounds for a Leonardo – around £3,000 in today's money – is rock bottom for one of the ten most desirable Renaissance masters on the mid-seventeenth-century European art market. But it might add another piece of evidence to the provenance narrative. One of the distinguishing features of Simon's *Salvator* is the very poor condition the painting was in when he bought it, and the extensive repainting it has undergone in the last five hundred years. Those two facts can be linked.

The story of the *Salvator Mundi* is not just a tale about who bought and treasured this painting. It is also a tale of who mistreated it. Art in seventeenth-century England could be loved, or it could leave people unmoved, or it could be reviled. As much as the Caroline court treasured art, the profession of art handling had not yet been invented. Works of art were often damaged in transit, as happened with some of Charles's purchases from the dukes of Gonzaga. Packed onto a ship in Venice, they were placed in the hold next to a vat of mercury. Unfortunately, there was a storm en route, and the mercury spilt over the cargo of Tintorettos, Titians, Raphaels and so on. Once the paintings had reached London, Charles's agent, Sir Nicholas

Lanier, tasked his relative Jerome Lanier, whose principal occupation was royal musician, to restore them, which he did with the seventeenth-century technology of saliva, milk and alcohol. According to the source of this story, royalist antiquarian and diarist Richard Symonds, it worked.[17] We already know that van der Doort's inventory gives horrifying condition reports on some paintings in Charles I's collection, advising that several had 'bin too much washed'. A Palma Vecchio had a 'warped panel', a Correggio had 'peeled and bubbled up', a picture of Lucretia was marred by 'spots', something from the school of Raphael was 'cracked and broken in the middle', and others were 'eaten and rotten'. They were sent off to be 'mended', but painting conservation could do more harm than good in those days.

The middle of the seventeenth century was a dangerous time for paintings anywhere in Europe. The deadliest religious conflict in history, the Thirty Years War, which had begun in 1618, was under way, pitching Protestant nations against Catholic empires. While Charles I was buying art in Europe in the 1630s, some of the warring rulers – Gustavus Adolphus of Sweden and his successor Queen Christina, and the Holy Roman Emperor Ferdinand – had been taking pictures off the walls of palaces in cities they had conquered and sending them back to their own capitals, where they were hung in their own residences and official buildings. In the following decade art became a target in England too, but for destruction, not plunder. The English back-to-basics Protestant movement, the Puritans, condemned Charles's art collection both for its cost and for its Catholic – or 'popish' – subject matter. In Parliament, MPs aligned with the movement criticised the king and his fellow collectors for the 'great sums' that 'were squandered away on braveries and vanities; on old rotten pictures' and 'on broken-nosed marble'.[18] For Puritans and other radical Protestant groups, pictures depicting saints were 'idolatrous'. It was 'sinful' to venerate such images by kneeling in

front of them to pray for the saint's intercession. New laws were passed authorising iconoclasm, or the destruction of images 'of any One or more Persons of the Trinity', and specifically 'the demolishing of all superstitious Pictures and Monuments in Whitehall, and all other Places of the King's Houses and Chapels'. That would of course include a painting of Christ as the Salvator Mundi, which was, we believe, hanging in the king and queen's private apartments in Greenwich Palace.

Of all the royal palaces, Greenwich suffered the most during the Civil War. Parliament sent men to dismantle it, and acting on orders they purged the chapel, destroying its stained-glass windows, if a glazier's bill from November 1644 is anything to go by. The *Salvator* was probably not hanging in the chapel, but the chapel was in a corner on the first floor, where a sequence of private rooms led to the king's bedchamber, then his privy chamber, then the presence chamber on one side and another intimate space for prayer, the Holyday Closet, on the other. There are invoices from the Puritan MP Sir Robert Harley for 'planing', by which he meant destroying images by shaving off the painted surface with a wood-planing tool. The *Salvator* was 'planed down from the front, that is the painted side', restorer Dianne Modestini would write in a technical essay about her work on the picture. 'The blade cut deep into the paint on the proper left side of the face and shaved away many of the curls, exposing fresh wood in some places. It is not possible to determine when this happened.' Modestini tells us that the planing tool was 'razor sharp', which to her implies a later, perhaps nineteenth-century date. But it is difficult to imagine anyone planing down the front of a painting by Leonardo unless as a deliberate act of violence.

* * *

The low price of the *Salvator* supports the idea that it was damaged very early in its life. That theory is based on the fact that Robert Simon and Alex Parish's painting is the 'Peece of Christ' – the same picture that belonged to Charles I. But what if that 'fact' is an assumption? If you study the inventories of the art collections of Charles I and his courtiers closely, you will find several other possible descriptions of a *Salvator Mundi* painting by Leonardo. About these Robert Simon, Margaret Dalivalle, the National Gallery and Christie's auction house remained silent in the texts, interviews and comments they would make publicly about the painting, until they were reported in the trade press and national newspapers.

CHAPTER 9

LITTLE LEONARDOS

Unlike most artists, who rented dark *bottegas* in the backstreets, Leonardo was often given very grand accommodations by his patrons. When he went to Florence in 1500, he occupied halls in the church complex of Santa Maria Novella. When he moved to Rome in 1513, the pope renovated a suite of rooms for him in the palace of the Belvedere. Such studios often contained stables, a laboratory for experiments, a kitchen and dining area, a bedroom or bedrooms and Leonardo's study, with its collection of books (some printed, some manuscripts) about science, nature and art, and a few volumes of the classics.

In the years that Leonardo was working in Milan as the court artist of Ludovico Sforza, his studio was located inside a former ducal palace, the Corte Vecchia. Visitors in the 1490s, walking over large flagstones through its rusticated thirteenth-century entrance arch, would have seen the giant clay model for Leonardo's equestrian monument for his patron in the courtyard. Inside one hall they might have spied a strange contraption with a wooden frame, levers, two long protruding surfaces with canvas stretched over them, and a rudder at the back, which looked like a cross between a boat and a

bird (although Leonardo might have hidden this prototype flying machine on the roof of the palace, so no one could see what he was developing).* In smaller rooms they would encounter several artists, Leonardo's assistants, with palette and paintbrush in hand, working at small easels on which were paintings at different phases of execution.

This collection of apprentices and followers – the exact number is unknown but is thought to have fluctuated between three and ten at any one time – became known as the *Leonardeschi*, or Little Leonardos. They were a mixture of teenage students, young artists and older established painters who wanted to work with the master. The scraps of information we have about them suggest a diverse group, whose ages ranged from ten to fifty. They were often from comfortable backgrounds, a sign of the respectable status of artists in Italy's cities. As Cennino Cennini wrote in his Quattrocento treatise on painting, the profession was 'really a gentleman's job'. Giovanni Boltraffio was the most intellectual of Leonardo's assistants, a friend of several poets and, like Leonardo, from a well-to-do family but born out of wedlock. Andrea Solario came from a family of painters. Cesare da Sesto, who is not mentioned in Leonardo's notebooks but whose work is so Leonardesque he must have spent time with the master, came from the nobility. Francesco Melzi, who joined the studio at the age of fifteen, was the son of a captain in the Milanese militia. He became Leonardo's personal assistant, and inherited the artist's notebooks when he died. Evangelista and Ambrogio de Predis were brothers and

* A page in the *Codex Atlanticus* notebook has sketches of a wide-winged flying machine with a ladder leading up to it. Next to it is written: 'Close up the large room above with boards, and make the model large and high. It could be placed up on the roof above, which would be in all respects the most suitable place in Italy. And if you stand on the roof, on the side where the tower is, the people on the tiburio [a lantern above a dome – Leonardo is probably referring to workmen] won't see you.'

distinguished local artists with whom Leonardo collaborated on large commissions. Bernardino Luini came from a peasant family near the Swiss border, and was admired for the speed with which he could execute a large commission – just thirty-eight days, apparently, for a *Christ Crowned with Thorns* featuring many saints. Girolamo Alibrandi's family wanted him to study law, but instead he chose painting. Marco d'Oggiono was, according to the account of one priest, 'a good drinker'. He became probably the wealthiest of all Leonardo's assistants, thanks to both his success as an artist and his rich wife. At different times Leonardo employed two Germans, known to us from his notebooks as 'Jacopo' and 'Giulio'.

Camaraderie, banter and mischief filled Leonardo's studio. He once wrote that he liked to be surrounded by companions when he worked: 'Drawing in company is much better than alone.' According to Matteo Bandello, Leonardo liked to tell one of Pliny's stories about Apelles, the legendary painter from Ancient Greece and the godfather of Western art. Leonardo related how Alexander the Great visited Apelles in his studio and was sounding off about painting in such a way that he made 'the boys who mix the colours laugh'. No doubt Leonardo's studio revived this antique tradition, which has an unbroken line of continuity to this day, of artists sniggering at a collector's efforts at art appreciation.

Contemporary biographer Paolo Giovio, who built up his art collection by cannily offering to include leading personalities in his *Lives of Illustrious Men* if they gave him a portrait of themselves for free, wrote that Leonardo's studio was crowded with a '*turba adolescentium*' (a 'multitude of young people'). A panoply of visitors passed through the workshop. One day it might be Leonardo's friend and travelling companion the brilliant mathematician Luca Pacioli, whose book he illustrated with geometrical shapes. On another occasion Leonardo recalls that 'some peasants' dropped off 'a large sack' of fossils which they had collected from the mountains north of Milan: 'among

them there were many which were still in their original condition'. The fossils fascinated Leonardo, and seemed to him 'destroyed by time … with bones stripped bare, serving as a support and prop for the mountain'. One evening Leonardo invited over for dinner a group of strangers he had picked up off the street. One of the artist's sixteenth-century biographers, Gian Paolo Lomazzo, writes:

There is a story told by men of his time, who were his servants, that he once wished to make a picture of some laughing peasants. He picked out certain men whom he thought fitted the bill, and having become acquainted with them, he arranged a party for them with the help of some friends, and sitting down opposite them he started to tell them the craziest and most ridiculous things in the world, in such a way that he made them fall about laughing. And so without them knowing he observed all their gestures and their reactions to his ridiculous talk, and impressed them on his mind, and after they had left he retired to his room, and there made a perfect drawing which moved people to laughter when they looked at it, just as much as if they were listening to Leonardo's stories at the party.

The best-known to us of all Leonardo's pupils was Gian Giacomo Caprotti da Oreno, nicknamed 'Salai' or 'little devil', who came to work for the artist at the age of ten in 1490. Within months of his arrival, Salai was caught stealing the tools of Leonardo's senior assistants, as recorded in Leonardo's notebook:

On the day of the 7th September he stole a silverpoint of the value of 22 soldi, from Marco who was living with me. He took it from his studio. After Marco had searched for it a long time, he found it hidden in Giacomo's box … Again on the 2nd April Giacomo stole a silverpoint stylus, worth 24 soldi, which Giovanni Antonio [Boltraffio] had left on one of his drawings.

Salai stole money and belongings from Leonardo, once taking a leather hide, selling it and spending the money on 'aniseed candy'. When Leonardo took him to the house of a client, Salai went through someone's wallet. When he took him to a friend's home for dinner, Salai ate enough for two, broke crockery and spilt wine. Leonardo famously summarised Salai's character as 'Thief, liar, obstinate, greedy'.

But the scamp must have exercised some kind of power over Leonardo, because the artist continued to indulge him, and Salai grew up in the studio. He became the studio manager, and also an effective painter of copies of Leonardo's work. His own portrait of Christ, now hanging in Milan's Pinacoteca Ambrosiana, offers clues to the history of the *Salvator Mundi*. Salai's painting is signed and dated 1511, and his Christ looks remarkably similar to Simon and Parish's *Salvator*, with its rich *sfumato* texture, long nose, protruding upper lip, complicated curly hair and serene long-distance gaze. It also has the same beard, with a central parting, as in Wenceslaus Hollar's etching.

Leonardo was running a business with significant overheads. He once wrote that the studio was 'a constant strain on my salary and expenses'. Cash flow could be a problem. In a letter from the mid-1490s Leonardo complained to the Duke of Milan that he had had to sack two assistants because the duke had not paid him for two years: 'If your Lordship thought that I had money, your Lordship was deceived, because I had to feed six men for thirty-six months, and I have had 50 ducats.' To survive, the studio needed to make and sell paintings. Lots of them.

The majority of successful Renaissance painters, including Leonardo's own master Verrocchio, ran workshops in which their assistants produced copies of the master's work.

From around 1500 onwards – so covering the time when the *Salvator Mundi* was painted – Leonardo developed a kind of

production line process in his workshop. He would work slowly on an original or 'prototype' painting, while his assistants produced copies based on his developing painting or on his drawings. Hence there is an original *Mona Lisa*, with its enigmatic smile. There is a prototype *Virgin and Child with St Anne*, in which Mary's mother, St Anne, sits benignly behind her daughter and grandson while he clutches at a lamb. There is the *St John*, with the impish face and finger pointing up at the heavens. These are known as 'autograph' works. Then there are numerous copies of these compositions, painted by Leonardo's assistants, which he supervised and on occasion worked on himself. To complicate matters there are also a few paintings that exist in numerous copies, but for which Leonardo may only have drawn the design, such as the *Ledas*, the mythological princess who was raped by Zeus disguised as a swan, and *Madonna of the Yarnwinders*, in which the baby Jesus tugs on a spool of thread. Art historians label this type of painting as 'Leonardo plus Workshop' or 'Workshop plus Leonardo'.

The assistants also made small devotional panels of subjects like the Madonna and Child, St John the Baptist, Christ crowned with thorns or carrying the cross, or indeed the Salvator Mundi. There was a ready market in Milan and further afield for these small-scale works – roughly the same size as the *Salvator Mundi* – which would be hung in the homes and chapels of well-to-do citizens as an aid to prayer and a symbol of piety. Often an assistant would rifle through a drawer full of Leonardo's sketches, pick out, for example, a head, a hand, a drapery study of an arm or chest, and an orb, and make a composite of them in a new painting. One often finds a pretty face from one of Leonardo's drawings reappearing in different paintings by his assistants. Sometimes the face is reversed, as it had been traced on. These kind of pictures are called simply 'Workshop'.

The quality of these workshop paintings ranges from the superbly polished copy of *The Last Supper* at the Royal Academy in London

to numerous weakly half-smiling saints attributed to Giampietrino. Leonardo advised his disciples to produce paintings of varying quality and price for customers, 'so they can say: this is an expensive work and this of medium quality and this is average work, and show that they can work to all price levels'. That price could depend not only on the size of the painting, but the extent of the involvement of the master.

It was very difficult to persuade Leonardo himself to paint one of these small devotional panels, as the patron and occasional regent Isabella d'Este, the Marchioness of Mantua, discovered. Isabella had rooms in a tower in her palace over two levels, a *grotta* and a *studiolo*, in which she exhibited a careful arrangement of her classical sculptures, gems, cameos, antique vases, curiosities, and paintings by Mantegna and Perugino, among others. Leonardo visited Mantua around 1500, and made a beautiful and characterful drawing of Isabella in profile. Her face is slightly rounded and her mouth begins to pout and smile in an expression that is wilful, capricious and seductive. Isabella instructed her aide Fra Pietro Novellara on 29 March 1501, 'Sound him out, as you know how, as to whether he intends to take up the commission to paint a picture for our study: if he is willing to do it, we will leave to his judgement both the theme of the picture and the date of delivery. And if you find him reluctant, you could at least try to persuade him to do me a little picture of the Madonna, in that devout and sweet style which is his natural gift.'

Four days later Fra Pietro replied, not holding out much hope of success: 'Since he has been in Florence he has only done one drawing, a cartoon.' Six weeks later, in the middle of May, Isabella herself wrote a letter to Leonardo, tempting him with another subject: 'Understanding that you are settled in Florence, we are hopeful that we can get from you what we have so much desired, which is to have something from your hand … a Youthful Christ, of about twelve

years old, at the age when he disputed in the Temple, done with that air of sweetness and smoothness in which your art so especially excels.' Two years later Isabella was still trying, this time using as an intermediary a relative of Leonardo's, Alessandro Amadori, who was canon of Fiesole and the brother of the artist's first stepmother. Amadori reported back to her that he had spoken to 'my nephew Leonardo', and 'I do not cease to urge him to make an effort to satisfy Your Ladyship's desire concerning the figure for which you asked him … he has promised he will begin work shortly.' But alas, Isabella d'Este never got her teenage Christ. Salai offered to paint the subject for her, but she didn't want a workshop painting.[1]

Half the argument over the attribution of the *Salvator Mundi* is over which category of Leonardo's workshop's output Simon and Parish's *Salvator Mundi* belongs in: 'autograph' Leonardo, 'Workshop plus Leonardo' or simply 'Workshop'. There is usually an obvious difference in quality between autograph and workshop. But not always.

Leonardo's studio produced around a dozen images of Christ as the Salvator Mundi in three variants: teenage Christ, twenty-something Christ, and Christ minus the blessing hand and globe. The versions of a teenage Christ date from the very early years of the sixteenth century. There are two examples attributed today to Marco d'Oggiono – one in the Villa Borghese in Rome, the other in a museum in Nancy in France – and a third in Moscow by Giampietrino, which is a significant painting for our story. In terms of their poses, these teenage Christs are more Leonardesque than Simon and Parish's *Salvator Mundi*. Christ is turning, not front-on, and is still in the act of forming the blessing gesture with his hand.

Simon and Parish's *Salvator* belongs to a second, distinct group of young adult Christs. There are variants of this type in the storerooms

of the Detroit Institute of Arts and in the collection of Wilanów Palace in Warsaw. There are also two which belonged to the Vittadini and Ganay private collections. Another is known to us only from a photograph from the last century, when it was in an English collection that was formerly owned by Lord Worsley and then the Duke of Yarborough.

The third variety is a subset of young adult Christs, but as simple portraits, minus the arms, such as the 1511-dated Salai in Milan's Ambrosiana.

Finally there is one contemporary documentary reference to a *Salvator Mundi* among the papers of Salai. The first ever probable identification of a *Salvator Mundi* is to be found in an inventory of paintings belonging to him, written after he died suddenly in 1524, killed in a duel with a French soldier armed with a crossbow. It lists twelve paintings, some with the same titles as Leonardo's most famous paintings like the *Mona Lisa* and *St John the Baptist*, others more generic devotional subjects. It includes a 'Christ in the Manner of God the Father', which is almost certain to be a description of a *Salvator Mundi*. The inventory also lists prices for these pictures, which are set at such a low level that most Leonardo scholars have concluded they were workshop copies by Salai and possibly other artists.[2]

All these various *Salvator*s overlap and diverge in several ways, beyond the age of Christ's face. The decoration on the borders of the robe can have floral or classical motifs, or an angular geometry, possibly derived from the patterns on Arabic cloth. The thumbs may be bent or straight. The orb in Christ's hand can have a kind of map on it, as if it represents the earth, or a metallic sheen of gold, or be transparent as if made from crystal. Sometimes there is a golden cross on top of the orb. The reflections in the orb are sometimes white highlights, as if coming from a window, and in one instance a glitter of gold from the embroidery. Such variations are to be explained both

by the freedom Leonardo's students had to deviate from his blueprint and the demands of particular clients.

In the light of the profusion of *Salvator Mundi*s, and the mistakes Charles I and his courtiers made about attributions, how can one be sure whether the painting owned by Charles was by Leonardo, or by one of his assistants? We can't – not nowadays. A century ago, art historians thought it was an easy call. Until recently Leonardo's followers were derided as incompetents, whose pictures could easily be distinguished from those of their master. Bernard Berenson wrote that Boltraffio's work could be all 'sugar and perfume' and that Solario was 'lamentable', while Giampietrino and Cesare de Sesto were guilty of 'sickliness, affectation or sheer vulgarity'.[3] The twentieth-century Italian art historian Roberto Longhi called them 'dour draftsmen of chilly beauty, not one capable of reanimating the corpses which shortly before had trembled under Leonardo's miraculous anatomist's touch'.[4] As late as the 1980s, Martin Kemp had little time for the 'Milanese followers who repeated smiling Madonnas of Leonardesque mien as if dazzled into anonymity by his magic'.[5]

But over the last decade, art historians have begun reviving the reputations of Leonardo's assistants. True, there are plenty of tenth-rate paintings by them, with schematically drawn saints in uncomfortable poses, hands with fingers like sausages and prematurely aged babies, but others are of uncommonly high quality, such that no one is quite sure if Leonardo didn't add a few brushstrokes himself. Carmen Bambach, the Metropolitan Museum's curator of drawings, wrote in the catalogue of her exhibition of Leonardo's graphic work: 'It is commonly agreed that Leonardo's pupils could at times be more Leonardesque in their pursuit of aesthetic effects than Leonardo.'[6]

Salai, Francesco Melzi, Andrea Solario, Agostino da Lodi and Bernardino Luini all knew how to take one of their master's draw-

ings, trace it onto a panel, add dark undercoats, and then add thin layer after thin layer after thin layer of oil paint, gently rubbing the paint with their fingertips to soften the transitions from light to dark in order to concoct Leonardesque paintings. They learned to replicate exactly their master's *sfumato* style. Assistants and followers who outlived Leonardo, including Luini and Melzi, continued making paintings in this way for over a decade after his death.

Comparisons between the versions of the *Salvator Mundi* cast further doubt on the provenance story offered by Simon and his colleagues. In the last decade, technical examination of the versions has opened up the timeframe within which Simon and Parish's picture could have been painted. Some of the paintings have been dated through dendrochronology, or wood-ring analysis. The one in Wilanów Palace in Warsaw was tested in 2005. The little-publicised investigations show it to have been painted on oak, around 1585, meaning that it is a later copy and its former attribution to Leonardo's workshop can be dismissed. The oak is French. It is therefore a later copy of a version of the *Salvator Mundi*, which could have been painted in France or Northern Europe.

An even more important dendrochronological revelation came only in 2019, when the Detroit Institute of Art tested its own *Salvator Mundi*, and revealed that it was also a later copy, painted on Baltic oak, executed decades after Leonardo's death, sometime after 1569 (the date of the felling of the tree). Every major Leonardo scholar of the last hundred and fifty years accepted the attribution of this painting to Leonardo's assistant Giampietrino.* They were all wrong. It shows how easy it is in the field of Leonardo's workshop for even the most

* This roll call includes Wilhelm Suida, who in 1929 wrote the first study of the Leonardeschi, *Leonardo and His Circle*; Ludwig Heydenreich, who wrote the first study of the *Salvator Mundi* group in 1964; as well as renowned connoisseurs Bernard Berenson and Federico Zeri.

observant art historians to get it wrong, if they have nothing else to
go on but 'the eye'.

A third revelation is contained in the papers of the twentieth-
century German art historian Ludwig Heydenreich. In 1947 he
examined the so-called 'Stark *Salvator Mundi*', named after a previous
owner, which is now owned by an unknown collector in Zurich. The
Botanical Institute of Zurich looked at this painting and said it was
on cedarwood, according to Heydenreich. This is a very unusual
surface for a painting from anywhere except Spain.

Now if we add extra clues into this French–Baltic–Spanish mix,
we are drawn to a particular focus on one Dutch town where several
copies of a Leonardesque *Salvator Mundi* seem to have been made.
Firstly the Detroit, Warsaw and Stark *Salvator Mundi*s all share the
same rounded facial features, which link them together. The Detroit
and Stark have comparable classical-floral decoration on the crossing
bands. A historical perspective adds to our understanding of this clus-
ter. Baltic oak was a popular surface for paintings in Antwerp until
1585, when the Spanish took control of the city and then the Dutch
fleet blockaded it. Suddenly it was not easy to obtain Baltic oak, but
French oak could be brought in overland, while the Spanish conquer-
ors could order cedarwood panels from Spain. At this time, the
Counter-Reformation was in full swing in Antwerp, and it is highly
conceivable that the copyists decided to replace the geometric knot-
work of Leonardo's *Salvator*, which carried echoes of the Islamic
world, with cherubs and lilies. Thus it seems that, along with the
Hollar etching, these three *Salvator Mundi* copies were likely to have
been created in Antwerp: the Baltic Detroit before 1585 (the
wood-dating is 1569), the French Warsaw after 1585 (the wood-dat-
ing is after 1585) and the Spanish Stark at around the same time.
Hollar's etching differs from the other copies in that it shares the
same geometric embroidery pattern as Simon and Parish's painting,
but in other respects it is like these later copies. Ergo, Hollar is likely

to have copied another now lost version which looked like the Detroit or Stark, but still had the original geometric knot designs.[7]

If he did copy Simon and Parish's *Salvator Mundi* – either taking it upon himself to round out the face or copying a face that looked very different in 1650 to how it does now – then the picture was probably in Antwerp.

Simon and Parish, with the support of Martin Kemp, claim that their *Salvator* is the finest version of them all. They point to its details: the bubbly defects of the crystal orb and the ever-changing play of light on the golden filigree embroidery. They point to the individually rendered locks of Christ's hair. They point to the incredible refinement with which the blessing hand is painted. They point to the intense atmosphere or aura which their painting possesses. For Simon and Kemp and many other art historians, the existence of so many copies means that Leonardo must have painted an original, which, logically, must be the finest of them all – theirs.

Their arguments are adept, but inconclusive. There is another *Salvator Mundi* in Naples with a superbly rendered orb, specked with gold as if catching the reflections of the embroidery and featuring a bright white reflection of a light source, which is more realistic than that in Simon and Parish's painting.[8] Nor is there any certainty that theirs is the original in the series. The eighteenth-century librarian of Santa Maria delle Grazie in Milan, Vincenzo Monti, wrote of a painting depicting 'the Saviour' painted by Leonardo in a lunette above a door there, which had been destroyed when the door was enlarged during building works in 1603.

Comparison of Leonardo's preparatory chalk drawings with the *Salvator* workshop paintings further undermines the claim that Simon and Parish's painting is the original. If Leonardo's drawings were preparatory, and Simon and Parish's painting was the original, then

one would expect to see all the features of the preparatory drawings in it. However, their *Salvator* does not have the cuffed sleeve of one of the drawings, while exactly the same cuffed sleeve is visible in the Yarborough-Worsley *Salvator Mundi*, which is an undisputed workshop painting. Therefore, by deduction, Leonardo's preparatory drawings do not indicate that he himself painted a *Salvator Mundi*. He could have made generic drawings of parts of a figure, which were then used and adapted by his assistants to make *Salvator Mundi*s. This was the conclusion drawn in the landmark first-ever essay about the Leonardesque *Salvator Mundi*s, written by Ludwig Heydenreich and published in 1964 in the journal of Leonardo studies, *Raccolta Vinciana*. Heydenreich took the view that Leonardo's assistants made use of 'a highly developed study or possibly a cartoon-drawing by Leonardo'.

The well-organised geometry of the composition of all the adult *Salvator Mundi*s and their almost identical dimensions also support the idea that Leonardo produced a design for the painting, but that does not necessarily mean that he painted one himself.

Martin Kemp and Robert Simon's problems are further compounded by the inventory of Salai's paintings of 1525. They would like to claim the 'Christ in the Manner of God the Father' on that list as a contemporary documentary reference to their *Salvator Mundi*. But as they do that, it makes it more likely that their picture is a workshop painting.

The most visible difference between a work by Leonardo and one ascribed to his followers is the price. Works by the Little Leonardos or later copyists are sold for a small fraction of a Leonardo – anywhere between $7,000 and $1.5 million, depending on the quality. A seventeenth-century version of the *Mona Lisa* sold in New York in January 2019 for $1.6 million, and a version of Salai's *Christ* went for $1.1 million in December 2018 – remarkable sums which were surely influenced by the sale of the *Salvator Mundi* in 2017. More normal prices were the $656,000 paid for a Salai *Christ* in 2007,

$224,000 for a Luini *Madonna and Child with Saints* in 2017, and $468,500 for another Luini, *Madonna of the Grapevine*, in 2016. Boltraffios have been difficult to sell, with prices ranging from $20,000 to $80,000 in the last decade.

And yet, Simon and Kemp are on much firmer ground with anatomy and aura. If one examines the oeuvre of Leonardo's assistants, it is evident that although they can, on a good day, rise to the challenge of creating the delicate impression of anatomy under soft skin, and of modelling curls of great variety – this is not the case with their *Salvator Mundi*s, which are far from their best works.[*] Simon and Parish's blessing hand is certainly the most blessed of them all. The dealers' painting also achieves a greater auratic impact than other versions. This ultra-soft *sfumato* with which Christ's face is painted – so much more ethereal than that of other versions of the *Salvator Mundi* – is comparable to an indisputably autograph late work by Leonardo, the *Virgin and Child with St Anne* in the Louvre, the *sfumato* of which is again so much softer than the various copies made of it in Leonardo's studio.[†] There is a mysterious power in Christ's gaze and a strength of character in his face, which sets Simon and Parish's *Salvator Mundi* far apart from the others. Whoever painted this *Salvator Mundi*, it is – no question – the best of the bunch.

[*] You will find exceptional hands, for example, in Cesare da Sesto's *St Jerome* in the Brera, Milan. Giampietrino's *Penitent Magdalen* in the Hermitage shares the same double helix curls in the hair as Simon and Parish's *Salvator*, while the *Portrait of a Young Woman with a Scorpion Chain* attributed to Boltrafffio, but which could as easily be by Giampietrino or Cesare da Sesto, at the Columbia Museum in New York, has a dark *sfumato* comparable to the *Salvator*. Dietrich Seybold draws attention to the little stones on the ground of Cesare's *Madonna and Child* at the Poldi-Pezzoli Museum in Milan, which look remarkably similar to the internal flaws in the crystal orb.

[†] See the detailed study of the *St Anne* and its copies in the Louvre exhibition catalogue *St Anne: Leonardo da Vinci's Ultimate Masterpiece*, Vincent Delieuvin ed., Musée de Louvre, Paris, 2012.

THE *SALVATOR* SWITCH

Robert Simon and Margaret Dalivalle have identified their *Salvator Mundi* as Charles I's 'Peece of Christ', but there is evidence of other *Salvator Mundi*s in England during that period – in fact there are at least three inventory entries for potential Leonardo *Salvator*s. Simon and Dalivalle ought to have noticed, cited and discounted the other entries publicly if they wished to present a fully convincing case that their painting was the 'Peece'. Their 'Peece', the Commonwealth inventory records, was bought by John Stone in May 1651. A second, belonging to Edward Bass, is listed in the same inventory. A third is mentioned in an inventory of the Duke of Hamilton. There are, in addition, two visual sightings to add to the evidence on the table. As we have seen, the inscription on Wenceslaus Hollar's 1650 etching of the *Salvator Mundi* attributes the original painting to Leonardo. A second clue is, dramatically, a *Salvator Mundi* painting currently in a Russian museum. So the question emerges: is Simon and Dalivalle's claim that their painting had belonged to Charles I convincing?

* * *

After it had been catalogued and priced in the Commonwealth Inventory, the *Peece of Christ* was loaded onto a cart by workmen, along with the rest of the late king's art collection and other valuables, and taken to Somerset House, where everything was put on display for sale. At first there were few buyers. It was not a good time to sell art. England was impoverished after years of civil war, and most art collectors had been Royalists, and had gone into exile. Foreign kings did not want to be seen to be profiting from the death of one of their fellow rulers. For any remaining English *aficionados*, collecting paintings with Catholic subject matter had a vastly diminished appeal in Puritan England.

By May 1650 the Commonwealth had made only £7,750 from sales of the king's pictures. So Parliament changed its approach, deciding that instead of selling the pictures, it would use them as payment in kind to Charles's former employees and contractors, many of whom were owed money by the Crown for services rendered. Over seven hundred pictures were distributed among nearly a thousand of Charles's creditors in London. They were given to widows, orphans, goldsmiths, soldiers, vintners, musicians, cutlers, drapers and tailors. To cite just one example, a plumber who was owed £903 was given £400 in cash and a Titian. The art market was democratised for an instant, a short-lived cultural revolution never to be repeated anywhere in the world.

The creditors preferred money to art, so they pooled themselves into syndicates, or 'dividends', each one with an appointed head to whom they entrusted most of their paintings and sculptures for sale. The dividend leaders turned their homes or other premises into showrooms. There were Titians at £600, Correggios for £800 to £1,000, a Raphael at £2,000, while a Palma Vecchio could cost only £225, and a Tintoretto £120. The new *de facto* art dealers hoped to sell the works for more than they had been valued, and took it upon themselves, on occasion, to enhance the value themselves. The

contemporary chronicler Richard Symonds reported that one dealer, Captain Robert Mallory, 'bought a little piece from Mantua … He has caused to be daubed over bit, and endeavoured to make me believe 'twas so fresh always.' The *Salvator*, if it had been damaged by this time, may well have been 'restored' by such an amateur, the first of several ruinous repaintings that the picture underwent.

The 'Peece of Christ' was allocated to John Stone's consortium, the Sixth Dividend, on 23 October 1651. Alonso de Cardenas, Philip IV of Spain's envoy in London during this turmoil, saw an irresistible window of opportunity in the Caroline clearance sale, and dispatched English art advisers to scour the syndicates' viewing rooms for the best paintings at bargain prices. If he had ventured into the viewing rooms himself, it would have revealed the identity of his fabulously wealthy client, with the consequential risk of being charged higher prices. He then sent lists of recommendations of what to purchase back to his masters at the Spanish court.

His first list, from December 1649, described paintings on offer at Somerset House, St James's Palace, Greenwich and Hampton Court. It listed forty top lots, including four Correggios, three Raphaels, three Andrea del Sartos and sixteen Titians. In 1651 Cardenas sent his men to look at John Stone's pop-up gallery. They reported back that Stone had a whole series of Titians, the twelve Roman emperors (since lost), which the advisers said were 'well preserved', although one of the originals was missing, and van Dyck had painted a replacement. Cardenas struck a deal through his intermediaries, using the fact the set was incomplete to get a 50 per cent discount. The result, £600 for eleven Titians and a van Dyck, was a coup even in those days.

The second Cardenas list mentioned twenty-four paintings, including four each by Correggio and Giulio Romano, two each by Raphael, Mantegna and Palma Vecchio, and a Titian. It is bizarre that he makes no mention of a Leonardo for sale, despite the demand for

his works being as great in Madrid as it was in London. John Stone must also have been relatively well informed about Renaissance art. His father was the royal builder Nicholas Stone, who constructed many of the buildings of Inigo Jones, a great Leonardo aficionado, and his brother Henry was an artist and occasional art dealer. Stone was regarded as so knowledgeable about art that he was allowed to value the pictures in his dividend. He calculated a total of £1,614, including the Leonardo. It is inconceivable that he would not have displayed and drawn potential clients' attention to such a work unless he had good reason. The *Salvator* had a very low price, and kept a very low profile in Stone's stockroom, considering the fame of its maker and the expertise of its owner.

England's experiment in parliamentary rule was short-lived. After Charles II was restored to the throne in 1660 he was quick to order the return of works from his father's collection, without compensation. Parliamentary documents show that John Stone returned the 'Peece of Christ' and many other works. In the mid-1660s a list of Charles II's art holdings was compiled, the so-called Chaffinch Inventory. It is here that Margaret Dalivalle found the first clear description of a painting of the *Salvator Mundi* attributed to Leonardo. The inventory lists:

> No 311. *Leonardo da Vinci, Christ with a globe in one hand and holding up the other.*

There is, however, a second *Salvator Mundi* listed in the 1649–51 Commonwealth Inventory. Item number 123 is:

> A Lord's figure. In Half by Leonardo, *priced at £80 and given to Edward Bass in December 1651.*

Edward Bass was a merchant who had supplied lace to Charles I. He headed three dividends, and through them he acquired some of the king's finest paintings, including Raphael's *Holy Family*, the most expensive painting in the whole sale at £2,000. Bass sold several of his best pictures, including the Raphael, to Spanish agents, and they were dispatched to Madrid. You might imagine that the 'Lord's figure in half' could be any portrait of a nobleman, because it only says 'Lord', but in the same inventory, paintings of the Virgin Mary are sometimes described as 'A Lady'. More striking evidence that Bass's painting could be a *Salvator* derives from a French inventory of Charles I's collection, dated 1651. This one, compiled by agents for the French court, shares the same artist, catalogue number and price tag, but the Lord has become a Christ: '*No. 123, Bust of Christ, by Leonard[o], £80*'. It is unlikely that the French crown bought Bass's Leonardo, because it is not mentioned in subsequent French royal inventories.

The third *Salvator Mundi* is itemised in an inventory of the art collection of one of Charles I's courtiers which came to light months after the auction of the *Salvator Mundi*.[1] It is a list of pictures which hung in Chelsea House in London, the home of Lord James Hamilton, a distant Scottish cousin of Charles and one of the circle of collectors around him. The art historian who discovered the inventory has dated it to around 1638–42; the listing appears towards the bottom of the single page of works as '*Christ with a globe in his hands done by Leonardus Vinsett*'.[2]

This painting probably came from Venice, like others hung in the same room, perhaps from collections of the Venetian noble family, Priuli, or the French artist and dealer resident in Venice, Nicolas Régnier, from both of whom Hamilton is known to have bought pictures. We don't know where exactly it is from because it is not

listed in the inventories of the collectors from whom Hamilton is known to have bought, although there is a reference in Régnier's inventories to a picture of Christ by Bellini, whose work was very occasionally mistaken for Leonardo's.

During the English Civil War, in which Hamilton fought on the side of the Royalists, it seems that he planned to ship his art collection to safety in Scotland. It was packed into crates in 1643, and there is another inventory for this. The 'sixteenth' crate contained a *Christ holding up his two fingers*. No artist is named, but this is likely to be his *Salvator* again. The crates never went to Scotland.

After this, there is a fork in the road of the provenance of Hamilton's *Salvator Mundi*, one of which leads back to the English court, the other to the Netherlands. In August 1648 Hamilton was defeated by Cromwell's army at the Battle of Preston, despite having an army over twice the size of his opponent's. He was captured, and was executed in 1649. By then his relatives had shipped his collection to Antwerp, the centre of Europe's art market. There is no list of the works that were sent, but if the *Christ holding up his two fingers* is Hamilton's *Salvator Mundi*, it could have stayed in its crate, and the destination for the entire collection could have been switched from Scotland to the Netherlands.

In Antwerp most of Hamilton's collection was bought by the Archduke Leopold William, governor of the Spanish Netherlands, although there is no mention of a *Salvator Mundi* in his well-documented collection, which later formed the foundation of Vienna's Kunsthistorisches Museum. But it might have been sold to a Dutch collector.

On the other hand, Hamilton's painting could have remained in England. Hamilton, in common with other courtiers, gave numerous pictures to Charles I as gifts, as van der Doort indicates in his 1639 inventory, and these might have included his *Salvator*. In summer 1637, at the time of his purchase of the paintings from the Della

Nave, Priuli and Régnier collections in Venice, Hamilton wrote a
letter to his agent and brother-in-law Lord Feilding, saying that the
king wanted Hamilton to buy pictures on his behalf:

> His Majesty, having seen the noot [i.e. details] of Della Nave's
> collection, is so extremely taken therewith as he has persuaded me to
> buy them all, and for that end has furnished me with monies. So,
> brother, I have undertaken that they all come to England, both
> pictures and statues out of which he is to make choices of what he
> likes, and to repay me what they cost if I have a mind to turn
> merchant.[3]

Hamilton may have given Charles the *Salvator* sometime after 1638
or 1642. It may be difficult to imagine the royal court still swapping
paintings on the eve of the Civil War, but if that did happen, it would
explain why a Leonardo *Salvator* was in the 1649 inventory but not
in van der Doort's earlier 1639 one.

Fortunately, we do not have to rely purely on written clues for the
whereabouts of Simon and Parish's painting. Alongside the three
inventory entries are two pieces of visual evidence of a *Salvator Mundi*
at the English court. As has been mentioned, in 1650 the Bohemian
printmaker Wenceslaus Hollar, who had formerly worked at the
English court, made an etching of a *Salvator Mundi* on which he
wrote an inscription: '*Leonardus da Vinci pinxit. Hollar fecit aqua forti.
Secundum Originale*', or 'Leonardo painted this, Hollar etched it. After
the Original'. The fact that he wrote '*Secundum Originale*' suggests that
Hollar believed he saw the painting itself, not a copy, and that this was
a remarkable event for him.

The reproduction of images has long been a vital part of the
modern art market. In the era before postcards, posters and photo-

graphs, there were etchings, engravings and woodcuts. Wenceslaus Hollar was the master of this trade in London. 'The ingenious Mr Hollar', as his contemporary biographers John Aubrey and John Evelyn describe him, is buried in Westminster Abbey, an indication of the esteem in which he was held. Born in Prague in 1607, he was working in Germany in 1636 when he met the austere but art-loving Earl of Arundel, who was on a diplomatic mission to the Holy Roman Emperor Ferdinand in Vienna on behalf of Charles I. Arundel was an art collector of the first order; his mansion on the Thames, below The Strand, featured a vast collection of Renaissance master-pieces and classical sculptures which would best those of most modern museums, and included Raphaels, Titians, Andrea del Sartos, van Eycks, Dürers and numerous Holbeins. Inigo Jones built him a special room to house and display his collection of Old Master drawings.

Arundel was looking for a printmaker to create copies of his works of art, which could be mass-produced cheaply, combined into a cata-logue, or gifted or sold individually around Europe, to publicise his collection. Hollar was the right man for this job, and Arundel brought him back to London, writing to one of his art advisers, 'I have one Hollar with me, who draws and etches prints in strong water quickly and with a pretty spirit.'[4] If it had been realised, this far-sighted project would have resulted in the creation of the first catalogue of reproductions of an art collection in history. But although Hollar made numerous drawings of items in Arundel's collection, and some etchings from them, nothing comprehensive was done.

Hollar became, in terms of quantity, the most prolific artist of seventeenth-century England, and in terms of exposure, arguably the greatest of the century. He executed around 2,700 prints in his life-time, including views of London before and after the Great Fire, which give us today our definitive image of the city at the time. He is an example of a very different kind of artist to Leonardo da Vinci.

He never acquired Leonardo's glamour or fame. He never became rich, as a contemporary painter like van Dyck did. But he was no less important in the history of art, in which copies can be as interesting as originals, especially if the originals have gone missing.

In 1646, in the midst of the English Civil War, Hollar fled to Antwerp. His patron Arundel died the same year. Hollar now needed to earn a living. He made fashion series of women in contemporary dress. He made maps, some of England, which were probably useful to the armies on both sides of the Civil War. He also etched copies of works of art from various English and Dutch collections. Those from the Arundel Collection, which included some of Leonardo's *tronies* – sketches of people with deformities – must have been based on drawings he had made years earlier when he was in London, as must his prints of van Dyck's portraits of Charles I and his family. Hollar made 350 plates in this period, among them his *Salvator Mundi*, before he returned to England in 1652. His print has the same geometric embroidery pattern and the same folds in the drapery as Simon and Parish's *Salvator Mundi*. The only obvious difference is the thick, curly, carefully combed beard on Hollar's Christ.

No detailed official provenance of the *Salvator Mundi* was published by Robert Simon or Margaret Dalivalle before 2019, which makes it difficult to know who was responsible for the material that was published on this subject by the National Gallery in London in 2011, in disclosed legal filings by Sotheby's in 2015, and by Christie's in 2017. It is known that all three saw information which originated with Simon, including a long essay by Dalivalle. However, Christie's and the National Gallery's catalogues and documents all failed to mention Edward Bass's *Salvator Mundi*.

Instead, they weave an intricate and glittering French and English royal provenance for their *Salvator Mundi* from the threads of the

Commonwealth Inventory's 'Peece of Christ', the Chaffinch Inventory's *Christ with a Globe in One Hand*, and Wenceslaus Hollar's etching. They then bolster this narrative with the use of erroneous research about a different painting, which they apparently failed to fact-check.

In the late 1970s Joanne Snow-Smith, an American art history PhD student studying under the great Leonardist Carlo Pedretti, investigated the history of a *Salvator Mundi* known as the Ganay *Salvator*. She wrote a dissertation on the subject, attributing the painting to Leonardo. In 1982 the Ganay *Salvator* was shown at the Henry Art Gallery, a small exhibition space linked to the University of Washington. In an academic journal and in the catalogue she wrote for the exhibition, Snow-Smith argued that the painting had been commissioned by Louis XII of France in 1507.[5] Upon the death of his wife, Anne of Brittany, in 1514, Louis had given the painting to a convent in his wife's home town, Nantes. There it had been admired over a century later, when first Queen Henrietta Maria and then Wenceslaus Hollar went to see it. The queen, who knew Hollar from the period when he worked at the English court, commissioned him to make an etching of the painting, and he gave her his artist's proofs. Let us note for the moment that in this story, the Ganay never travels to England. 'This research shows,' she wrote, 'the probability that Henrietta Maria de Medici, the widow of Charles I, martyred King of England, was the patron and recipient of the proof copies of Hollar's etching after Leonardo's *Salvator Mundi*.'[6] Luke Syson, curator of the National Gallery's 2011 Leonardo exhibition, echoed Snow-Smith's findings in his catalogue essay on the *Salvator*: 'It is known that his [Hollar's] long-standing patron, the exiled Queen Henrietta Maria, received proof copies.'*

* Luke Syson has since told me that he was mistaken to include this in his catalogue entry.

The National Gallery mistakenly switched *Salvators*, and Christie's later followed suit. They took this apparent 'fact', belonging to another painting, and extrapolated an ambitious provenance for their painting from it. They suggested that Henrietta Maria's father Henry IV had given his daughter, the bride-to-be, Simon and Parish's *Salvator* to take to London in 1625, when she married Charles I. The queen had kept the painting in her private apartments at Greenwich, which is why van der Doort missed it. After her husband's execution she fled back to France. Hollar saw the *Salvator* at Charles's court while he was in London and made a drawing of it, which he later turned into a print in Antwerp, and he gave the queen copies of it. There is a useful feedback loop in this narrative for the attribution of the painting. If the *Salvator* had been a French royal commission, then it was more likely to be an original Leonardo, because kings were less likely to accept workshop paintings, and Leonardo spent the last part of his life in the service of the French king. Alan Wintermute, Senior Old Masters specialist at Christie's New York, brought the story to an emotional climax in his essay in the 2017 auction catalogue:[7]

> *The print after the painting, made by Hollar – himself a Royalist who had also escaped England in the 1640s – and presented to the queen a year after her husband's beheading, would therefore have held profound sentimental significance for her.* *

Here we must remember that Hollar's print shows a bearded figure, and thus we have encountered a small stumbling block. There is no

* There is an additional French clue. During the technical examination of the *Salvator Mundi* the restorer discovered that the original black background had once been over-painted green, which was a popular colour for the background of paintings in sixteenth-century France, but not in other parts of Europe.

evidence that the Christ figure on Simon and Parish's painting ever had a beard; nothing in the restoration process revealed any trace of it. This obstacle is overcome with the suggestion that either Hollar added a beard to his copy to make Christ look more conventional, or a beard was added to Leonardo's painting by a 'restorer' at the English court.

However, Simon and his colleagues' argument that Hollar or another artist added a beard is not plausible. Two other versions of the *Salvator Mundi*, the Ganay and Yarborough-Worsley, have beards that are very similar to Hollar's, neatly combed, with a central parting and small tight curls. If Hollar or a restorer had invented a beard it would not look identical to the ones on other versions of the *Salvator*, which neither of them could have seen. Furthermore, although Hollar's *Salvator* has the same geometric embroidery pattern as Simon and Parish's, its rounded face and nostrils are far closer to the facial features of the Yarborough-Worsely and Detroit *Salvators* than they are to Simon and Parish's. The conclusion must be that the print-maker copied another version of the *Salvator Mundi*. It cannot be the Yarborough-Worsley, because that painting was located in Italy until 1800.* It could be the Ganay, but it could also be another lost version, a kind of fusion of Detroit and Ganay perhaps. Whatever it was, the Hollar etching does not have a convincing role to play in the provenance story of Simon and Parish's *Salvator*.

* There is an inventory of paintings compiled by Lord Worsley at the end of the eighteenth century in which he writes that he bought his *Salvator* in Venice, and that it had previously been in the collection of the Loredano family of doge rulers of Venice, and before that it had been owned by the noble Veneto family the Colloredos, and before that, up until around 1750, it had been in Milan. The detail with which he described the provenance shows how important the painting's previous history was for its attribution; and Worsley was clearly convinced that he had bought a Leonardo. It was auctioned in London in 1929 to a buyer called 'Jacobsen', and auctioned again in Paris in 1962 for 30,000 francs, but no one knows to whom, and after that it vanished.

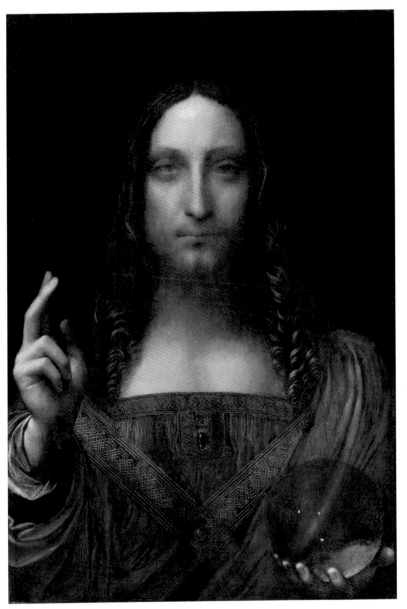

Salvator Mundi
Oil on walnut panel, 66 x 45 cm.
Photographed in 2011 after its restoration. Private Collection.

(left) Drapery study, forearm, Leonardo da Vinci, *c*.1503–10, Red chalk, touches of black and white chalks on orange-red prepared paper, 22 x 13.9 cm. (right) Leonardo (+ Workshop?), The drapery of a chest and sleeve, *c*.1503–10, Red chalk, touches of black and white chalks, some white heightening on orange-red prepared paper, 16.4 x 15.8 cm. Both Royal Collection, UK.

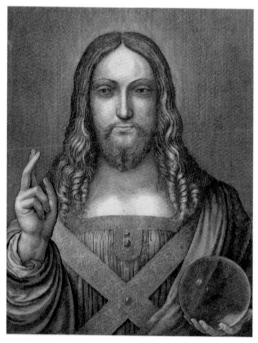

Jesus, after Leonardo 1650, Wenceslaus Hollar (1607–77), Etching, 26.4 x 19 cm. Royal Collection, UK.

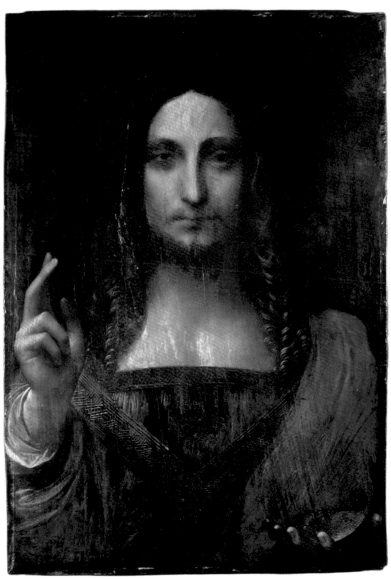

Salvator Mundi, pre-restoration (as-bought state), May 2005.

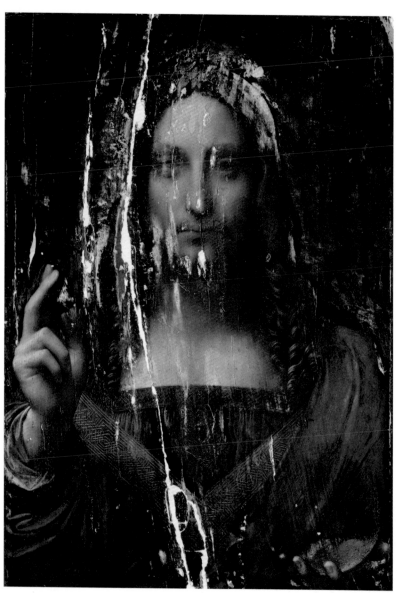

Salvator Mundi, cleaned state, 2006.

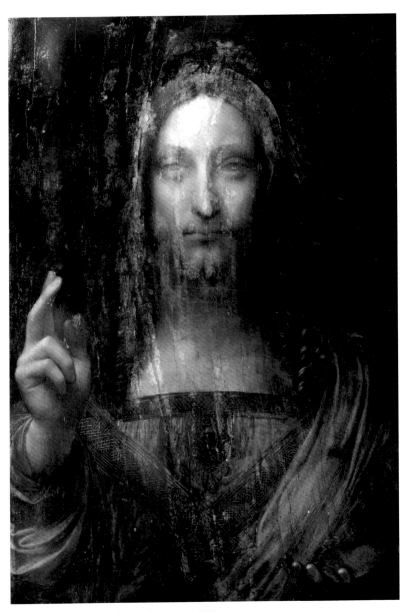

Salvator Mundi, infrared scan, September 2007.

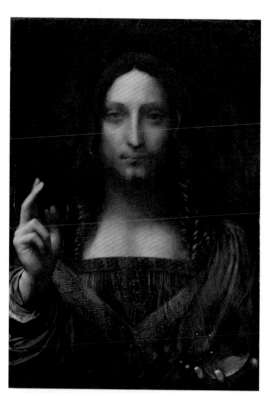

Salvator Mundi (with thumb *pentimento* revealed), 2008.

(below left) *Salvator Mundi* Free Copy After Boltraffio (1467–1516). Cook Collection, Richmond.

(below) *Salvator Mundi*, Girolamo Alibrandi (?) (*c.*1470–1524). Museo San Domenico Maggiore, Naples.

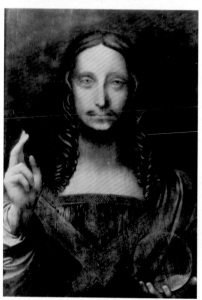

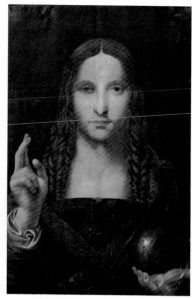

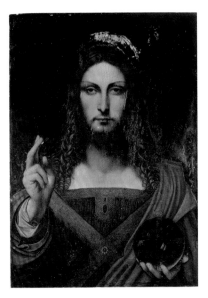

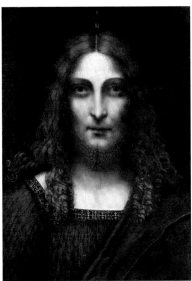

(clockwise from top left) *Salvator Mundi*, Workshop of Leonardo da Vinci, Private Collection; *Head of Christ*, 1511, Gian Giacomo Caprotti known as Salai (1480–1524), Oil on panel, 57.5 x 37.5 cm, Pinacoteca Ambrosiana, Milan; *Salvator Mundi*, Giampietrino (active *c*.1495–1540), Wood, tempera, 50 x 39 cm, Pushkin Museum, Moscow; Charles I stamp on the reverse of the Pushkin *Salvator Mundi*.

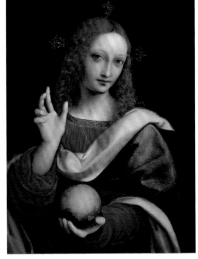

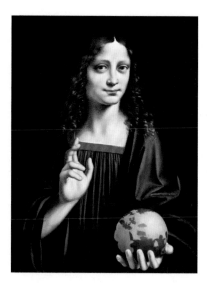
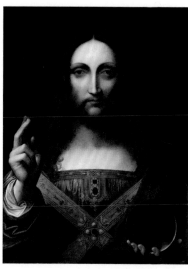

(clockwise from top left) *Salvator Mundi*s by Marco d'Oggiono (*c*.1467–1524), Oil on canvas, Galleria Borghese, Rome; Follower of Leonardo da Vinci (after 1569), Paint on wood panel, 65.4 x 48.3 cm, Detroit Institute of Arts; Follower of Leonardo da Vinci, 63.5 x 49.5 cm, Lord Worsley and then the Duke of Yarborough (painting now lost, photograph from Berenson Photo Archive, Harvard University Center for Italian Renaissance Studies); Follower of Leonardo da Vinci (*c*.1585), Oil on oak panel, Wilanów Palace.

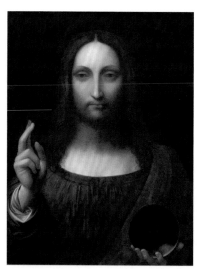
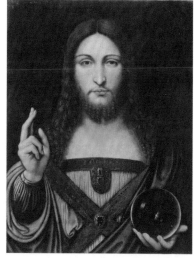

Both the beard and the queen are in fact red herrings. Joanne
Snow-Smith was making unsubstantiated claims about Hollar's rela-
tionship with Henrietta Maria. There is no indication in her book of
what her 'research' might be – no reference, no footnote. While it is
true that the former queen fled back to France in the wake of the
Civil War, there is no evidence that Hollar ever travelled there; none
that he met Henrietta Maria there; and also no sign that he ever gave
her proofs of his print. Consequently, the *Salvator Mundi* may have
held no particular significance for Henrietta Maria.

It is true that the French kings from Louis XII onwards revered
Leonardo and his paintings. Leonardo lived in France in the last two
years of his life in a mansion given to him by Louis's successor Francis
I. But this makes it rather unlikely that Henrietta Maria's father,
Henry IV, would have given one of Leonardo's pictures away, and if
he had, it would surely have been mentioned in the inventory of
Henrietta Maria's trousseau. But it is not, nor does it appear in later
inventories of her possessions in the 1660s. It is, anyway, unlikely that
Francis I ever owned Simon and Parish's *Salvator Mundi*. The first
record in French royal inventories of a painting by Leonardo of this
subject dates from 1625–30, when the French astronomer and
antiquarian Nicolas-Claude Fabri de Peiresc mentions '*un petit Jésus
de Leonard del Vins*' which is one of 'the rarest pictures of Fontainebleau'.
A French friar, Pierre Dan, mentions 'a half figure of Christ' 'by
Leonardo' in his book about Fontainebleau in 1642.[8] The painting is
listed again in 1683 in an inventory of the paintings of Louis XIV,
kept at his Louvre palace.[9] In 1731 a *Salvator Mundi* by Leonardo is
mentioned again at Fontainebleau, this time by an abbot, but it is 'A
young Christ, half-figure, which holds a globe'. There are
measurements – 48cm x 35.5cm. That is not only considerably
smaller than Simon and Parish's painting, it also corresponds in its
dimensions and subject matter to a version of the Salvator Mundi, as
a teenager and holding a globe of the earth, attributed to Marco

d'Oggiono and in the collection of the Musée des Beaux Arts in Nancy.[10]

The fact that Hollar wrote '*Secundum Originale*' on his etching suggests that he saw the picture itself very close to the time he made his etching. So he may well have been copying a painting he saw in Antwerp. At the same period he copied the paintings of at least one Dutch collection, inscribing the copies '*Ex Collectione Veerle*', in the same way he inscribed copies from Arundel's collection '*Ex Collectione Arundeliana*'. It is a mystery why Hollar does not say to whom the *Salvator* belongs. One possibility is that he didn't want to draw attention to the macabre fact that it had been in the collection of a dead king. Another is that the painting was simply on the market in Antwerp. As we learned in an earlier chapter, the types of oak, Baltic and French, used for other late-sixteenth-century copies of the *Salvator Mundi*, such as the Detroit and Warsaw, were widely used in the Netherlands at the time, and suggest, along with the Hollar etching, that Antwerp was a location where copies of the *Salvator Mundi* were made.[11] Hollar knew a good image, which would appeal to the Counter-Reformation market in Europe, when he saw one. He didn't need to know who owned it.

One further piece of visual evidence remains to be discussed. In a distant world of misspelt, unreliable, inaccurate and incomplete inventories of art, there is one indisputable proof that a painting once belonged to Charles I. Almost every picture from his collection was branded with a stamp burnt into its back. The stamp forms a crude symbol, a 'C' and an 'R' on either side of the outline of a crown. Simon and Parish's *Salvator Mundi* does not have one.

But there is a painting of the *Salvator Mundi*, which was attributed to Leonardo until the mid-nineteenth century, which does have this symbol on the back: it currently hangs in a museum in Moscow.[12]

THE RESURRECTION

Most of the Old Master paintings you see in art galleries are much more damaged than they appear. That damage can have been caused by physical mistreatment of the painting, natural decay of materials, or incompetent or inventive restorations. Cracks often opened up between the planks of wood on which the picture was painted, pink cheeks were scratched away, paint faded and flaked off landscapes and draperies, the colour of the background was altered. In past centuries restorers were often artists or craftsmen, who sometimes dealt in art too. Techniques were basic, supervision was non-existent and the results varied greatly. Several Leonardos have been severely damaged in the past. *St John the Baptist* was at one point cropped at the bottom and is missing a sixth of its whole picture area, while the head was cut out of the Vatican's *St Jerome*, taken elsewhere for a while and then reunited with the painting. The *Lady with an Ermine* has had its background repainted at some point. Raphael's *Madonna of the Goldfinch* was smashed into seventeen pieces in 1547 when its owner's house collapsed, and was then put back together with nails. Pisanello's *Virgin and Child with Saints* in the National Gallery in London was famously almost entirely

repainted by the nineteenth-century Italian restorer Giuseppe Molteni.

There are two stages to the restoration of a painting. The first is cleaning, which removes dirt, later additions (known as over-painting, carried out by restorers, other artists or amateurs) and all the layers of varnish. The second phase is restoration, in which losses are *in-painted*. Most Old Master paintings have been heavily restored, often several times over, and the further in time we progress away from the Renaissance, the more damaged the works become and the more they need to be repaired. It is perfectly normal practice for restorers to fill in missing strips and patches of paint inside an arm, on a fold of cloth, or even on a person's cheek, by painting it imperceptibly in the same way as the artist had executed it. Nevertheless, a very particular vocabulary is used by restorers to best present their interventions and protect the public from what they do not want to know. 'Losses' are 'bridged', while areas that have been damaged are 'consolidated', and the whole picture is 'integrated'.

Restoration is one of the most divisive and bitterly contested fields in art history. There is no clear set of agreed-upon rules in the global community, no guidelines or limits to how far a restorer can go to repair a work of art. Since the National Gallery's 'cleaning controversy' of the 1950s and 60s, art historians have fought over whether restorations which removed layers of varnish from old paintings and frescos also took off some of the final shading of the master, since some Renaissance artists added pigment to the varnish to add finishing touches to their paintings, or finalised their frescos *al secco* with oil paint. Feelings on the issue run so high that in 2011 two art historians resigned from the committee supervising the restoration of Leonardo's *St Anne* at the Louvre. In the recent restoration of *The Last Supper*, no attempt was made to *repair* the damage caused by time, the elements, wars and, above all, previous restorations. Instead, all the over-painting, the work of previous restorations, was removed and,

where there was nothing underneath, neutral watercolour tones were used. In the recent restoration of the Sistine Chapel, the accumulated grime and all the layers of varnish were removed, highly controversially, back down to the fresco surface, while Louvre curators resist removing the darkened varnish on the *Mona Lisa*, even if it would make the painting more colourful.

Every restorer dreams of working on a masterpiece by one of the famous artists of the Renaissance, among whom Leonardo is in the top three, along with Raphael and Michelangelo. It is the highest pinnacle that a restorer's craft and career can reach; so much the more if the work is in poor condition and needs intensive work. Names are made in the medical world when a surgeon pioneers a new technique in a life-saving operation and brings back to health a patient who only five years previously would have died. Much the same applies to restorers working with old paintings – although they may find invasive new techniques are questioned.

The *Salvator Mundi* was an exceptional candidate for restoration. No work of art whose authorship was uncertain but could be so significant had ever been discovered in such appalling condition by a private dealer. The *Salvator Mundi*, restorers widely agree, was considerably more damaged than other paintings by artists of Leonardo's standing. The overall percentage of the lost areas was greater, the size of individual losses was greater, and the areas where losses were incurred were more important in the composition, than in any other comparable painting that has been restored in the last century.

Less than two weeks after he received the *Salvator Mundi* from the St Charles Gallery in New Orleans, Robert Simon took a short cab ride from his Upper East Side gallery to the apartment of Mario and Dianne Modestini on Park Avenue. The Italian-American couple,

who shared a reputation as two of the finest restorers of Old Master paintings in New York, occupied the liminal space in Simon's Rolodex between acquaintances, contacts and friends. They were familiar faces in the Old Masters art world of uptown Manhattan and at museum openings, talks and gentlemen's clubs. Simon knew that Mario Modestini, who was old and frail and only rarely left his apartment, would particularly appreciate an interesting visitor with an even more interesting painting. 'I arranged to go over to his apartment for drinks one day, just at the time when we had acquired the painting,' recalls Simon. 'I mentioned the picture to him and I said, "Would you like to see it?" He couldn't really go out at all, so I said, "I'll bring it to you to have a look. It's a very *interesting* picture."'

The Modestinis' apartment is itself a step back in time. Antique inlaid furniture in walnut, cherry and beech, radiating the warmth of centuries of polishing, dot the rooms. And, naturally, there is the art – intense, beautiful, and all perfectly restored. Medium-sized and smallish paintings, all Old Masters, line the neutral yellowy-beige walls, not so close together as to be a jumble, nor so far apart as to suggest a limited supply – views of Venice and other Italian cities, classical scenes and the occasional portrait. Statuettes of classical gods in bronze, and antique clocks set in marble and gilt, are poised on consoles and side tables, so that a gauntlet of beauty, refinement and status must be run to reach a sofa or armchair.

When Simon returned with his painting, Dianne produced an easel and he put the *Salvator Mundi* on it. All three of them stared at it for a while, the silence broken only by the occasional enigmatic murmur from Mario. Mario Modestini was an elegant, slim man who exuded a confidence about art, both authoritative and informal, that was infectious. After the Second World War he played a major role in the development of American museum collections of Renaissance paintings, as both a restorer and a dealer.

Born in Rome in 1907, Mario had worked as a restorer in Italy before being invited to move to America in 1949 and become conservator of the Kress Collection, which was at the time the largest single-ownership holding of Old Masters and Renaissance paintings in America. It included three thousand works in all, amassed by the five-and-dime chain-store magnate Samuel H. Kress in the late nineteenth and early twentieth centuries and then slowly donated to museums all over the United States. There were so many great pictures in such imperfect condition that Mario and Dianne had spent fifty years restoring Kress paintings.

Mario was widely respected for the quality not only of his restorations but also of his attributions. Like most highly esteemed figures in the art world, he often doubled as an adviser and occasional dealer, buying and selling art on the side. In 1967 he was instrumental in the first acquisition of a Leonardo painting by an American museum, when he helped Paul Mellon buy the *Ginevra de' Benci* for the National Gallery of Art in Washington, DC.

Dianne and Mario examined the painting in front of them. It no longer looked like the photograph taken in the early 1900s for the Cook Collection; it had clearly been restored at some point in the intervening hundred years. Christ's face had a reddish tinge. There were crude outlines around his tired and empty eyes. The shadow underneath his chin looked like splodges of coffee stain. The chest and forehead were streaked with crumbly white deposits. Still, a mysterious glow emanated from his superbly foreshortened blessing hand, which seemed to project out through the picture frame, like the hand of a man submerged in a dark lake, reaching for help, his last chance. Mario was an expert on early Leonardo, and had been one of the first to argue that Leonardo painted parts of Verrocchio's *Baptism of Christ*. Now, after having inspected the *Salvator Mundi* for

a while, he announced, 'It is by a very great painter, probably a gener-
ation after Leonardo.'[1]

At that point, no one in the room, least of all Robert Simon,
thought they might be looking at a genuine Leonardo. Would the
Modestinis accept the task of restoring the painting, Simon asked.
Dianne's first response was to suggest one of her former pupils, but
Simon replied, 'I think this needs a grown-up.'[2] Mario had been
retired for several years, so Dianne agreed to take the job.

'We realised it had to be knitted back together,' Alex Parish told
me, 'but only enough so you could show it to some of these experts
and some of these museum people. They're really woeful in terms of
their practical application of looking at pictures. People in the trade,
they look at five thousand pictures a year, if you add all the auctions
together and all the pictures they're shown. Somebody who's an asso-
ciate curator, he's looked at the same two hundred pictures in his
collection over and over again, but they're not getting out there.
That'll get me lynched, but this is the truth. They don't have the
practical experience to be in the field, as it were, on their feet, judg-
ing pictures as they come in. It's all well and good once they come
in and they've got a name plate on it but, if it doesn't … "Who's this
by? Hmmm, I don't know."'

Although she did not have the fame of her husband, Dianne
Modestini was also a highly regarded restorer. In the 1970s she
worked in the conservation department at the Metropolitan Museum
of Art, and in the 1990s she joined New York University's
Conservation Center of the Institute of Fine Arts, where she still
practises and teaches today. Over many years, she has trained over
sixty restorers who now work in museums and institutions across the
world. She has restored several works by Milanese painters and
followers of Leonardo, including Bernardo Zenale and Bernardino
Luini. When Simon brought his picture round, she had just finished
restoring one of Cesare da Sesto's most complex works, the altarpiece

of the *Madonna and Child with Saints George and John the Baptist* in San Francisco.

Dianne immediately set to work on the *Salvator*, beginning to clean the picture in front of Simon with the traditional cotton wool dipped in a solvent of acetone and mineral spirits. The painting had a recent coat of 'gloppy and thick'[3] varnish on it, which immediately began to come off. After Simon left, Dianne continued her work. As she did, cracks in the panel became visible. They had been filled in with a white putty, which she was surprised to find 'seemed relatively modern' and 'could be softened easily'.[4] She scraped it out with a tiny scalpel.

Two days later, Simon came back to see the picture in its cleaned or 'stripped' state – that is, with the layers of varnish and later over-paint removed. Now, for the first time, he could truly see what a horrific mess the picture was in. The hair at the top of Christ's head had been completely worn away, creating a halo of destruction around his face. The face had been 'completely repainted', and what now emerged had a ghostly quality that indicated it had been 'abraded', meaning that layers of paint had been lost. Strange patches of green glimmered under the muddy background. Leonardo never painted his backgrounds green, so that alone indicated that the back-ground had been repainted at least twice. The transparent orb in Christ's hand was virtually invisible.

As for the panel itself, a huge crack ran down the centre of the picture; the large knot could now be seen through the crossing of the stole. Worst of all, the front of the painting had been shaved off, or 'planed down', at some point in its history, in a clumsy attempt to level the wonky surface of the picture. You could see the raw, brown grain of walnut wood exposed like a bone emerging from deeply scraped skin.

Overall, as much as 60 per cent of the painting could have lost Leonardo's top layer of paint. Perhaps only 20 per cent of Leonardo's

final layer of paint – the picture as he intended it and as he finished it – has survived. Another 20 per cent was completely lost.* The greatest damage had been done in the areas of greatest importance. The *Salvator Mundi* is a portrait, and the face – particularly the *eyes* – are of the essence. And the face and eyes were the two most damaged areas of the painting. 'It was shocking,' says Dianne Modestini. The condition of the *Salvator* raises a new question about attribution: if this had once been a Leonardo, is it still now a Leonardo?

* When the restored painting was put on view and controversy erupted about the extent of Dianne Modestini's restoration, critics made the claim that only 20 per cent of Leonardo's original painting remained. Simon, Modestini and Martin Kemp furiously contested this. But in a podcast on 9 December 2017, Kemp offered a contradictory assessment of how much of the panel had Leonardo's final finishing layers of paint, as the following transcript makes clear:

Interviewer: Only 20 per cent or so of this painting is original and the rest is basically in-painting and the restoration. And very well done. But in your opinion, at what point does a masterpiece not become considered the work of an Old Master?

Martin Kemp: First of all, '20 per cent' is absolutely 100 per cent misleading. If you say how much survives of the Leonardo's surface in its absolutely pristine condition, then you might get down to that kind of level. But if you look at the picture, when it was stripped down and you are back to original paint, it is quite high. I would not wish to quantify it very precisely, but I would say about 80 per cent of the panel is covered in paint that Leonardo put on. Some of that is underpainting or lower layers. In some places the top layers have not survived. So it is quite complicated. I have to say that if you saw all the pictures we now delight in in galleries, whether the Met Museum, the Louvre or National Gallery, if we saw them stripped down, all the infilling and the conservation work removed, we would be quite shocked by how damaged a lot of these pictures are. The 80 per cent is a nonsense.

Interviewer: So that is misleading in all the articles you see out there? I'm glad you cleared that up.

Martin Kemp: Yes, people cite this. It's sloppy. Journalists looking for sensation tend to be rather sloppy, and they pick up that figure as if it has some authority. I don't know where it comes from. Fake news gets repeated.

From Martin Kemp, 'Behind the Scenes of Leonardo da Vinci's $450 Million *Salvator Mundi*', Martin Willis Live Shows, Streamed live 9 December 2017. https://www.youtube.com/watch?v=e6Eld8n5GAs.

Despite these afflictions, there were still glimmers of genius in the picture. Simon was struck by the quality of the painted hand, especially the way the light fell on it. It had subtlety, grace and mystery. Now that the over-painting was removed, it also evidently had two thumbs. The second thumb was in a more upright position than the existing one, and had been painted over. Leonardo had decided to bend the thumb. These *pentimenti*, as such marks showing where an artist has made changes are known, have long been recognised as a sign that the restless brush of Leonardo was once at work.

Somewhere in the back of his mind, the possibility now occurred to Robert Simon that he might have the long-lost Leonardo original of lore – but 'not consciously', he says. In an oversight that he would later regret, he didn't take any high-quality photographs during this initial phase of restoration, apart from a single large-format transparency of the painting in its cleaned state, the least a potential buyer would expect to see. 'If we had known that this was a Leonardo from the beginning, obviously we would have done much more photographic and technical documentation,' says Dianne Modestini. 'If I'd known it was by Leonardo, I would have called in a committee, but it was just me and Robert.'

Before any restoration work could be done, the *Salvator* had to be pieced back together properly. Simon considered sending it to Italy, where the greatest experts in Renaissance wood panels were based. However, 'My fear was that somehow if we sent the picture to Italy, even if it was done with the proper temporary importation documents, if somehow people there thought it might be by Leonardo, they would never let it out again.' So in the autumn of 2005 one of Modestini's former pupils, Monica Griesbach, slowly chiselled down the wooden struts of the cradle that had been attached to the back of the painting and removed a supporting piece of wood that had been glued to it. The cradle offered another clue to the painting's history. Like a piece of furniture, a building or a painting,

cradles can be roughly dated by style: this one looked nineteenth-century English. Without its cradle, the *Salvator Mundi* separated into five pieces. Griesbach carefully lined up the fragments using an elaborate jig, and created a channel along the major split, into which she inserted tiny wedges of seasoned wood. After everything was aligned she applied an adhesive, and clamped the panel in place until it had set. Finally she added a new flexible plastic support to allow the wood to move.

In the spring of 2006 the *Salvator*, minus its old cradle, was returned to Dianne Modestini so she could begin the main phase of restoration. By this time she was a widow, Mario having passed away that January at the age of ninety-eight. Dianne was heartbroken. She had met Mario in 1982, when she was a mere thirty-six to his seventy-five, but they married and became a restoring team with their own private practice. She says he was her 'lover, companion, father figure and mentor', and that they became 'almost the same person'. Their A-list clients included the Frick and a cross-section of American museums, as well as some in Europe. 'My grief was profound and unrelenting. For months, I could do nothing but cry. I subsisted on white wine, sedatives and sleeping pills,' Dianne wrote in a memoir. But the *Salvator* offered a kind of hope. 'I knew by then that the painting could possibly be the lost Leonardo.'[5]

Restoration is a slow and meditative profession. The restorer spends hours at a stretch in a closed-off world, peering through magnifying visors, engrossed in the most minuscule details of a painting, where the tiniest brushstrokes seem to have been applied by a gigantic broom and the picture surface transforms into a rugged undulating landscape. In her light-filled studio in the conservation department of the Institute of Fine Arts, Dianne Modestini worked on the picture with 'the tiniest brushes I've ever used'. She used a base for the paint that had been developed by Mario in the 1950s, which she mixed with pigment to create ultra-thin translucent

glazes – heavily diluted mixtures of pigment. Sometimes she used watercolours and sometimes opaque applications of paint known as scumbles 'to achieve the *sfumato*'.[6] Immersed in this bubble, the restoration of the *Salvator Mundi* took on an emotional and symbolic role in Dianne's life. She worked on the painting day after day, sometimes for eight hours without a break, 'as if in a trance'.[7] For her the work became a way of honouring her late husband's legacy, and of staunching her grief. In an essay she wrote as the last chapter of her husband's memoirs, *Masterpieces*, which she published after his death, she says:

> I carried on a conversation with Mario in my head. Everything he had ever taught me came into play, and when I made a mistake, I could hear him say, 'The nose is crooked,' or 'He looks like he has toothache' … I went home exhausted, and Mario stayed with me until I fell asleep. I had conjured him into being, and I know that I couldn't have done the restoration without his help. The mystical power of Leonardo's conception added to this sensation.[8]

In late 2007, by which time she had been working on the painting for over a year, Modestini turned her attention to Christ's lips, which were faded and crisscrossed by crackles. A dark fissure ran from his nose down through the centre of his mouth, the right of which appeared bruised and swollen. It was difficult to see how it had originally been painted. Modestini consulted a book of scientific photographs of the *Mona Lisa*, published by the Louvre, which contains greatly enlarged, high-resolution details of the painting. She told the art critic and essayist Milton Esterow in 2011:

In order to restore certain damages to the painting, I had been looking
at [the photographs of details of the Mona Lisa*] for weeks and held*
them close to the Salvator Mundi*, trying to understand how to fix*
the little damage to the mouth of the painting. All of a sudden I
realized, comparing the mouths, that Salvator Mundi *was by*
Leonardo, because nobody but Leonardo painted that way. The final
glaze – pigment mixed with an oil binder – in the area around the
mouth was like smoke. It was so thin that you couldn't see the
brushstrokes. It was like it was blown on or breathed on.[9]

Modestini, it seems, blurred the line between observing the similarity
between the mouth of the *Salvator Mundi* and the mouth of the *Mona
Lisa* and actually using the mouth of the *Mona Lisa* as a template to
restore the mouth of the *Salvator Mundi*. In an account of the resto-
ration that she wrote for an academic publication, Modestini states
that 'an imitative or mimetic approach was chosen', although it was
'used with great care in order neither to interfere with, nor impose
anything, onto the original'.[10]

One evening, after finishing working on the mouth for the day,
Modestini covered the painting as usual, but this time more tremu-
lously, by her own account. She sat down at her computer and sent
Robert Simon an email, telling him she was convinced she was
working on a Leonardo.

Meanwhile, technical photography also seemed to reveal the hand of
Leonardo. Eight microscopic samples of paint were removed from the
painting by Modestini's assistant Nica Gutman Rieppi. She sent them
to be photographed by high-resolution microscopic cameras at the
Museum of Philadelphia's Conservation Department, where the
images were examined by Beth Price and by Ken Sutherland. They
revealed that the *Salvator* had been painted in many thin layers, at least

five on the face and eight in other areas. The infrared reflectography photographs also showed that Leonardo had pressed the palm of his hand into the paint on Christ's forehead, as a way of further softening the transitions from light to dark – that was said to be another tell-tale sign of the artist's presence. Rieppi submitted a draft report,[11] which Robert Simon has never made public. In fact, no technical photographs were published until 2012, and then only a few in low resolution, although a photograph of the cleaned painting was taken in 2006 and shown to a handful of art historians. Modestini says she was 'working on the *Salvator* by myself, as if it were any ordinary battered-up sixteenth-century Italian painting'.

Normally, technical photographs of works of art are made before restoration commences, but in January 2008, with the restoration work already under way Simon took the painting to be photographed by infrared cameras in the Metropolitan Museum of Art's conservation department. The resulting images revealed further *pentimenti* made by the artist as he painted the picture. The positions of the embroidery on Christ's robe had been shifted too. The second thumb was more visible than ever. There were swishing marks around the hand with the orb, revealing that the artist had adjusted its position. Simon and Modestini greeted these discoveries with mounting excitement, even if they did not agree about exactly what Leonardo had changed. 'He's shifted the whole hand. He didn't just shift the thumb. Maybe at a relatively early stage,' says Modestini. 'The first thumb he painted doesn't have all its layers. It wasn't completed, and then Leonardo painted it out with the background colour.'

One early visitor to Modestini's restoration studio was the Metropolitan Museum of Art's Drawings and Prints curator, Carmen Bambach, the world expert on Leonardo's drawings. Robert Simon was present when she came. After a long pause, she asked him and Modestini, 'Who do you think it is by?' Simon knew it would be unwise, as a dealer, to be the first to attribute. But Dianne could not

resist. 'I'm just a restorer, so I don't have any historical reputation to defend, so I said, "I think it's by Leonardo."' According to Dianne, Bambach replied, 'Well, it's not by Boltraffio,' citing the name of Leonardo's most accomplished protégé.

As she continued her work, Modestini found other proofs of Leonardo's hand. 'Leonardo's assistants all paint hair in a similar way, with just little fine lines. It is beautifully done, but it's not how Leonardo does it.' Leonardo had painted each defect inside the supposed crystal orb with its own dab of white highlight and black shadow. 'Only Leonardo, with his interest in the natural sciences, would have gone to such obsessive lengths,' she says.

Modestini completed her first phase of restoration in the early months of 2008. She had left her in-painting and 'bridging' less defined than the surviving paintwork, so that the most highly restored sections, above all the hair on the top of Christ's head, were evident to tutored eyes. She left the entire background, which was a later addition, in place for the moment. She revealed the *pentimento* of the thumb, thereby leaving two thumbs clearly visible. Some art histori- ans' eyes might strain to see if she hasn't neatened the outline of the new thumb a little – something she denies.

The painting was now ready to be shown to assorted art historians, museum curators and restorers, among them the Leonardists. After the years of toil and love that she had dedicated to the *Salvator Mundi*, Modestini was utterly convinced about the painting: 'I think it's a no-brainer. I don't understand why anyone would doubt it. Because, if nothing else, even if you're not talking about the technique, the power of the picture is so transcendent.'

And yet, the list of features that Modestini and Simon found, and which they read as signs of Leonardo, also occur in paintings by his assistants. These too sometimes have *pentimenti*. These too sometimes

have paint smudged by the artist's hand, though the examples are of fingerprints rather than palms. In these too, not often but on occasion, the anatomy of the hand under the skin can be rendered with great subtlety, and the strands and ringlets of hair with great individuality. And these too are executed in many thin layers of oil paint. Larry Keith, head of conservation at the National Gallery in London, told me, 'Within the more "engaged" group of *Leonardeschi*, I would say that the general approach to the build-up of paint layers to create the desired effects would be essentially the same as in Leonardo's work.'

Another problem emerges if one carefully examines infrared reflectography images of the *Salvator Mundi*. In an appraisal of the painting drawn up by Sotheby's in 2015, and published in legal documents online, it is suggested that Christ may not originally have been intended to have a blessing hand:

> In the infra-red digital composite photograph and, more clearly in the infra-red reflectogram, a difference in the preparation can be noted. A diagonal line running from lower left to upper right and crossing through the middle phalanges of the small and ring fingers and just below the thumb separates a darker area above from a lighter area below. This line roughly corresponds to the location of the contour of Christ's proper right shoulder and suggests that the motif of the raised blessing hand may not have been part of the first conception of the composition.[12]

This shoulder *pentimento* has never been mentioned again, to my knowledge. According to Dianne it was an early tentative interpretation of a line revealed in the infrared photograph, which was 'later rejected'. But if the original painting may not have had the blessing hand, then logically it may not have had the other hand and the orb. That means it might have looked very similar to Salai's painting of Christ dated 1511. And that, in turn, means that it might have been

built up, even cobbled together, from separate drawings by Leonardo, a procedure that assistants sometimes followed in their workshop productions.*

The Salvator's face presents another challenge. At the time of her restoration work, Dianne Modestini – and Robert Simon as well – insisted that all the original layers of paint on the face of the *Salvator* were intact. 'There is abrasion, whether from solvents or scraping, in certain passages, especially the eyes … But much of the face retains all these modelling layers,' Modestini told me in 2018. 'The parts that are not damaged are intact, in other words they have all their layers.' 'This face is miraculous,' Robert Simon told me at the same time. 'It's lost layers, but the losses are very contained.' They both also insisted that the 2006 photograph of the cleaned, or 'stripped', painting contained no residual later additions of paintwork, aside from the background.

By 2019, Modestini had revised her opinion. She told me that, after examining a new, high-resolution scan of the same 8 x 10" large-format transparency of the cleaned painting, 'I can now see that some parts of the painting, which remained after I had cleaned it,

* A little more support for this theory is offered by the right-sided double helix curls in a drawing of the head of an old man, by a follower of Leonardo, dated 1520, in the British Royal Collection (Catalogue number RCT 12501). The curls are almost identical to those on the right side of the *Salvator Mundi*'s head, which suggests both may be based on a specific hair study by Leonardo. In addition, it is difficult to reconcile the garments Christ wears on his blessing arm with those on his chest and orb arm, which also suggests the *Salvator* was composed out of different sketches. Christ wears a blue cloak and tunic, yet underneath the blessing arm there are generous drapery folds in white and dark brown, which, if they come from the sleeve of the tunic, should be blue, and, if they are underwear of some kind, should be considerably less copious.

were painted in later restorations in the eighteenth or nineteenth century. There are restorations on the big losses on the forehead, on the shadow side of the nose and the piece of hair on the damaged side of the face.' She also now believes that 'neither the interlacing of the stole in the centre nor the jewel are the original paint'.

It is a shame for Simon and Modestini's cause that the face is so unreliable. Even through the veil of destruction, it appears intensely charismatic, arrestingly individualised, of striking originality, even eerily modern. It is hard to imagine one of Leonardo's assistants conceiving such an unprecedented physiognomy for a copy. Alas, in the continued absence of independent technical analysis of the *Salvator*'s face, such impressions cannot be trusted; they may be the product of later additions, or wear and tear.

The origins of this over-painting lie on the lunar dark side of art history, in backstreet workshops where restoration blurs with forgery. Little is known about this world, because forgers never sign or date their work, and restorers, until recent times, rarely documented their interventions on privately owned pieces. These are the most invisible artists of art history, but their brushes have touched most of the Old Master paintings that we see today, often transforming them in undetectable ways.

The first ever database of British restorers is currently being compiled by the National Portrait Gallery in London, and it shines a spotlight onto an unknown world. If the *Salvator Mundi* was restored in nineteenth-century Britain, it might have been by Charles George Danieli (1816–66), who claimed ten years' experience as an artist and said he could restore pictures by the 'Italian method'. Another possibility is Ramsay Richard Reinagle (1775–1862), who worked on the restoration of Leonardo's Burlington cartoon, now at the National Gallery. There was also Joseph Henry Carter (1862–1937), who

claimed to be a 'personal assistant and expert restorer' to Sir John Charles Robinson, who as we shall see is linked to the *Salvator Mundi*; or by John Bentley (c.1794–1867), 'repairer of paintings' and 'curiosity dealer'.[13] If there were even earlier repairs to the *Salvator*, at the time of Charles I, they may have been by Thomas de Critz, who worked on a Holbein and a Titian for the king, or by Richard Greenbury, who undertook restoration and made copies of paintings for the court.

France, Germany and Italy had their own developed art market ecosystems at the time, though on a smaller scale than London. But the quality of restoration was abysmal everywhere. In 1883 the godfather of modern connoisseurship, Giovanni Morelli, walked his readers through the galleries of Italian paintings in German museums, bemoaning time and again that they had been 'subjected to barbarous restorations, so that ... there is no possibility of recognising the hand of the master, or of distinguishing an original from a copy'.[14] The painter James Barry made much the same observation in his Letter to the Dilettanti Society in 1799:

> *Reflect on the calamitous intervention of the race of picture-cleaners, on what they necessarily take away in cleaning and lifting off the coats of varnish ... and also, what these cleaners afterwards add in the way of refreshing, restoring, and repainting. Like a pestilential blast, they sweep away every vestige of the pristine health and vigour of well-nourished tints, leaving nothing to remain but a hoary meagreness and decrepitude.*

The nineteenth-century art market was plagued with 'hyper-restorations' in which highly damaged works were reconstructed by forger-restorers. In 1845, John Pye wrote wryly of 'skilful dealers, who, finding that knowledge of art was not invariably the companion of the wealthy collector, introduced to him, besides originals of rare

merit, pictures ... which had been so frequently repaired by repainting, cleaning, and varnishing, that the various processes of restoration conferred upon them an originality very different from that for which they were sought'.[15]

In an article, 'Italian Experience in Collecting Old Masters', that he wrote for *Atlantic* magazine in November 1860, James Jarvis, the first American to collect Italian Renaissance paintings, warned of the 'deception' of the 'alteration of pictures by artists less known or of inferior reputations to suit more fashionable and profitable names'. Sir John Charles Robinson related how he was offered a Botticelli forgery made in this way in an essay, 'On the Spurious in Art', printed in the journal *The Nineteenth Century* in November 1891:

> It was not at all difficult in Florence to find an old quattrocento painted panel, with some ruined or valueless picture upon it, and on the ancient groundwork, taking advantage of numerous real evidences of antiquity, such as cracks, rugosities, and other accidents of the ancient surface, the copy was executed with infinite care and circumspection. So close and perfect, indeed, was the verisimilitude thus attained that even the most experienced connoisseur or expert might have been deceived had the case rested on that evidence alone.

Mary Berenson described a visit to the workshop of one of the most famous forgers of the turn of the twentieth century, Icilio Federico Joni:

> A rollicking band of young men, cousins and friends ... turn out these works in cooperation, one drawing, one laying in the colour, another putting on the dirt, another making the frame, and some children with a big dog keeping guard over the pictures that were put in the sunshine to dry out.[16]

Three quarters of a century earlier, the Liverpudlian dealer and auctioneer Thomas Winstanley cautioned, 'I should advise the young Collector carefully to avoid giving high prices for Pictures that have sustained injury, – either by accident or by injudicious cleaning or rubbing, and which, in order to cover these defects, have been "retouched".'[17]

High-quality copies of Leonardo paintings, some made in France, were on the market throughout the eighteenth and nineteenth centuries in both Europe and America, some commissioned by wealthy families who liked to have a 'masterpiece' in their homes, some produced in order to trick wealthy families into buying such a 'masterpiece'. 'Leonardos' that fall into these categories include a beautiful seventeenth-century copy of the *Mona Lisa* which was once owned by Joshua Reynolds and was briefly exhibited at the Dulwich Picture Gallery in London in 2006, and a version of *La Belle Ferronnière*, probably eighteenth-century, given to the American Hahn family by 1919 by a French godmother. After the greatest art dealer of the day, Joseph Duveen, called the painting a copy, the Hahn family sued. The case was settled out of court, with Duveen agreeing to pay the Hahns $60,000 in compensation. In 2010 the picture was sold at auction by Sotheby's for $1.5 million.

The 'Minghetti Leonardo' is another example.[18] The godfather of connoisseurship, Giovanni Morelli, claimed to own an original Leonardo – at least so he told his protégé Jean Paul Richter, and probably Bernard Berenson too. In 1891 Morelli bequeathed the painting – 'believed to be a work by Leonardo', as his will stated – to Donna Laura Minghetti, the socialite wife of the then Italian prime minister Marco Minghetti, whose home in Rome was renowned for its stuffed peacock on a chimney, profusion of cut flowers, and stairway leading to nowhere. The 'Minghetti Leonardo' is a portrait of a young woman in profile, a little like *La Bella Principessa*, but on panel. It seems that Morelli had already admitted to Laura Minghetti that he did not

really think the picture was a genuine Leonardo, since her friend Mary Enid Layard wrote in her diary that Laura had told her that 'as she had admired the picture in his rooms and he had given only a few francs for it at Florence and knew that, altho' a pretty thing, it was not by Leonardo, he had given it to Donna Laura'. But the Roman socialite did not share this inside knowledge with art historians. Richter took an American collector, Theodore M. Davis, to see the portrait, and he bought it for the astronomical sum of 60–70,000 French francs. Two years later Berenson, who had formerly declared it to be a Leonardo, revoked his attribution and demoted it to a Leonardesque neo-Renaissance painting by a nineteenth-century Italian artist.

Much later, in 1908, Richter wrote a memorandum testifying that Morelli had called it genuine:

It is difficult to believe that a painting of doubtful authenticity could have given such intimate pleasure to a critic of Morelli's calibre, that he not only selected it as the sole ornament of his rather spartan bedroom, but also hung it where it could delight his eyes every day as he woke. Often, however, as I stood before it in admiration, I wondered why Morelli, in view of the rarity of easel pictures by Leonardo, did not hang his treasure in a more public room, where it might delight more admirers.

One day I ventured to express my surprise, and I have a vivid recollection of the conversation which ensued. He shook his head. 'It is not a picture for the herd,' he said. Then he drew my attention to the signs that it had been heavily retouched and added, 'These retouches could easily be removed, but the process is a dangerous one, and I prefer to keep the lovely thing, as it is, for myself, & for those whom I think worthy. These retouchings are obvious; they do not however conceal the master's soul, they only veil it; there may be some however who lacking love & knowledge fail to see through the veil to the beloved features behind. So here is a good place to hang it.'[19]

The Donna Laura Minghetti Leonardo is an intriguing instance of an art historian deliberately leading his colleagues up the garden path.

To this shortlist of fake Leonardos, some of which fooled great art historians, we can tentatively add the *Bella Principessa*, almost certainly another nineteenth-century neo-Renaissance exercise, which as we have seen has been championed by Martin Kemp.

However, we can rule out the worst-case scenario. It is impossible that the *Salvator Mundi* is a pure forgery or a nineteenth-century copy. The fact that the panel has broken into fragments, the nineteenth-century cradle and the three layers of over-painted background mean that it had been through too much by 1900 to be the work of a nineteenth-century artist. That it is a seventeenth- or eighteenth-century copy with later restorations is somewhat less improbable. But there is a third possible attribution: not purely Leonardo, not simply Leonardo plus workshop, but a hybrid painting, a palimpsest, as art historians term them, whose original appearance has been transformed by multiple restorations over three hundred years.

The capabilities of connoisseurship reach their limits in the *Salvator Mundi*. Those who argue for its attribution to Leonardo have recourse only to notions of quality and 'aura', and the claim that only their 'trained eye' can make these judgements. One great 'eye' finds itself competing with another, like children trying to outstare each other in the playground. Art historians tell us plaintively that they are using their superpowers, which we mortals do not possess. This is the very thinnest ice of art history, on which scholars have often proven them-selves to be unreliable guides.

CHAPTER 12

LOST IN A CROWD

According to its official history, we left Simon and Parish's *Salvator Mundi* safely back in the possession of the English crown, recorded in Charles II's Chaffinch Inventory of the mid-1660s. Thereafter, the narrative for the painting becomes ever more vague until 1900. The next chapter of Simon and Dalivalle's provenance hinges on an art auction held in London in 1763.

In the intervening century, the interest of the English royal crown in collecting Renaissance paintings had diminished. None of Charles I's successors collected with the same passion or on the same scale as he had. Charles II's largest bulk purchase was seventy pictures, almost all Italian Renaissance, bought from a Dutch dealer, William Frizell, just before the Restoration, and perhaps motivated by the fear that the walls of the palace he was coming back to would be empty. Later that year the governing council of the Low Countries proffered 'the Dutch Gift', another haul of twenty-eight paintings and twelve sculptures. Charles II amassed the finest collection of Leonardo drawings in the world, but we don't know how, beyond the fact that many had previously been in the Earl of Arundel's possession. The emphasis of Charles II, James II and later Queen Anne's patronage in the late

seventeenth and early eighteenth centuries was on new commissions from British and European artists, not on buying Old Masters.

Royal interest in art ebbed further with the first Georgian kings. George II's vice-chamberlain, Lord Hervey, relates an illuminating anecdote in his memoirs. The queen had removed 'several very bad pictures out of the great drawing room at Kensington palace, and put very good ones in their place', Hervey recounts. The king was not happy with this, and told the chamberlain that 'he would have every new picture taken away, and every old one replaced'. Hervey suggested that perhaps the king should let the two van Dycks remain in position by the chimney, 'instead of two sign-posts, done by nobody knew who', which were there before. The king let those paintings stay, 'but for the picture with the nasty frame over the door and the three nasty little children, I will have them taken away and the old ones restored'. 'Would your majesty have the gigantic fat Venus restored too?' Hervey asked. The king replied, 'Yes, my Lord, I am not so nice as your Lordship. I like my fat Venus much better than anything you have given me instead of her.' The painting was probably *Venus and Cupid* by Palma Giovane.

Simon and Dalivalle have proposed that James II inherited the *Salvator Mundi* from his brother, Charles II. Then he possibly gave it to (or had it taken from him by) his mistress Catherine Sedley. She passed it on to her daughter, who married John Sheffield, the Duke of Buckingham. Dalivalle has discovered that Sheffield acquired several paintings from the collection of James II – whether by inheritance, as a gift, or by theft we do not know. Sheffield was commissioned by James II to compile an inventory of the king's art collection in 1688, which may have exposed him to temptation. According to the Dalivalle hypothesis, Sheffield may then have bequeathed the *Salvator Mundi* to his son, Sir Charles Herbert.

Sir Charles sold Buckingham Palace to George III in 1761, and it remains the royal family's London residence to this day. Two years

later he consigned much of his art collection to Prestage's auction house, one of the most upmarket salerooms in London's fledgling art market. Simon and Parish's painting was sold to an unknown buyer – for only £2.10*s* – on 24 February 1763 as 'Lot 53 *L. Da. Vinci A head of our Saviour*'.

However, it is also possible that James II never parted with his *Salvator Mundi*, and that it remained in the English royal collection for at least another fifty years after the catalogue of Charles II's collection was compiled. An entry in one little-cited royal inventory suggests it may have been inherited by Charles's successors. A list of paintings at Kensington Palace in the collection of Queen Anne, who ruled from 1702 to 1714, includes '*Number 40, a small piece of a young Christ laying his hand on a Globe*'.

Anne's painting was kept in the storeroom of Somerset House or St James's Palace, suggesting that it may already have begun its trajectory towards London's auction houses. Can Anne's ownership be wound back in time to Charles II's *Salvator*?

There is yet another inventory, dated 1674, this time a list of the pictures owned by the future James II when he was Duke of York. On page 17 one reads of a painting: *Our Saviour in a brass gilt frame*, located in the 'green mohair closet at Whitehall'. It had not yet made it to the storeroom. There is no painter given in this description, but the location offers a provenance clue. The 'green mohair closet'* is almost certainly the same room as the one described as Charles II's 'King's Closet' in which we found his *Salvator Mundi* in 1666: '*No 311. Leonardo da Vinci, Christ with a globe in one hand and holding up the other*'.

The *Salvator Mundi* in Queen Anne's collection is arguably unlikely to have been Simon and Parish's because its Christ is described as

* A closet is a word for a cabinet room, where a collector kept his smaller, intimate pictures, along with statuettes, coins, jewellery, vases and other collectibles.

'young', and theirs is adult. But there is another painting of the Salvator Mundi which was once thought to be a Leonardo, which depicts a teenage Christ and has a Charles I stamp on the back.

After Prestage's Buckingham House auction, Simon and his colleagues say that their painting vanished from view for almost a century and a half, only to re-emerge 137 years later, in 1900, in an English collection. In fact, the painting's problem is the very opposite of this. It is not that there were no potential sightings of their *Salvator Mundi*; it is that, as time went on, there were more and more of them.

The London art market was by this time of an entirely different scale than in the era of Charles I. The English collecting base had expanded beyond a court clique to growing numbers of the Georgian aristocracy and wealthy merchants. London now had its own 'art world', which took its place amidst the middle-class consumer society emerging in Georgian England.

'Many English families were collectors, and the practice soon increased, until, towards the close of the [eighteenth] century, it had become a kind of mania amongst them,' wrote John Pye in *Patronage of British Art*, published in 1845. Art collectors formed clubs which met in coffee houses like Old Slaughter's and the Turk's Head Tavern. In 1732 the first public commercial exhibition was staged, in pleasure gardens in south London. In April 1760 the first exhibition of contemporary art was put on in The Strand by the painter Francis Hayman, with the help of Samuel Johnson. They sold an astonishing 6,582 catalogues in two weeks. Artists began staging exhibitions of their own work and advertising them in newspapers – 20,000 people came to see John Singleton Copley's *Death of Chatham* in 1781. The origin of the headline-grabbing 'sensational' work of art dates from this time: Nathaniel Hone put on an exhibition of his paintings in 1775 which included one rejected by the Royal Academy – *The*

Conjuror depicted the painter Angelica Kaufmann naked and holding a torch. Artists made fortunes by selling the reproduction rights to their paintings, which were mass-produced as etchings.

Above all, there were art auctions for Old Master paintings. Both dealers and collectors sold their work through auction rooms rather than galleries or private sales, which only took shape in the nineteenth century. Between 1689 and 1692 an incredible 35,000 paintings were auctioned.[1] British government customs files show that 45,642 paintings were imported into the country in the five years 1833–38. In the eighteenth century and the first half of the nineteenth, auctions were the main way paintings changed hands.

The French artist and art critic André Rouquet, who wrote a satirical book about painting technique called *The Art of Painting in Cheese* (1755), has left us a vivid description of London's auction houses, which is still recognisable today. The auction house exhibited the lots for a number of days before the sale in 'halls' which were 'lofty, spacious and ... receive full light through the glass windows which range all around them'. Anyone was allowed to visit, 'except the meanest of the populace'. For the sale, 'which is twelve at noon', bidders and visitors sat 'on benches opposite to a little rostrum, which stands by itself, and is raised in the further end of the room about four feet from the ground. The auctioneer mounts with a great deal of gravity, salutes the assembly, and prepares himself, a little like an orator, to perform his office with all the gracefulness and eloquence of which he is master. He takes the catalogue, he orders his servants to present the first article, which he declares aloud; in his hand he holds a little ivory hammer, with which he strikes a blow on the rostrum.'

Rouquet remarks on the shady tactics of dealers and the impulsiveness of buyers:

*Nothing can be more entertaining than this sort of auctions; the
number of the persons present, the different passions which they
cannot help showing on these occasions, the pictures, the auctioneer
himself and his rostrum, all contribute to diversify the entertainment.
There you may see a tricking broker, who shall employ another
secretly to buy what he himself runs down before the company, or who
shall lay a dangerous snare by pretending to purchase with the greatest
eagerness a picture belonging to himself. There some shall be tempted
to buy, and others sorry for having made any purchase. There a man
shall give fifty guineas thro' vanity and pique, when he would not
have given five and twenty, had he not dreaded the shame of being
outbid in the presence of a numerous assembly whose eyes were all
fixed upon him.*[2]

Art dealers worried then, as some do now, about the rising prices for
the art they sold. The dealer Thomas Winstanley, who auctioned a
Head of Christ 'by' Leonardo, 'painted on gold ground, and exqui-
sitely finished', from the collection of the Liverpool abolitionist,
banker and historian William Roscoe in September 1816, complained
of 'prices at once ruinous to the purchaser and hurtful to the progress
of the Arts among us'. The painting, which the catalogue said was 'not
excelled by any production of the master' and was 'full of composed
dignity and deep feeling', now hangs at Holkham Hall in Norfolk; it
is a copy of some kind.

In fact, most of these pictures were copies. In his *Retrospective of a
Long Life 1815–83*, the art critic S.C. Hall estimated that out of
81,000 pictures imported into England only two hundred were
painted by the artist to whom they were attributed – a large handful
of these were *Salvator Mundi*s, supposedly by Leonardo da Vinci.[3]

Between 1750 and the 1840s the English art market swarmed with
'Leonardo' *Salvator Mundi*s.[4] Within this timeframe there were at least
nineteen auctions of such paintings attributed to the master, about

the same number of sales of *Heads of Christ*, and at least three auctions of *Salvator Mundi*s attributed to his follower Luini.[5]

Simon and Dalivalle's proposal that Charles I's *Salvator Mundi* was sold at Buckingham's 1763 auction is plausible in one regard: it was the most prestigious sale of the century with a *Salvator Mundi* listing, and the one most likely to have paintings which were once in the royal collection. Our *Salvator* is unlikely to have been in the 1796 Christie's auction of 'a catalogue of a capital and valuable collection of high finished cabinet pictures, comprising some of the works of the most esteemed and ancient modern masters', which belonged to 'a gentleman, Kent', and at which a Leonardo 'Head of Christ' sold for £1.11s. Nor is it likely to have been in the sale of the property of a former head of the East India Company, Joseph Salvador, at which another head of Christ was auctioned for an unrecorded amount in 1773. Nor is it probable that it was among the treasures of antiques dealer Henry Constantine Jennings, whose gambling debts compelled a sale in 1778, at which a third head of Christ was sold for £4. Nor would it have been the Leonardo *Salvator Mundi* sold in March 1785 at Christie's by the French dealer Jean-Baptiste-Pierre Lebrun, whose lots came from French aristocrats. Nor would it surely have been the *Salvator Mundi* which sold for £17.12s in November 1798, again at Christie's, from the collection of 'A Gentleman, Deceased, Brought from his late Residence in the Adelphi'. But nor does Buckingham's 1763 auction ring true: £2.10s is an inconceivably low sum for a Leonardo. The average price of paintings sold during the eighteenth century was £80.6s, with a median of £31.7s.[6] If that bargain *Salvator* was Simon and Parish's, it must have been an unimaginable wreck by then.

Poring over the records of these *Salvator* auctions, a few which are described in detail sound very like Simon and Parish's painting. For example, in 1802 the art dealer Richard Troward owned a

painting of *Our Saviour by Leonardo da Vinci*, which he had bought
from a Mr Hamilton of Richmond (no relation to the Duke of
Hamilton) for the significant sum of £3,000. Mr Hamilton had,
according to its description in an auction catalogue, apparently
'obtained the picture from France (The Louvre) during the troubles
of the Revolution'. After buying the *Salvator* Troward apparently
'speculated in the soap business' and lost a fortune. He put the paint-
ing up for sale at Peter Coxe's auction house in 1808. It was described
in the catalogue:

> *This extraordinarily excellent Picture was painted for* [the French
> King] *Francis I … The Son of God represented (in an Allegorical
> allusion) as in the Act of creating the Universe – The Globe is in the
> left hand describing the Ptolemaic Hypothesis, which was the
> prevailing System acknowledged in the Painters Time … the
> representation of the Divine Saviour; not as the Man of Sorrow and
> acquainted with Grief, but as the sublime Creator of the World,
> decorated with all the Majesty of beauty and animated by apparent
> solicitude for the welfare of Mankind before the fall. Art stands
> challenged in this sublime Performance; it cannot be surpassed.*

Today this painting is thought to be the *Salvator Mundi* now in the
Houston Museum of Fine Arts in Texas, currently attributed to a
late-sixteenth-century Flemish copyist.

On Saturday, 16 June 1821, 'Mr. Christie' announced the sale of
'The Genuine and Highly Valuable Cabinet of *Italian French Flemish
and Dutch* PICTURES OF A WELL-KNOWN AMATEUR. Who
has indulged his Taste in collecting for a Series of Years, by selecting
from the most distinguished Cabinets offered in this Country, besides
purchasing Abroad, and who is about to leave England for the
Continent'. The catalogue stated, 'Many of these pictures have never
before been seen in this country, among them, are – A SALVATOR

MUNDI BY L. DA VINCI, A RARE AND PRECIOUS SPECIMEN OF THE HIGHEST MERIT.'

On Saturday, 7 May 1836 Messrs Christie and Manson, the forerunner of today's Christie's, offered the same painting, lot 47, described in the catalogue:

> *The sublime aspect of the Saviour, so placid – so serene – and yet so firm in intellect, indeed with a mind more than human, yet compassionating human infirmities – superior to all, but disregarding none. These, as far as pencil can portray, Da Vinci has represented. The glass globe held in the Saviour's hand, at once the emblem of universality, and of that mind to which the Universe itself is but a transparent bubble, is indeed a sublime idea, and the direct front view of the figure gives a majesty, which proclaims the original far above human frailty. The coloring of this picture is so deep and rich, and yet so true to nature, that it leaves other works, even of the same artist, at an unreasonable distance; and the exquisite drawing and finish of every part place it among the most extraordinary performances in existence. This picture was in the collection of the King of France, at St Denis, before the Revolution, and is carefully described in the catalogue now preserved in the French library. It was engraved by Hollar ...*

This painting, which went unsold and was brought in for £100, was not Simon and Parish's *Salvator Mundi* either. It has been traced as the *Salvator* now in the Detroit Institute of Arts, now known to be a later copy painted after Leonardo's death. The auctioneer is suggesting that this *Salvator Mundi* remained in France until the Revolution, in the aftermath of which the collections of many French nobles were sold off.

Listings like these show how a trio of facts from Simon, Dalivalle and Kemp's story about their painting – namely, the legend of the French king's *Salvator Mundi*, the etching of it by Hollar, and the

significance of the cosmological transparent orb – were well known even in the eighteenth century. With only verbal descriptions to rely on until the late nineteenth century, it was as easy then as it is now to bolt the story onto any of several versions of the *Salvator Mundi*.

We can identify the specific paintings in some of the auction sales and rule them out as Simon and Parish's *Salvator Mundi*, but a handful of contenders remain. Most of the auction catalogues do not provide colourful stories about the paintings, they simply say '*Christ*' or '*Salvator Mundi* by Leonardo'. In June 1805 a *Salvator Mundi* sold at Christie's for £3.3s. '*A beautiful and highly finished head of Christ, very fine* by Leonardo' was sold at Robins auction house for £18.18s in February 1808. In March 1815 George Squibb auctioned the contents of the London mansion of the late MP and wealthy land-owner Henry Dawkins. They included a *Salvator Mundi* which went for £6. A '*Head of Christ; and early picture of the master, but possessing much of the grandeur and truth which distinguish his latter performances*' was consigned in July 1820 to William Bullock's saleroom by the Manchester mill magnate David Holt and sold for £20.9s. In October 1823 the heavily indebted sugar-plantation heir, novelist and art collector William Beckford was forced to sell the contents of his extravagant neo-Gothic mansion Fonthill Abbey. They included a *Salvator Mundi* which went for £18.18s, and about which one news-paper critic at the time wrote damningly, 'If this be a good painting, those of the same subject that are esteemed the most perfect differ from it most essentially.' In May 1843 Phillips auctioned a *Salvator Mundi* for £35.14s in a sale of the estate of the diplomat Lord William Berwick. And so on.

At the most only one, and probably none, of the thirty or so Christs and *Salvator*s auctioned as 'by Leonardo' were genuine autograph. Most of them would have been workshop paintings, later copies or imaginative restorations of the two preceding categories, which bordered on fakes. Collectors frequently took legal action

against dealers whom they believed had sold them a copy while promising, or 'warranting', that it was an original. The difficulty, then as now, was to know for certain if that was indeed the case, and if it was, to establish if the dealer was aware of it. In 1796 the lord chief justice, Lord Kenyon, ruled in one such trial:

> *It is impossible to make this the case of a warranty. Some pictures are the works of artists centuries back, and there being no way of tracing the picture in itself, it can only be a matter of opinion, whether the picture in question was the work of the artist whose name it bears or not … If the seller represents what he himself believes, then he can be guilty of no fraud.*

Beyond Britain's shores there were other *Salvator Mundi*s in European collections, each with its own colourfully half-imagined provenance and attribution. They were traded in auctions and private sales in the eighteenth and nineteenth centuries until they spread around the world. Today you can find examples in Warsaw, Carrera, Bergamo, Naples, Rome, Nancy, Leonardo's home town of Vinci, American museums, and private collections in Switzerland and elsewhere, guarded by owners who prefer anonymity but who occasionally consign their *Salvator*s to auction.

Art historians have long argued over which of Leonardo's follow-ers painted each of these versions. Was it Giampietrino, because the colours are bold and the contours firm? Or Marco d'Oggiono, because the skin is so pallid? Or Salai, because the *sfumato* is fuzzy? Luini, because the *sfumato* is so smooth? There has been, however, agreement amongst most scholars that since there were so many versions, Leonardo must have painted an original. But they do not concur on which one it might be, or if it still survived.

Before Simon and Parish's *Salvator Mundi* surfaced, the top contender for the title of *the Salvator Mundi*, Leonardo's original, was the Ganay

Salvator, which can be firmly traced back to the collection of Clément Baillardel, Baron de Lareinty (1824–1901), a monarchist aristocrat from the Loire who in 1887 fought a notorious duel with a French general in which both men deliberately missed, and who in his youth had financed one of the world's first shopping malls, a three-storey arcade in Nantes which opened in 1843 and is still operating today. Lareinty said, and there is no reason to doubt him, that he bought his *Salvator* from the Convent of St Clare in Nantes, where it had been hanging in obscurity for centuries. In the aftermath of the French Revolution the nuns' property, in common with that of many other religious institutions, was seized and sold off. Some art historians have suggested that the painting was originally owned by the French royal family, but the claim is as tendentious as those made for Simon and Parish's picture. They cite a vague entry in an inventory of the collection of the French queen, Anne of Brittany. Under the heading '*Tableaux d'Eglise*', Church paintings, dated 17 February 1499, there is listed *a painting on wood in which is depicted the face of our Lord*. They suggest, rather imaginatively, that Anne – or, upon her death in 1514, her husband Louis XII – may have given this picture to the Convent of St Clare in Nantes, because Anne's heart is buried in the cathedral of the city.[7]

But back to our Baron de Lareinty. In 1866 he lent his *Salvator* to an exhibition in Paris, where it was shown as a Leonardo, alongside paintings lent by the Rothschilds and other wealthy French industrialists and merchants. The catalogue stated that the painting had been 'engraved by Hollar'. However, it notably failed to attract the attention of critics who reviewed the show. When Lareinty died in 1901 his heirs sold the *Salvator* to the Countess Martine de Béhague for the huge sum of 110,000 francs.

Béhague was a Parisian society figure who hosted a salon for writers, artists and musicians at her *hôtel* in the rue Saint-Dominique, on the walls of which hung paintings by Tiepolo, Watteau and Titian. Her guests included Marcel Proust and Paul Verlaine, whom she

received reclining on a sofa covered with animal skins, and wearing a green wig. Fauré conducted his requiem and Bizet put on *Carmen* in her private theatre. The countess was convinced all her life that her *Salvator Mundi* was an authentic Leonardo, but her friend Bernard Berenson disagreed, telling her that it was 'a poor copy by an inferior pupil of Leonardo'.[8]

In 1939, Béhague's nephew the Marquis Hubert de Ganay inherited the *Salvator*. He was less convinced of the painting's authenticity than his aunt. Berenson's verdict had doomed the picture, and the issue was not discussed in the family. By 1952 the *Salvator* was hanging in the marquis's library, where it was seen by his friend Elmer Belt, an American pioneer of sex reassignment surgery and collector of Leonardesque artworks – 'in a corner of the library, where the light was filtered by the curtains in the style of a Leonardo, there suddenly appeared the radiant image of the *Salvator Mundi*'.[9]

In the late twentieth century, as we have seen, the painting was promoted as a genuine Leonardo by a Los Angeles postgraduate student, Joanne Snow-Smith, supported by her supervisor Carlo Pedretti, a friend of Elmer Belt. Snow-Smith claimed that the German art historian and Leonardist Ludwig Heydenreich had told her shortly before his death that he thought the painting was a Leonardo. But Heydenreich's correspondence with Snow-Smith, kept in the archives of the Munich state library, does not reflect this view. Heydenreich did not reject Snow-Smith's proposition outright, but, following the convention among art historians to avoid directly criticising colleagues, he sent the coded response that her theory was 'very bold', and the research was 'entirely your own property'.

There is another letter in the file, however, in which Snow-Smith wrote angrily that Pedretti had published all her research on the Ganay in his book on Leonardo before she could publish it herself. All the worse for him: despite the fact that he was the world's

acknowledged Leonardo expert at the time – the Martin Kemp of his day – Pedretti's endorsement of the Ganay *Salvator* as a genuine Leonardo did not outlast the twentieth century. In 1999 Sotheby's auctioned the painting, attributing it to Leonardo's studio, for $332,500.

Shortly before his death in 2018, Pedretti published an article rejecting the attribution of Simon and Parish's *Salvator* to Leonardo, even though he had never actually seen it. In the Vatican's newspaper *L'Osservatore Romano* he dismissed the painting as a 'chimera', the product of a 'sophisticated marketing operation' based on a 'phantom provenance in the royal collections of the English Kings'.[10] But his own *Salvator*'s track record was no cleaner.

The Ganay affair should serve as a lesson to us of how attributions to Leonardo can be driven by personal connections, professional networks and rivalries, academic ambitions and financial interests. As a consequence, even when they issue from academics teaching at renowned universities, with long bibliographies, they may be insecure and short-lived. The Ganay, incidentally, does not have a Charles I stamp on its back.

The one *Salvator Mundi* with a Charles I stamp branded on it emphatically, in a darkly burnt black, hangs in the Pushkin Museum of Fine Arts in Moscow. The museum acquired it in 1924, when it absorbed the collection of the Rumyantsev Museum, which had acquired the painting in 1914 from the grandson of Nikolai Semyonovich Mosolov, a Russian landowner whose passions were breeding horses and collecting art. The writer Sofya Engelgard, pen name Olga Novosiltseva (1828–94), recalled how in her childhood her family used to be invited to Mosolov's country estate each summer.

I remember, once he was sitting at the window. A herd of cattle was moving to the stables; a cow had run into the yard and was nibbling grass.

'A painting by van de Velde,' said the old man, in whom every phenomenon of nature awakened artistic feelings.

The old man went to bed after sunset and got up at dawn, occupied himself with painting, reorganised his prints, enriching the collection with new acquisitions, and never complained of boredom. Such feelings were foreign to this philosopher. From the time he settled in Zhernovka until his death he went to Moscow little more than three times, and only in extreme circumstances. On one of these occasions, the rumour had spread that Yakovlev, Herzen's father or uncle, had brought back from abroad a picture by Domenichino, Prometheus. Nikolai Semyonovich could not resist, went to Moscow, went to Yakovlev, looked at the picture, dismissed it with a wave of his hand and returned to Zhernovka.

'The picture is not bad, it is good,' he told me, when he recounted his trip. 'But the fact is, they claimed that it was Domenichino! And I blundered, I did not immediately realise that was nonsense. Domenichino! Easy to say!'

Novosiltseva mentions Mosolov's *Salvator Mundi* in her concluding paragraph about him:

Nikolai Semyonovich died in 1861. Weakening every day, he was not getting out of bed, and, anticipating the end, he wanted to die surrounded by paintings. They were transferred to the bedroom, newly upholstered for that purpose with beautiful wallpaper. The old man's favourite picture, the Saviour by Leonardo da Vinci, hung beside his bed, and he fell asleep and woke up admiring it. His last days were quiet and bright, like his life; he died, surrounded by the family and all that was dear to him.[11]

Mosolov had bought the picture in the early nineteenth century from Cerfolio, a leading Moscow art and antiques dealer[12] who, the Russian writer Alexander Chayanov remembered, 'filled the buildings and palaces of the Moscow nobility with paintings by the great masters, born under the hot sun of Italy and in the ghostly mists of Amsterdam'. Although Mosolov's collection of only thirty paintings was small in size, it was of high quality, including works from the collections of Louis XVI and Catherine the Great.

Nothing is known about where Cerfolio bought his *Salvator*. There is thus a two-hundred-year gap in the Pushkin *Salvator*'s provenance. While this might appear substantial, it is at least a hundred years shorter than the gap in provenance for Simon and Parish's picture. One possibility, however, is that Cerfolio acquired it from a Scottish merchant named John Theores, who imported art to Russia in the 1790s and 1810s. He is said to have bought in France and England, with much of the work originating from post-Revolutionary sales of the collections of the French nobility. Theores's Russian clients were emulating the new passion for art collecting of their ruler Catherine the Great, just as Charles I's courtiers had done.

There are very patchy records for John Theores. He was a member of the Freemasons in London from 1768 to 1813, and a 'John Thiorais' is listed as a painter and student of the Royal Academy in 1783.[13] Since the Masonic register says that Theores was forty in 1796, there is a strong possibility that this was the same person. He arrived in St Petersburg in the 1790s, offering his services as a dealer. He bought paintings at the legendary sale of the collection of the Duke of Orléans. He bought in the Netherlands. He bought in England, including a *Susanna and the Elders* by Rubens's workshop.

A few facts about Theores can be gleaned from a petition written in 1818 by his impoverished daughter, Elizabeth, in her plea for financial assistance from the state.[14] According to her account, Catherine the Great sent Theores 'to foreign countries and collected

paintings', which pushed him into debt. After the empress's death in 1796 Theores went bankrupt. His paintings were sold, apparently for only a third of their value, and he left Russia.

When his prospects improved after 1801 he returned to Russia, but shortly thereafter Russia's entry into the Napoleonic Wars bankrupted him again, and in 1804 an auction was held of his paintings. A 'Catalogue of a large and beautiful collection of paintings and prints, Italian, Flemish Dutch and French schools, in this collection' was printed, listing items for sale. There is no surviving copy of this catalogue, although many advertisements for the sale were carried in Moscow newspapers,* so we cannot know if the Pushkin/Mosolov *Salvator Mundi* was included in it.

There is a clue, perhaps in the listing in the Queen Anne inventory mentioned at the beginning of this chapter of '*a small piece of a young Christ laying his hand on a Globe*'. The words 'small', 'young,' and 'globe' may be significant. In Simon and Parish's painting Christ has an orb, not a globe. Their painting, at 66 x 45cm, is larger than the Pushkin's, which is 50 x 39cm. The low price of £30 supposedly paid for Simon and Parish's painting in the Commonwealth sale could be explained by the poor quality of this painting by Giampietrino. As has been mentioned, the Christ in Simon and Parish's *Salvator* is not young, whereas the Pushkin's is. But it is not a perfect fit, since Queen Anne's *Salvator* has his hand *on* a globe, no artist is named, and 'small'

* In Russia's largest-circulation newspaper of the early nineteenth century, *Moskovskie Vedomosti*, we find an announcement on 30 January 1804 that Mr Thiorais (sic) has invited the public to buy his paintings and engravings, since business reasons compel him to leave the country. He welcomes visitors until 10 February, the day when he is planning to leave. On 3 February the 'Moscow Auction' organisation announces that the governor of Moscow has permitted a Frenchman, 'Ivan Teores', to sell his collection from his home on Wednesdays and Thursdays starting from 11 a.m. Both announcements were repeated several times in subsequent issues. There are no announcements that Theores left Russia.

could mean really tiny. Nevertheless, even if we set Queen Anne aside, it is highly likely that the *Salvator Mundi* which Charles I, then John Stone, and then Charles II owned, is the Pushkin's rather than Simon and Parish's. And if Charles had two, there appears to be no evidence that the second was Simon and Parish's.

The provenance given by Christie's for Simon and Parish's *Salvator Mundi* was published a month or two before the 2017 auction in a catalogue devoted entirely to the painting, containing page after page of high-quality reproductions of close-ups and related drawings, interspersed between essays by art historians and in-house specialists. Alan Wintermute, senior specialist in Old Masters at Christie's New York, informed the reader in the opening essay that it was 'known for certain' that the *Salvator* 'belonged to Charles I', and that this was an 'indisputable provenance' which 'securely located' the painting.[15] Wenceslaus Hollar's etching also 'attested' to the fact that 'the present painting' was 'in the collection of Charles I and not one of the twenty known copies and replicas'. And lastly, 'proof copies' of the print were 'sent to the Queen in exile, six years after Henrietta Maria and the Royalist print-maker had fled to England'. Definitive assertions, every one.

Where such certainty, conviction and confidence came from, one may only guess.

The exact contributions of Simon and Dalivalle to the Christie's and National Gallery catalogues are not clear. Christie's says that

Most of the information that we utilised was previously published by these scholars [Margaret Dalivalle, Martin Kemp, Robert Simon and Luke Syson]*, with a few instances of additional information being provided to us by authors prior to being published. We relied on scholarship that was produced by the most esteemed scholars in the*

*field. We have no reason to mistrust their findings when they have
given their absolute confidence in the matter.*

Simon and Dalivalle's provenance research was frequently cited in an
essay about the painting published by Dianne Modestini in 2012[*] and
in the catalogue of the National Gallery's Leonardo exhibition in
2011. It is known that Simon and Dalivalle's research was made avail-
able to the National Gallery for its Leonardo exhibition catalogue in
2011, and to Christie's for its auction catalogue in 2017. But no
official contracts to supply information were drawn up. Dalivalle, I
understand, did not officially or directly supply Christie's or the
National Gallery with any material. Consequently, it is not clear who
is accountable.

Simon told me that he had not been aware of the existence of a
Charles I stamp on the Pushkin's reverse until 2018. But both he and
Dalivalle definitely knew about Edward Bass's *Lord's figure in half*, and
the Pushkin *Salvator's* Charles I provenance. Simon showed me a
document consisting of a summary of his provenance research, which
he had written by May 2008:

*This document was shared with several scholars including Nicholas
Penny and Luke Syson at the National Gallery. At the National
Gallery meeting in May 2008 I was first introduced to Martin
Kemp. Later that year Martin put me in touch with Margaret*

[*] In the indirectly published material Dalivalle seems to identify the *Salvator*
with the 'Peece of Christ'. She is cited by Dianne Modestini in Modestini's
2012 article on the restoration of the *Salvator*: 'According to Margaret
Dalivalle's research, this *Salvator Mundi* can be identified in the 1649–50
inventory of the collection of Charles I, made after the regicide.' In a footnote
Modestini adds: 'The following information and quotes from inventories are
from a yet to be published essay [by Dalivalle], "A *Salvator Mundi* Attributed
to Leonardo da Vinci in the Collections of King Charles I & II Known
through its copies".'

Dalivalle who, as you know, would undertake further research on the provenance of the painting, and I shared my material with her. At some point, and I cannot remember exactly when, Margaret suggested that there was some ambiguity in the description 'A lords figure' and that it might refer to a portrait of a Lord — that is an aristocrat or peer — rather than a portrait of the Lord — that is, Christ. As one not expert in seventeenth-century conventions, I deferred to this judgement and eliminated the 'Bass' reference from later versions of my research summary — a document that was regularly revised and updated as new references, information, and opinions became available. The National Gallery was furnished with one of these revised versions (with the 'Bass' reference omitted) prior to the exhibition, as well as the version with both references that I had shared in 2008. I do not believe I furnished Christie's with any information directly, but they clearly utilised the single 'Stone' citation, as by then widely published.

It remains a mystery why neither Christie's nor the National Gallery mentioned Bass's *Lord* or the Pushkin *Salvator Mundi*, at least to explain why the two works did not undermine the provenance of their own painting. Whether this was an innocent oversight or a deliberate omission of facts, which could have weakened the provenance narrative and the commercial value of their *Salvator Mundi*, remains to be discovered.

THE HIGH COUNCIL

Robert Simon was well aware that he needed to be strategic and accumulate the right allies if his painting was to be authenticated as a fully-fledged Leonardo. 'Part of the reason for the secrecy was the mechanics, if you will, that Bob had to employ in order to get the utterly fantastic consensus that he compiled,' says Alex Parish. 'Because in academic realms, if A says yes, B's going to say no, just to be a dick. It's not unheard of that certain experts are contrarians just because an opposing expert has said something else.'

After the initial period of restoration, Simon and Parish began showing their picture to close contacts. The first to see it was Mina Gregori, not a Leonardo expert but a friend of Simon's who had made some hotly contested attributions to Caravaggio in the past. She came to see the picture in New York in November 2007, and said nothing at all while she was standing in front of it, but as Simon walked her back to the lift she turned to him and said, with an Italian sense for melodrama, '*È lui*' – It's him.

'Once the picture was cleaned and repainted,' Parish remembers, 'and put on the wall in a proper frame, in a proper light situation, we brought people who we knew in. It was like a thunderclap when they

would walk in. They always came through the door with this, "Ha! You think you've got a da Vinci. Ha, ha, ha." And then, POWWW! You would see these people almost brought to tears. It's the stuff of mythology or something. This sort of thing just never, never, never happens. But it happened.'

Several curators and restorers from the Metropolitan Museum saw the partially restored *Salvator Mundi* in early 2008, but it is not clear what exactly was said about the painting. According to Robert Simon and Christie's, a majority of the Met experts agreed that they were looking at a Leonardo. One of its Italian Renaissance specialists, curator Keith Christiansen, certainly did, and still does. Another senior staff member, Andrea Bayer, deputy director for collections, told me she would not comment on the painting. One senior academic source close to the museum told me, on condition of anonymity, that 'The Met curators don't believe that it is by Leonardo. One curator told Simon that the Met would be glad to accept the painting as a gift for study purposes. That means they thought it was a wreck and not by Leonardo.' Another highly placed museum source informed me that one of the Met's curators 'judged the painting a Leonardo but didn't want it in his collection because of its condition'. If the museum's specialists did consider the possibility that it was a Leonardo, it's unusual that they made no attempt to make Simon an offer for it at the time – or since. This inaction suggests that they were not very enthusiastic about the painting, although some explain it as due to the Met's financial problems at the time.

Robert Simon knew a British curator, Nicholas Penny, who was then head of the sculpture department at the National Gallery of Art in Washington. He had recently sold Penny a sculpture for the museum, which some claimed to be a missing Michelangelo but which was more firmly attributed to a seventeenth-century Italian sculptor. 'Robert's had quite a lot of dealings with me, and I think he probably knew that I was not too frightened to stick my neck out,'

Penny told me. Simon showed Penny the painting, and he responded, 'You have a really interesting problem.' By that, he did not mean that the attribution was an issue. He was referring to the difficulty of establishing widespread agreement in the art historical community for new attributions to A-list masters. 'I meant that a lot of people will be very envious of you if you do have a Leonardo, and you're going to have to pay massive insurance bills if it is by him, and there will be people, who ... well, great scholars like to see things at an early stage.'

Penny had just accepted his appointment as the new director of the National Gallery in London, though he had not yet taken up the position. The National Gallery was planning a major Leonardo exhibition under the curatorship of a young and dedicated British curator, Luke Syson – so Syson's soon-to-be boss told him about the *Salvator*. 'Nick Penny told me there was a picture that would merit further thought,' says Syson. 'We're all bombarded by hopeful petitioners saying, "I've found a Leonardo and no one believes it, but you will when you see it." It's usually a hideous, ghastly, sad thing. I had looked at the Ganay *Salvator* but it seemed too stiff to be a Leonardo. Just for the sake of the research, it seemed like a good idea to go and have a look at the New York picture.' Syson examined it under a microscope in the conservation studios of the Met, and saw the thin glazes of paint. 'The technical information is important,' he says. 'But the sense of how a painting communicates is just as important, and it felt extraordinarily right. It had that sense of how the natural is assembled to make the supernatural. The picture seemed to hover somewhere between our realm and something spiritual.'

Syson and Penny saw an opportunity for a dramatic pictorial premiere in their Leonardo exhibition, but they knew that exhibiting a painting such as the *Salvator* – newly discovered, with uncertain attribution and on the market – would break a universally accepted convention of public collections not to legitimise or promote

entrants to the field. To overcome this hurdle, Syson came up with a high-stakes solution. He organised a seminar, a gathering of the world's top art historians, to examine the *Salvator* in London 'with an open mind'.

And that is how we found Robert Simon on a plane in late May 2008, flying to London with the *Salvator* tucked away in a custom-built attaché case. 'I felt like Don Corleone,' he says. He brought the *Salvator* to the National Gallery by a side entrance. The painting was put up on an easel next to another famous Leonardo owned by the National Gallery, its version of the *Virgin of the Rocks*, which was undergoing a thorough restoration. This critical juxtaposition revealed a parallel agenda of the museum that would work in Simon's favour, and that he may have been strategic enough to be aware of. The Louvre, the National Gallery's Parisian rival, had the largest trove of undisputed Leonardo paintings, while London had only a large cartoon drawing and its version of the *Virgin of the Rocks*. For more than a century art historians had been arguing over whether the London *Rocks* was painted by Leonardo or by assistants – Ambrogio de Predis, Boltraffio and so on. The consensus was that the painting was primarily the work of assistants, but the National Gallery had long been campaigning for its attribution to Leonardo. The restoration was the latest effort towards that end.

Five great Leonardo experts attended this meeting. From Milan came Professor Pietro Marani, who had supervised arguably the most challenging restoration in art history, that of *The Last Supper*, for which he had opted for the conservative approach of leaving the damaged parts without in-painting or touching up. Also from Milan was Maria Teresa Fiorio, who had run two of that city's major muse-ums and was an unrivalled specialist in Leonardo's assistants and pupils. Carmen Bambach, the curator of drawings at the Met, had already seen the *Salvator* in New York on several occasions. From Washington, DC, arriving a little later than the others, came David

Alan Brown, the revered curator of Italian paintings at the National Gallery of Art, who had long ago in his PhD thesis expressed his belief in the existence of a 'lost *Salvator Mundi*' by Leonardo, depicting 'a mature bearded Christ ... frontally posed and strongly lit from the left, against a dark background with his right hand raised in blessing and his left holding a globe'.[1]

The last guest to arrive was Martin Kemp. He is the only member of the group who has since given accounts, in print and on a podcast, of the meeting. First, Kemp took a deep breath. He is keenly aware of the traps his fellow Leonardists are prone to fall into, and of the particular hazard that beholding a potential new Leonardo poses. 'You can easily, by wishful thinking, start seeing what you want to see. You can make yourself look a big idiot,' he told the *Sunday Times*. But on this occasion, he himself could not resist an instant reaction: 'On the left, as I walked in, there was this painting that immediately had this presence.' Luke Syson recalls, 'I remember carrying it down the corridor from one studio to another and Martin Kemp meeting it, as we opened the door, and the look of recognition on his face.' Kemp's expression visibly changed as he realised 'that this wasn't a fool's errand'.

'It was quite clear. It had that kind of presence that Leonardos have,' Kemp explained to the art website Blouin Artinfo. 'The *Mona Lisa* has a presence. So after that initial reaction, which is kind of almost inside your body, as it were, you look at it and you think, well, the handling of the better-preserved parts, like the hair and so on, is just incredibly good. It's got that kind of uncanny vortex, as if the hair is a living, moving substance, or like water, which is what Leonardo said hair was like. So it almost ceases to become hair, and it becomes a source of energy in its own right ... Then the blessing hand has got a lot of very understated anatomical structure in it. What Leonardo had done, and the copyists and imitators didn't pick up, was to get just how the knuckle sort of sits underneath the skin. And the bless-

ing hands of the ones in the copies are all rather smooth and routine, but this is somebody who actually knew … how the flesh lies over the knuckles. So, that's pretty good.'

In short, the painting had the *zing*.

The doors were closed, and the meeting began. The art historians were in one of the National Gallery's light-filled restoration studios, situated on the top floor and lit by many skylights. Magnifying glasses came out, and Simon passed around some technical photographs of the painting. The enlargements were so precise that the experts could see the tiny chunks of ground lapis lazuli in the blue of Christ's garment, and below that the other layers of paint, black then white, magnified so that they resembled the side of a quarry or a collapsed cliff, a beautiful jumble of jagged coloured fragments of stone. Simon could only listen to the academics who surrounded him. It was not for him to voice an opinion.

It must have been a nerve-racking few hours for him, but he didn't show it. On the upside, at least two of the guests had incentives to recognise the picture as a Leonardo. Pietro Marani was organising a magnificent Leonardo exhibition in Milan, which would take place in 2015.[2] At the time he did not know that the National Gallery had its own Leonardo show in the planning stages, and that it would open before his. He would have seen the headline-making opportunity to premiere a star attraction in Milan. Martin Kemp was the other likely supporter. In the 1990s he had taken a more inclusive attitude to Leonardo's studio production than many of his colleagues, observing the hand and mind of the artist at work in two versions of the *Madonna of the Yarnwinder*.

Of the many downsides, there was no particular reason to think that any of the scholars present would agree with each other about the *Salvator*. They rarely did with other attributions, and most of them had rejected Kemp's *Bella Principessa*. Each of them had their own controversial pet Leonardo attributions which at one time or another

they had found themselves defending.* Even the great Bernard Berenson, considered the most accurate attributor in the history of connoisseurship, had been wrong 20 per cent of the time. If Syson and Penny could get so many experts to agree so quickly and simultaneously that this was a Leonardo, it would be a remarkable feat, unprecedented in the annals of art history.

It was a rare event indeed to have almost all the world's leading Leonardo experts in one place, but there were some conspicuous absentees. One was Carlo Pedretti. This was understandable, because in his old age the Italian Leonardist had presented a range of reattributions to Leonardo of works which were owned by wealthy friends, but which found no acceptance whatsoever from his peers. His connoisseurial opinions now had junk status.

A second, stranger omission was Jacques Franck, a Leonardo expert who was a trained painter rather than an academic, and who had advised Syson on the restoration of the *Rocks*. Syson felt that Franck was too far outside the world of academic and institutional art history to be invited into this project.

A third omission, the most surprising, was Frank Zöllner. A professor of art history at Leipzig, Zöllner was the author of the bestselling, multi-edition *catalogue raisonné* of Leonardo's paintings. A possible explanation for his absence may be found in the final paragraph of his introduction to the 2007 edition of *Leonardo da Vinci: The Complete Paintings*, written before he knew of the existence of Simon's *Salvator*. Zöllner stated firmly: 'In conclusion, mention must be made of the

* In the late 1990s Marani and Brown had both claimed that the fish in *Tobias and the Angel* from Verrocchio's studio was painted by Leonardo. That attribution was never widely accepted, though Walter Isaacson reprised it in his biography of Leonardo. Marani attributes the *Dreyfus Madonna*, in the National Gallery of Art in Washington, to Leonardo, but nowadays most scholars believe it is by Verrocchio's other pupil Lorenzo di Credi, whose work has more of his master's prosaic realism than Leonardo's elusive idealism.

increasing attempts, above all in recent years, to attribute second- and third-class paintings to Leonardo's hand. In this context it should be noted that the catalogue of paintings by Leonardo presented here is definitive. While there may be works circulating in the fine art trade that stem from Leonardo's pupils, the likelihood of an original by the master himself ever making a new appearance is extremely small.' Syson says that leaving Zöllner off the guest list in London was, in retrospect, 'a mistake'.

No minutes were taken at this meeting. No declaration of any kind was signed by those present. No official announcement was issued after it ended. There was no formal process by which the attribution of the painting was conducted. The National Gallery did not ask to have the painting left with it to be examined by its own restorers in its own restoration studios, as the Albertina Museum and Academy of Fine Arts in Vienna had done with the *Bella Principessa*, before reaching a negative conclusion. For all the outside world knows, incense may have been shaken and incantations uttered in Latin, along with Knights Templar oaths. After the meeting, Syson informed Nicholas Penny, who had not himself attended, that the experts had agreed that the painting was indeed by Leonardo himself.

Syson remembers that there was 'pretty much a unanimous agreement that what they were looking at was Leonardo. When you're seeing a copy, then one's often struck by how the parts don't quite gel. They haven't been thought through together. They've been thought through individually because each piece is being imitated from something else.' He continued, 'With Leonardo in particular, you always have a sense of shimmering movement. It's very, very subtle but there's a kind of hum. There's a sort of hum to the *Salvator*.'

When Simon landed back in New York with his painting a few days later, he showed the customs official the blue form that everyone entering the United States must fill out. It listed 'One painting by

Leonardo da Vinci'. The customs agent told him to open the crate. 'Is that necessary?' Simon asked. 'Yes.' 'Why?' 'Because I'm an Italian-American and I have to tell my grandchildren.'[3]

Two weeks after the meeting, Penny contacted Simon and told him that the art historians had judged his painting to be a Leonardo. Simon recalls: 'He said something like, "There's some discussion about whether there's some workshop participation, or what the date might be, or whatever it is, but everyone is basically in agreement that it's by Leonardo."' Penny formally asked Simon if the National Gallery could borrow the painting for its exhibition three years hence, and also asked him to keep it a secret until then. Simon recalls that when he continued to research the painting in libraries and archives in the intervening years he had to cover up the books he was reading when friends and colleagues spotted him working away.

However, the art historians who attended the National Gallery meeting did not in fact reach an official attribution or an informal consensus about the *Salvator Mundi*. Nor were they asked to. 'I have never issued an official opinion on the *Salvator Mundi*, and in any case, I have never been asked to do so,' Maria Teresa Fiorio told me. 'I discussed the painting informally with colleagues, and I do not know by what means my opinion was made known. If the *Salvator Mundi* was exhibited as an autograph work at the National Gallery, then that was an autonomous decision by my London colleagues.'

'We were invited to the National Gallery to examine the progress of the scientific restoration of *Virgin of the Rocks*,' says Professor Marani, who edits the esteemed periodical *Raccolta Vinciana*, the 'Vincian Harvest', established a century ago and the only academic journal devoted solely to the study of a single artist. 'On this occasion they showed us the *Salvator Mundi*. It took me by surprise. We had a general discussion about the two works of art. After the discussion, the owners considered we were positive. I was not asked for an

attribution, and we did not offer a "consensus". I said, "Yes, it may be.""*

'There are no shortcuts to historical research, and much fewer when the evidence is so complex,' says Carmen Bambach, who has just published a four-volume study on Leonardo. 'What might this painting mean within Leonardo's work? I can tell you, it's fairly incidental. Leonardo should not be a vehicle to make an art historian famous. This is completely misconceiving what the purpose of art history is. I think you can read between the lines of what I say to you.'† Bambach told me her dissenting opinion had led to a heated argument at a conference at the Courtauld Institute. 'I was shouted at by a very distinguished Leonardo art historian in London. "You are wrong," he said. I knew the evidence I was sitting on and I pointed it out. This isn't about louder voices.'

Only two of the art historians at the National Gallery meeting believed the *Salvator Mundi* was a bona fide Leonardo: Martin Kemp and David Alan Brown. 'While the others were cautious, I had one of my proudest moments as a connoisseur when I recognised the painting immediately as the master's work,' Brown wrote to me. 'As a museum curator, I had to keep my opinion to myself and only

* In an article published in April 2012 in French art journal *Dossier de l'art*, Marani wrote: 'Criticism is very divided as far as the attribution of this panel to Leonardo goes. The researchers who had the opportunity to examine it in the restoration workshop of the National Gallery in London in 2008 supported this eventuality, whereas other specialists, for the most part Italian, see in it rather the work of the hand of a pupil.' In 2013, in another short essay, he said it was only '*molto probabile*' that the *Salvator* was a Leonardo, 'notwithstanding the loss of essential parts (especially the face)'.

† In a review of the National Gallery's exhibition for the art journal *Apollo* in February 2012, Bambach wrote: 'The attribution of the *Salvator Mundi* … requires a more qualified description. Much of the original painting surface may be by Boltraffio, but with passages done by Leonardo himself, namely Christ's proper right blessing hand, portions of the sleeve, his left hand and the crystal orb he holds.'

joined in the collective view that the work was more or less certainly by Leonardo.'

'The discussion was not recorded, because you don't have a free and easy discussion under those circumstances,' Nicholas Penny told me. 'You can't try to establish a scholarly consensus if you set up a highly formal situation where everyone is going to place their hand on the Bible. That would backfire anyway, because the art historians [Syson] invited wouldn't agree to it. So, he did his best to try and get them to concur. But that is better than if he didn't consult them at all. If he didn't consult them at all, I think he could really not have shown the picture.'

'The meeting was not about proving something in one direction,' says Syson himself. 'It was about gauging opinion and seeing if we were going to expose ourselves to ridicule. If everyone said clearly "This isn't him," we would not have shown it. There are all sorts of reasons for people to be more circumspect about their views now, because so much has happened.'*

The final score from the National Gallery meeting seems to have been two Yeses, one Maybe, one No and a No Comment. There was some common ground between those present, to be sure – they agreed that Leonardo had added his brush to parts of the picture, notably the orb and its foreshortened hand, the golden embroidery and, above all, the blessing hand. And the majority agreed that the face had been so badly damaged that they could no longer tell who had painted it.

* * *

* Syson and Penny showed me emails from Pietro Marani in 2014, in which he sought their assistance to borrow the *Salvator Mundi* for his 2015 Leonardo exhibition in Milan, and in which he referred to the painting as 'by Leonardo'. Marani was not successful in his loan request.

The *Salvator*'s owners were by now running out of money. They still hadn't made a cent from the picture, and it was beginning to look as if they would never sell it. 'There were a lot of expenses,' says Simon. 'The photography and the storage were expensive. When we insured it at its value, the insurers wouldn't allow me to keep it in the gallery. It had to be kept in a vault in an art storage facility. There were my research costs, going to Europe five times, and Milan five times, and London, New York, and going and checking the libraries. We were both getting all tapped out. Dianne was helpful in terms of not requiring us to pay everything in advance.'

Parish says that several times he and Simon considered putting the painting into an auction, 'but both of us were seasoned veterans of the art market and the auction market, and what you don't read about in the newspaper are the failures. And there's not a deader-in-the-water than a picture which you put up for auction and which then bombs. Supposing we had put a pretty reasonable price on *Salvator Mundi* – let's say we put $100 million reserve on it – and it tanked, where do you go from there? Absolutely dead.'

An offer of help came in 2009 from a reputedly well-connected New York dealer, Warren Adelson, who has a gallery in a magnificent uptown townhouse. 'I made a proposal to Robert and Alex to buy a share of the picture,' Adelson says, 'because I wanted to run with the ball and help them sell it.' He negotiated a 33 per cent stake in the painting in return for a $10 million advance payment. It was the first money Simon and Parish had received from their purchase around eight years previously. For certain periods, the painting hung in Adelson's gallery. 'I've been in the art business for over fifty years and I love pictures,' says Adelson, 'but to be around a Leonardo was very special. We had it in the townhouse on the top floor, where we have a flat. Often my wife and I would stay over, and I'll tell you an anecdote … We used to put a black velvet covering over the front of the painting every

evening, because my wife Jan is a Catholic and she felt she wanted to cover the painting up at night out of respect to Jesus. That's how intense her response to the painting was. I'm not Christian, I'm Jewish, and my response was equal to hers. It was so powerful to be in the same room with it.'

'Warren Adelson was going to be the rainmaker,' says Parish. 'Lo and behold, those clouds were a little dry, but he got us over the rough patches in terms of financing.'

Warren Adelson then struck a remarkable deal with a renowned and ultra-well-connected antiques and carpet dealer, Michael Franses. According to Franses' account, Adelson asked him 'to find a buyer outside of the USA' and gave him 'a written exclusive contract for one year'. Robert Simon, Franses says, 'was aware of this contract as I was directly in touch with him over the year'.

Franses put together two large dossiers of documents, one for restoration, the other for provenance, and he also says he made an expensive 'thirty-minute video in five languages based upon the manuscripts by [Martin] Kemp and [Margaret] Dalivalle'. This in turn suggests that Oxford scholars Kemp and Dalivalle played a part, whether knowingly or not, in early efforts to sell the painting. Franses made approaches to the Louvre, Hermitage, Prado, Vatican, Berlin's Gemäldegalerie and the Qatari royal family to see if anyone would take the *Salvator Mundi*. The plan was to get a museum to agree to accept it as a Leonardo and then find wealthy donors who would pay for it for that museum. But these renowned public museums did not share the same confidence in the *Salvator Mundi* as the National Gallery in London.

Franses' mission was not a success. He could not get an appointment with a senior staffer at the Prado in Madrid. When he went to see Vatican museum curator Arnold Nesselrath, the latter apparently fell asleep during the meeting. Mikhail Piotrovsky, the director of the Hermitage in St Petersburg, told me, 'The State Hermitage Museum

was shown the materials [i.e. photographs and documentation] but did not think they needed to start fundraising.' Simon says in 2009 he showed the painting to Scott Schaefer, the senior curator of paintings at the J. Paul Getty Museum, but that the Getty did not make an offer. The painting was shown in 2010 'to curators at the Museum of Fine Arts, Boston', Milton Esterow reported for *Artnews* in 2011, adding, 'Frederick Ilchman, the museum's curator of paintings, declined to comment.'[4] The Qatari royal family, who were building collections for their museums and investing in modernist paintings, were reported in the press to have declined an invitation to buy at $80 million.

Alex Parish remembers, 'We were trying, unsuccessfully, to pull a few people aside and say, "Hey, by the way, we've discovered this da Vinci. It's really incredible. How would you like to spend $150 million on it?" Their quite rightful reaction was, "If it's as great as you say it is, then how come I've never heard of it?" So we were caught in this conundrum.'

The director of Berlin's Gemäldegalerie, Bernd Lindemann, says he was offered the painting for €200 million. 'The dealer who visited me had two huge folders,' Lindemann told me. 'In one of the two files were photographs of Hollar's engraving from the seventeenth century and the whole history of the painting, and in the other file was the documentation of the restoration. I was very surprised that he showed the latter to me, because looking at it, it was obvious that a lot of the painting was remade. I think the man was a little bit naïve, showing me all this. I said to myself, "Well, this is a carpet dealer, he has no idea about paintings, he doesn't realise that he has a ruin." Eighty or 90 per cent of the painting was no longer the original surface. There were too many abrasions and there were not only abrasions on the surface, but these abrasions were very, very, very deep. If I had that painting in the Gemäldegalerie I would label it "Attributed to Leonardo" or "Leonardo or follower with later addi-

tions or with later repairs". By the way, the price was €250 million, and you can imagine this was impossible.'

Lindemann also sits on the vetting committee of the renowned European Fine Arts Fair (TEFAF) in Maastricht. Every dealer who wants to exhibit at the fair has to run selections past this panel, who reject works they consider to be unreliably attributed or of insufficient quality. 'If this painting had been put forward for TEFAF, we would have decided to reject the painting,' Lindemann told me. 'The condition was too bad. Look into the eyes, look into the eyes.' Lindemann judges the *Salvator*'s value at 'not more than $500,000'.

Another approach was made to the German auction house Lempertz. Its director, Professor Henrik Hahnstein, recalls only that 'It was all very vague, and the offer came from a bizarre middleman. At the time we consulted the Leonardo expert Professor Hans Ost, who was very sceptical about the attribution of the painting, as he still is today. The scholarly community continues to harbour considerable doubts about the picture.'

'We came very close a couple of times,' Parish says. 'We had offers over $80 million, and we turned them down. Maybe in retrospect we should have grabbed the first, best offer.'

Franses seems to have come closest to clinching a deal with the Louvre in Paris. He claims that the museum director at the time, Henri Loyrette, was ready to declare the *Salvator Mundi* a national treasure if the owners would only send it to his museum for examination and find someone to buy the painting for it – a purchase which, Franses points out, 'would have in turn given the donor a 90 per cent tax deduction'. Simon, according to Franses, baulked at sending the picture to the Louvre for examination, in case they didn't like it: 'Simon was scared that if the Louvre did not authenticate the painting, then Luke Syson might have changed his mind about exhibiting it. This meant that Syson might not have been certain of his own convictions, and Simon was not sure too of the outcome,

even though Delieuvin [the Louvre's co-curator of the 2019 Leonardo exhibition] was at the time convinced of its authenticity, so much so that he wanted it for the Louvre. We should have been home and dry.'

For three years nothing was heard of the National Gallery meeting. Then, in the summer of 2011, a few months before the blockbuster Leonardo exhibition opened, the curtain was finally pulled back. Simon sent the art historians who were at the National Gallery meeting a draft press release about the painting, asking for their approval of the text, which, he says, described the painting as an autograph Leonardo, whose attribution the National Gallery panel had collectively endorsed. The most enthusiastic reply came from Maria Teresa Fiorio, who wrote, 'Of course there are no problems to include my name in the statement.'

The responses from Pietro Marani and Carmen Bambach were rather more qualified. 'It seems to me right and appropriate, especially if you will give together with it a picture of the painting after restorations,' Marani wrote back in English, which is not of course his first language.

Carmen Bambach responded, 'Many thanks! The press release is interesting and to the point; I would have liked to see more said about the fact that the picture is damaged and exhibits much restoration, but of course, I'm ok with it, if the Met [Metropolitan Museum] is ok with the wording.' Simon was reluctant to tell me if he actually followed up with officials at the Met, as Bambach requested. He also was not keen to show me the press release draft text, but he did inform me that it contained *no* mention that the *Salvator Mundi* would be shown at the National Gallery in London as a Leonardo, based on views expressed at the 2008 meeting. Thus, aside from Martin Kemp, the Leonardists did not apparently know the full purpose to which their support for the painting would be put.

Then on 7 July, Simon issued his press release. 'A lost painting by Leonardo da Vinci has been identified in an American collection,' it began. He carefully listed the names of the illustrious art historians to whom he had shown the painting. 'These scholars are convinced the painting is by Leonardo,' he wrote, because of

> the painting's adherence in style to Leonardo's known paintings; the extraordinary quality of its execution; the relationship of the painting to the two autograph drawings at Windsor; its correspondence to the composition of the Salvator Mundi documented in Wenceslaus Hollar's 1650 etching; and its manifest superiority to the more than twenty painted known versions of the composition. Further crucial evidence for Leonardo's authorship was provided by the discovery of pentimenti – preliminary compositional ideas, subsequently changed by the artist in the finished painting, but not reflected in the etching or other copies … Technical examinations and analyses have demonstrated the consistency of the pigments, media, and technique discovered in the Salvator Mundi with those known to have been used by Leonardo.

Simon claimed that there had been 'an unequivocal consensus that the Salvator Mundi was painted by Leonardo, and that it is the single original painting from which the many copies and versions depend'. Knowing that the National Gallery would face an outcry if it became apparent that the painting was for sale, he added, 'The Salvator Mundi is now privately owned and not for sale.'

Penny and Syson knew that this was not factually correct, although it is highly unusual for a public institution to show a painting that it knows is for sale. 'I did know, of course, that the picture was potentially on the market when we borrowed it,' says Penny. 'Some people have professed to be astonished by this, but I'm pretty sure I would

have discussed this with the relevant trustees and with the chairman.'

On 13 July the National Gallery issued a statement of its own that was considerably vaguer than Simon's:

We felt that it would be of great interest to include this painting in the exhibition as a new discovery. It will be presented as the work of Leonardo, and this will obviously be an important opportunity to test this new attribution by direct comparison with works universally accepted as Leonardo's.

That statement, with its carefully crafted ambiguity, did not explicitly state that the gallery accepted the attribution of the painting to Leonardo, but it was implied. When the *Salvator* went on show at the National's Leonardo exhibition in November, there was nothing in the exhibition leaflet or catalogue that suggested its being on display would help 'test' its possible attribution, nor that there was any kind of question mark over it. Instead, it was simply described as 'Cat 91 *Leonardo da Vinci (1452–1519) Christ as Salvator Mundi*'.

Luke Syson told me, 'I catalogued it more firmly in the exhibition as a Leonardo because my feeling at that point was that I was making a proposal and I could make it cautiously or with some degree of scholarly oomph. It is important not to float an idea without saying where you yourself stand on it.'

Five years later, when Christie's auctioned the painting, its catalogue stated:

As the possibility of Leonardo's authorship became clear, the painting was shown to a group of international scholars and experts in Leonardo's works … The study and examination of the painting by

these scholars resulted in a broad consensus that the* Salvator
Mundi *was painted by Leonardo da Vinci, and that it is the single
original painting from which the many copies and student versions
depend.*

There was one final opinion cited by Christie's in its online history
of the painting, '*Salvator Mundi*: The rediscovery of a masterpiece:
Chronology, conservation, and authentication', posted on 3
November 2017 – that of the Louvre curator of Renaissance paint-
ings, Vincent Delieuvin, who had by this time begun his preparations
for the Louvre's five-hundredth-anniversary Leonardo exhibition in
2019. 'The authenticity of the piece as an autograph work by
Leonardo was confirmed by Vincent Delieuvin at the Louvre, Paris,'
Christie's stated.

When I sought to corroborate this, the Louvre advised me to read
an essay by Delieuvin in the catalogue of another exhibition,
'Leonardo in France', which had been held at the Italian embassy in
Paris in 2016. Of the *Salvator*, Delieuvin wrote ambiguously: 'The
autograph version appears [*semble* is the French word used] to have
resurfaced very recently, unfortunately in very bad condition. The
circumstances of the creation of this work are unfortunately
unknown.'[5]

* Christie's was referring to the combined views of many art historians who
had seen the painting in New York and London. These included Syson, Penny
and Christiansen, who, as we have seen, all supported the attribution. Another
art historian, David Ekserdijan, professor of art and film history at the
University of Leicester, saw the painting and told me that he also supported
the attribution. I was not able to verify the verdicts of all of the art historians
listed in Christie's *Salvator Mundi* catalogue (p.22).

ENTERTAINER AND ENGINEER

If you look at a map of sixteenth-century Milan, the Castello Sforzesco seems to have inflated the whole city, which spreads around it like the expanded cheeks of a frog. Duke Ludovico Sforza's fortress-cum-palace stood on one edge of the town, a hexagon surrounded by strikingly tall, elegant brick walls. In the surrounding piazza you could sometimes see the duke's monkeys scampering about in special Sforza uniforms. A constant stream of diplomats and officials, supplicants and servants poured in and out of the palace gates, and amongst the courtyards and buildings inside. The smooth stone staircases were so long that women sometimes rode horses up them, to avoid tiring their legs. Eight hundred people lived within the walls. In their secluded apartments, the duke and his wife slept under silk veils designed to protect their dreams.

The duke was known for his extravagant parades and ceremonies, celebrating the arrival of an ambassador, a family marriage, the election of a pope or a military victory. On one such occasion — for the entrance of his wife into the city — there was a procession of nearly five hundred horses, representatives of thirty-six different orders of priest, sixty knights and fifty ladies, accompanied by sixty-two trum-

pets, along a route covered in white fabric leading from the castle to the cathedral. Along the way, the walls were covered with tapestries and garlands of juniper and orange blossom. The Florentine ambassador observed that 'everything was so well organised that there was not even the slightest of trouble in the street, which is no small thing, because the crowds in this city are enormous'.

The duke attracted a cross-section of Italy's leading artists and scholars to his court with stipends and commissions, and he expected something in return: an obsequious chorus of great intellects and imaginations celebrating his transition from ruthless military commander to man of arts and letters. The court poet Bellincioni wrote in hackneyed verse that Milan was Athens and Parnassus,* presided over by the 'divine' Ludovico Sforza, 'a guide, a star'.

The highest pinnacle an artist could reach in Renaissance Europe was to be appointed court artist, a position conferred on Leonardo by the Duke of Milan by 1490. There were now many other pressures on his time aside from painting. The court valued his skills as a set designer and entertainer as highly as his abilities as a painter. He played the *lira da braccio*, a forerunner of the violin; he entertained gatherings with riddles, jokes and cryptic prophecies; he took part in ritualised philosophical debates in which scholar-courtiers discussed which art was superior, painting, music or poetry – painting, Leonardo always argued. He worked as an interior designer, decorating rooms in the palace, including the spectacular Sala del Asse, 'The Hall of the Wooden Boards', which he transformed into a forest of mulberry trees whose canopy of leaves and branches covered the ceiling in knot-like patterns.

Leonardo combined his skills as an artist and engineer to stage spectacles with dramatic transformations and moving parts. In one

* The mountain that was, in Greek mythology, the home of the muses, and frequented by Apollo and Dionysus.

he created a vision of Paradise which, a member of the audience noted, 'was made to resemble half an egg, which from the edge inwards was completely covered with gold, with a very great number of lights representing stars, with certain gaps where the seven planets were situated, according to their high or low ranks'. Inside the egg, many singers performed 'accompanied by many sweet and refined sounds'.[1] One can imagine that it would have looked like a living Leonardo painting as actors, often members of the court, in elaborate costumes awkwardly recited classical myths, chivalric codes of honour and contrived allegories to flatter the duke and his guests.

For another, Leonardo designed elaborate decorations for a horse. The Duke of Milan's secretary Tristano Calco gave an eyewitness account of this sight: 'First a wonderful steed appeared, all covered with gold scales which the artist has coloured like peacock feathers … the head of the horse was covered with gold; it was slightly bent and bore curved horns.' Astride the horse was a rider, from whose 'head hung a winged serpent, whose tail touched the horse's back. A bearded face cast in gold looked out from the shield.'

Leonardo was staging such shows for the French rulers of Milan at the Castello Sforzesco between 1506 and 1513, when the *Salvator Mundi* was on an easel in his studio. His biographer Paolo Giovio was at court at this time, and wrote how Leonardo 'was a marvellous inventor and arbiter of all elegance and theatrical delights'. He drew sketches for a stage set of a range of mountains, which were to open – as he wrote next to the design drawing in his notebook – by means of pulleys, ropes and weights to reveal a large cave, where 'Pluto is discovered in his residence' along with Cerberus, devils, furies and 'many naked children'. In 1515 a mechanical lion designed by Leonardo was the star attraction in a pageant for the young French King Francis I. Another Leonardo biographer, Gian Paolo Lomazzo, tells how the lion 'moved from its place in the hall and

when it came to a halt its breast opened, and was full of lilies and other flowers'* The lion was a symbol of Florence, the lilies a symbol of the French monarchy, so the ensemble represented the new alliance between the two powers.

The constant stream of entertainment, engagements and commissions from the court left Leonardo little time to paint. And even when he wasn't dragooned into designing events for Milan's rulers, he did not immediately pick up his brush; he had better things to do. From the mid-1480s, when he was already past the age of thirty, he began a campaign of self-education across the fields of the arts and sciences, which included teaching himself Latin, in a self-conscious effort to elevate himself from artisan to intellectual.

He built up a substantial library for his time. He owned forty books by 1492; by 1503, 116. On his shelves you would find biographies of the philosophers, texts on maths, military science, agriculture, surgery, law, music, precious stones, health and palm-reading, grammar and rhetoric, travelogues, Aesop's fables, Ovid, Livy, Petrarch, Aristotle, Archimedes, Euclid, Ptolemy, psalms and the Bible. Among his great friends at this time was the mathematician Luca Pacioli. Leonardo drew illustrations of geometrical forms and knots for *Divina Proportione*, one of Pacioli's books on mathematics, and Pacioli thanked him for his 'invaluable work on spatial motion, percussion, weight and all forces'.

In the 1490s, Leonardo began to fill his notebooks. Occasionally he wrote lists of people he wanted to consult. In one of these, dated to 1495, he scribbled, backwards as usual, 'Ask Maestro Antonio how mortars are positioned on bastions by day or night; Ask [Medici banker] Benedetto Portinari by what means they go on ice in

* Either Leonardo sent his blueprints for this automaton to the French court and it was built there, or he built it in his studio and sent it to France, because he was not present when it was put into operation.

Flanders; get the master of mathematics to show you how to square a triangle; find a master of hydraulics and get him to tell you how to repair, and the costs of repair of a lock, canal and mill in the Lombard manner.' Leonardo was open-minded and receptive, adept at drawing on the skills of others and absorbing their knowledge.

This is all to say that, after 1500, the focus of Leonardo's interests turned decisively away from painting. His preoccupation with mathematics, the natural sciences and technology consumed him. Fra Pietro da Novellara visited him in 1501 and reported back to his employer Isabella d'Este that 'He devotes much of his time to geometry, and has no fondness at all for the paintbrush.' Leonardo believed that everything came down to mathematics, writing that 'He who defames the supreme certainty of mathematics feeds on confusion.'

And he recorded it all. He covered thousands of pages with drawings of basic machines, anatomical studies – he famously dissected the corpse of a centenarian – mathematics, optics and geometry. His notebooks contain references to two hundred species of plants and over forty varieties of trees. They are dotted with questions, as he sought to articulate the physical laws for all manner of natural phenomena. 'Why does a solitary rock in the level of a stream cause the water beyond to form many protuberances?' he asked himself on one occasion. On another he posed the question: 'Why do dogs willingly sniff one another's bottoms?' He came to the wrong conclusion: 'The excrement of animals always retains some essence of its origin … if by means of the smell they know a dog to be well fed, they respect him because he has a powerful and rich master; and if they discern no such smell of that essence [i.e. of meat] they judge the dog to be of small account, and to have a poor and humble master, and therefore they bite him.'[2]

Leonardo's empirical approach to understanding the world was a striking break from the past. His central tenet, that 'All our knowl-

edge has its origins in our perceptions,' derived, admittedly, from Aristotle, but the artist-engineer combined it with a new commitment to experiment, in which general laws were tested: 'First you must explain the theory, then the practice.'*

Leonardo invented instruments including proportional compasses, tools for drawing parabolas and for constructing parabolic mirrors. He was a brilliant technical illustrator – the first engineer to draw architecture from the standard viewpoints of plan and perspective – and the first to draw exploded diagrams, so one could see how the parts fitted together. His anatomical drawings were far in advance of his contemporaries in their accuracy and clarity, and were still used by doctors and biologists centuries later. He was the first astronomer to perceive that the grey colour of the moon is caused by the light of the sun reflected off the earth's oceans.

Leonardo's notes were intended for publication. He planned treatises on anatomy, hydraulics and the elements of machines, as well as painting, but he never got to the editing stage. None were published in his lifetime, and the only one published after his death was on painting. The historical orthodoxy is that Leonardo was a prophetic genius, who conceived of countless modern inventions before the science and technology existed to realise them. But he was more human than that. There are subjects he struggled to understand. There are rabbit holes. There is the sense of a quest that never reaches its destination.

Much of the time, Leonardo is less a genius than a determined student. He paraphrases the histories of art written by other Renaissance art theorists such as Alberti and Ghiberti. He obsesses

* Vasily Zubov argued that 'Leonardo asserted, with much greater persistence than his predecessors like Brunelleschi and Ghiberti, that the practical efforts of the technician and artist should be based on conscious generalisations, on general laws.'

over geometry. He struggles with algebra and with Latin vocabulary. He engages in long-prevalent scientific fantasies. It is said that he invented the parachute with a sketch, dated around 1485, of a four-sided pyramid covered in linen, attached to which 'a man ... can jump from any great height whatsoever without injury'. Yet others before him had had the same idea – in Spain in 852, in Constantinople in 1178, and at various times in China, as well as at least one of his Italian contemporaries, the mathematician Ignazio Danti from Perugia. His analysis of the flight of birds and the way their wings worked was close to that found in medieval treatises on falconry.[3] The analogies he drew between the earth and the human body, and between tides, breathing and the circulation of blood, all had precedents in medieval scholarship. Many of his rules are, as the Russian Leonardist Vasily Zubov pointed out, personal observations rewritten as formulae.

The military technology and hardware which Leonardo boasted he could offer the Duke of Milan – the great guns, mortars and chariots – were, so far as we know, never manufactured. Leonardo was a dreamer, a doodler and a dawdler.

His aspirations were marked by their grandiosity. He developed plans for a canal from Florence to the sea by diverting the River Arno, calculating that a million tons of earth would need to be moved, a task that would take 54,000 man-days. He drew designs for various machines to partially mechanise the digging, though these were never manufactured. In fact, in 1504 work on the diversion of the Arno began, but without Leonardo's participation. The project was a failure, many workers perished, and within only two months the project was abandoned. A few years later Leonardo designed a beautiful villa for the French governor of Milan, Charles d'Amboise. It would have a landscaped garden with little classical follies, islands with temples, and a water-powered windmill with huge sails which would work as a giant fan and keep the French

elite cool in summer.* This was also never built. All we know for certain of his designs that actually left the drawing board are an elaborate scaffolding platform that he could raise and lower to paint the huge fresco *The Battle of Anghiari*, and the renovation of the plumbing and sewers of the San Salvatore dell'Osservanza church in Florence. Such are the known engineering achievements of the 'universal genius'.

All these scientific interests meant Leonardo did not have much time to paint. But this did not mean that he did not paint at all. After 1500, visitors to the duke's palace remarked on various stages and versions of the *Virgin and Child with St Anne* and the *Madonna of the Yarnwinder*, and these were not the only paintings they said the master's brush touched. After his visit to Leonardo in Florence, Fra Pietro da Novellara wrote to Isabella d'Este that although he was not making paintings as such, 'two of his assistants make copies, and from time to time he adds some touches to them'. Sixteen years later an aide of the Cardinal of Aragon, Antonio de Beatis, wrote much the same thing when he visited Leonardo in France. Leonardo was no longer producing masterpieces himself, he wrote. 'He can no longer colour with such sweetness as he used to,' but 'He is none the less able to do drawings and teach others,' and he had 'trained up a Milanese pupil who works well'.

* 'With this mill I will generate a breeze at any time during the summer,' wrote Leonardo. 'And I will make water spring up fresh and bubbling … the mill will serve to create conduits of water through the house, and fountains in various places …'

THE GREATEST SHOW ON EARTH

Luke Syson began work on his Leonardo show in 2007. Five years later he had assembled the largest number of Leonardos under one roof since the Milan retrospective of 1939. By the time the exhibition opened on 11 November 2011, tickets had sold out and were changing hands on the black market for hundreds of pounds. The show would attract 323,897 visitors over three months, more than six times the normal number for a National Gallery exhibition. Syson and Nicholas Penny could claim to have staged one of the greatest exhibitions of all time.

Securing loans of art from other museums is a highly political, time-consuming operation, not unlike negotiating a hostage swap. Often a loan will only be granted if the favour is returned. The Hermitage got a National Gallery painting by the gloriously decorative Venetian Renaissance artist Carlo Crivelli in return for its *Madonna Litta*; the Ambrosiana got a Botticelli for a future exhibition in return for its *Portrait of a Musician*, which had never been shown outside Italy before; the Louvre obtained Leonardo's Burlington cartoon, a preparatory study for its *Virgin and Child with St Anne*, around which it was building its own Leonardo show for 2012, in

return for sending its version of the *Virgin of the Rocks* to London, the painting's first ever journey abroad. A fee was paid to the National Museum Krakow for the loan of *Lady with an Ermine*. Of Leonardo's generally acknowledged paintings, numbering somewhere between fourteen and nineteen, Syson had nine in his exhibition.[1] It was an unprecedented feat of diplomacy, considering that one, *The Last Supper*, is on a wall and can't move, while another, the *Mona Lisa*, is too famous to travel again.

If you are a curator nowadays, it is key that a major exhibition should tell a story, and museums seek larger narratives than those contained by art history. 'Leonardo: A Painter at the Court of Milan' set the artist within the context of the court of Ludovico Sforza, a man known, like so many other great art collectors, as much for his assassinations and mistresses as for his patronage of the arts. There was one room dedicated to male portraits, another to female ones – where two of the powerful duke's lovers faced each other, Cecilia Gallerani, otherwise known as *Lady with an Ermine*, and Lucrezia Crivelli, *La Belle Ferronnière*. The magnificent show built towards a never-before-seen visual climax, a staged tournament between masterpieces, in which two versions of the same composition faced off against each other on opposite walls: the Paris vs the London *Virgin of the Rocks*. Finally, there was the Hollywood ending as visitors were confronted with a brand-new Leonardo, the *Salvator Mundi*, hung between the two preparatory drawings from Windsor.

Syson's catalogue established the *Salvator* as a Leonardo:

> *The re-emergence of this picture cleaned and restored to reveal an autograph work by Leonardo comes as an extraordinary surprise.*[2]

Although the earlier press release had said that the attribution of the *Salvator* would be 'tested' in the exhibition, there was no sign of that in its labelling and catalogue description. On the basis of material

provided by Martin Kemp, Robert Simon and Margaret Dalivalle, as well as his own research, Syson described the painting's provenance as having come from the court of French kings, been brought to London by Henrietta Maria, and later copied by Wenceslaus Hollar.

For Simon, Alex Parish and Dianne Modestini this was the end of a long process, whose outcome had been uncertain for many years. Now they had scaled the highest peak in art history. Simon told an Australian reporter, 'Seeing this picture on the walls of the National Gallery, something I have held under my arm in a bin liner, had in my house for a night and that I have worked on for probably an hour a day for six years, was absolutely thrilling, an extraordinary feeling.'

Modestini says she had to catch her breath as she caught sight of the painting: 'It was beautifully lit and seemed to glow from within, as if with pride at the fact that it had survived so much abuse and ignorance.'[3] In the following months she received emails from people she had never met congratulating her on her restoration, some suggesting that she was 'holy' because she had resurrected the painting.

Alex Parish flew in for the exhibition opening. 'Although my participation was not widely known, some people knew. I had a very touching moment in a bar. I'm sitting having drinks with an old friend from Christie's, and there was a group of younger guys all in the business. Most of them running dogs, the same way I spent my life in the trade. One came over and he leaned over to me, and he said, "You give us hope." I just burst into tears.'

There was, however, a certain art historical laxity to the exhibition. Syson was rather unorthodox with the dating of Leonardo's works, so as to slot them into his Milanese timeframe, artfully using the scant facts known about when Leonardo started and finished paintings to his chronological advantage. Leonardo was only at the Milanese court from around 1482 until 1499. The *St Jerome* was moved from its conventional Florentine date at the beginning of the 1480s to

'1488–90'. The *Madonna of the Yarnwinder*, known from eyewitness accounts to have been under way in 1501, was pushed back to 'about 1499 onwards'.

The *Salvator Mundi* enjoyed similarly innovative dating. The picture is widely agreed to have been started well after 1500, since the two drapery studies for it, with their soft red chalkiness, bear all the stylistic and technical hallmarks of Leonardo's drawing in the 1500s. However, Syson attempted to link these sketches to red-chalk drawings of the apostles from the 1490s and to the portrait drawing of Christ from *The Last Supper* from the same period, referring also to patchy evidence that Leonardo sometimes did drawings for parts of his compositions after he had begun the actual painting. These clues, he suggested, raised the possibility that Leonardo could have begun his *Salvator Mundi* before he made the preparatory drawings. Thus, Syson dated the *Salvator* conveniently to 'about 1499 onwards'. The paucity of facts surrounding Leonardo's life enable almost any revision of the chronology of his work, but this one sailed dangerously close to the margins of possibility. The *Salvator*'s very developed *sfumato* compels a dating to 1503 at the very earliest.

'Rarely have I left an exhibition with such a sense of elation,' wrote the art dealer and *Financial Times* commentator Bendor Grosvenor. 'Is this the best exhibition the National Gallery has put on in modern times? Yes. Is it the best art exhibition ever? Quite possibly.' It was, wrote Waldemar Januszczak in the *Sunday Times*, 'a show that can make a decent claim to be the most important Leonardo exhibition ever'. The *Guardian*'s Jonathan Jones called it 'a revelation from first to last'. For Charles Hope, former director of the Warburg Institute, it was a 'triumph'; for Frank Zöllner it was 'one of the best of the past few decades'; and for Charles Robertson, writing in the *Burlington Magazine*, it was 'beautiful and satisfying'.[4]

Reviews of the exhibition were ecstatic, but the response to the *Salvator* was mixed. Waldemar Januszczak was convinced: 'The sheer

strangeness of the image makes it feel Leonardesque.' But Andrew
Graham-Dixon of the *Daily Telegraph* was not: 'Its expression seems
to lack a certain subtle Leonardo magic.' Scholars were also divided.
Cambridge art historian Paul Joannides said it 'carried conviction',
but Charles Hope thought it was 'hard to believe that Leonardo
himself was responsible for anything so dull', while Frank Zöllner,
who had been so conspicuously excluded from the high council who
viewed the painting on Simon's earlier trip to London, concluded
that it was 'a high-quality product of Leonardo's workshop', and
might even have been painted 'by a pupil or follower of Leonardo
after the master's death'. So, despite its aspirational labelling, the
painting had not quite passed the National Gallery's 'test'.[5]

What neither critics nor the general viewing audience seemed to
hold against Syson was that so little background information was
provided about this astonishing, previously lost painting. Never before
had a newly restored and newly attributed Renaissance masterpiece
been exhibited at a major public collection with so little written
about it and so little photographic documentation of the restoration
process. Never before had a newly discovered painting been exhibited
in a public collection after so informal a process of authentication.

There was talk of a book by Robert Simon and his team of Kemp,
Dalivalle and Modestini, but that was published in autumn 2019 in
tandem with a website detailing the restoration, eight years after the
National Gallery's Leonardo show. That is a long time to wait, *after*
exhibition by a public institution, to read the scholarly evidence for
the attribution and the documentation detailing its restoration. 'The
documentation was at the level of museum restorations,' Simon
claims, 'and its dissemination to the public was already much greater
than museums would dare.' But if there is a broad consensus among
art historians on one thing about the *Salvator*, it is that Simon and his
team have not released enough information about its restoration. The
painting was attributed before it had been fully researched and docu-

mentation made available. Dietrich Seybold, a Swiss-based historian of connoisseurship, aptly points out that in this case *expertise* – the term used by the art world for the assessment of a work of art by scholars – preceded scholarship.

In Germany, the meticulous Frank Zöllner found himself faced with a dilemma when he came to write the second edition of his definitive *catalogue raisonné* of Leonardo's works. When reviewing the London exhibition, his verdict was that the *Salvator* came from Leonardo's workshop, but that it would have been painted 'only after 1507 and possibly much later'. Robert Simon had sent Zöllner photographs of the stripped painting before restoration, but no infrared or microscopic images. Zöllner did not feel he had enough material to judge properly whether the painting was Leonardo, or Leonardo and workshop. Elements of the peripheries of the painting – the blessing hand and the fingers holding the orb – looked good, but the face was extremely bizarre. He wanted to include the painting in his new edition, but should he credit it as Leonardo, or Leonardo plus workshop? In the end, it was a decision he did not have to make. He received written notice regarding his intended use of the 2011 post-restoration photograph which said: 'The owners of the painting, and the copyright owners of the photograph have required the following caption and credit line for its use: Leonardo da Vinci (Italian, 1452–1519) *Salvator Mundi*.' But there were no instructions about how the painting had to be described in the accompanying text. Zöllner says: 'So in the captions of my book of 2015 it is "Leonardo", but the text clearly says differently: "Workshop painting done after 1507 or much later with possible participation of Leonardo."'

In the 2019 edition of his book, Zöllner attributes the painting carefully as 'Workshop of Leonardo, after a design by Leonardo and with Leonardo's participation'.

* * *

These days, Robert Simon gives talks about how he found the long-lost last Leonardo. He has appeared several times at the Lotos, an exclusive jacket-and-tie members' club on New York's Upper East Side. The Lotos has a beautiful, if indulgently ornate, turn-of-the-century interior, which seems to juggle styles and motifs from three centuries of European culture. Simon delivers a smooth, often witty presentation. He remarks on the odd facial hair of the *Salvator* in the Cook Collection photograph, and jokily compares it to a mugshot of a shady-looking young criminal with similar features, with the headline 'Woodbury Police Make Large Pot, Hash and LSD Bust'. He has an explanation for why the *Salvator* lay unrecognised for so long, blaming its damaged state: 'If someone has a big pimple on their nose, that's all you look at.' He has polished his line on the importance of his painting:

> *It's been called the* male Mona Lisa. *This is not just hype, I think, because of the similarities in the way the two paintings are painted.* Mona Lisa *is a somewhat androgynous woman and the* Salvator Mundi *is a somewhat androgynous man. I see* [Leonardo] *trying to create a universal figure, man and God and with female and male characteristics.*

With admirable candour, he tells his audience that at first Dianne Modestini had done the in-painting in 'a very conservative way', and 'without much creativity'.

The painting then went to the National Gallery for the Leonardists' summit, and when it came back, apparently endorsed as a Leonardo, he and Modestini launched another, bolder phase of restoration: 'At this point we felt we could be a little more creative and make this live again as a work of art.'

Much controversy surrounds the second phase of the restoration of the *Salvator Mundi*. Despite the fact that the painting had been

authenticated as a Leonardo for a future exhibition, Simon and Modestini chose to alter its appearance again. Simon still did not organise a supervisory committee to oversee its restoration, which, he says, is not the custom in America as it is in Europe. He and Modestini did, however, feel emboldened enough by the attribution to make a series of creative decisions.

When she saw the painting again, Modestini was unhappy with it. She and Simon 'wanted to make it live again', but parts were so damaged that she could not see how Leonardo had originally painted it. The orb was a 'very damaged area of the picture'. It had been abraded, meaning that layers had been rubbed away. This was particularly problematic because Leonardo had painted it 'with practically nothing'. Modestini set herself the goal to have 'rendered it convincing'.[6] For guidance, she turned to other versions of the *Salvator Mundi* by Leonardo's followers. 'I looked at a couple of the copies,' she says. 'The copy that I think is really closest to it is the Naples picture.' This one, hanging in San Domenico Maggiore in Naples, is attributed to Girolamo Alibrandi, who worked with another of Leonardo's followers, Cesare da Sesto, on a big altarpiece for a monastery near Naples around 1514. When Cesare left Milan a few years earlier, he might have taken tracings or drawings after the *Salvator Mundi* with him, and then shared them with Alibrandi. Alibrandi's *Salvator* shows a huge range of quality in different parts. The face and blessing arm look schematically and quickly executed, while some of the embroidery's golden pattern, and above all the orb – its shower of golden dots suggests reflections from the embroidery inside the 'inclusions' or defects in the orb – are rendered with great delicacy. Modestini instructed an Italian photographer to take a high-resolution image of the Naples *Salvator Mundi*. Looking at the photo, she could see that the Naples orb had two major differences from the painting on her easel: the gold dots, and a strong white highlight as a reflection of a light source. 'I photoshopped out the highlights because I never knew

if they were original or not, and they don't show up in the X-ray,' she says. She now turned back to her and Simon's *Salvator*.

> *I went around it with a compass from the centre, where it was clear the edge was. Then, with watercolour, I glazed back because there is some black paint in the best-preserved part, which is where the inclusions are. Then I glazed down with watercolour within the circumference all the places where the blue robe was, but where it had clearly been abraded. When I'd glazed it, it made a certain amount of sense. It made enough sense.*

Effectively, she added a new layer of definition to the outline and volume of the globe, darkening its circumference and increasing the areas of shadow within it. There was no certainty that Leonardo had done that, no certainty that he had painted the top of his orb like the bottom of it. Modestini was now patently restoring the painting to look like an autograph Leonardo, and at the same time using a work of one of his followers for guidance.

She turned to the eyes last. They were so badly damaged, especially the one on the left of the picture, that they baffled her, despite all her years of experience. She thought, at the time, that Leonardo had painted them without using any lead white paint – a radical deviation from convention that only he would have been bold and experimental enough to try:

> *I don't know of any other painter around Leonardo, even Boltraffio or even Luini, who painted the eyes the way Leonardo did. He doesn't use any lead white for the cornea. The eyes are just glazes of brown and black over the preparation. That's all there is. There's not even highlight in the eye lead.*

That was why they looked so otherworldly. It is true that Leonardo used progressively less lead white in his skin tones in his late *sfumato* style,[7] but in 2018 Modestini revised her opinion: 'I think I slightly overstated the absence of any lead white in the eyes. There may be an extremely thin layer of grey paint for the cornea, rather abraded in the *Salvator Mundi*.'

Modestini worked on the eyes for months. 'The ambiguity between abrasion and highlight made the restoration extremely difficult and I redid it numerous times,' she later wrote. 'I could see through the microscope, where it was abraded, that Leonardo started out with this very, very bright pink layer. So I first put in bright pink everywhere where the paint was completely missing, and then I started putting in scumbles and glazes, with these incredibly tiny brushes, trying to integrate it so that I wasn't going over the original. I had to use at least as many layers as Leonardo did. Otherwise, it didn't look right.'[8]

Modestini and Simon knew, and still know, that they were at the precipice of what is and is not permissible in restoration. They had arrived at a place where, to be blunt, the border ran between conservation and invention. One tell-tale sign of this is the contradictions and qualifications in the language they use to describe their approach. Modestini says, 'The first time the restoration was about not drawing attention to the losses but making them very evident, and the second time it was about not making them very evident.'

A second, much more dramatic indication is the existence of a mysterious photograph of the cleaned painting, taken during the course of its second restoration, that no one has ever seen. When the painting came back to Modestini after the National Gallery exhibition, the biggest change she made was to repaint the entire dark background. She had seen the *Rocks* in London, and had admired the blacks in its background. The *Salvator*, she could see under the microscope, had three backgrounds painted one on top of the other. The

top layer, which she had left, was a muddy black. Underneath it lay a coat of green, a later addition, but an early one, perhaps from the sixteenth or seventeenth century. Under that was Leonardo's original, which was black. She and Simon decided to remove the additional background layers, which were so firmly stuck to the picture they had to be scraped off millimetre by millimetre. The problem was that there was very little of Leonardo's original background paint left. Simon says that an official photograph of the painting in this state was never taken, but there was an image circulating on some mobile phones. Martin Kemp saw it, of course, and he has suggested in unpublished material that it might show that there could have been a lighter area, like a diffuse halo, around Christ. One highly placed source who saw it says, 'It looked horrific. There wasn't much left of it after they took off the background.' Simon, the source says, did not dare show the photograph because he was worried that it would hinder his chances of selling the painting as a Leonardo. If people saw how much of the surface Modestini had had to paint, they might think they were looking at a new kind of hybrid, a Leonard-*estini*.

The restoration troubles Frank Zöllner, and adds to his hesitation about making a decisive call on the painting's attribution, especially without proper documentation of the restoration process. 'I would need to see photographs of every stage of the restoration – before, during and after – in order to be able to properly assess whether this is a Leonardo or a Modestini,' he says. 'I have only partly been able to study any high-resolution, infrared or X-ray photographs of the *Salvator Mundi*. What Simon has released so far has not been sufficient. It looks to me like certain parts of the painting, like the light on the hands and the face, are painted in such detail that they have work by Leonardo in them, but they were also probably mostly painted by assistants or repainted by Modestini.'

The German art historian's reaction to the fact that Modestini had restored the orb in the painting by studying that in a photograph of the Naples *Salvator Mundi* is astonishment: 'You cannot do a restoration after a photograph of a second-class painting!'

Simon had sent Zöllner some photographs of the painting in various states: one from 2005 (taken with a mobile phone) which showed it as it was when Simon bought it; the cleaned version from 2006, when all the over-paint had been removed; a 2008 shot from when the painting was shown to the Leonardists in London, with two thumbs visible; another from 2011, after it had been restored and was to be shown in the National Gallery exhibition; and finally the Christie's photograph from 2017. When Zöllner enlarged the images and placed them in sequence, they revealed alterations in the folds in the blue drapery on the right shoulder. In each one they varied in number, thickness and shape.

'Look how they have changed!' Zöllner exclaimed to me. 'In the cleaned photograph, very little detail in the folds is visible, and the garment looks fold-free next to the curls of the hair. In 2008, deep, shadowy creases emerge across the whole shoulder. These new creases bear a strong resemblance to the folds in the shoulder in Wenceslaus Hollar's print of the painting. As if Modestini restored the picture to look more like the Hollar print.' In the 2011 post-restoration photograph the creases are neatened up. However, another major change comes in 2017, evident in Christie's photograph for the auction, when suddenly the folds look reduced and simplified. 'If you look carefully at these images, it's clear that the painting has been altered since its first public presentation in 2011. The photograph of 2011 shows, in the right half of the picture (i.e. on Christ's left shoulder), a whole series of drapery folds of differentiated shapes. But if you look at the photograph taken in 2017, you can see a reduced number of simplified drapery folds. Their course beneath the orb has also been simplified and is less visible. These comparisons prove that even

after its exhibition in 2011, and during the period in which it was being marketed up to 2017, the New York *Salvator Mundi* was altered through its restoration in a questionable manner.'

In response, Modestini and Simon say that the apparent variation in the folds is explained by the different lighting conditions for each photograph, natural changes in the appearance of the blue lapis lazuli pigment over time, and revarnishing of the painting. Zöllner rejects this: 'There are just different folds.'

LOOK, COOK FORSOOK

There is a famous row of houses on the crest of Richmond Hill on the outskirts of London, a higgledy-piggledy series of Jacobean and Georgian mansions with façades of creamy white plaster, weathered red brickwork and black ironwork balconies. Across the street is a tree-lined promenade before a grassy meadow that slopes down to the River Thames. It looks like a Gainsborough brought to life. In the first half of the twentieth century one of these fine residences, Doughty House, was the home of the *Salvator Mundi*. Of this we are certain.

According to Christie's, Simon and Parish's *Salvator Mundi* resurfaced in the first decade of the twentieth century for the first time in about two hundred years. An alternative view would be that it didn't *re*surface, but rather emerged for the first time ever – a painting with no history at all. Whatever life it had led hitherto, it now had a visual and verbal identity for the first time, but not yet as a Leonardo.

From the mid-1800s Doughty House was the home of Sir Francis Cook. The *Salvator* was listed in the home's abridged catalogue in 1907 as '*1a. Milanese School (circa. 1520)*'. The unusual 'a' tells us that it was inserted into a space in the collection between other pictures that Cook had bought earlier.

Six years later, a three-volume catalogue of the entire collection was published. This was written by the colourful Finnish art historian Tancred Borenius, commissioned by Sir Herbert Cook, who inherited the collection from his father, Sir Francis, upon his death in 1901. In this catalogue the *Salvator* listing appears in the same place it did in 1907, amid Milanese paintings by Luini, Giampietrino and others. But this time it is

No. 106: *Salvator Mundi. Bust of Christ, who has dark auburn hair and wears a blue tunic, with brown bands. He raises his right hand in benediction and holds in his left a transparent glass globe. The flesh tints are reddish. Dark background.*

Cataloguing had advanced since the age of Charles I, but the basic combination of a description of the painting and an account of its history remained the same. Thus, in Cook's 1913 catalogue we learn that the painting was 'purchased for £120' in 1900 by Sir John Charles Robinson (more on this fellow, who was essentially the art dealer who mediated the sale of the painting to Cook, later).

As for the attribution, the 1913 catalogue describes it as 'Giovanni Antonio Boltraffio (Free Copy After)'. Boltraffio was one of Leonardo's most gifted assistants, but according to Borenius this is no Boltraffio. It is a *copy* of Boltraffio. Since Boltraffio often copied designs by his master Leonardo, that meant the *Salvator* was now considered a copy of a copy, the lowest rung on the ladder of art history.

There is no photograph of the *Salvator* in the 1913 catalogue, but there is a reference to one: 'Photo Gray 28992'. This indicates that a photograph was taken by the renowned Edwardian photographer William E. Gray, who gave his negative a number. Gray was known for his photographs of paintings, and was an official fine art

photographer to Edward VII and then George V. This must have been the photograph that Robert Simon found in the Witt Library at the outset of his research.

In the Cook catalogue, Borenius noted the poor condition of the painting: 'This picture ... has suffered both by over-cleaning and repainting.' The original, he said, was another version of the *Salvator*, painted by Boltraffio, and was in the collection of Signor G.B. Vittadini, an Italian collector.* But if you look closely, there is a tantalising ray of hope in the small print of this relentlessly negative catalogue entry, a short sentence underneath the main text, initialled 'HC', for Herbert Cook.

I will explain later what he wrote.

Between 1900 and 1958, when the Cook heirs eventually sold the *Salvator*, a long line of distinguished art historians took a look at the family's picture. Unfortunately, none of them recognised it as a Leonardo.

The first was Sir John Charles Robinson. Born in 1824 into a family of modest means in Nottingham, the son of a printer, Robinson was brought up by his grandfather, a bookseller. He studied painting in Paris, whiling away his spare time in the shops of antiques dealers and the homes of collectors, where eclectic arrangements of sculptures, antiques and trinkets filled sideboards, tables and mantelpieces, overlooked by oil paintings whose subjects emerged from ever-darkening varnishes. When he returned to England he became a teacher, and in 1853 he was appointed as the first Superintendent of Art Collections at the newly formed Victoria and

* Ironically, these days the reverse is believed to be true, and the Vittadini painting has been relegated to the status of low-quality copy of the Cook picture. Such are the fickle vicissitudes of art history.

Albert Museum, then called the Museum of Ornamental Art, and later the South Kensington Museum.

His portrait by John James Napier shows a thin-faced man with a sandy beard and sunken, bloodshot eyes. His gaze is intolerant, irascible and intelligent. Over the course of twenty-five years Robinson collected art for the V&A, as well as acquiring both on behalf of collector clients and for himself. He bought antiquities, works of art, bric-à-brac and objects of *vertu* – altarpieces, reliquaries, tapestries, the marble mouldings of tombs, shields, ivory carvings, walnut cabinets, and paintings of course, as well as plate, bronzes, painted terracotta statues, ebony and gilt metal bedsteads, wrought-iron candlesticks and, above all, his first love, majolica ceramics. In those days you could buy a Donatello sculpture for £300 and a Luca della Robbia painted terracotta for £60.

His hunting grounds ranged from London and Paris's great auction houses – Christie's, Phillips and Drouot – to jewellers in the backstreets of Venice and dealers in the villages of Portugal. He travelled to the Italian hinterlands – 'where', he wrote, 'as a rule all classes are willing to barter away their artistic possessions' – and to Spain, whose north-west regions were 'almost as unknown as the interior of Africa'.[1] He often paid a generous commission to middlemen who would guide him to a particularly secretive vendor, as is still the custom today.

Robinson also took Europe's nineteenth-century catastrophes, whether floods or wars of unification, as opportunities. 'Now is the time,' he wrote from Spain in 1866. 'This country is in semi-revolution, money has disappeared, distress prevails, and whatever there is to be sold is on the market for a fraction of what would formerly have been asked.' In 1871, while the Prussians besieged Paris, he made his way to Spain, 'not without some adventures', he wrote, 'the most exciting being a carriage drive from Versailles to St Denis, where, from the summit of one of the towers of the old abbey, a splendid panorama of the siege was to be seen'. Anyone

accompanying him on his expedition, like his museum colleague Richard Redgrave, Inspector General for Art at South Kensington, found himself rummaging in heaps of dust-collecting articles'. Robinson was well used to spotting the greatness behind the dirty, damaged pictures and

Thanks to him, during his tenure the V&A accumulated the best collection of Italian Renaissance sculpture in Europe outside Italy. But he shared the trait of so many connoisseurs, past and present: snootiness. The trade secret of connoisseurship is that art historical acumen carries little weight unless it is accompanied by a superior air towards rivals, sometimes patronising, and scathing when necessary. Robinson eventually clashed with the director of the V&A, Henry Cole. At the time the market was flooded with copies and forgeries, and Robinson told the museum that Cole was buying 'made-up' pieces, and had fallen 'into a hotbed of falsification and fraud in matters of art'. On one occasion Cole acquired a set of playing cards supposed to be French, late fifteenth century. Robinson said they were fakes. Cole sent them to the British Museum to get a second opinion, which went in his favour, but Robinson wrote a twenty-three-page report in response, calling for scientific tests. The tests were carried out, and showed the cards were not genuine.

Robinson had other gripes. He complained to Cole that his £600 annual salary was too low, and he clashed with the museum's board over the amount of money he was spending on acquisitions. By 1863 he had been demoted to 'art referee', a kind of external consultant. Then, on 12 May 1868 he opened the kind of letter still written today: 'Sir, I am directed to inform you that the room recently occupied by you in the South Kensington Museum is now required and to request that you will be good enough to clear out your desk at your earliest convenience.'[2] He had been fired.

Fortunately, he had other sources of income. He set up the first art collectors' association, the Fine Arts Club, and was later appointed

Surveyor of the Queen's Pictures all, he bought and sold art
and antiquities to a circle of code, that included the legendary
German art historian Wilhelr who admired his discerning
eye.

Robinson was workin new, more disciplined age of art dealing.
He and his peers to ie view that museums, private homes and
auction sales were of falsely attributed copies, because there
couldn't possibly that many Leonardos, Michelangelos, Raphaels
and Rembrand n existence. In short, the supply far exceeded what
could ever h been produced. So it was at this time that art histo-
rians got to vork separating the men from the boys, the works by the
master fran those by his pupils, assistants and followers.

The godfather of this new approach was Giovanni Morelli, an
Italian art historian and member of Italy's first national parliament.
Morelli himself owned two Leonardo workshop *Salvator Mundi*s, one
of which he attributed to Marco d'Oggiono and which is now in the
Accademia Carrara in Bergamo. He introduced a supposedly scien-
tific method to connoisseurship, founded upon 'indisputable and
practical facts'. Each artist, he argued, could be identified through the
ways in which they painted particular features and details – fingers,
faces and other anatomical motifs, drapery and landscapes. An art
historian should operate like a detective, a *Polizei-Kommissär*, distin-
guishing these clues and spotting similarities between the vast sea of
unnamed and undated works of art to identify the artist, or at least
the timeframe and place in which they were painted. Morelli, the
patron saint of 'the eye', could identify an artist, or so he claimed, by
the ears – that is, by the way he or she painted them. 'Bellini's ear is
round and fleshy; that of Mantegna is longish and more gristly,' he
wrote in *The Works of the Italian Masters*, published in 1880 under the
pseudonym Ivan Lermolieff.[3] In that book Morelli provided diagram-

matic woodcut illustrations of the typical ears of Renaissance artists such as Botticelli, Lippi and Signorelli. So the godfather of 'the eye' was also a student of the ear; he produced similar diagrams of artists' hands.

The relatively new technology of photography was vital to this new practice. Photography studios like Alinari did a thriving business photographing works of art in museums, churches and collections up and down Italy. Connoisseurs assembled their own cabinets crammed with thousands of these images, as precious to them as the works of art they reproduced were to collectors. They laid them out on tables, matched like with like, moved them into new sequences, building up tentative chronologies and geographies of style. On the backs of them they scribbled notes about the supporting historical documents they had read.

As a result of this practice, the authorship of virtually every undocumented Renaissance painting was now up for discussion. In 1903 Robert Ross, the dealer, *Burlington Magazine* contributor and former lover of Oscar Wilde, wrote a poem called 'The Christmas Attribution',[4] about the experts vacillating over attributions:

> *'Twas whispered by Fry,[*] it was muttered by Dell[†]*
> *And at Holmes[‡] for a space was permitted to dwell,*
> *And B.B.[§] heard faintly the sound of a sell.*
> *It was nursed out at Foster's[¶] and sold for a song.*

[*] Roger Fry, art critic.

[†] Robert Dell, first editor of the *Burlington Magazine*.

[‡] Charles Holmes, another *Burlington* editor and an artist.

[§] Bernard Berenson's nickname.

[¶] An auction house in London.

At Willis Rooms it was called Edwin Long.†*
In Christie's by Douglas‡ as Longhi§ baptised,
*And at Buttery's¶ hatch relined and resized.***
Horne†† thought the picture a rather late Etty‡‡
And then relapsed into Baldovinetti,§§
While Ricketts and Shannon, and D.S. MacColl¶¶ …
*Said Alunno*** van Ruben, Amico di Bol.*

What a jumble of names! A long list of dealers and art critics argue over and revise the attribution of the painting, which at some point undergoes dubious restoration. *Plus ça change.*

For Giovanni Morelli, the misattribution of works made by assistants to their masters was only one of the problems his method

* Concert venue and music hall.

† A kitschy nineteenth-century British artist who specialised in Oriental scenes with women in see-through dresses.

‡ Art historian Robert Langton Douglas.

§ This could refer to either of two well-regarded sixteenth-century Venetian painters who had this surname. One was known for scenes of his home town, the other for portraits.

¶ Horace Buttery, restorer and art dealer.

** Two restoration processes designed to improve the look and feel of a picture.

†† Herbert Horne, one of the founders of the *Burlington*.

‡‡ William Etty, a nineteenth-century English history painter, best known for his nudes.

§§ Alesso Baldovinetti, an early Renaissance painter in Florence.

¶¶ Charles Ricketts was an author, illustrator and printer; Charles Haslewood Shannon was a contemporary portrait painter; MacColl was Keeper of the Tate.

*** Here come the linguistic jokes, using the Italian for 'pupil', *alunno*, and adding a van to Rubens while losing the 's', and then comes 'friend', *amico*, of Ferdinand Bol, another Dutch seventeenth-century artist.

could overcome. There was another equally malign process which he set out to counter: the works of the masters were also often misattributed because they had been subject to misguided and invasive restorations. Time and again in *Italian Masters* he described pictures as 'much damaged by restorations … Suffered so much by various restorations … almost entirely ruined by a new restoration'. In the introduction to the book, Morelli wrote:

> By far the greater number of pictures which have descended to us from the best periods have been subjected to barbarous restorations, so that instead of beholding the physiognomy of a master in his work, the connoisseur sees only the black mask with which the restorer has covered it, or, at best a skinned and utterly disfigured surface. In such a ruin there is no possibility of recognising the hand of the master, or of distinguishing an original from a copy. Only a close observation of the forms peculiar to a master in his representation of the human figure, can lead to any adequate results.

Morelli had many followers, among them Sir John Charles Robinson. Studying the Ashmolean's collection of Michelangelo and Raphael drawings at Oxford, Robinson produced the first *catalogue raisonné* of a body of drawings. He was careful to make distinctions between preparatory drawings by artists and later copies by assistants. In many instances the drawings were unsigned and undated, and he could only attribute them based on the evidence of style.

Robinson took a conservative approach to attributions even with his own collection. In 1868 he sent a large part of it to be auctioned at Christie's, to support himself after he lost his job at the V&A. He wrote a fond farewell to his paintings in the form of a pamphlet, *Memoranda for Fifty Pictures*. 'The present highly finished little picture offers a typical example of the works of the "little masters", the copyists of Michelangelo,' he wrote of one work. He had a Boltraffio, 'that

rare follower of Leonardo', and another work which had been attrib-
uted to Leonardo when he bought it but which he was now only
prepared to assign to the 'Milanese School'. He wrote:'There can be
little doubt that this picture was executed during the lifetime of
Leonardo, and that it is one of those works produced in the district
of Milan, at the period of the enthusiastic admiration, which the
novel and fascinating manner of the great Florentine seems to have
excited amongst the painters, both young and old, of the Lombard
School.'That could easily have been a description Robinson would
have given to the *Salvator Mundi*.

Robinson was a specialist on Leonardo and the work of his follow-
ers, and he pioneered a revival of interest in their work in Britain. In
1851, on his first trip to Italy, he had filled pages of his diary with
notes on *The Last Supper*. And in the 1880s and 1890s he discussed
Leonardo and his followers in letters and in meetings with the
Leonardo experts of his day, like the art historian and connoisseur
Jean Paul Richter, who was the first to study Leonardo's notebooks,
later publishing them as *The Literary Works of Leonardo da Vinci*.

Richter and Robinson were always arguing over what was a
Leonardo and what wasn't. In 1886, Robinson wrote to Richter
telling him he had found a new *Madonna and Child* by Leonardo.
Richter wrote back telling him he knew the painting and it was only
by a follower, Marco d'Oggiono. In 1887 Richter went to visit
Robinson in London and reported that a painting owned by his host
was a 'marvellous' Boltraffio, which Robinson had rated a Leonardo.
Robinson soon put it on the market. Richter told a German collec-
tor he thought the price was too high for a work by a follower, but
it went to an American collector for a large sum. That painting is
almost certainly the *Girl with Cherries* at the Met in New York, which
is now, for the moment, attributed to Marco d'Oggiono, but has also
been previously ascribed to Ambrogio de Predis, an indication of
how mobile attributions to Leonardo's followers have always been.[5]

Robinson discussed with Wilhelm von Bode the *Pala Grifi*, an altarpiece in Berlin, today attributed to a team of Marco d'Oggiono and Boltraffio. Was it by Leonardo, or one of his followers? If so, whom? Robinson found a drawing which looked like a preparatory sketch for the piece, and Bode asked him to try to buy it for him – unsuccessfully. If anyone at the time would have been thrilled to discover a Leonardo, and to gain widespread acceptance for it, it would have been Robinson. It seemed he would never succeed, but not for lack of trying.

One day, around the turn of the century, Robinson saw or was told about a shabby painting of Christ, which had been consigned to auction at Christie's on 31 March 1900 as a 'Salvator Mundi' by 'B. Luini', i.e. Leonardo's follower Bernardino Luini. Its owners were the heirs of the estate of a Leeds wool merchant, Joseph Hirst (1814–1900), to whom this picture had belonged. Hirst had been a distinguished figure in Leeds, the president of the town's Chamber of Commerce, a local magistrate and a member of the Literary and Philosophical Society. He and his wife converted to Catholicism in 1849, and their son had become a priest, ordained in Turin and later rector of the Catholic Ratcliffe College. Also called Joseph, the son was a respected archaeologist too, published in contemporary journals. In the last decade of his life, the cloth magnate had moved to Wimbledon in London.

The Hirst Luini must be the same one as Cook's *Salvator Mundi* since it bears the same title and attribution as the one in the Cook catalogue, was bought in the year given in the Cook catalogue and because, most importantly, for the first time in the history of *Salvator Mundi* auctions in Britain, its dimensions are given in the catalogue: 24.5 inches by 17 inches. These measurements match almost exactly the dimensions of Simon and Parish's *Salvator Mundi* – the height and width are less than an insignificant inch smaller. A preserved copy of the catalogue is annotated with the names of the buyers and lists a

Gribble, who may be Thomas Gribble, a dealer who had previously bought art for Robinson at auction, or George Gribble, a nephew of Francis Cook, who was a member of the art historical Walpole Society.[6]

No one has yet discovered where Hirst obtained the *Salvator Mundi*. In the 1900 auction his heirs consigned only twelve of his other pictures, a miscellany of Old Masters on religious and secular themes and a few mid-nineteenth-century landscapes by Dutch and British artists. There are a few vague possibilities for its source that come up if you trawl the databases of works of art. There is a Mr Ley who put an advertisement for his London shop in a newspaper in 1872. 'Mechanical curiosities repaired,' it says, and gives an address near Leicester Square. He offers a 'Luini Head of Christ' from the collection of an Italian painter and printer, Luigi Calamatta, who had died in 1869.

Another possibility surfaces in the 1872 sale at Phillips of the collection of the late English picture dealer William Pearce of New Bond Street. One of the final lots, seemingly added at the last minute, was a Luini *Salvator Mundi*, which was sold to the picture dealer and restorer Louis Hermann. Perhaps Hermann's picture found its way to Joseph Hirst. We shall never know, because the account books of Pearce and Hermann have not survived and no mention of it has yet been found in the papers of Joseph Hirst and his family.

Hirst, Cook, and Simon and Parish's *Salvator Mundi* may have come from a British collection, or it may have come from Europe. It could have been hanging somewhere on the wall of an old Catholic church or institution in Britain for most of the nineteenth century, and have arrived in the country from France after the Napoleonic Wars, or from Italy. The turmoil in Italy produced by the wars of unification, one of the effects of which was the closure of many religious institutions, and the instability in France, produced by invading Prussian armies and assorted revolutions, stirred up the

muddy bottoms of the rivers of art history once again. This brought
to the churning surface another tide of Renaissance antiques and
artworks which could now be prised out of their former owners'
flailing hands.

There was a steady stream of British amateurs who travelled to
Italy in the first half of the nineteenth century and brought works of
art and antiquities back with them.* Joseph Hirst, the son, was one.
As an archaeologist he spent considerable time in Rome on excava-
tions. He brought an odd assortment of objects back with him
including an Egyptian mummy and the flag that hung over the
German governor's residence in Cameroon, which were put on
display in Ratcliffe College. There is no record of the *Salvator Mundi*,
but it is possible that the son found the *Salvator Mundi* in an antiques
shop in Italy, and bought it with his father's money.

Wherever it might have come from, Robinson, with all his experi-
ence of examining badly damaged Renaissance works of art, took a
long hard look at the *Salvator Mundi* in 1900 and he did not see a
Leonardo. But he did see something he could sell to his most voracious
collector client, the millionaire British textile merchant Sir Francis
Cook – whom he described as 'an excellent good man' – for a vast
profit. Gribble paid a mere £6 6s, so when Robinson sold the picture
to Cook for £120, he made eighteen times what he paid for it.

Francis Cook was born in 1817, the second son of seven children. He
was a classic example of the self-made Victorian art collector, an
entrepreneur working his way into high society by building a large

* For example, Richard Forester of Abbot's Hill, Derby. Forester was a doctor
and a member of Erasmus Darwin's Derby Philosophical Society. He toured
Europe and collected Old Masters, brought them home and then sometimes
lent them for public exhibitions. In 1843 he lent a School of Leonardo 'Head'
and a 'Luini *Mona Lisa*' to a local exhibition.

business, donating to good causes and collecting art, in a manner that differed little from Charles I and his court.

His father, William, was a self-made businessman, the son of a sheep farmer who, beginning with 'five sovereigns, given him by his father, in one pocket and in another a letter of introduction',[7] set off for London and landed an apprenticeship with a linen draper. Eventually he took over his employers' firm and grew it into an immense wholesale business that traded silk, linen, wool and cotton goods across the British Empire. His headquarters in London was referred to as 'an eighth wonder of the world'. Suffice to say, William Cook had become a very wealthy man.

His son Francis, who had become a partner in the firm in 1843, eventually took over its operations. He cultivated the image of a man without airs and graces. He walked to his local train station to commute to work, and was seen unconcernedly carrying brown paper parcels of the kind usually reserved for the arms of delivery boys. He was described as being very careful with his money, very controlling of his first wife Emily, and very fond of art.

In 1849 Francis and Emily moved into Doughty House, a square-built Georgian mansion with a cottage attached to it. His niece Maude Gonne would remember its 'two long picture-galleries', and a 'winter garden with tropical palms and bamboos the whole height of one side of the house'.[8]

Cook met Robinson in the 1860s and began collecting art in earnest in 1868, buying a hundred paintings from Robinson's collection in one fell swoop. He aimed to assemble a comprehensive collection of Old Masters, just like Charles I, but with an extra two centuries to cover, and he bought as fast as Charles I's nobles had done. By 1876 he had amassed over 510 paintings, though by his death the number had shrunk somewhat because, his grandson remembered, 'Sir Francis himself, like all wise collectors, was constantly "weeding" his Gallery.'[9]

In the 1870s he added the Long Gallery, an incongruous two-storey neoclassical extension at the back of his house, inspired by Buckingham Palace's own Long Gallery, and lit by a skylight that ran its whole length. The gallery was extended in the 1890s when another skylit space, an octagonal room, was added at the end, modelled this time on the Uffizi's Tribuna. Cook crowded his whole house with his pictures, organising them, as was the convention, geographically according to 'school' – Florentine, Siennese, Umbrian, Milanese, Flemish, English, French and German. He also collected Greek and Roman marbles, Etruscan pottery, Roman glass, Egyptian antiquities, jewels, ivories, amber, bronzes, miniatures, Oriental ceramics and majolica, antique and contemporary furniture.

The art market boomed in the second half of the nineteenth century. Raphael's *Alba Madonna* sold for £14,000 in 1836; almost fifty years later, in 1885, the National Gallery in London bought his comparable *Ansidei Madonna* for more than four times as much – £70,000 (around £7 million today). Prices for Italian Renaissance painters shot up. As the art periodical the *Connoisseur* put it in 1901:

> *Within the last decade the number of collectors has grown by leaps and bounds, as those of us know to our cost who began to collect some years ago and whose desires are less limited than our purses. One has but to compare prices now with prices ten or twenty years ago to realise how enormous has been the increase in the interest in and desire for things old and beautiful and rare.*

Prices grew faster after 1870, when a series of economic recessions and agricultural depressions compelled hard-up British aristocrats, incentivised also by tax rebates, to sell their collections – often to newly wealthy American businessmen. Cook's grandson remembered proudly that Sir Francis avoided the 'ten thousand pounders',[10] and that 'Thanks to Sir Charles' extraordinary knowledge and flair at a

time when experts were few and opportunities many is due the successful acquisition by Sir Francis of numberless treasures worth today ten times what he paid for them.'[11]

The prices Cook paid are often recorded, somewhat indecorously, in the 1913 catalogue: just £120 for the *Salvator Mundi* for example. But Robinson was as hard-nosed a businessman as any art dealer today. His account books show that he added huge mark-ups to the prices he himself had paid. He bought a Rubens for £90 and sold it to Cook for £300. He paid £70 for a Tintoretto and sold it to Cook for £500. He bought a Pontormo for £5 and sold it to Cook for £375. A Veronese he bought for £42 went to Cook for £700. His underhand business practices are perhaps best described by an agent of the Florentine dealer Bardini, who once knocked on the door of Robinson's Harley Street apartment, found it unlocked, and left this account:

I went to see Sir Robinson this morning but I could not find him. I went into his living room to wait for him and I found myself in an antique store. Dozens of paintings leaning against the walls, marble busts, bronze, old frames ... It made me think a lot, and since he was not coming back, I went out, thinking I would come back the next day, making one promise to myself: find out who I was dealing with. What I came to know is that Sir Robinson is a dealer who, when he sees an object which he knows he can sell, sends right away a third party to buy it. This third party then shows it to an amateur, who calls Robinson for his opinion, which is of course positive.[12]

However much Sir Francis overpaid, his investments were still sound, as his collection increased in value many times over. At the time he died he owned about 450 pictures, including five Rubens, five Jacob van Ruisdaels, five van Dycks, three Rembrandts, three Poussins, two Titians, two Dürers, two Claude Lorrains, a van Eyck, a Frans Hals, a

painting by Filippo Lippi and Fra Angelico, a Mantegna, a Raphael and a Velázquez. Today, these works have ended up in the world's leading museums, mostly in America, sold off by Cook's descendants in the first half of the twentieth century. They include the Courtauld Institute and the National Gallery in London, the Met in New York and, above all, the National Gallery of Art in Washington, DC. Five of the most famous Old Master paintings in the world come from Cook's collection: Fra Angelico and Filippo Lippi's *Adoration of the Magi*, van Eyck's *Three Marys at the Sepulchre*, Velázquez's *Old Woman Cooking Eggs*, Poussin's *Rape of the Sabine Women* and Rembrandt's *Portrait of a Boy*.

It was, however, sometimes difficult for Cook to find major works by Renaissance masters at prices he was prepared to pay, so he bought minor works and copies. He had a little Raphael *predella*, for example, but he also had copies of three of the Florentine master's well-known paintings. He did not own any Leonardos, but he had a small number of works by Leonardo's Milanese contemporaries. It was probably in this context that Robinson approached Sir Francis in the last year of his life with an apparently inferior work in a Leonardesque style which would fill a gap in his collection: the *Salvator Mundi*. Cook bought it, but clearly did not rate it highly, because he didn't hang it in his gallery.

Sir Francis died on 17 February 1901, leaving a fortune of £1.6 million. Newspapers reported that a thousand mourners attended his funeral and that businesses closed their doors that day out of respect. His art collection was inherited by his elder son Frederick, who served as an MP for Kennington; his ceramics and antiques went to his other son, Humphrey Wyndham. Frederick only added one picture to the collection, but his granddaughter remembers that 'he entered into his inheritance with zest and I am sure enjoyed playing the leading part, looking proudly at the vast array of paintings through clouds of tobacco smoke and slapping everyone on the back with

loud cheerful greetings'.[13] In the meantime, Sir Francis's grandson Herbert Cook took over management of the collection. Now, for the first time, there was a glimmer of hope for the *Salvator Mundi*.

Like many of the offspring of wealthy art collectors today, Sir Herbert Cook went into the art world. He studied law, practising as a barrister at Middle Temple in London in his mid-twenties, as well as carrying out his duties as head of the family business. But his passions lay elsewhere. He became an 'amateur' – the word was still used as it was in the age of Charles I, and it meant a self-taught connoisseur.

In the 1890s Sir Herbert began to contribute to art journals such as the *Gazette des Beaux Arts*, combining Giovanni Morelli's detective work with research into historical documents buried in archives. He placed a primacy on the visual study and analysis of works of art, telling the reader he had 'repeatedly … personally seen and studied' the works he wrote about. He exchanged letters with the legendary art historian and connoisseur Bernard Berenson and his equally engaged and engaging wife Mary, and with the English art critic and future Bloomsbury Group member Roger Fry. Together they set up Britain's first art historical periodical, the *Burlington Magazine*.

The *Burlington* professed its independence from the market. It aimed to replace impressionistic and mythologising art criticism with the 'disinterested' research of historical documents and the study of the details of an artist's style, most conveniently done with photographs of works of art. It observed and criticised the phenomenon of collectors who bought for profit, which it called 'the possibilities of collecting at one and at the same time works of art and money', declaring sanctimoniously:

> *To collectors of this class, rapid alterations in the values attached to*
> *particular works are as important as the fluctuations on the Stock*
> *Exchange are to the broker, and thus a disturbing element is*
> *introduced into that estimation of real values which our study*
> *proposes. The atmosphere becomes tainted, and the study itself acquires*
> *ill-repute by the presence of these knowing ones, these tipsters of the*
> *saleroom.* [14]

Nevertheless, the leading figures of the *Burlington Magazine* were usually both dealers and critics, and as connoisseurs and art historians they also often charged for their opinions, or took a percentage of the sale price of a work of art they had assessed. Then as now, art historical scholarship was intertwined with the market.

Sir Herbert was a great connoisseur of Leonardo, and when he saw fit he was quick to make an attribution to the master. In 1909 a new Leonardo emerged from the fog of nineteenth-century art collections, the first in many centuries and the last before Simon and Parish's painting. The *Benois Madonna*, it was called. Sir Herbert went to see the picture when it was put on show in St Petersburg. He had it photographed and proceeded to publish it as an early Leonardo for the first time in the *Burlington* in December 1911. He wrote:

> *How wonderfully human it all is! … The child trying to focus its*
> *vision on the flower held out to it – the backward tilt of the head –*
> *the eager clutch of the tiny hands – the happy interest and devotion of*
> *the girl-mother … And how lovingly he has played with the pretty*
> *coils of hair, plaited as only Leonardo knew how, and the folds of*
> *sleeve and mantle! Yes, it may be precious, but that is Leonardo's way*
> *too; and it may have strange harmonies and stranger beauties of subtle*
> *import, but that is Leonardo's spirit, the spirit which was afterwards to*
> *find fullest expression in the exotic beauty of the Mona Lisa's*
> *haunting smile.*

Two years later, in 1913, the *Benois Madonna* was bought by the tsar of Russia for a record $1.5 million.

In March 1912 Sir Herbert became the first British connoisseur and critic to endorse the attribution by Wilhelm von Bode of the *Ginevra de' Benci* – up until that point attributed to Verrocchio – to Leonardo. Here, he showed that he knew how to work with copies to discover details about an original. The *Ginevra* had no date on it. So when was it painted? Cook knew of another copy in the possession of a Florentine aristocrat, in which the composition was wider, meaning that you could see the sitter's hands, and she is wearing a ring. From this he deduced that she had just been, or was just about to be, married. Documents showed that Ginevra was married in 1473. The juniper bush was further evidence of the date – it is a symbol of chastity. The wider setting of this composition would normally suggest that it was the original – unless the other picture had been cut down in size at some point, something that often happened in the history of Renaissance paintings, even Leonardos. Analysis of the original Leonardo showed, indeed, that the panel had been trimmed at some point. Sir Herbert could confirm that it was the original, and give it a date. It was good detective work, but for Herbert such specific clues were not the basis of his attribution to Leonardo: 'Each creation of Leonardo (as I believe) stands alone, united only by an indefinable bond of quality and instinct with that mysterious spirit of subtle fascination which eludes mere words.'[15] Even back then, there was the *zing*.

Sir Herbert saw a huge gulf between the quality of a Leonardo and that of work by his followers, although that did not mean he derided their work. Like Robinson, he was a champion of the 'Little Leonardos', and of Milanese painters in general. Back in 1898, before he was managing his grandfather's collection, he was one of a committee of five who staged an enormous exhibition of 'Pictures by Masters of the Milanese and Allied Schools of Lombardy' at the

New Gallery in London, featuring three hundred works attributed to Leonardo, his followers and other Milanese Renaissance artists. Sir Herbert said the exhibition was 'intended to illustrate the history of a particular school of Italian painting, and afford an opportunity of appreciating the scale of its excellence'.[16]

The exhibition included a photographic section, with over a hundred black-and-white images of works which the curators considered important, but which they had not borrowed for the exhibition, for one reason or another. Among them was a *Salvator Mundi* attributed to Boltraffio, and owned at the time by the leading Milanese collector Giovanni Battista Vittadini. Today it is in an anonymous private collection, and not very securely attributed to Boltraffio. Sir Herbert wrote that Boltraffio's paintings 'charm by their high finish and by their absence of vulgarity or display'. They had a 'singular refinement'. There were two particular series of works by Boltraffio that he was aware of: 'His sacred subjects are not numerous – a few Madonna pictures – and two or three renderings of the *Salvator Mundi*.'[17] The *Salvator Mundi* was on Sir Herbert's radar.

Leonardo's assistants were talented, but they weren't Leonardo. Sir Herbert accused art historians of diluting the master's greatness by ascribing the works of his studio to him. In articles in the *Burlington* he set to work analysing various Leonardesque series, including the *St John the Baptist* and the strangest of all of them, a number of topless *Mona Lisa*s. From these studies, the brilliant and wealthy scholar-collector became the first to truly understand how Leonardo ran his studio:

> *Leonardo did indeed treat the subject himself in a drawing or cartoon to which his pupils had access and from which each worked out his own version with varying degrees of freedom. That this was constantly the practice is proved by the innumerable copies, more or less contemporary, which were made of Leonardo's motifs.*

The *Salvator Mundi* series emanating from Leonardo's studio had been admired by Sir Herbert since his Milanese exhibition in 1898. It is highly likely that he had been looking out for a *Salvator Mundi* for himself since that date, and that Robinson knew that. The fact that Sir Francis acquired it in the last year of his life adds to the likelihood that Sir Herbert was a prime force in the acquisition of the *Salvator Mundi*.

After his grandfather died, Sir Herbert rehung the entire collection, and as the abridged 1907 catalogue states, 'a few additions were made'. The *Salvator Mundi* was one of them. Sir Herbert moved the painting, this Cinderella of art history, to a prominent place in the most important of his family home's exhibition spaces, the Long Gallery. It was hung in a historically appropriate position, surrounded by the other great Milanese works in the Cook Collection, the Luini *Madonna and Child with St George and an Angel*, Vincenzo Foppa's *Madonna and Child and Angels*, and Giampietrino's *Nativity*. It can just about be identified in one photograph, on the right wall, far down towards the end on the second tier.

In 1913 Sir Herbert commissioned three art historians to write separate volumes on his family's collection of Italian, Dutch and Flemish pictures, and works from other schools. Tancred Borenius was given the Italian volume. Born in Finland in 1885, Borenius was close to the Bloomsbury Group, and had worked as an art adviser for British aristocrats and royals. He was a specialist in the early Italian Renaissance, and became the first professor of the history of art at the University of London; he is later said to have worked for British intelligence and to have been the man who lured Rudolf Hess to Britain.

Borenius's accounts of the provenance and acquisition of works in the Cook Collection are reliable. He was helped by the accounts Sir Francis kept, which have now been lost. Sir Herbert also consulted

with Sir Charles Robinson, who was still alive, 'and although the memory of a man in his 89th year can hardly be accurate in every detail, yet his wonderful vitality and still active interest in art matters have been of great service to myself in editing this catalogue'.

Borenius was prepared to push an attribution if he believed in it. Thus he attributed the small painting *St Jerome Punishing the Heretic* to Raphael, quoting Bernard Berenson among others in support of his thesis. But when he looked at the Cook *Salvator* he did not see a Leonardo, nor even a work by one of his followers, but instead a copy of a workshop painting.

Sir Herbert, too, did not think his *Salvator* was a Leonardo, but nor did he think it was as poorly done as Borenius did. The annotation he added to the attribution – the brief sentence I mentioned earlier in this chapter – was 'I should prefer to say a parallel work by some contemporary painter of Leonardo's school – H.C.' Sir Herbert had lifted the *Salvator* up a peg by putting the entire workshop in the frame, but he had not elevated it to a work by the master. Nevertheless, he wrote in the *Burlington* around this time: 'In the sphere of painting so little comparatively remains to us of Leonardo's own creations that what is vaguely called the Leonardesque demands our closest study.'[18]

The beacon of hope which Sir Herbert offered the *Salvator* was quickly snuffed out. Other art historians, with varying relationships to Leonardo, passed through the Long Gallery without noticing the picture up on the wall in one corner. When Bernard Berenson and his wife Mary visited Doughty House in 1916, they scribbled down in their notebooks what they had seen, but failed to mention the *Salvator*.

In 1916 Sir Herbert became a trustee of the National Portrait Gallery, and in 1923 of the National Gallery. In the 1930s he sat on the board of the National Gallery. He knew its thirty-year-old direc-

tor Kenneth Clark, who simultaneously held the position of Surveyor of the King's Pictures and was the personification of Britain's emerging patrician ideology of national heritage in the mid-twentieth century. Together they worked on what they called the 'Paramount Pictures List', a shortlist of 'supreme masterpieces' that had to be 'acquired for the nation at any cost' so as to prevent them being bought up by wealthy Americans. There was, of course, another reason why Sir Herbert was on the National Gallery board. Kenneth Clark wanted him to donate pictures from his family's collection – but he didn't.

Born into money in 1903, Kenneth Clark was an art historical prodigy who gravitated towards the supreme being of art history: Leonardo. A protégé of Bernard Berenson (though Berenson later castigated him as 'a great vulgariser'), he was suave and engaging, a socialite as well as an aesthete, as brilliant at bringing art to life with words as he was at managing elite professional networks; a populariser of culture with an unrivalled ability to make his air of superiority charming.

In the mid-1930s Clark delivered a series of lectures on Leonardo which were published in 1939 as his monograph *Leonardo da Vinci: An Account of His Development as an Artist*. Around the same time he catalogued the six hundred Leonardo drawings held at Windsor Castle, which the Earl of Arundel had bought in the reign of Charles I and which had later somehow passed into the Royal Collection. Clark toiled for three years, describing each folio in elegant and vivid, if somewhat old-fashioned prose, meticulously identifying where drawings could be linked to paintings, and articulating a development of Leonardo's style and media. He came across two drawings which he recognised were close to three versions of the *Salvator Mundi* he was familiar with – the Yarborough, Vittadini and Cook ones – as well as the Hollar etching. He analysed the style of the drawings beautifully in the drafts for a lecture, now in his archive at Tate Britain: 'A drawing

for a sleeve for a lost picture of Christ Blessing, commissioned about 1504, is in red and black chalk on red paper and shows Leonardo taking full advantage of these opulent media in a way in which the fastidious taste of his earlier years might have rejected.' But for Clark, neither the Cook version, nor any of the others he knew, was the original of 'the globe-bearing Christ which is lost'. He had also examined the Cook, which he forsook.

Jean Paul Richter also visited the Cook Collection with his wife. In 1922 he was revising the art historical sections of the Baedeker guide to London for a new edition. In his diaries, he records how he and his wife discussed one of the Cook Collection's masterpieces, Titian's *Schiavona*, which he thought was by the sixteenth-century north Italian portraitist Giovanni Battista Moroni. He argued with his wife about it the following week, and she told him, 'You are a blind chicken.' There was, however, no mention of, let alone marital bickering over, the *Salvator Mundi*.[19]

In 1932 the then curator of the Cook Collection, S.C. Kaines-Smith, compiled an updated catalogue. His notes described the *Salvator* as 'frightfully over-painted' and 'not to be restored'. In 1940 a restorer, W.H. Down, was invited to assess works in the collection. The *Salvator Mundi*, he reported, was in a 'most amateur state of repaint', and he included it in a list of 'pictures mostly in bad condition, which must be tested to ascertain whether of sufficient quality and value to justify the necessary outlay for restoration'.

The Cook *Salvator* had found no saviours in turn-of-the-century England – a fact which can be read in two ways. You may consider it impossible that so many scholars and dealers, all of them accustomed to seeing Italian Renaissance paintings in terrible condition, plastered with over-paint, restorations and dark varnishes, all trained to identify the author of a painting from the qualities of the hands as well as the ears, could miss a Leonardo staring them in the face, as the *Salvator* does. Alternatively, you might conclude (more favourably to Simon

and Parish's cause) that it was yet another misfortune for the world's unluckiest masterpiece, to re-emerge at a time when the thrust of art history was the de-attribution of paintings previously assigned to the great names.

All this time, the Cook family business, Cook, Son & Co. was faring badly. The coming of the twentieth century, the acquisition of the *Salvator Mundi* and the death of Sir Francis all marked a turning point in the fortunes of the company. A business model that was forward-thinking in the mid-nineteenth century had become old-fashioned. Far worse was the rise of high-street chain stores like Marks & Spencer, which bought direct from manufacturers, cutting out the distributors. Sir Herbert had no head for business, and the interwar years were difficult times for cloth merchants. By 1920 the company was on the verge of bankruptcy, and went public in an effort to raise funds. The following year it lost over £400,000. Sir Herbert, suffering from Parkinson's disease, resigned in 1931. He died in 1939.

His son and successor Sir Francis Ferdinand Maurice Cook, born in 1907, proved to be even less business-minded than his father. The great-grandfather had been a collector, the grandson an art historian, and so, following the tradition of so many similar families, the next Cook scion, Sir Francis Ferdinand, was an artist, at least in his own mind. Sir Francis Ferdinand painted hundreds of landscapes, still lives and portraits, with a bright palette and generically modernist style. His life was as colourful as his pictures: he owned a pink Rolls-Royce for a time, and married seven times, divorcing his first wife for adultery during their honeymoon, and his third for the same offence – although not at such an early stage of their marriage. He was divorced by his fifth wife for committing the same sin himself. One contemporary from an arts board he sat on called him 'a degenerate

Baronet'.[20] When he died in 1978 he bequeathed 1,400 of his pictures to the island of Jersey, where he had moved after the war, along with a converted chapel in which to display them, known as the Sir Francis Cook Gallery.

The break-up of the Cook Collection had begun immediately after Sir Herbert's death. Fifty pictures were sold within months, including the van Eyck *Three Marys at the Sepulchre*. The British government, even on the eve of the Second World War, had offered £100,000 for it, but a Dutch collector put up £250,000 (the equivalent of £60 million today), and the picture went to Holland, where Hermann Goering was soon chasing it. Others went to the Met and the Frick Collection in New York.

When the Second World War began, Sir Francis Ferdinand Cook shipped most of the valuable works remaining in the collection to one of the family's country estates. The *Salvator Mundi* was, predictably, not one of these, and it was packed away in the cellar of Doughty House. In 1944 a German bomb fell on the family home, which suffered extensive damage, but the *Salvator*, for once, was unscathed. After the war, various touring exhibitions of works from the Cook Collection were organised. The *Salvator Mundi* was included in one of these, titled 'Sacred Art', and was sent to the bomb-ravaged cities of Wolverhampton, Bolton and Eastbourne in 1947 and 1948. In the exhibition catalogues it was once again downgraded to simply 'Milanese School, c.1500'. It was then placed in storage in west London.

Sir Francis Ferdinand sold off the collection slowly from 1944 onwards, often struggling to find buyers. The biggest customer was Samuel H. Kress's American foundation, which bought scores of Cook paintings, donating twenty-one of them to the National Gallery of Art in Washington, DC. The biggest prize was the Filippo Lippi and Fra Angelico collaboration, bought on the recommendation of Bernard Berenson. By 1952, 242 paintings from the Cook

Collection had been sold, but scores still remained, among them the *Salvator*.

The costs of storing all this art were high. Sir Francis Ferdinand generously lent many works to museums and institutions across Britain. There was even a loan to Canterbury Cathedral. But he decided to sell off most of the remaining pictures in a sale devoted entirely to the family collection. On Wednesday, 25 June 1958, top international Old Masters dealers and a sprinkling of Britain's great-est art historians gathered under the chandeliers of Sotheby's Bond Street saleroom, whose walls were decked out with the Cooks' largest and most valuable paintings. In total, 136 lots were on offer, including the *Salvator Mundi*. Agents representing the most powerful London Old Master dealer, Agnew's, were there, alongside the Arcade Gallery; Charles Duits, with branches in London and Amsterdam; Giovanni Salocchi, who sold antiques and Old Masters in Florence; and Pieter de Boer from Amsterdam, who had done a roaring trade with Nazis during the war. The German-born Jewish émigré art historian Alfred Scharf, a specialist in Renaissance art who worked at the Warburg and Courtauld Institutes in London, and whose Polish wife Felicie Radziejewski was herself an art dealer, also attended. The lawyer, ex-secret agent, wine connoisseur, art historian and collector of miniatures Robert Bayne Powell raised his hand to bid. Sir Kenneth Clark, at the time chairman of the Arts Council and also of Britain's first independent television channel ITV, bought two pictures. Ellis Waterhouse, one of the first scholars of the history of collecting and a lifelong friend of art historian Anthony Blunt, later to be exposed as a Soviet spy, visited the sale and studied the paintings. He was keenly aware of the problem of attributions. At the beginning of the twentieth century he wrote that 'Most Italian Renaissance paintings were wrongly attributed and at least half of them were unlisted.' Waterhouse scribbled assessments of interesting lots in his personal copy of the catalogue. It was here that he dismissed the *Salvator Mundi*

with one word: 'wreck'. Thus, a roll call of the most distinguished art historians, dealers and collectors on both sides of the turn of the twentieth century had all looked at the Cook *Salvator Mundi*. They all dismissed it.

The sale total was £64,680. The dealers and art historians bid up many of the lots to high prices, but not the *Salvator Mundi*. However, one man in the audience was interested in the painting – a little-known collector from New Orleans, who was travelling in Europe and buying art with his wife Minnie. Warren Kuntz bought the *Salvator Mundi* for just £45, a sum so low it suggests he was the only bidder.

PART III

PART III

OFFSHORE ICON

Even with the endorsement of the National Gallery, the *Salvator Mundi* would prove very difficult to sell. First, Robert Simon had to work out how much the picture was worth – no easy task, given that so few bona fide Leonardos had come onto the market in the past two centuries.

In 1879 the sale of the *Virgin of the Rocks* for £9,000 (approximately $45,000) set a record price paid for a work of art at the time.

In 1914 the *Benois Madonna* was purchased by the tsar of Russia, Nicholas II, for $1.5 million.

In 1967 the National Gallery in Washington, DC, bought the *Ginevra de' Benci*, supposedly for $5 million, although it is rumoured that the actual price was much more.

In 1994 Bill Gates acquired the *Leicester Codex* for $30.8 million.

Simon consulted the Mei Moses Art Index, developed by two New York University professors in 2001 to calculate the value of works of art. It told him that, given the rise in value of the art market, the *Leicester Codex* would now cost around $100 million. He told me that he judged that an underestimate, since 'These things don't account for the rarity – for the fact that they aren't making any more

of them, and that there are only fifteen paintings by the artist, and that there are fewer as time goes on.' Using calculations based simply on the consumer price index, he estimated that $1.5 million in 1914 and $5 million in 1976 both became around $34.5 million in 2012. But if he calculated using relative income and wages, the figure rose to $200 million; and if he used relative output, it became $660 million.[1] In the end, he settled on a target price for the *Salvator Mundi* of $125 million to $200 million. The painting was now back on the market as a Leonardo for the first time in around 250 years. In the intervening centuries, both it and the business had been transformed to such an extent that they were only superficially recognisable.

The twenty-first-century art market still had some of the dynamics of the seventeenth-century art market of Charles I and Europe's absolute monarchs, and of the nineteenth century. As in centuries past, the incoming tides of mercantilism, globalisation and technology carried a new flotsam and jetsam of *arriviste* financiers, industrialists, entrepreneurs and rulers, millionaires and billionaires, onto the shores of the art market. They bought from the previous generation of collectors at a new, higher price point, taking the art market up a level, perhaps adding a zero or two to prices. The ever-growing middle classes added bulk to the middle and lower end of the market.

At the top end, the *arrivistes* bought in quantity and quickly. The super-wealthy collectors chose artworks based on images on Instagram, harkening back to the late-nineteenth-century American collectors who bought paintings on the basis of telegrams, or of photographs shown to them by art advisers. Where the nineteenth century had its Paris Salons and Royal Academy Summer Shows, the twenty-first has a rolling global schedule of art fairs and biennales, a frothy contemporary art scene in which a shifting cast of artists are hyped and speculated upon by a network of dealers. A new high

price or two is set at auction. That, in turn, is used as a benchmark in a few private sales and subsequent auctions. Quick profits are made for a few months or even years, and then, as interest in that artist wanes, the dealers move on to another and repeat the process, leaving behind them the burnt carcasses of artistic careers cut short, monstrous chimeras of misdirected artistic enthusiasm, and occasionally a disproportionately large bank balance for a lucky artist. So far, this is a world Charles I would have recognised.

Since the late nineteenth century, art had become both a commodity which could be speculated in and an asset in which one might invest. Canny dealers, collectors and even critics like John Ruskin bought works of art and sold them five years later for three times the price they had paid. In the first years of the twentieth century the Parisian entrepreneur and art critic André Level famously created a syndicate of investors who bought Impressionist and Post-Impressionist paintings, then sold them at auction ten years later for a handsome profit. That was an art market that Sir Herbert Cook and Sir John Charles Robinson would have recognised.

But behind this familiar and predictable structure lay new developments. By the twenty-first century financial investment in art was widespread, but it had also moved on a stage. Art is now being used almost as a kind of futures option or derivative. Perspicacious investors in the 1990s and early 2000s built up extensive collections of contemporary Chinese art, for instance, confident that the emergence of a new class of Chinese millionaires and billionaires would make their country's artworks more expensive. Today art is an asset class. It takes its place in many wise investment portfolios in which, typically, 10 per cent of a personal fortune might be invested in art. At the same time, art is also a tool that can be used for credit and for tax 'optimisation'. Governments offer fiscal incentives to the wealthy for patronising artists, donating to public collections and building museums. Banks accept art as collateral for loans. Furthermore, the

financial instrument of art is integrated into the offshore economy, a network of bank accounts and shell companies in tax havens where companies with anonymous owners pay no tax, and in countries with strict banking secrecy laws, such as Switzerland. Here, art can be used to hide or disguise one's wealth, and high-value transactions can be conducted as art sales without the paperwork having to be filed with national tax offices, as is required for other types of financial transactions.

After the National Gallery exhibition the three-dealer consortium of Simon, Parish and Adelson now approached the flamboyant newly appointed director of the Dallas Museum of Art, Max Anderson, who was impressed by the *Salvator*'s 'beauty, power and majesty'.[2] He persuaded Simon to lend it to the museum so he could show it to patrons and try to raise the necessary sums. Anderson thought the *Salvator* could be a 'destination painting' that would draw crowds to the museum. There is, after all, only one Leonardo on permanent public view in the United States: the *Ginevra de' Benci* in Washington, DC's National Gallery of Art.

The *Salvator* arrived in Texas in March 2012. It was not exhibited publicly at the Dallas Museum, but was placed on an easel in a storeroom for viewing. The asking price at this point was variously reported as $125 million or $200 million. Anderson and museum board members rounded up potential donors to take a look. After several months Anderson offered to pay for the painting, in part with a lump sum and in part with payments spread over ten to fifteen years, and giving the sellers a cut of ticket sales, merchandising and licensing. 'We were strung along by him for some time,' says Parish, and then 'at the eleventh hour, they offered just $40 million, and $25 million of that was meant to be a swap with another painting. Apparently some of those real Bible Belt people had little or nothing

good to say about the picture. One guy – I won't tell you who – said, "Boy, that is one faggy-looking picture of Jesus," or something to that effect. I was really like, "O-o-oh, great. This is going so well."'

'It was a maddening process,' says Adelson. 'It is certainly the greatest painting I've ever been involved with. It was frustrating not to be able to get it into an American museum. There was the rumour mill and the press saying ugly things about its condition, which were untrue. There were people knocking it and saying it wasn't authentic. There was a whole range of nastiness out there. But that is the human condition. There was nothing we could do about it.'

Parish and Simon were becoming desperate and disillusioned. 'I don't think any of us calculated the emotional toll that this was starting to wreak on us,' says Parish. 'Dallas unquestionably was a crushing blow. This was the most prime time of that picture's life, coming immediately after the exhibition in London, and you have to remember that it was preceded by a decade of anticipation. So we were starting to think, "Christ, let's get what we can and go."'

It was clear that it would take a very particular kind of collector to buy the *Salvator Mundi*. He would need to be very rich, of course, but also either less discerning than those who came before him, or more desperate to own a Leonardo, or poorly advised. Or all of those combined. And then, along came Dmitry Rybolovlev. In 2013 Simon, Parish and Adelson were tipped off that one of Russia's richest oligarchs was in the process of assembling an exclusive collection of masterpieces. They sent an email to Rybolovlev's office in Monaco, which was answered with a reply from his staff expressing an interest in their picture.

'In the spring of 2013 I was approached about buying the *Salvator Mundi*,' Rybolovlev told me. 'I looked for more information about it from different sources. I liked the painting a lot right away. The picture intrigued me.'

* * *

Berezniki is a small industrial mining town at the feet of Russia's Ural Mountains, a flat spread of prefab houses and ageing Communist-era apartment blocks with a population of just over 150,000. The town became a labour camp under Stalin in the 1930s.[3] A thousand feet below its streets lies a network of underground mines full of mineral-rich deposits of a substance that is a vital component of agriculture all over the world: potash, an internationally traded commodity that is used as a raw material for nonorganic fertiliser.

Today Berezniki and the surrounding area are scarred by giant sinkholes, often tens of metres deep and wide, where the ground has given way and collapsed into the mines. Since the late 1980s several hundred mines have collapsed, some with a force registering up to five on the Richter scale, and some as deep as fifty storeys underground. Berezniki's chasms are polluted with zinc and ammonia in concentrations that are 1,850 times the permissible levels. In 2006 the town suffered 'the worst ecological disaster in the former Soviet Union since Chernobyl', as Russian newspapers headlined it, when a 170-metre x 90-metre sinkhole opened up.[4] Hundreds of homes have been abandoned, and thousands of people have been rehoused. There is an ongoing debate about whether to relocate the whole town to the opposite bank of the river on which it sits, before it is swallowed up by these abysses.[5]

Sometimes the world's greatest art collections are built on wealth made in the most unaesthetic ways. Berezniki was, until recently, Dmitry Rybolovlev's town. It was here that he made his multi-billion-dollar fortune. He owned the mining companies. He backed the victorious election campaigns of local politicians, including the town mayor, Yuri Trutnev. He was known locally as 'the Fertiliser King'. In 2008 the Russian authorities began a series of investigations into the sinkholes, and the Ministry of Natural Resources and the Environment, headed by one of Rybolovlev's former business associates, appointed a commission of inquiry. It concluded that an

'unknown geological anomaly' had caused the sinkholes, and that the potash company Uralkali, formerly controlled by Rybolovlev, was not liable.[6] By that time, however, Rybolovlev no longer lived in Russia, nor did he run the fertiliser business. He was an art collector, resident in the tax haven of Monaco, and about to become the owner of the *Salvator Mundi*.

To buy the *Salvator Mundi* in 2013, you had to be incredibly rich. Dmitry Rybolovlev certainly was. Tall, trim, conservatively dressed, Rybolovlev emits that blank air of many of the world's wealthiest businessmen. Those who are acquainted with him describe him as 'a cold, changeable creature who is impossible to decipher', according to a profile in the Swiss newspaper *Le Temps*: 'Ice man, stone man, snake or even an "endive", the metaphors abound to describe this man who is of unrivalled intelligence, yet inexpressive, capable of shutting down the slightest hint of emotion on his face.'[7] He only speaks to the media in carefully calculated arenas, such as the society magazines *Tatler* and *Town & Country*, and once to the *New Yorker*. This is usually after a long process of negotiation, so that the journalist's relief at finally attaining an interview with the elusive oligarch overwhelms any desire to challenge his utterances. In such articles, 'Rybo', or 'Mr R', as he is called by those who work for him, permits himself to be photographed gazing out across the marina from his $330 million apartment in Monaco, or perched on the deck of the yacht he has named after his younger daughter Anna, or standing on the elegant parquet floor of his living room with a small selection of books in the background.

Rybo was born in 1966 in the Ural city of Perm. His father was a practitioner of an alternative medical therapy based on magnets – a popular but scientifically unproven form of treatment in Russia. Rybolovlev's interest in business was stimulated in his early teens

when he discovered a copy of *The Financier*, a 1912 novel by Theodore Dreiser about late-nineteenth-century American capitalism. 'It was one of the only books available that talked about the mechanisms of the market economy because, during the Soviet era, we hardly knew anything at all about business and its modus operandi. I was inflamed and impressed by it,' Rybolovlev recalls.[8]

At first he worked with his father, setting up a medical company called Magnetics. He married young, as was the custom in Russia in those days, wedding a classmate, Elena, at the age of twenty-two, in 1989. The following year he graduated from the Perm Medical Institute, but in 1992 he went to Moscow to study economics, otherwise known as capitalism. His timing was good: the post-Communist Russian state, following the advice of the World Bank, was just beginning the massive crash programme of privatisation that would create the class of oligarchs and the authoritarian kleptocracy that rule Russia today. Around 15,000 companies, amounting to 60 per cent of the country's GDP, were privatised. The state distributed shares in these companies, in the form of vouchers, to Russian citizens, who then sold them for small sums to entrepreneurs. Rybolovlev established an investment bank and bought shares in twenty companies, focusing on the Urals potash mining firms Uralkali and Silvinit. By 1996 he owned 66 per cent of Uralkali shares, and headed its board. He benefited from the support of his business partner Yuri Trutnev, at the time the mayor of Perm, who later became a government minister and a senior adviser to Vladimir Putin. Rybo now had bodyguards, and wore a bulletproof vest. In 1995 he moved his family to Switzerland, where he and Elena planned to build a new mansion for themselves in the plush Geneva neighbourhood of Cologny, modelled on the Petit Trianon at Versailles.

Rybo was a textbook oligarch, although he may not always have done things by the book. At the age of twenty-nine, while on a visit back to Russia from Geneva, he was accused of ordering the assassi-

nation of a business associate, Evgeny Panteleymonov, who was gunned down at his front door in 1995. Panteleymonov ran a small metallurgical company Neftekhimik in which Rybo had a 40 per cent stake. Oleg Lomakin, a local businessman with a dubious reputation, was arrested for the killing. Under interrogation, Lomakin implicated Rybo.

Lomakin's testimony landed Rybo in prison in late 1996. Rybo says that the local mafia had framed him. At one point, he says, he shared a cell with sixty other prisoners, with bunk beds three tiers high.[9] He remembers that he survived prison by making use of his medical qualifications to advise them on how to take the medicines their relatives had sent them. 'You can be at the top of any game; it doesn't give you any guarantees in prison. Prison forces you to be humble. I tried to understand how the internal rules worked; it's vital to adapt. You can no longer control everything. I thought of it as an experience,' Rybo told the French sports reporter Arnaud Ramsay, speaking in that curiously generic way in which oligarchs talk about themselves.[10]

After eleven months, Rybolovlev was freed on $150,000 bail. Lomakin and other witnesses either retracted their testimony or disappeared. The murder victim's wife told the police that in fact her husband had had good relations with Rybolovlev. By December 1998 Rybolovlev had been cleared of all involvement and Lomakin had been sentenced to fifteen years in prison.

Following his release from prison, Rybolovlev began a close association with the Russian Orthodox Church, like many members of the country's political elite. He funded the restoration of a church in Berezniki, and has since funded the restoration of the Oranienbaum Palace in Vladimir Putin's home town St Petersburg, as well as of the Cathedral of the Nativity of Theotokos in Moscow, and the construction of a gleaming new Russian Orthodox church with gold-plated onion domes in Cyprus. The interiors of these churches

are filled with golden-painted icons of saints, many of them in a similar hieratic frontal pose to the *Salvator Mundi*. Prison had changed the oligarch's outlook in another way. 'I risked my life to make a fortune,' he said, and he became determined to 'protect every cent'.[11] Art, now an established asset class with the benefits of mobility and secrecy, would soon become one of his new fortresses.

By 2006 Rybo had become an international industrialist, whose companies supplied 40 per cent of the global potash export market (the Russian domestic market is also large). In 2007 he listed 12.5 per cent of his company on the London Stock Exchange, instantly becoming a billionaire and one of the hundred richest people on the planet. His company's share price rose 300 per cent in the next eight months, but Rybo was losing favour with the Russian state. It is said that Putin had been annoyed by Rybo's joint venture with the Belarusian potash company Belaruskali, which he viewed as an attempt by Belarus President Alexander Lukashenko to tap into Russian wealth. In 2008 Putin's deputy Igor Sechin launched a new inquiry into Berezniki's sinkholes, and this time Rybolovlev's company was found negligent and required to pay $250 million in fines. Meanwhile in the United States, a class action lawsuit brought by American agribusinesses accused Canadian, US and Rybolovlev's companies of price-fixing, using their dominant market position to artificially inflate the price of fertiliser, which increased sixfold between 2003 and 2008.*

Then, in 2010, the textbook oligarch followed in the footsteps of other Russian billionaires, like Roman Abramovich, who had been relieved of the ownership of their businesses by Putin's circle. The Fertiliser King agreed to sell a majority stake in his company for $6.5 billion cash to three businessmen close to the Kremlin; they had been

* The case was settled in 2013, when the potash companies agreed to pay $100 million without admitting any wrongdoing.

lent $3 billion by the Russian state bank VTB, currently under American and European sanctions, to partially fund this transaction.

There were also personal misfortunes. Rybo's wife Elena filed for divorce in 2008, citing 'a prolonged period of strained marital relations'.[12] She wanted $4 billion, half his fortune, to which Swiss law seemed to entitle her. Her lawyers claimed that Rybolovlev had 'a history of secreting and transferring assets in order to avoid his obligations'. Elena began trying to freeze her husband's assets around the world, including his yacht in the British Virgin Islands and 'some extremely valuable property'. Rybo was prohibited 'from removing from Singapore twelve paintings by various artists such as Modigliani, van Gogh, Picasso, Monet, Gauguin, Degas and Rothko'.[13] He had been buying a lot of art, and – divorce be damned – he was going to buy much more, including the *Salvator Mundi*, his second most expensive purchase.

No major art deal these days is complete without a string of middle-men. Thus, Rybolovlev bought the *Salvator Mundi* not from Robert Simon and his partners, but from one of the world's most low-profile but best-connected art dealers: Yves Bouvier.

A Swiss citizen, Bouvier wasn't a dealer per se. His main business was in the logistics side of the art world, that is, the storage and transport of the merchandise. His low-key appearance – sweep of sandy-brown hair, crumpled expression with a slight smile, unremarkable wardrobe of loafers, jeans and jacket – gives no clue about the global business empire he once ran, little of which remains today.

In 1997, at the age of thirty-four, Yves Bouvier took over the family business, a storage, shipping and removals company called Natural le Coultre. At the time only 5 per cent of the company's business related to art, but he pivoted it entirely towards that market. 'Personally, I preferred moving boxes with sculptures inside to moving

boxes of archives,' he told me, laughing. 'It was good timing. The art market was developing, and the need for storage was increasing, because collectors in general have addictive behaviour, so they buy more than what they have space for in their homes. Like it and change it. Like it and resell it to buy something else. Look at the number of art fairs today compared to 2000! Look at the number of sales by auction that there are these days, and the weight of the catalogues! Look at the number of new collectors, the number of foundations that have opened, and the number of private museums! And these days the museums have all understood that exhibitions are a business, to sell tickets. Plus, artists these days have become industrialists, who produce stock and distribute their works of art. So there is stock, as in other fields. From the 2000s onwards the artists were making bigger pieces as well. So there was a greater need for storage space.'

Bouvier set up a technical department to carry out condition reports and restore works of art, and he invested in art fairs. From 2005 to 2008 he ran an art fair in Moscow. But above all, he stored art. His company grew to become the primary renter of space at Geneva Freeport – more formally known as the Ports Francs et Entrepôts de Genève SA, a series of warehouses close to Geneva airport, and officially in neither France nor Switzerland, meaning that tax and transparency laws do not apply to it. As the art market began to boom in the early 2000s, his business took off.

The Freeport was established in 1888 as an old-fashioned bonded warehouse, like others around the world, where traders could store goods, untaxed, before moving them to their destinations, where they would be taxed. In the globalised economy of the early twenty-first century this giant, ultra-secure lock-up of 150,000 square metres of space, and mile after mile of anonymous corridors lined with units, became a highly attractive location for the rich to store their art collections tax free. There was no obligation to tell anyone what exactly they had. If they transferred ownership of the works to an

offshore trust, they could then buy and sell them through the Freeport without the knowledge of any tax authorities. If an artwork went to another collector or dealer with a locker at the Freeport, it only needed to be trolleyed down the corridor. Another benefit came from the swiftly expanding market for loans – collectors could use the art they kept in the Freeport as collateral to borrow money almost anywhere in the world.*

Bouvier entered this credit market by financing loans for dealers to buy paintings, and offering the use of offshore companies he could set up which made buyers or sellers relatively invisible to the authorities.[14] The Freeport was, and still is, where the art-collecting dynasty of the Nahmads store an immense holding of Impressionist and Post-Impressionist paintings. Until the leaks of millions of documents from private banks and legal firms it was also popular with Belgian and Israeli diamond dealers, who could convert their profits into works of art without the money ever reaching the eyes of their national authorities. It was a good business, in which the Swiss government, at the local level, had a stake: the Canton of Geneva owned 86 per cent of the shares in the Freeport.

In the early 2000s the international economic organisation the OECD and US tax authorities began applying pressure to erode the banking and corporate secrecy of Switzerland and other tax havens around the world. Yet the privacy of the ownership of art was left untouched. That intensified its attractiveness. Art as an asset class is not as liquid as shares, property, gold or cash in the bank, but it has other advantages. It is easy to disguise its value (since expertise is required to value it); it is easy to pretend it is not an investment, but

* Globally, the freeport business boomed – a byproduct of the expansion of the art market. The number of freeport-like depots increased from one hundred in 1975 to 30,000 in 2008, spread across thirteen different countries, according to the international G7-linked Financial Action Task Force.

rather an indulgence or passion; and it is easy to hide from the taxman and from divorcing spouses.*

Today, according to the independent industry information service Artprice, more than half of all the art bought and sold across the world at auctions or private sales passes through the Geneva Freeport. Defenders of the contemporary art market will tell you that the secrecy and tax-free status of freeports are just a minor additional benefit to collectors and dealers. However, when the Geneva Freeport came under investigation in 2015, Artprice's founder Thierry Ehrmann pronounced, 'If the Geneva Freeport collapses, the whole global art market … will collapse.'

Yves Bouvier saw the opportunity to build a global empire. He began to plan a second high-end freeport in Singapore in the mid-2000s, and later a third in Luxembourg, countries both known for their low tax regimes and borderline tax-haven status. He planned others in Dubai and China. He set up viewing rooms in these facilities so that dealers and collectors could buy and sell works of art without ever having to leave the freeport zones, but could simply move between lock-ups. 'The idea was to create what you might call "axes of competence". That meant to have, in the same place, the storage, the restoration, the analysis, the photography, because it's simpler to move people than to move works of art. I wanted to make centres, and then it was a question of putting them in triple-A countries, where there was political, economic, fiscal,

* The growing demand for freeports has been attributed in part to the increasing crackdown by governments on bank secrecy and tax evasion. The introduction of the Foreign Account Tax Compliance Act (FATCA) in the USA (2010) and the commitment of OECD members to the organisation's 2014 Common Reporting Standards (CRS) – transposed in the EU via the Directive on Administrative Cooperation (DAC) – make it hard for individuals to escape taxation on proceeds of funds held in bank accounts. 'Money Laundering and Tax Evasion Risks in Free Ports', European Parliament Research Service Report, 2018, p.13.

social stability, no strikes, no robberies. So that's why Switzerland was a good base.'

Bouvier also increasingly dealt in art himself. 'The fact that I'd transported a lot, wrapping up and unwrapping, it allows you to develop an eye,' he told me. 'What is important about the art market is, on the one hand, to have good information, and on the other – the art market, I'm not going to say that it's a bit of a game, but you have to reflect about what will work, what won't work.' In the secretive and opaque art market, transportation and storage managers have a unique position: they know exactly who has what. This means that, if they are smart, they can guess what collectors do not yet have, but might greatly desire. Conventionally these 'logistics managers' kept to their side of the street, so to speak, if only out of fear that they would lose business from dealers who thought they were interposing themselves as middlemen. But in the turbocharged atmosphere of the twenty-first-century art world, such cold calculations were melted by the heat of the market.

Dmitry Rybolovlev began to buy art in the early 2000s through trust funds he located in Cyprus and the British Virgin Islands, registered as owned by his daughter Ekaterina. His primary motivation is unclear. It was surely a way to move his wealth a few leagues further from the reach of the Russian authorities. Additionally, as he later found out to his benefit, under Swiss divorce laws a spouse could make a claim only on wealth owned in Switzerland. Rybo retained control of the trusts through power of attorney. The trusts specifically authorised him to use their funds to buy art because of his 'special knowledge in any kind of artwork including but not limited to paintings, drawings, statues and antique furniture, investments in art and valuable items'.[15]

His first purchase was a circus painting by Chagall, the lowest common denominator in modern-art collecting. Chagall's pretty

fairy-tale scenes, with translucent colours that glow like stained glass, are impossible to dislike. The acquisition, like most high-value private sales in the art world, was brokered by an intermediary, Tania Rappo, whom the Rybolovlevs had befriended in Switzerland. A Bulgarian socialite who spoke Russian, French and English, she was a former publisher and librarian, and the wife of Rybolovlev's dentist.

When Rybo went to see the Chagall with Rappo for the first time, the painting was being held at the Geneva Freeport. At this viewing Rappo introduced the Rybolovlevs to Yves Bouvier. Bouvier recalls that Rybolovlev was very worried about his new acquisition. It lacked an authenticity certificate, and he was afraid it might not be genuine. Bouvier offered to obtain the certificate for him from the previous seller, which he duly did. Rybolovlev remembers that Bouvier told him that his position 'as depositor and transport agent of works of art for some of the greatest collectors in the world gave him unique and direct access to such collectors and the works which were not available on the market'.[16] Rybo says Bouvier then told him and his wife that they should buy anonymously, because 'On the one hand, revealing their identity as a wealthy buyer would have a negative influence on the sale price of the item concerned. On the other it was customary in the art market for both seller and buyer to remain anonymous and in the background in deals involving artworks, and that the sale would be handled by a commission agent.'[17]

'I think he thought that I was more discreet, possibly, than the rest of the market,' Bouvier told me. 'No one had any idea of the volume of clients I had across the world.' He then asked me to turn my recorder off, and told me how many hundreds of millions of dollars' worth of art he had sold every year.

Rybolovlev was impressed by Bouvier's pitch, and tasked him with helping him build an unparalleled collection of masterpieces. Bouvier gave his terms: he would find and sell Rybo works of art, and would receive payment for them plus a 2 per cent commission for expenses

and administration. 'And after that I sold him the first picture in summer 2003. It was a van Gogh,' says Bouvier.

Both Rappo and Bouvier became close friends of Dmitry and Elena Rybolovlev. Bouvier accompanied the Russian couple to biennales, museums and art fairs. 'Dmitry thinks he's superior to everyone,' he says. 'That means, if you're discussing art with him, he thinks he's superior to you. You discuss real estate, he's superior to you. You talk about medicine, he's superior to you. You discuss any subject at all, he thinks he's more intelligent than the rest of the world. He's quite a solitary person. He's not a party person. I've never drunk alcohol with him. He is very hard. He's a very structured person. He'll get up at eight o'clock. At ten o'clock he'll go to do some sport, at eleven o'clock he'll go out visiting, at midday he's going to eat such-and-such a thing. Everything is like in the army!'

As Tania Rappo spoke Russian, and Rybo had never learned French or English, he was pleased to have met someone he could talk to in his own language. She helped him enter Monaco high society by, for instance, taking him and Elena to parties and facilitating their membership of an exclusive golf club. The Rybolovlevs appreciated her efforts. Rappo flew in their private jets and enjoyed time on their yacht, and became so close to them that she is godmother to their younger daughter, Anna. Bouvier, for his part, arranged private viewings of paintings in the Rybolovlevs' chalet, and was invited to all of Rybolovlev's 'birthday parties, even those only for a few select guests and taking place in Hawaii or New York', as his lawyers later stated. But Bouvier and Rappo had cut their own secret deal: Rappo would receive from Bouvier a commission of 5 per cent (so, rather strangely, more than twice Bouvier's) on every piece of art the oligarch bought.[18] Eventually that would add up to over $100 million, say Rybolovlev's lawyers.

Bouvier was soon helping Rybolovlev to acquire the greatest hits of Modernism – first a Picasso, then a Modigliani, then another

Picasso, three more Modiglianis, another Picasso, a Degas, a Gauguin, yet another Modigliani (Rybo's fifth), a Rothko, two Monets, a van Gogh, a Renoir, and so on. Just like Charles I, Rybo was imitating the taste of the leading art collectors of his day, who were, this time around, American rather than Spanish.

After Elena filed her divorce petition, Rybolovlev went on a multi-billion-dollar spending spree. He bought a 6,744-square-foot apartment in New York for his daughter Ekaterina. At $88 million, it was the most expensive apartment in Manhattan at the time. He moved to Monaco, where he bought what was at the time the world's most expensive apartment, the legendary 'La Belle Époque' penthouse, with views overlooking the marina, the palace and the casino. It has an external lift fronted with bulletproof glass, and cost $330 million. He bought aeroplanes worth $80 million, including an Airbus A319 jet, the Greek island of Skorpios for a reported $154 million, and a football club, AS Monaco, into which he pumped $200 million. The guests in his box at the stadium have included tennis player Novak Djokovic, Formula 1 driver Lewis Hamilton and U2's Bono. His most mysterious purchase was of Donald Trump's Florida mansion, for which he paid $95 million in 2008. Reports have long pointed out that Rybo paid over twice what Trump had bought it for a few years earlier, which was $41.35 million.

But more than anything, Rybo binged on art. Using his daughter's offshore trusts and affiliated companies, he spent an astonishing $2 billion over twelve years – on the face of it, around a third of his total wealth (although the collection may also have been financed with loans). He bought only four artworks between 2003 and 2006, but twenty-three between 2009 and 2014. The purchases took place in Switzerland, and the pictures were stored at Bouvier's Singapore Freeport facility. The storage certificates issued to Bouvier contained

a clause providing for the exclusive jurisdiction of Singapore courts and for Singapore law to be the governing law. As Bouvier recounts it, Rybo's relations with the Kremlin were becoming uneasy: 'In 2006, when Rybolovlev's mine collapsed in Russia and it caused huge ecological damage, he became afraid that the Russians would start proceedings against him, and that Switzerland would cooperate with Russia on that. So he asked me to transport most of his works of art to Singapore and a very little part of them to London. At that moment, I became more important to him, because it was me who was holding the bulk of his assets, on his behalf.'

When Yves Bouvier found something promising, an email would land in the inbox of Rybo's office in Monaco. For example, in June 2010 Bouvier had a piece by Toulouse-Lautrec – *Le Baiser* (The Kiss). He wrote: 'The owner is quite prepared to sell … I think I could get him to accept €20 but I want to try lower with a fast payment.' Bouvier was so keen to secure works for Rybolovlev that on occasion he offered to forgo his own percentage: 'In order to remain within DR's budget of 36.5, I am waiving my fees on the total value of this purchase,' he wrote to the office in Monaco. 'So the total cost for DR is similar.'[19] Bouvier found a Modigliani, a reclining nude, *Nu couché au coussin bleu*, and told Rybolovlev that 'The owner has bought a set of different works and for financial and tax reasons I think he is going to sell this very important painting.'[20] Tania Rappo accompanied Rybo on almost every appointment to view prospective purchases, and escorted the Rybolovlevs to art galleries, offering them a crash course in art history. During a visit to the Prado in Madrid, Rybo is said to have stopped in front of an El Greco and exclaimed, 'I like that. I need to have it.'[21] In 2010 he bought an El Greco from Bouvier for $39.2 million.

A small hint of what was going on behind the scenes came in the glittering and golden form of a Gustav Klimt, the Austrian Art Nouveau painter and a godfather of Modernism. In 2012 Bouvier

was offered an erotic masterpiece by Klimt, *Water Serpents II*, for around $110 million, in a sale brokered by Sotheby's. Bouvier told Rybo's office that he was negotiating hard to buy the picture for a much higher sum. 'They're holding back for 180 and are at the breaking point,' he emailed. 'I think they are ready at 190. But I should be able to twist them to reach 185.'[22] He bought the painting for $115 million, and Rybolovlev agreed to pay him $183.8 million for it. Even after paying Tania Rappo her 5 per cent cut of the $115 million, Bouvier's profit on the deal was close to $60 million.

A year later, a newspaper report appeared which stated that the sellers had actually sold the painting for $120 million. One of Rybo's aides saw the article and, says Rybo, asked Bouvier if his boss had paid him much more for the picture than he had bought it for. Bouvier denied it, and offered to obtain 'proof' of payment to Sotheby's. No such document was ever received, but a year later Sotheby's provided Bouvier with an insurance valuation of the Klimt at around $180 million, which Bouvier forwarded to Rybolovlev's office.

This brings us to Sotheby's, which, alongside Robert Simon's consortium, Bouvier and Rybolovlev, was the fourth player in this game. Auction houses such as Sotheby's not only organise the public sales for which they are well known, and which make headlines around the world with their record-breaking prices; they also conduct a much more discreet backroom business of private sales, using their contacts and reputations to broker major deals between buyers and sellers. If successful, they are paid a percentage of the sale price as their commission. Sotheby's was involved as a middleman in at least eleven of the thirty-seven purchases Rybolovlev made through Bouvier.

In March 2013 the vendors of the *Salvator Mundi*, Robert Simon, Alex Parish and Warren Adelson, felt their luck beginning to turn. Rybolovlev had responded positively when they reached out to him

– 'The picture intrigued me,' he had said. His office had enquired about the price and been quoted €190 million. Rybo asked his office to consult Bouvier about the painting.

'Bouvier sent an email to our representative advising against buying *Salvator Mundi*, and he was very blunt,' Rybolovlev told me. 'He said that the acquisition of this painting was not a good investment and never would be. He also stressed that someone spending too much money on this picture would be seen as naïve, and would be considered a "laughing stock" by everyone on the art market.'

Bouvier says, 'I had seen all the technical documentation relating to the restoration, a hundred pages of it, including the infrared photographs and the photograph of the painting without restoration. I had doubts about this picture. Why? Because this picture was well known in the market. I knew it was for sale and no one was taking it. And there had been a lot, but a lot, of restoration. I didn't have doubts about its authenticity, since it had been in the exhibition in the National Gallery London. If it hadn't been in that exhibition, it would have been impossible to sell that painting. I had doubts about the amount of restoration. When I talked to Monsieur Rybo about it, I warned him: "If you want this picture I can sell it to you, but you should regard this above all as a decorative purchase."'

The oligarch, however, told Bouvier that he really liked the painting: 'I couldn't get rid of a feeling that there was something special about this da Vinci, the last da Vinci.'

So Bouvier agreed to set up a viewing. He did not approach Simon, Parish and Adelson directly. Instead he asked Sotheby's to show him the painting.* Sotheby's contacted Simon and Parish to

* This was because Bouvier had already made enquiries about the *Salvator*, independently of Rybo's office, to Sotheby's: had they heard there was a Leonardo on the market? Where was it? It seems he had already thought the painting was something Rybo might like.

tell them it had a potential buyer for the *Salvator Mundi*, and persuaded them to sign an agreement under which the auction house would act as another middleman in the sale. Simon and Parish, keener than ever to sell, agreed to lend Sotheby's the *Salvator* for between three and fourteen days, to show it to their mystery buyer. At no stage in the following sequence of events did Simon, Parish and Adelson have any idea that Yves Bouvier was acting on behalf of Dmitry Rybolovlev.

Sotheby's now organised a viewing of the painting for Bouvier. Later, in a court filing, Sotheby's gave a blow-by-blow account of this meeting. Bouvier, it said, asked for the *Salvator* to be sent to 'an apartment at 15 Central Park West' – which was in fact the $88 million apartment owned by Rybolovlev's daughter. Sotheby's specialist Sam Valette brought the painting in a box to the building, where, most unusually, rather than being told which apartment number he was visiting and making his own way there in the lift, he was met by Bouvier in the lobby and 'escorted to an apartment where a small group of people was gathered'. The painting was then taken 'by Bouvier and one of the men in the room' to another room where it could be examined in private. The other man was Dmitry Rybolovlev, who was there incognito.

Bouvier recalls, 'I received the *Salvator Mundi* in one of those black picture-carrier cases with two handles … I said to Dmitry, "You really want the da Vinci? Have you seen the picture?" He said, "No, I haven't seen it yet." I discussed it with him for ten minutes. I gave him the documentation, where I'd marked up all the things that weren't right with it, in Russian. He read it. He says, "Yes, that's the picture." So I open the case, I take it out, then I say, "Is this the one you want?" He was struck dumb!'

'The first time I saw *Salvator Mundi*,' says Rybo, 'I felt a very special, bright, positive energy. It was a remarkable feeling. I couldn't take my eyes off the Christ. To see the wider context we need to return

several years back. My family and I lived in Russia and I had been focused exclusively on my business. Russia was going through difficult and turbulent times in the 1990s. We had no time to enjoy art.'

Bouvier told me, 'Then I said to him, "I'm going to sell it to you, but I'm going to sell it to you for less than the other middleman, for less than 190." I said to Dmitry, "Tell the fellow asking 190 that you no longer want this picture."'

Shortly after the meeting in the Manhattan penthouse, Alex Parish says, one of Rybolovlev's representatives contacted them and told them that the oligarch had changed his mind, and didn't want to see the painting after all. 'These oligarchs are surrounded by echelons of grafters, you know. Everything gets stepped on, and everything gets mish-mashed, and we heard this all third-, fourth-, fifth-hand. But the word comes back, "No longer interested in the picture. Hear it's in terrible condition. End of story."'

From Simon and Parish's perspective, it looked as if yet another potential sale was going to fall through; but Rybolovlev had in fact handed over the reins to Bouvier.

Bouvier now negotiated the purchase of the *Salvator* on behalf of Rybolovlev. He told Sotheby's that his intention was to loan it to La Pinacothèque de Paris, a five-thousand-square-metre private museum opened by Marc Restellini, an art world entrepreneur who had partnered with Bouvier to open a similar museum in Singapore. (Two years later Restellini's company Art Heritage France, which operated the Pinacothèque, went into receivership, leaving many unhappy creditors.[23])

Finally, there was movement on the sale of the painting. Sotheby's told Simon, Parish and Adelson that they should go to Paris to meet an agent for the buyer. Adelson, who had after all been brought in because of his selling skills, duly went to Paris for a meeting on 10 April 2013. He thought he was going to meet Bouvier in a restaurant, but when he turned up as arranged, Bouvier wasn't there. He

had sent one of his associates to strike the deal, a Corsican called Jean-Marc Peretti who had been the subject of a series of criminal investigations in France since 2004, involving alleged money laundering and illegal gambling.

Bouvier reported back to Rybolovlev on this meeting as if he had been there himself, describing hard-nosed negotiations with the seller of the painting. Rybo was willing to pay $100 million in cash for the *Salvator*, but Bouvier wrote that this offer was 'rejected without a moment's hesitation' by Adelson. He told Rybo that the sellers were 'one tough nut, but I'll fight and take as long as it is necessary'. He said that he had tried to buy the painting for $97.5 million, then $117 million, then $122 million, before clinching the deal at 124.4 million Swiss francs ($127.5 million). 'Terribly difficult, but it's a very good deal with regard to this unique masterpiece by Leonardo.'[24]

That was not an accurate representation of what had happened. In fact Peretti had offered Adelson $68 million in cash plus a late Picasso, *Le Fumeur*, from 1964, apparently worth $12 million. This was an example of the part-swap deals often made in the art market today. By the time of the Paris lunch, Simon, Parish and Adelson were, in Parish's own words, 'running out of money and desperate to sell'. They reluctantly accepted Bouvier's part cash/part Picasso offer.

'The Italians are very good at negotiations,' says Parish, referring to Peretti. 'They start much lower. They insult you. They act like they don't want it. After you've been dragged all the way to Europe to do this, you're crestfallen. It's a psychological game. Go buy a car in the United States and you'll get a taste of it, because all those dealerships play all sorts of games. And it's about teasing your desire to try to do something. They know you want to. It's real psychological abuse, and this guy was real good at it. And I'm afraid he took my partner to the cleaners.

'But,' Parish continued, 'if you've been through what we had been through! There had been eight years of development of this picture, all cash out, no cash in. It wasn't the cheapest thing in the world to

do. We were beat up, because we had this Dallas thing, a couple of other failed attempts, and it looked to us like this guy Rybo pulled out at the last minute. You can imagine the state of mind we were in when finally we were being approached. We were just dying for a lot of reasons. We were just emotionally done with this. And Warren goes over there and gets real beat up. As I recall it, I'm the one who finally said, "OK, fine." And we caved in.'

Sotheby's officially arranged the sale of the *Salvator Mundi* by the consortium of Simon, Parish and Adelson to Bouvier for $80 million. The next day, Bouvier invoiced Rybolovlev's company for $127.5 million, plus his commission of $1.275 million, which probably made him in dollar-profit-per-minute terms the most successful art dealer in history. He had made over $48 million in less than a day. Tania Rappo was given her percentage – almost $5 million. Sotheby's has stated that it made a $3 million profit on the sale of the *Salvator* to Bouvier. It was also a good day for the *Salvator Mundi*. The sale price of $127.5 million was a record for a Leonardo. The picture had risen over 100,000 times in value in eight years, to become the most expensive Renaissance painting ever sold.

'We didn't get anything like what we were told we were going to get,' says Parish, 'but at the end of the day we still made more money than any of us – with the exception of Warren – had ever seen. And then, it was about two years later that we started to read that the guy we had approached [Rybolovlev] ended up buying the picture from this other guy [Bouvier]. And this guy got $50 million more for it than we did.'

In April 2013 Simon, Parish and Adelson made a lot of money on the *Salvator Mundi*. They have never revealed exactly how much, of course, but one can estimate the sums. The dealers made a profit of around $80 milllion on the painting before expenses. Parish has intimated to me that the $12 million Picasso did not turn out to be worth that much on the market, and one can imagine that the consortium had costs of around $1–2 million. Therefore the dealers

surely made $70–75 million profit, which they split three ways, each netting around $20–25 million.

Parish remembers going to see the picture one last time before it was shipped off to its new owners. 'There was this sense that it might be time to say goodbye to it. I remember going and viewing it, and just thinking, "OK. This is probably the last time I'm going to see this. But I'm happy it's on its way."'

Six months later, Rybolovlev was vacationing for New Year's Eve of 2013–14 on the Caribbean island of St Barts when he crossed paths with the legendary art adviser Sandy Heller. Rumours of Rybolovlev's many art acquisitions had spread, and Heller said to the oligarch, 'It looks like you bought the Modigliani we sold.' He was referring to *Nu couché au coussin bleu*, which had belonged to a client of Heller's, hedge fund manager Steve Cohen.* Heller divulged the price Bouvier had paid for the picture, and Rybo immediately realised that Bouvier had sold it to him for a much higher amount – in fact, $20 million more.[25]

Three months after that, on 9 March 2014, the *New York Times* published a story about the *Salvator Mundi*. Under the headline 'Putting a Price on Leonardo', it revealed that Simon, Parish and Adelson had sold the picture to Bouvier for somewhere between $75 million and $80 million. Rybolovlev only read this article months later, in November, when one of his staff drew his attention to it. He brought it up in a conversation with Bouvier, still not knowing that Bouvier himself was responsible for the mark-up, and asked inno-

* In 2013 Cohen's hedge fund, SAC, received the largest ever fine for insider trading, of around $1 billion, from the Securities and Exchange Commission (https://www.telegraph.co.uk/finance/financial-crime/10438374/Steven-Cohen-a-spectacular-downfall.htm).

cently if he and Bouvier might have overpaid for the work. Bouvier replied that market conditions were 'tough'. In December Rybolovlev asked Bouvier to sell some of the paintings he had bought from him for the price he had paid Bouvier for them. Bouvier resisted, offering only to put the Toulouse-Lautrec back on the market. That was the last straw. Bouvier says, 'Dmitry withdrew all the works of art from my storage facility. He waited until the last piece had been delivered, and then he invited me to Monaco.'

On 25 February 2015 the Freeport King flew to Monaco to meet the Fertiliser King. Bouvier had ostensibly been invited to Rybolovlev's apartment so that Rybo could settle the remaining bill on their last deal, a Rothko. But it was a trap. The well-connected Rybo, who counted Monaco's Prince Albert II among his friends, had decided to go to the authorities, and his lawyer had advised law enforcement of the time and date of Bouvier's appointment.

As Bouvier entered the lobby of La Belle Époque, a squad of twelve men in black uniforms swooped in, put him in handcuffs and bundled him into an unmarked car. He was told he was under investigation for fraud and money laundering, and was interrogated for three days before being released on €10 million bail, later reduced to €3 million.

Now everything would unravel, not just for Bouvier, but for Rybolovlev too. Each would drag the other down, the *Salvator* an impassive catalyst. The hidden, linked mechanisms of both the unregulated art market and the invisible offshore economy were to be exposed as never before. Over the following three years, lawsuits multiplied around Leonardo's Christ in layers, like rings of toxic gas around a beautiful planet. Rybolovlev's lawyers initiated legal proceedings against Bouvier in Switzerland, Singapore, the United States, France and Hong Kong. In Monaco there was a police inves-

tigation and a civil case filed by Rybolovlev on behalf of his daughter and her trusts. This was, Rybo's legal team claimed, 'the largest art fraud in history'. The prosecutors and police forces of national governments were involved. Authorities in Switzerland, France and America began their own investigations into Yves Bouvier for tax evasion, money laundering and even theft.

Rybolovlev's complaint against Bouvier was that he had pretended to work for him as an agent while actually behaving as a seller, which would constitute fraud. As an agent, it would be argued, Bouvier had legal responsibility, known as a 'fiduciary duty', to obtain the best possible price for his client. In return for this he was paid a commission or 'fee' that was a percentage of the sale price. Rybolovlev's lawsuit added up Bouvier's sales to him and accused him of having fraudulently marked up the works of art by a grand total of $1,049,465,009. Tania Rappo was said in the same lawsuit to have received commissions from Bouvier totalling $100 million. Rybolovlev's lawyer, Tetiana Bersheda, told Arnaud Ramsay, 'For almost fifteen years, Yves Bouvier portrayed himself to them [the Rybolovlevs and his office] as their representative and adviser, charged with finding and negotiating artworks at the best price, on behalf of them, and to their advantage. But actually, he worked to his own advantage by pocketing the hidden profit on each transaction, thus creating a loss for my clients totalling almost $1 billion. And he did that via offshore companies and accounts.'[26]

Another set of lawsuits revolves around Sotheby's. This time Robert Simon and Alex Parish are involved, as well as Dmitry Rybolovlev. In February 2016 the New Yorker published a deeply-researched essay by Sam Knight, 'The Bouvier Affair'. For the first time Simon and Parish learned how much Bouvier had sold their painting to Rybo for. They now suspected that Sotheby's had known Bouvier was

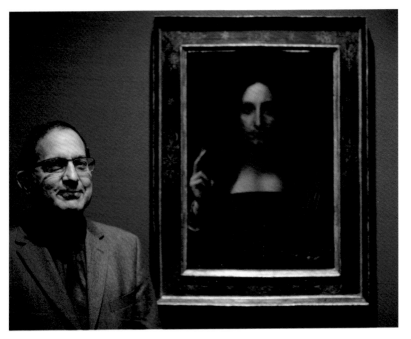

Robert Simon at the National Gallery's Leonardo Exhibition, November 2011.

Heraclitus, thought to be a portrait of Leonardo, detail, *Heraclitus and Democritus*, Bramante, *c.*1487, Fresco, Brera Picture Gallery, Milan.

Alex Parish, Old Masters dealer, who discovered the *Salvator Mundi* with Simon.

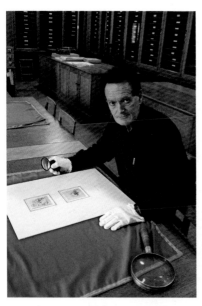

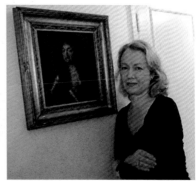

(left) Martin Kemp, Emeritus Professor of the History of Art, Oxford University, the world's greatest living expert on Leonardo. (below) Margaret Dalivalle, art historian and provenance researcher, who Kemp recommended to research the painting.

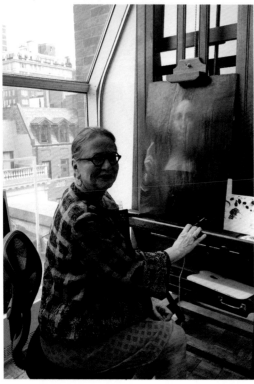

Working on the picture with 'the tiniest brushes' she had ever used, Dianne Modestini, restorer, spent years restoring the *Salvator Mundi*.

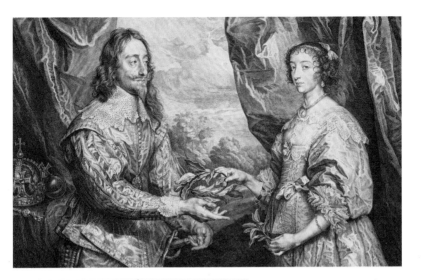

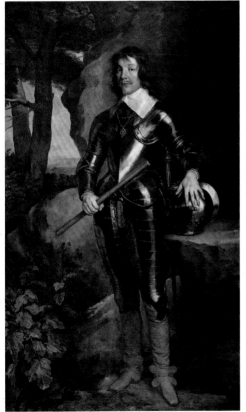

The owners: Charles I and Henrietta Maria, the Duke of Hamilton (left) and Sir John Charles Robinson, art dealer and curator.

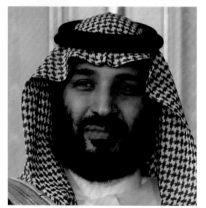

The owners (clockwise from top left):
Sir Francis Cook, Herbert Cook, Yves
Bouvier, Mohammed bin Salman and
Dmitry Rybolovlev.

Doughty House, London (above), home of the *Salvator Mundi* during the first half of the twentieth century. The *Salvator Mundi* hung on the right wall down by the corner. It is probably in the second row from the back, at the top. In June 1958, the Cook heirs auctioned the family's most valuable paintings at Sotheby's (below). In total, 136 lots were on offer, including the *Salvator Mundi*, which sold to a little-known collector from New Orleans for £45.

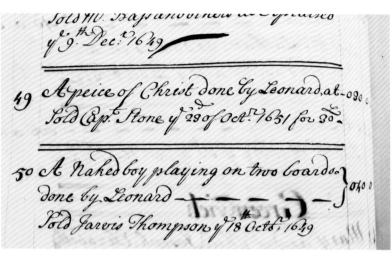

'A peice of Christ done by Leonard': item 49, Commonwealth Inventory 1649–51 (Different copies of the inventory spelled 'piece/peece' in various ways).

'A Lord halfe figure by Leonardo': item 123, priced at £80 and given to Edward Bass. A second *Salvator Mundi* that was listed in the Commonwealth Inventory 1649–51.

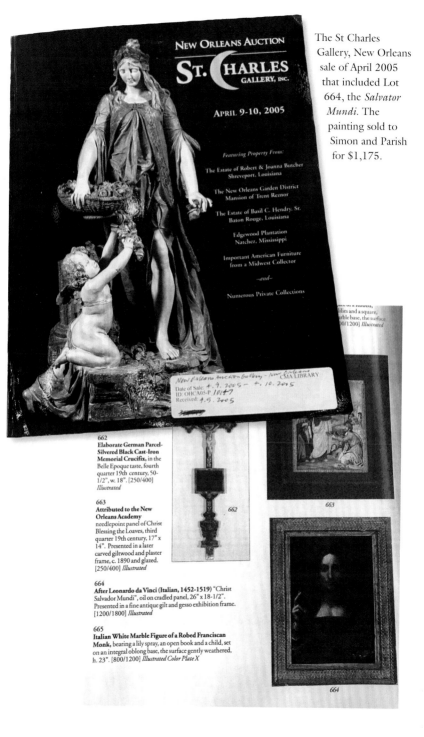

The St Charles Gallery, New Orleans sale of April 2005 that included Lot 664, the *Salvator Mundi*. The painting sold to Simon and Parish for $1,175.

NEW ORLEANS AUCTION

ST. CHARLES GALLERY, INC.

APRIL 9-10, 2005

Featuring Property From:

The Estate of Robert & Joanna Butcher
Shreveport, Louisiana

The New Orleans Garden District
Mansion of Trent Reznor

The Estate of Basil C. Hendry, Sr.
Baton Rouge, Louisiana

Edgewood Plantation
Natchez, Mississippi

Important American Furniture
from a Midwest Collector

–and–

Numerous Private Collections

New Orleans Auction Gallery - New Orleans CMA LIBRARY
Date of Sale: 4.9.2005 – 4.10.2005
ID: OHCA05-P 10147
Received: 4.5.2005

662
Elaborate German Parcel-Silvered Black Cast-Iron Memorial Crucifix, in the Belle Epoque taste, fourth quarter 19th century, 50-1/2", w. 18". [250/400] *Illustrated*

663
Attributed to the New Orleans Academy needlepoint panel of Christ Blessing the Loaves, third quarter 19th century, 17" x 14". Presented in a later carved giltwood and plaster frame, c. 1890 and glazed. [250/400] *Illustrated*

664
After Leonardo da Vinci (Italian, 1452-1519) "Christ Salvador Mundi", oil on cradled panel, 26" x 18-1/2". Presented in a fine antique gilt and gesso exhibition frame. [1200/1800] *Illustrated*

665
Italian White Marble Figure of a Robed Franciscan Monk, bearing a lily spray, an open book and a child, set on an integral oblong base, the surface gently weathered, h. 23". [800/1200] *Illustrated Color Plate X*

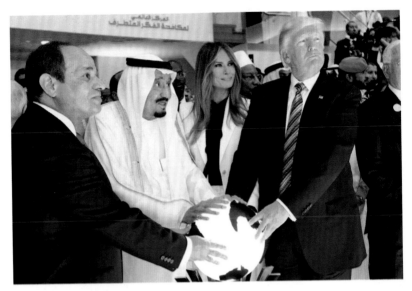

Opening of the Global Center for Combating Extremist Ideology, Riyadh, during President Trump's state visit to Saudi Arabia, 21 May 2017.

'Lot 9b. Leonardo da Vinci. Salvator Mundi, Saviour of the World. The property of three English Kings, Charles I, Charles II and James II.' Christie's auction of the *Salvator Mundi*, 15 November 2017, for $450 million.

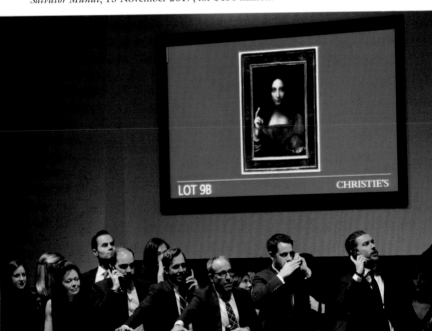

acting on behalf of Rybolovlev, and had known about the mark-up Bouvier made on the price of the *Salvator Mundi* and other paintings.

Sotheby's contract with Simon and his partners specified that the auction house was operating as an agent for them, and was to receive a commission on the sale of the *Salvator Mundi*. That gave it the legal obligation to secure the best possible selling price for its clients. Bouvier was known to Sotheby's, which had been a party in at least eleven of the thirty-seven sales to Rybolovlev that Bouvier had been involved in. Surely, thought Simon and Parish, Sotheby's Sam Valette must have known that Bouvier was selling on to Rybolovlev at a significantly higher price. 'The truth is, we were getting more and more indignant by the hour,' says Parish. 'The painting was extremely expensive. Surely when Valette took the painting up to Rybolovlev's daughter's $88 million apartment, he would have known the name of the person whose apartment he was visiting?'

Sotheby's state that they did not know to whom Bouvier was selling: 'Neither Sotheby's nor Mr Valette had knowledge of the relationship between Mr Bouvier and Mr Rybolovlev. Also, neither Sotheby's nor Mr Valette had knowledge as to the prices Mr Bouvier charged to Mr Rybolovlev.'

'They actually told us, at one point, they sent the picture, but they didn't know where it was going,' Parish recalls. 'I was once a porter at galleries. That's what I did a lot of the time for people like Colnaghi. You can't ship a picture across the street without a bill of lading and insurance coverage. They're telling us they took a $125 million picture and they didn't know quite where it was going? Somewhere on the West Side of Manhattan? Total nonsense, right?'

Legal meetings were held between the two sides. It was nerve-racking, Parish told me: 'If you're a dealer, what's the quickest way to go out of business? Sue Sotheby's! I think that's probably the quickest route. It was clear they were going to play hardball and it was really

an education, I have to say. But at the end of the day, they blinked.' Sotheby's settled out of court with Parish and Simon for an undisclosed amount rumoured to be around $10 million, and a non-disclosure agreement was signed. 'I think they knew they had even bigger problems on the horizon. So they wanted to get rid of us,' Parish concludes.

Meanwhile, Rybo also suspected that Sotheby's had known that Bouvier was buying on his behalf, and had colluded with Bouvier to overcharge him. Sotheby's denied this, claiming that it never knew to whom Bouvier was selling. Rybo's lawyers demanded to see all the emails between Sotheby's and Bouvier, relating to all twelve sales, as well as communications between Robert Simon and his consortium and Sotheby's relating to the sale of the *Salvator Mundi*. After two years of wrangling, Rybo's team obtained the communications: 972 documents with 2,622 pages of discovery material. In late 2018, after years of preparation, the Russian collector filed a bombshell lawsuit for $380 million damages against Sotheby's. The writ alleges:

> *Sotheby's – one of the world's largest and most famous art brokers and auction houses – materially assisted the largest art fraud in history. Plaintiffs, two companies based in the British Virgin Islands, were the victims. Yves Bouvier, their art adviser, masterminded the fraud. Sotheby's was the willing auction house that knowingly and intentionally made the fraud possible. Sotheby's actions instilled Plaintiffs' trust and confidence in Bouvier and rendered the whole edifice of fraud plausible and credible.*

Over the years, the complaint states, Sam Valette sent Bouvier many appraisals for works of art which he had himself sold to Bouvier and which Bouvier was offering for sale to Rybolovlev. Bouvier then forwarded these to Rybolovlev as evidence that he was going to pay a fair market price. The appraisals contained information about the

works of art, and on one known occasion a high valuation. On 24 July 2012, Valette emailed Bouvier a valuation for Modigliani's *Head* for \$100–\$120 million. Bouvier forwarded this valuation to Rybolovlev's office. Two months later, Valette sold the work to Bouvier for only \$37 million. Bouvier then sold the work to Rybolovlev for \$46 million cash plus a Degas *Dancer in Pink*, for which Rybolovlev had paid Bouvier over \$30 million in 2008. So Rybolovlev effectively paid \$76 million for the Modigliani. Later, when Rybo expressed concern that he might have been overcharged, Bouvier organised another set of valuations for individual works of art from Sotheby's, with prices in the vicinity of what Rybo had paid. Rybo's lawyers claim that by then Valette knew the lower prices which Bouvier had paid, because he had himself been involved in the sale of the works to Bouvier. Valette's valuation documents included a provenance list which included, where known, the prices paid, but 'Sotheby's concealed the evidence that Bouvier had in fact purchased the artworks at much lower prices by omitting the sales to Bouvier from the works' transaction histories it prepared'.

An amended complaint, filed in June 2019, contains remarkable citations of emails from Valette to Bouvier. Two memorable sentences include: 'The next day, Bouvier sent Petitioners' representative [i.e. one of Rybolovlev's staff] an email copied in large part from Valette's'; and 'The next day, Valette sent Bouvier a largely identical email stating that Tête was likely worth €80 to €100 million, with no explanation for the change.'[27] An email from Bouvier to Valette ran, 'I thought no one in Geneva was supposed to know about this operation!!!!!!' To which Valette responded reassuringly, 'I had a very clear and direct discussion on this subject with my colleagues in "risk management" in London. The message has been clearly heard and accepted.' Regarding the *Salvator Mundi*, Rybo claims to have the smoking gun proving Valette knew all along that Bouvier was buying for Rybolovlev. His legal filing asserts that: 'On March 24, 2013,

Valette told one of the da Vinci sellers [Simon, Parish and Adelson] that "the Russian" (i.e. Rybolovlev) wanted to pay less than $100 million.'[28] Sotheby's however deny that Valette ever made such a statement.[29]

No one can predict the victor in this quagmire of litigation. On the face of it, Rybolovlev appears to have a strong case. He had tasked Bouvier with finding him works of art, and Bouvier had charged him a percentage of the selling price in fees, as an agent would. He only ever bought works of art after Rybolovlev had agreed to buy them. He sent Rybolovlev email after email telling him how negotiations were going, as if he was reporting back to his client. He was also sometimes lying in those emails, claiming to have secured a price from the seller far above the one he was actually paying.

However, Bouvier and Sotheby's have better counter-arguments than one might initially think. Bouvier's defence is that he was operating simply as a dealer. He had first bought the works of art through his own company, and then that company had sold them on to Rybolovlev. The 2 per cent cut, he says, represented administrative fees, not commission, which by convention was anyway 2.5 per cent in the art world. As for his emails with their excited progress reports on supposed hard bargains, that was just normal salesman's patter, *les arguments de vente*.

In Singapore the judges were sympathetic to him. A ruling in 2018 ran: 'It is at least doubtful, even if not wholly incredible, that the respondents [i.e. Rybolovlev] genuinely believed that the remuneration for Mr Bouvier's services was limited to the 2 per cent fee that the respondents plainly knew they were paying him.'[30] The judge noted that auction houses took a 20 per cent commission on a sale, from both buyers and sellers. The Singaporean appeal court's verdict was that Rybolovlev's art-collecting companies

'received what they bargained for and at the price they were willing to pay'.*

With regard to Sotheby's, the auction house points out that it was part of the chain for only a third of the sales from Bouvier to Rybolovlev. It says that some of the valuations which Valette sent to Bouvier were 'informal market estimates of what particular works might be worth, a practice that often occurs in the art market', and adds that 'These were Mr Valette's personal speculations on how much a piece might be worth.' Other valuations, particularly the ones sent from autumn 2014 onwards, were *insurance* valuations, which, Sotheby's lawyers say, by definition, do 'not attempt to approximate the fair market value of a piece or what it might sell for at auction or private sale ... An insurance valuation often is higher than other types of valuations for a number of reasons, including because such valuations contemplate that the replacement piece would have to be purchased at retail, and also because there would be one less comparable piece if an original is destroyed.' Sotheby's legal team assert that 'While some of the insurance valuation prices were close to the amounts that Mr Rybolovlev claims he paid, others are significantly different from those prices.'

As for the charge that Sotheby's 'concealed' the prices Bouvier had paid for works of art in the provenance sections of their insurance valuations, the auction house argues that it had no obligation to list them, because it was writing the valuations for Bouvier, who would already know what he had paid.[31]

Even if Rybolovlev's lawyers were able to convince the American court that Sotheby's knew Rybo was Bouvier's client – something

* On past precedent, collectors rarely win cases against dealers and auction houses on such pricing issues, because law courts are generally confused by the lack of rules, and anyway cannot muster much sympathy when one billionaire accuses another of overcharging him in an unregulated offshore market.

the auction house explicitly denies – that would not mean that it was necessarily helping him with his profit margins. Collusion – as we know from Robert Mueller's inquiry into Donald Trump's Russian connections – is difficult to prove. And even if Rybolovlev's lawyers persuaded the court that Sotheby's insurance valuations were also market valuations, who is to say, given the fluctuations in the art market, that the auction house was not simply quoting the market prices at the time, and that Bouvier, in his good fortune, had been able to buy the art at a great discount?

'For me, the aim is sell at the highest price possible,' Bouvier told me. 'It's not moral, but it is legal. That's the problem!' At that, he laughed heartily.

Rybolovlev's lawsuits in Monaco have fared no better than those in Singapore. Whatever the benefits for him had been of purchasing art through his daughter's offshore trusts, they now put him at an unexpected financial disadvantage. During hearings held in the principality in 2016 and 2017, the judge asked Rybolovlev why he claimed to have been wronged by Yves Bouvier when the works of art did not belong to him but to another company, named Accent Delight, which was owned by a trust registered in the name of his daughter. Rybolovlev maintained that he had an 'oral agreement' with Bouvier that the latter would receive '2 per cent of the purchase price of works of art' as a commission. The judge then asked, 'How do you explain that this agreement with you was applicable to Accent Delight?'[32]

But far worse for Rybolovlev is the fact that in his relentless pursuit of Bouvier, he inadvertently drew the attention of the Monaco authorities to suspicious activity of his own, connected not to art but to politics. Rybolovlev's young lawyer, Tetiana Bersheda, made the mistake of secretly recording a conversation over dinner

between Rybolovlev, Tania Rappo and herself in an attempt to obtain proof that Rappo knew how Rybolovlev was being defrauded. She took her recording to the Monaco police, convinced that she had secured evidence against Rappo. But under Monégasque law recording someone without their permission is illegal. Soon enough, Rappo found out about the recording and sued Bersheda and Rybolovlev for contravening her privacy rights.

The Monaco police were less interested in Bersheda's illegal recording than in the friendly messages between Rybolovlev's team and senior Monaco politicians and civil servants, which they discovered by chance when Bersheda handed over to them her mobile phone, on which she had recorded the dinner. 'Monaco-Gate', as the excited press of the French Riviera called it, showed that the oligarch had been schmoozing Monaco's political elite by offering free tickets to football matches and ballet performances, skiing holidays, helicopter rides, expensive gifts of caviar and champagne, and jobs at his football club for their children. He had been building a network of patronage, Russian-style. Bersheda's phone logs also showed that she had been in close contact by text message with members of the Monaco police force in the run-up to Bouvier's arrest. The intensity of the police operation against Bouvier appeared to be a product of these connections. Monaco's minister of justice, Philippe Narmino, suddenly took early retirement.

All this has generated yet another tier of investigations into Rybolovlev himself. In November 2018 he was detained by the Monaco police and placed under formal investigation for corruption. Rybolovlev's lawyers have pointed out that he has not been charged with any crime and that he denies any wrongdoing. A year later, in December 2019, a judge in Monaco's Court of Appeal threw out Rybolovlev's case against Bouvier, on the grounds that the Monaco authorities' investigation of the Freeport King had

been 'conducted in a biased and unfair way without the defendant being in a position to retrospectively redress these serious anomalies that permanently compromised the balance of rights of the parties', by which the court was referring to the close relations between Rybolovlev's team and Monaco's police and judiciary. And so it has come to pass that an art market scandal, which was originally about whether a collector had been defrauded by a dealer, has now snowballed into a question of whether an art collector corrupted an entire political system.

The lawsuits have yet to run their course. In the meantime, the repercussions of the 'Bouvier Affair' have been immense. The reputations of both the dealer and the oligarch lie in tatters. Bouvier's clients have deserted him, and he has sold his art storage business. 'I'm blacklisted at Sotheby's. I'm blacklisted at Christie's. I'm blacklisted everywhere,' he says. 'Rybolovlev wanted to destroy me.' Sources say that several other collectors who sold artworks to Bouvier, and which he in turn sold to Rybolovlev, are talking to their lawyers. Rybolovlev's dream of building the finest art collection in the world is over, and he faces the shame of being under official police investigation.

The scandal prompted change at the Geneva Freeport. Its president, Christine Sayegh, resigned. Her replacement, David Hiler, said, 'The Bouvier affair shook the basket. It exposed the financialisation of the art market, a market that is not regulated, hence the risk of money laundering and tax fraud.'[33] New regulations have been introduced regarding the transparency of ownership, though whether these contain convenient new loopholes remains to be seen.

Dmitry Rybolovlev told me that 'After everything I've gone through I still love art,' but he also told the *New Yorker* that he felt 'a complicated energy' when he looked at his paintings. 'It's also about feeling you have been fooled,' he admitted to *Tatler*.[34] He has sold

many pieces from his collection since 2016, usually for tens of millions less than he paid for them. The Gauguin *Te Fare*, bought for $54 million, went for just $25.2 million; a Picasso, *Joueur de flute et femme nue*, bought for $35 million, sold for $5.7 million; a Magritte bought for $43.5 million fetched only $12.7 million. Fortunately he only lost $14 million on his most expensive purchase, Klimt's *Water Serpents II*, bought for $183.8 million and sold for $170 million.

In the litany of Rybo's misfortunes, there is one ray of light. His wife Elena's divorce proceedings had been continuing all this time through the Swiss legal system. A Geneva court ruled initially that all the assets he had bought through his daughter's trusts had to be included in the divorce settlement, which was therefore calculated at $4.5 billion. But Rybolovlev appealed, arguing that Swiss matrimonial law should not be applied to assets held by a trust that was registered outside the country.* A Swiss cantonal appeal court eventually agreed with that argument and reduced the divorce settlement to $604 million, calculated as 50 per cent of the comparatively modest value of Rybolovlev's fortune in 2005, before he began collecting art in earnest and building a global luxury property empire through his daughter's trust funds. Rybolovlev may have lost $1 billion on the art, but the offshoring of his art collection and other assets has saved him $4 billion on his divorce.

* * *

* Elena Rybolovleva's lawyers argued that Rybolovlev's purpose in these various investments had been to place his wealth as far out of the reach of his wife as possible. But the oligarch's lawyer Tetiana Bersheda has countered, 'The purpose was asset protection and succession planning. During that period, many leading Russian businessmen were creating foreign trusts to protect their assets from potential risks of corporate raiding in Russia – it was a common practice amongst the top cadre of entrepreneurs to which Mr Rybolovlev belonged.'

The *Salvator Mundi* also came out on top, so to speak. To trace the ledger of its Cinderella-like transformation in just eight brief years:

In 2005, Robert Simon and Alex Parish bought it from a New Orleans auction house for $1,175. In 2013, Yves Bouvier bought it from Simon, Parish and Warren Adelson – via Sotheby's – for $80.6 million (or, $68 million plus a $12 million Picasso). One day later, Dmitry Rybolovlev bought it from Bouvier for $127.5 million.

Nothing in the known universe – no item, object or quantity of material – has ever appreciated in value as fast as the *Salvator Mundi* attributed to Leonardo da Vinci. But even the figure of $127.5 million would be dwarfed in turn four years later, when Dmitry Rybolovlev decided to sell the *Salvator Mundi* by auction at Christie's in New York.

LDV RIP

In the autumn of 1516 a small caravan of mules and men wound its way towards France, carrying the sixty-four-year-old Leonardo da Vinci, his longest-serving assistant Francesco Melzi, his household furniture and at least three paintings (though possibly several more): the *Virgin and Child with St Anne*, *St John the Baptist* and the *Mona Lisa*. Salai probably followed them a few months later.

The French court had already fallen in love with Leonardo da Vinci. In 1499, after Naples and Milan fell to France in the Italian Wars, the French minister of finance Florimond Robertet commissioned a painting from Leonardo, a *Madonna of the Yarnwinder*. Leonardo turned down local commissions, such as Pietro da Novellara's requests for Virgins and Christs for Isabella d'Este, citing his obligations to the French court. The French king himself, Louis XII, is said to have gone to see and to have admired *The Last Supper* in 1501, and to have explored the possibility of removing it from its wall and taking it home with him. Five years later, in 1506, when Leonardo left Florence for Milan it was at the insistence of the French. As he prepared for his departure he promised the governor of Milan, Charles d'Amboise, that he would bring with him 'two

pictures of … Our Lady of different sizes … for our most Christian
King or for whomsoever your Lordship pleases'. After finally meeting
his hero, Charles d'Amboise wrote glowingly:

> We loved him before meeting him in person, and now that we have
> been in his company, and can speak from experience of his varied
> talents, we see in truth that his name, although it is already famous
> for painting, has not received sufficient praise for the many other gifts
> he possesses which are of extraordinary power.

Charles d'Amboise commissioned 'certain designs and architecture',
while the French king said he wanted Leonardo to paint 'small
pictures of our Lady or other things according to what I might devise
in my imagination'. Indeed, a painting by Leonardo was delivered to
the French court in 1506–07. It was described as 'a little picture by
his hand that has recently arrived here and is held to be an excellent
thing'. This was probably the *Madonna of the Yarnwinder*, which he had
begun in 1500 in Florence and eventually finished in Milan, but the
description is vague: it could, in theory, have been Simon and Parish's
Salvator Mundi.

After Louis XII died in January 1515, the new French monarch,
Francis I, appointed Leonardo 'First painter, architect and engineer to
the King'. He lured him to France with an annual pension of 2,000
ecus, a huge retainer for an artist, on a level with that of a high-
ranking military officer, and five times the salary that Louis XII had
paid him in Milan. Leonardo's secretary and assistant Francesco Melzi
received 800 ecus per year. Francis I gave Leonardo and his modest
retinue a pretty red-brick-and-stone mansion, Clos Lucé, not far
from the king's summer residence, the Château d'Amboise on the
Loire.

The king is said to have visited Leonardo – or invited him to the
palace – every day. He even built an underground tunnel connecting

his castle with Leonardo's new home. The Florentine sculptor, gold-smith, poet and soldier Benvenuto Cellini, who worked at the grand-est palace in the royal property portfolio, Fontainebleau, in the 1540s, described the king's fondness for the artist:

> *King Francis was so extraordinarily enamoured with Leonardo's great*
> *talents, and took such pleasure in hearing him talk, that he would*
> *deprive himself of his company on only a few days of the year ... I*
> *cannot resist repeating the words, which I heard the King say about*
> *him, in the presence of the Cardinal of Ferrara and the Cardinal of*
> *Lorraine and the King of Navarre. He said that he did not believe*
> *that a man had ever been born who knew as much as Leonardo, not*
> *only in the spheres of painting, sculpture and architecture, but that he*
> *was also a very great philosopher.*

Leonardo remained active as an artist, architect and mathematician in his last years. He drew up designs for a new palace for Francis I's mother Louise of Savoy in the Romorantin area of the Loire Valley, which was never built. He made turbulent drawings in black chalk and ink of floods and storms, offering art historians a conveniently apocalyptic set of images with which to frame the final chapter of their monographs on him.

In October 1517 a papal envoy, the Cardinal of Aragon, and his aide Antonio de Beatis visited Leonardo. Antonio's travelogue is the only eyewitness account we have of the artist in these last years:

> *After the meal we left Tours where we had been staying since the*
> *beginning of the month, to go to Amboise, a distance of seven leagues*
> *... We went to pay a visit, in one of the nearby towns, to Mister*
> *Leonardo da Vinci, a Florentine,* more than seventy years old [de Beatis got Leonardo's age wrong by five years], *a most excellent*
> *painter of a time, who showed three pictures to our Lordship, one of a*

> *certain Florentine lady, painted from the model, at the request of the late Magnificent Guiliano de' Medici* [the *Mona Lisa*], *another of a young St John the Baptist, and one of the Madonna with the child sitting on the knees of St Anne, all three being of a rare perfection.*

Leonardo also laid out his notebooks for the visitors, which Antonio and his master pored over in amazement:

> *This noble spirit has compiled a most unusual book of anatomy, illustrated by means of painting, with the limbs, muscles, nerves and veins, different parts of the intestine, a book which permits the discovery of the human body, man and woman alike, which no other before him had yet done. We saw this book with our own eyes and he told us he had undertaken more than 30 dissections of bodies of men and women of all ages. He has also written on the nature of water, on various machines, and on so many other things, that he might, after what he told us, use to fill numerous tomes, all in the common tongue, which, if they ever saw the light of day, would be beneficial and most pleasant.*

The last dated drawings and words Leonardo committed to paper were on 24 June 1518 in the '*palazzo del clu*', as he called Clos Lucé. The page is dotted with geometric forms as he returns yet again to his obsessive study of geometry, theorems and proportions:

> *If a straight line is divided in two equal parts and in two unequal parts, the result of the multiplication between the unequal part and the other, with the square of the difference, which is equal to the unequal part, is equal to the square of the equal part …*

In the top margin, upside down, he writes, 'I will continue …'

* * *

Clearly, Leonardo was obsessed with mathematics and science until the end. What is less clear is his stance on spirituality and religion. Some scholars suggest that the *Salvator Mundi* was in his studio at this time, but that he didn't show it to anyone outside a small circle of his assistants (who must have seen it in order to produce copies), because it was his reckoning with God, his spiritual testament. It was a painting about which he was more secretive and possessive than any other. Perhaps he began it in Milan and still did not consider it finished. Perhaps he was never satisfied with his portrait of Christ, finding it as difficult to paint as he had the head of Christ in *The Last Supper*. Perhaps he did not dare show the world his idiosyncratic interpretation of one of the most ancient of Catholic iconographies, a bravely experimental picture in which the traditional red and blue of Christ's garments had been reduced to a simple blue, and where the *sfumato* is more ethereal than in any of his other paintings, to conjure up an image poised between an impression left on a shroud and a living person, between Byzantium and Renaissance portraiture, between the past and the future.

But there is no evidence in Leonardo's notebooks of a radical Christian piety. Like many Europeans on the eve of the Reformation, he criticised the Church's venality and rituals. Of people who prayed before pictures of saints and lit votive candles, he wrote, 'They will ask pardon from one who has ears and does not hear; they will offer light to one who is blind.' He called friars 'pharisees'. Certainly, he questioned religion from the point of view of science. Fragmentary lines suggest that he did not believe in the flood, or that the foetus had a soul. He pointed out that the resurrection was physically impossible: 'The spirit … if it should assume a body, could not penetrate or enter where the doors are shut.'

Leonardo was neither a fervent believer nor a heretic. His belief in the primacy of mathematics was not as far from contemporary Christian thought as you might think. The artist acclaimed 'the

supreme certainty of mathematics', echoing the words of the influ-
ential Christian theologian St Augustine written a thousand years
earlier: 'Numbers are the universal language given to us by the deity
as confirmation of the truth.' Leonardo had no inclination 'to write
or give information of those things of which the human mind is
incapable and which cannot be proved by an instance of nature', but
he also conceded that 'the sacred books … are the Supreme Truth'
and priests were 'those fathers of the people who know all secrets'.
Scholars agree that the great artist subscribed to the Augustinian idea,
widespread in the Renaissance, that there were some things only
clerics could understand.[1]

Irrefutable evidence that Leonardo painted Simon and Parish's
Salvator Mundi continues to elude art historians, but there is one
strong clue which supports their suggestion that the painting was
commissioned from Leonardo's workshop by the French court: the
blue colour of Christ's garment. In Italian Renaissance paintings,
Christ is almost invariably depicted wearing a red tunic and a blue
robe. In certain devotional paintings of scenes from the Passion, he
may be seen only in red. In German and Flemish paintings and
manuscript illuminations Christ either wears garments in two
colours or, if just one, then purple. Dianne Modestini says that
there is no possibility that part of the cloth may originally have
been red, and that a later restorer painted it over with blue. The
monochrome blue of Christ's clothing is the single most unusual
and anomalous feature of the *Salvator Mundi*, making it all the more
surprising that it was never mentioned in any research on the
painting until 2019.

All the other clues presented to suggest the provenance of the
Salvator Mundi in the sixteenth and seventeenth centuries have multi-
ple possible explanations. But the blue colour of Christ's garment is

so unusual and unprecedented that it cannot be mere chance. If it has a rationale, there can only be one – the French court.

Blue and gold were the colours of the French royal house, the Valois – golden *fleurs-de-lys* on an ultramarine background – and also of patron of the arts Florimond Robertet's coat of arms. In some Books of Hours, the beautiful illuminated medieval manuscripts of prayers and psalms, such as those belonging to the Duke of Berry, as well as in fifteenth-century French chronicles such as the *Grandes Chroniques de France*, illustrated by Jean Fouquet or the Limbourg Brothers, one finds scenes in which French kings and nobles wear blue robes decorated with gold *fleurs-de-lys*. In the Duke of Berry's Hours, and those of Etienne de Chevalier in New York's Morgan Library & Museum, which was finished for Jean Robertet, Florimond's father, around 1470, there are also New Testament scenes in which Christ wears a plain blue robe, sometimes with a golden geometric-patterned border.*

Leonardo's client is unlikely to have been Charles d'Amboise or Louis XII's widow Anne of Brittany, because the colours of their coats of arms were red and yellow. Anne of Brittany's Book of Hours, furthermore, contains no 'blue Christs'. The Valois King Francis I was a descendant of the Duke of Berry, but he is unlikely to have been the recipient of the painting, since it is not among the five Leonardos which the papal secretary and collector Cassiano del Pozzo described seeing when he visited the palace in 1625. One realistic contender is

* Frank Zöllner writes in the 2019 edition of his *catalogue raisonnée* of Leonardo's paintings: 'An aspect of the New York *Salvator Mundi* that has been wholly ignored up till now is the exclusively blue raiment worn by Christ. This uniform drapery colour is unusual in a portrait of Christ painted on panel in this epoch, but is found in French and Netherlandish book illumination. Blue robes furthermore played a central ceremonial role in the coronation of French kings, who were anointed in a reference to the anointing of Christ. Further research in this area could be useful.'

Florimond Robertet, who owned a painting of St Veronica by the Bolognese artist Lorenzo Costa in which Christ's face is imprinted, as the story tells, on a piece of cloth. Another possible patron is Louise of Savoy, who was briefly regent of France and who, as we have seen, commissioned Leonardo to design a palace for her.[2] But that, as we shall shortly see, is only one of two possible interpretations of the blue clue.

It is unlikely that the *Salvator* was in Leonardo's studio when Pietro da Novellara visited back in 1501, or even when Antonio de Beatis came in 1517, but Leonardo and his assistants may have painted it in the sixteen years between those dates. It could have been begun around 1504–08 – a date which matches the style of the preparatory drawings – and been given to the client before 1517. It is thus rather likely that Leonardo supervised and finished Simon and Parish's *Salvator Mundi* during the period when he worked for the French king and his courtiers.

If this is a workshop painting for the French court, then its style implies that it was actually completed *before* Leonardo left for France. But by whom? Every Leonardo scholar has their own pet theory. The latest theory of Oxford art historian Matthew Landrus is that Leonardo left the *Salvator* unfinished and then Bernardino Luini completed it,* while Carmen Bambach from the Met wrote in her recently published four-volume study of Leonardo that 'most of the beautiful original painting surface is by Boltraffio, with some

* Landrus writes: 'In 1508, Luini moved his studio to Milan and was soon in contact with Leonardo, who was then working for Louis XII. Coincidentally, one of Leonardo's red chalk grotesque head studies of around 1508 was copied by Luini or an associate. With this drawing is an early sketch for Luini's *Christ Among the Doctors*. Facial features of both the Abu Dhabi and De Ganay *Salvator Mundi*s compare remarkably well with Luini's Christ, visible when the faces of the *Salvator Mundi* and *Christ among the Doctors* are overlapped.' Matthew Landrus, '*Salvator Mundi*: Why Bernardino Luini should be back in the frame', *The Art Newspaper*, 3 September 2018.

retouches by Leonardo himself, especially on Christ's proper right blessing hand and portions of that sleeve, his left hand and the magnificently painted crystal orb he holds'. Independent Swiss art historian Dietrich Seybold points out similarities in the *Salvator*'s dark *sfumato* with a handful of obscure workshop paintings, such as Columbia Museum's *Young Woman with the Scorpion Chain*, which today is attributed to Boltraffio but which was once attributed to Cesare da Sesto, or the Louvre's *Virgin with Scales*, whose author no one dares even guess at. The curators of the Louvre's anniversary Leonardo exhibition, Vincent Delieuvin and Louis Frank, both think Salai is the most likely author of the *Salvator Mundi*. Frank Zöllner does not think it is possible to name the assistants involved and in the latest edition of his *catalogue raisonnée*, he attributes the picture to 'Workshop of Leonardo, after a design by Leonardo and with Leonardo's participation'.

Nor is there any firm view about where the picture was painted. The preparatory drawings and walnut wood suggest Leonardo's second Milan period, but Margaret Dalivalle and Frank Zöllner believe that there is a remote possibility that the picture was painted during his little-documented period in Rome, 1513–16. The blue garment and raised blessing hand of the *Salvator Mundi* are close to the Christ enthroned in Giotto's monumental *Stefaneschi Altarpiece*, commissioned for the original St Peter's Basilica, while Christ's crossing bands were also worn by Renaissance popes, and can be seen in a statue of Pope Leo X.*

In my view one contender who cannot be ruled out is Giampietrino. He is the least studied of Leonardo's well-known assistants. There is no monograph about his life and work. The Hermitage in St Petersburg holds a number of his paintings – *Christ with the*

* Statue of Leo X by Domenico Aimo, 1513–21, in Santa Maria in Aracoeli, Rome.

Symbol of the Trinity, a *Penitent Mary Magdalen* and a *St John* – which bear comparison with the *Salvator Mundi*. They are all small devotional paintings, with a single saint on a black background, just like the *Salvator Mundi*. They share the golden *sfumato*, helix curls and softly modelled anatomy of Simon and Parish's painting. The *Penitent Magdalen* is painted on walnut. Giampietrino outlived Leonardo by three decades and continued to paint in a Leonardesque style until his death in 1549. The Hermitage's paintings were probably painted after Leonardo's death, and, if Giampietrino painted the *Salvator Mundi*, it was surely after the master's death. On the other hand, the Hermitage's paintings are all dominated by a red palette. There is not a trace of lapis lazuli.

My money, for what it is worth, is on Cesare da Sesto, his late style. Cesare is one of the most mysterious of the Little Leonardos. Next to nothing is known of his life, aside from the fact that he was born in Lombardy, the son of nobility, in 1477 and died in 1523 from a long fever, six months after his father, probably of the plague. His name is mentioned very occasionally in a contract or a payment for an altarpiece, and once some monks recorded that he offered them a drink when they came to settle the bill on a commission. He spent several years working in southern Italy, including Rome, where around 1508 he painted frescos at the Vatican at the same time as Raphael and Michelangelo – so he must have been regarded as a top-tier artist. Cesare and Leonardo's locations are likely to have overlapped in Milan in 1506–08 and in southern Italy in 1513–15, during Leonardo's Roman sojourn. In 1515–18 Cesare returned to Milan, where he established a studio. There, like Luini, Cesare continued painting with heavy *sfumato*, utilising Leonardo's drawings after the latter's death.[3] In Cesare's *St Jerome* in Southampton and *Christ Carrying the Cross* in Grenoble, we find the elegant and softly modelled anatomy of the *Salvator Mundi*; in Cesare's *Virgin and Child with Saints* on the wall of the drawing room of the country house

Elton Hall in Cambridgeshire, we find the intense, almost pastiche-like *sfumato* of the *Salvator Mundi*; and we even find, as I have mentioned (see footnote, page 107), that the little stones on the ground at the feet of the Virgin in Cesare's *Madonna and Child* at the Poldi-Pezzoli Museum in Milan look remarkably similar to the internal flaws in Simon and Parish's painting's crystal orb. Cesare painted on at least one occasion on walnut.[4]

On 2 May 1519 Leonardo da Vinci died of a stroke, at the age of sixty-seven. Francesco Melzi and a few priests were at his bedside. Melzi sent his condolences to Leonardo's relatives in an extraordinarily heartfelt letter:

> *I understand that you have been informed of the death of Master Leonardo, your brother, who was like an excellent father to me. It is impossible to express the grief I feel at his death, and as long as my limbs sustain me I will feel perpetual unhappiness, which is justified by the consuming and passionate love he bore daily towards me. Everyone is grieved by the loss of such a man whose like Nature no longer has it in her power to produce. And now Almighty God grants him eternal rest.*

Leonardo's will prescribed a funeral that was perfunctory and unostentatious by sixteenth-century Roman Catholic standards. A short cortège wound its way through the grounds of the Château d'Amboise towards the chapel of Saint-Florentin (which is no longer standing). Sixty poor men, each carrying a candle – hired mourners, as was the custom, albeit a relatively small contingent – followed his coffin. His body was interred in the chapel, and three high masses were celebrated for his soul, while, as he stipulated in his will, 'on the same day thirty low masses' were performed at another church, St

Gregory, and a further three at the larger Romanesque basilica of St Denis. There is one final clue to the authorship of the *Salvator Mundi*, in a burial document, in which Leonardo is described not as court painter but as *l'ancien directeur du Peincture du Duc de Milan*, the former director of painting of the Duke of Milan, emphasising his role running a studio, rather than painting pictures himself.

In his will, Leonardo largely divided his belongings between his two former apprentices Gian Giacomo 'Salai' Caprotti da Oreno and Francesco Melzi. Melzi was given his master's tools, notebooks and drawings, as well as his clothes and some money. Leonardo divided the land he had been given many years before by the Duke of Milan between Salai and another servant, and it seems that Salai received another substantial gift before his friend and employer died. There is no mention in the will of paintings, but in 1518, Leonardo probably entrusted Salai with the task of selling to the French king the works of art which he had kept with him. An invoice shows that Salai sold them for the vast sum of a little over 2,604 *livres tournois*,* one of the currencies in circulation in France at the time; unfortunately we do not know which paintings were in this sale. The deal made Salai a very rich man for the remainder of his days.

Five years after Leonardo's death, in 1524, Salai was shot and killed by French troops besieging Milan yet again. He left behind paintings, twelve in all, which were most likely his versions of his master's masterpieces, including a *Mona Lisa*, a *St Anne* and a *St John*. At the bottom of the list is a *Christ as God the Father*, which was surely a version of the *Salvator Mundi* – perhaps Simon and Parish's; perhaps the portrait of Christ, signed and dated 1511, which is now in the

* Comparisons reveal how expensive they were: the Leonardesque painter Andrea del Sarto was earning 225 *livres tournois* per year, while in the 1530s the French king bought a consignment of Italian paintings for 645 *livres tournois*.

Ambrosiana in Milan; or perhaps yet another painting of this subject. This listing is the last of a possible *Salvator Mundi* by Leonardo or his followers for over a hundred years. The next occurs in 1642 in an inventory of the contents of the royal palace at Fontainebleau, which lists *un Christ a demi corps*, a half-length figure of Christ, by Leonardo.

After Leonardo's death, Francesco Melzi carefully preserved his master's notebooks and drawings, and shared them with artists who lived in or visited him in Milan. The poses, limbs and faces drawn by Leonardo appeared in hundreds of pictures made by artists long after his death. Various manuscript copies of Leonardo's notes on painting were in circulation from the 1570s onwards. Melzi's son and heir Orazio was, however, less reverential towards the great artist. He sold a few of the documents, and gave others to the monk and architect Giovanni Ambrogio Mazenta and the sculptor Pompeo Leoni, who later took some of them to Spain, where some drawings would be bought by courtiers of Charles I of England.

Over the next five hundred years, Leonardo's paintings, notes and drawings were haphazardly spread around the world, his masterpieces handed from queen to prince and from lord to empress. Pages of drawings and notes were torn from their bindings and hawked in the corridors of palaces and castles. Paintings were copied, and the copies copied again. His body of work, already fragmentary, fragmented once more into a myriad of shards and slivers of knowledge and imagination, each one carried, spinning, on the currents of commerce and culture to far-flung destinations. First to Paris, Madrid, Cologne, London, then St Petersburg, Warsaw, Washington, New York; Hong Kong, Riyadh and Abu Dhabi, until, like the micro particles of plastic one finds in the human body, traces of Leonardo's free-thinking spirit can be found in almost every human mind on the planet, part of the anatomy of civilisation.

Leonardo is for us today an icon of intellectual and artistic genius, but also an icon of more human attributes: of the untiring and playful

curiosity of a child, of grandiose plans made but never executed, of impossible dreams and schemes, and even of disappointment in oneself.

NINETEEN MINUTES

'And so, ladies and gentlemen, we move to the Leonardo da Vinci, the *Salvator Mundi*, the masterpiece by Leonardo of Christ the Saviour, previously in the collection of three kings of England, King Charles I, King Charles II and King James II,' auctioneer Jussi Pylkkänen announced, signalling the start of the bidding. It was 15 November 2017, and the *Salvator Mundi* was back in America, and up for sale once again.

Every seat and available standing space in Christie's saleroom was filled at the auction house's headquarters in New York's Rockefeller Center. Along a side wall, staff manned an array of phones through which bids could be taken from UHNWIs (ultra-high-net-worth individuals) who were unable to fly in for the occasion, or who wished to conceal their identities. At the front of the room the auctioneer stood behind a dais, flanked by a podium of Christie's specialists on one side and administrative staff at a desk on the other. Crammed together in a pen in a corner were the art market reporters, notebooks and smartphones at the ready. On the mezzanine level, another set of opportunities for anonymity took the form of skyboxes – viewing rooms fronted by smoked glass. One could only guess as

to whether Christie's owner, the luxury goods magnate François Pinault, was in one of them. There was a spillover room, also packed, with video links to the main hall.

The crowd featured familiar faces seen at every contemporary art auction – gallerists, dealers, collectors, art advisers, and members of the public who are excited by ostentatious displays of wealth. Many were armed with a numbered paddle which they could use to bid for works of art to add to their collections, or to defend the value of artists they represented, for whom the bidding might be sluggish, or to try to encourage higher prices for artists they admired. Among them were mega-gallerist Larry Gagosian, who runs a network of sixteen art spaces around the world; David Zwirner, who has five; and Marc Payot of Hauser & Wirth, with a chain of nine outlets. Collector Eli Broad, the founding chairman of the Museum of Contemporary Art, Los Angeles, and the owner of his own museum, The Broad, was in the audience, as was Michael Ovitz, co-founder of Hollywood's Creative Artists Agency and former president of the Walt Disney Company. Martin Margulies, a property developer who exhibits his own collection in a 45,000-square-foot warehouse in Miami, was in attendance. Most of those present were further down the art world's food chain, of course, such as the thirty-five-year-old London-based Russian art adviser who had risen from running the door at up-market Moscow nightclubs to travelling between Moscow, New York and Bermuda buying art on behalf of wealthy Russians. Like scores of other voyeurs, she would raise her hand, holding an iPhone rather than a paddle, to record the bidding in wobbling videos destined for YouTube. Robert Simon did not normally attend contemporary art auctions, but tonight he made an exception.

The room hummed with a smooth burble of excitable whispers and private confabs. Most unusually there were two colours of paddles for the evening's proceedings. Christie's had issued special red ones exclusively for clients who had submitted to an extra set of

financial checks to prove that they could afford to bid on the *Salvator Mundi*.

The auction had been preceded by a multi-million-dollar global marketing campaign. By the time the *Salvator* arrived in New York it had been shown in pop-up exhibitions on a whistlestop tour of San Francisco, Tokyo and London. Approximately 27,000 people had come to see the picture in those four locations, including celebrities like Leonardo DiCaprio, Patti Smith, Jennifer Lopez and baseball superstar Alex Rodriguez. Christie's had printed large posters in the style of movie advertisements, emblazoned with the title *The Last da Vinci*. The auction house commissioned the photographer Nagav Kander to make a portentous film that showed a diverse sequence of onlookers, one after another, isolated against a black gloom just like the *Salvator*, staring in awe at the painting. Age, youth, smiles, astonishment, tears and sunglasses – the four-minute film had it all. The journalist Alistair Sooke, the *Daily Telegraph*'s art critic, was persuaded to make a promotional film for the painting in New York. 'I've just come inside from the city streets, a maelstrom of activity, human hustle and bustle,' he told the camera. 'And here suddenly you are stopped in your tracks and it sucks you towards it. It has this quiet aura, and it's really quite humbling and moving to be confronted by this face-to-face. You are right up close next to divinity itself.' Finally, Christie's had, quite exceptionally, printed a separate catalogue, thick and glossy, with numerous essays and close-up illustrations, entirely devoted to one lot: 9b, the Leonardo. On the opening pages was a quotation from Dostoevsky: 'Beauty will save the world.'

In the weeks preceding the auction, questions regarding the painting's authenticity had mounted in the media. Print reporters and television crews called on Dianne Modestini regarding her restoration work, and she felt a duty to come to the painting's defence. She remembers, 'It was frenetic. There were all these constant ill-informed journalists, and these other people who call

themselves Leonardo experts, writing about how it wasn't by Leonardo. All the talk was about its condition.' Jerry Saltz, the legendary art critic of the *Village Voice*, wrote, 'One look at this painting tells me it's no Leonardo. The painting is absolutely dead.' Scott Reyburn in the *New York Times* wrote that the painting came 'with plenty of baggage'. Frank Zöllner published a piece in *Monopol* magazine in Germany saying, 'The design certainly comes from Leonardo but this is a workshop painting. It is about money. A good workshop painting would fetch an estimated $20 million, a work only by Leonardo $200 million.'[1]

Every aspect of the sale of the *Salvator Mundi* broke down rules and conventions. For one thing, the painting was placed in the wrong category of sale. It should have been, by definition, in an Old Masters auction, but for the first time Christie's put a Renaissance painting in a contemporary art sale. That radical idea came from Christie's maverick staffer Loïc Gouzer. 'I was always saying, one day I would like to try to get this painting for auction,' Gouzer told an audience at a promotional Christie's talk in Hong Kong. 'It's the ultimate. In the last few years I've been regularly calling the owner [Dmitry Rybolovlev] and saying I think it would be a good moment.'[2]

Since joining Christie's in 2011 Gouzer had established new record prices for a Picasso of $179.4 million and for a Giacometti of $141.3 million, in auctions with action-movie-esque titles such as *Looking Forward to the Past* and *Bound to Fail*. He once posted a photograph on Instagram of a Modigliani nude, up for auction for $100 million, with the accompanying line 'Difficult to say which you would want more, the painting for a lifetime or the model for a night?' As for the *Salvator Mundi*, Gouzer told the international media that it was 'the greatest discovery of the last two hundred years'.

No Old Masters collector had ever been persuaded to consign a painting to an auction for the reason Gouzer offered: 'I was working with a colleague of mine in New York on securing an Andy Warhol

called *Sixty Last Suppers*, which is a work that he did after a repro-
duction of da Vinci's *Last Supper*. Suddenly, we had this incredible late
Warhol and I called the owner [of the *Salvator Mundi*] and said, if you
ever want to do it, it's the time to do it because we have the perfect
context for it.'[3]

Gouzer and his colleague Alex Rotter were seeking to capitalise
on the market for trophy works among the world's handful of
multi-billionaire collectors, who concentrate almost exclusively on
the modern and contemporary art market. The contemporary art
market had grown fifteen times over since the early 2000s, with total
global revenue rising from under $100 million in 2000 to over $1.5
billion in 2016.[4] Meanwhile, the Old Masters market has been stag-
nant.[5] If the *Salvator* had been consigned to an auction for its rightful
category, it would probably have fetched under $10 million, not only
because wallets are lighter there, but because minds are more cautious
and eyes more discerning. Gouzer says he and Rotter had no idea
what estimate to give for the *Salvator*. 'There's never been a painting
of this importance, ever, at auction. We just decided that $100 million
seemed like a good, round number. If I bring a Francis Bacon to
auction and we have an estimate of $60 million to $80 million, we
immediately have people calling the front desk asking, "Why are you
selling a painting for so much money? This is so expensive, it's a
scandal. How dare you?" But in the case of the Leonardo, it was the
opposite. We had people calling the front desk every day, saying this
should be a $2 billion painting.'[6]

Christie's organised the now-conventional third-party guarantee,
provided by a wealthy investor – a minimum guaranteed price with-
out which sellers would not have been persuaded to part with their
pictures. The *Salvator* was backed by a third-party guarantee of around
$80–100 million. That meant that if higher bids failed to materialise
the guarantor would buy the *Salvator* for $100 million, and the seller,
in this case Dmitry Rybolovlev, would get back most of what he had

paid for the work. The exact nature of these guarantees varies, and they are confidential, but the guarantor would typically receive 25 per cent of the profit made by the auction house in the event that the work sold above the guarantee, with the auction house raking another 25 per cent for itself for the deal. It could be a very lucrative night's work, if one had $100 million or so sitting in the bank.

Such third-party guarantees are common for high-value lots in art auctions today. No one knows for certain the identity of the *Salvator's* guarantor, but it is strongly rumoured to have been Taiwanese collector Pierre Chen.*

The sale of *Salvator Mundi* was one of the longest and strangest auctions of an individual lot ever held. The Renaissance painting was sandwiched between an austere conceptual black-and-white oil painting of the sea from 1969 by Vilma Celmins, and a fluorescent piece of 1980s graffiti art by Keith Haring. One art pundit joked that the reason the *Salvator* had not been put in an Old Masters sale was because most of it had been painted in the last ten years by Dianne Modestini.

Bidding commenced at $75 million, beginning with the auctioneer's usual fake calls, known as 'chandelier bids', to get the sale going. Critics say that chandelier bids are the first sign of the smoke and mirrors of the art market; insiders that they are a part of the theatre that everyone knows. 'Selling for $90 million,' said Pylkkänen within

* The *Salvator* was also rumoured to have been backed by a very unusual double guarantee: Rybolovlev and the owner of the Warhol were said to have guaranteed each other's consignments for undisclosed sums, shoring up their value to mutual advantage in a way that, some art market commentators say, distorted an already opaque and unregulated market. In return for the *Salvator*'s insurance policy, Rybolovlev is said to have guaranteed the Warhol for around $60 million. Cristina Ruiz and Anna Brady, 'Was a "Double-Bind Guarantee" Behind the $450m Leonardo Sale? Rumour Mill has Gone into Overdrive Over Record-Breaking Auction', *The Art Newspaper*, 30 November 2017.

twenty seconds, a signal that the painting had achieved the reserve price, which is never disclosed in the catalogues. Bidding swiftly sailed past $100 million. After only one minute and fourteen seconds it exceeded the last price paid for the painting, $127.5 million in 2013. It took two minutes and ten seconds for it to reach $180 million, surpassing the record auction price paid for a painting, $179.4 million for Picasso's *Women of Algiers* in 2015, and rose steadily to $220 million as four or five anonymous collectors competed via the Christie's staff on the phones.

Then the pace slowed. There were pauses, but Pylkkänen knew how to fill them. At $200 million he took a glass out from under the table. It surely contained only water, but he sipped it as if it was vodka, staring around the room with a deadpan expression as if he were a comedian in an old silent movie. The audience laughed indulgently. Bidding stalled around $280 million, and the picture was almost sold for $300 million. That would have equalled the record price for the private sale of a painting, jointly held at that time by a Gauguin bought by the Qatari royal family and a de Kooning sold by Hollywood magnate David Geffen to hedge funder Kenneth Griffin. 'Three hundred million. A historic moment. We will wait,' said Pylkkänen.

On the *Salvator* chugged, creeping up slowly as two remaining anonymous bidders duelled via the phones, one represented by Alex Rotter, the other by the Old Masters specialist François de Poortere. At nine minutes and ten seconds in, Pylkkänen remarked, 'Still two of you in the game here,' a croupier unselfconsciously indicating the proximity of the art market to a casino. He called out the numbers with the unblinking insouciance that is *de rigueur* for the job: 'Three hundred and twenty million. I'll have to hurry you … 325 million? Oh, 322 million – do tell me! … At 325 million are we all done? … 328 million … 350 million was called on the phone … and looking for another bid … we will pause …'

A difference in temperament emerged between the two competing bidders. Clues to their identities filtered through their appointed front persons on the phones. One bidder was slow and considered, adding $2 million–dollar increments to his offer. The other was unorthodox, responding quickly and ostentatiously, hiking up the price from time to time far beyond what was necessary. Once he added $10 million to the price, and later $18 million. It was this collector who won the prize, finally delivering by phone an incredible $30 million increment which took the price from $370 million to $400 million. One might deduce either that he had something to prove, and that therefore he knew or thought he knew who his anonymous rival was, or that it was not his money. Perhaps both. 'At 400 million …' called Pylkkänen. The audience gasped. 'And the piece is sold.' The gavel clunked. Applause rang out, drowning out the sound of a collective exhalation of breath. It was 8.50 p.m. local time. It had taken nineteen torturous minutes to reach this price point. Most items are sold in under five. The final price was $400 million, plus Christie's commission of $50 million charged to the buyer. Once again it was payday for the *Salvator*. The third-party guarantor earned their percentage of the 'upside', the profit above the circa $100 million guarantee, which was in the region of $350 million, so taking home up to $85 million. Christie's made $50 million in fees plus its share of the upside, possibly $85 million – so an astonishing total of perhaps $225 million. Rybolovlev went home with a return on the painting which could have been around $135 million.[7]

Dmitry Rybolovlev was not at the auction, but one of his daughters was in attendance. 'She kept me updated by text message,' he told me. 'When the price reached $200 million, I was satisfied and put my phone down. But the texts just kept coming. I looked at my phone again and saw that it was more than $300 million. So I kept hold of my phone this time and didn't put it down until the auction was over. I was amazed. It was an unbelievable price.'

Robert Simon had gone to see the *Salvator* shortly before the auction. 'It was the first time I'd seen the painting in four or five years, and I started to tear up. It's so much a part of me and my life, and I think it's such a powerful and great work of art.' He professes not to have been surprised by the new price, $320 million above what he had sold it for four and a half years earlier. 'I'm one of the people who thinks the Leonardo was not sold for a crazy amount of money. I think this is the rarest thing on the planet.' Dianne Modestini was gleeful. After her restoration she had been 'questioned, mocked and vilified'.[8] She felt the *Salvator* had now triumphed.

'I've always felt this picture had a mission,' Alex Parish told me. 'As long as I have known it, I always felt it had a sense that there was something bigger going on than what you, I and whomsoever was thinking. It seems guided. There are too many coincidences, too much synchronicity. I'm a Christian but I purposefully never bought Jesus pictures. They're impossible to sell. But for whatever reasons – I can't go back in my mind and figure out exactly why – I bought this one. So, thank you, Lord.'

Later that night the sale was celebrated at the exclusive restaurant Cipriani's by some of the wealthiest and most famous people in the world. Loïc Gouzer was there of course, with his friend the other Leonardo, DiCaprio, who had recently handed over to the US government a $3.2 million Picasso and a $9 million Basquiat, given to him by the world's biggest money launderer, Jho Low, who is currently hiding from American and Malaysian arrest warrants which accuse him of misappropriating $1 billion in a Malaysian government slush fund. Art adviser Sandy Heller, who had first tipped off Rybolovlev about Yves Bouvier's mark-ups, was also there. Others at the restaurant included members of the Nahmad family. One family member, Helly Nahmad, confessed in 2013 to running an illegal $100 million gambling ring, for which he was sentenced to a year in prison. In 2015 the Panama Papers, a leak of 11.5 million documents

from the hard drives of the offshore law firm Mossack Fonseca, revealed that the Nahmads owned a Modigliani looted from the Nazis which they had long denied was in their collection. These beneficiaries of art looting, illegal gamblers and friends of money launderers partied late into the night with the elite of the art world, celebrating the sale of the most expensive painting ever.

Many art world professionals, however, were appalled. Curator and art historian Carolyn Christov-Bakargiev tweeted, 'If auction house, buyer and museum are one and the same, you create Leonardo with 200 years lack of provenance. Detail: it is a bad painting. History will haunt you.' Thomas Campbell, former director of the Metropolitan Museum of Art, posted, '450 million dollars?! Hope the buyer understands conservation issues #readthesmallprint.'

In the days following the auction, there was intense speculation about the identity of the buyer. One suspect after another published denials. It was not the Getty. It was not the Qatari royal family. It was not the fashion designer Valentino and his partner Giancarlo Giammetti. On 30 November the president of the Louvre, Jean-Luc Martinez, said he hadn't bought the painting, but hoped to borrow it for the museum.

Often, the identities of the winning bidders for works of art whose prices reach the hundreds of millions remain secret or unconfirmed forever. But not this time. On Wednesday, 6 December 2017, Prince Badr bin Abdullah bin Mohammed bin Farhan Al Saud, a relatively modest member of the Saudi royal family notwithstanding the length of his name, was revealed as the winning bidder by the *New York Times*. The following day the *Wall Street Journal* reported that US intelligence sources had told them that Badr had bid on the painting as a proxy for Crown Prince Mohammed bin Salman, the *de facto* ruler of Saudi Arabia and son of the Saudi King Salman. Then a day later, the government of Saudi Arabia's neighbour Abu Dhabi insisted that Badr had been acting as *its* agent to acquire the work for display

in the country's flashy new Louvre museum. Let me speculate that Christie's 'KYC' (know your client) financial tests on potential buyers for the *Salvator Mundi* had required a referral to the FBI, whose operatives, no doubt amused by the crazy sums paid for art, leaked the information to the American newspapers. At any rate, information also came from inside Saudi Arabia. According to reports, Badr had only registered for the auction the day before, telling Christie's staff that he was in 'real estate' and was 'just one of 5,000 princes'.

On 8 December, Abu Dhabi's Department of Culture and Tourism tweeted 'Da Vinci's Salvator Mundi is coming to #LouvreAbuDhabi.' The Saudi embassy in Washington then announced that Prince Badr had been acting as a middleman for Abu Dhabi:

> *His Highness Prince Badr, as a friendly supporter of the Louvre Abu Dhabi, attended its opening ceremony on November 8th, and was subsequently asked by the Abu Dhabi Department of Culture and Tourism to act as an intermediary purchaser for the piece.*

No one seems to have yet identified the underbidder in the auction, who topped out at $370 million, although the evidence is hiding in plain sight. It was almost certainly the Chinese billionaire art collector, who began his working life making handbags and is now chairman of Sunline Group, a Shanghai-based investment company, Liu Yiqian, and his wife Wang Wei. They own the Long Museum, based in Shanghai and Chongqing. In November 2015 Liu had paid what was then the second highest price for a work of art sold at auction when he bought a reclining nude by Modigliani for $170.4 million. He paid with his American Express credit card, whose points system meant that he earned himself and his family free travel for the rest of their lives through that one purchase. Some art world observers mock Liu for only bidding for the top lots on the covers of catalogues, but his wife told the *Financial Times* in 2016, 'The art on the cover is

verified. No auction house would use fake art on their cover and they put the best art on the cover.' Liu told the *New York Times* in 2015, 'The message to the West is clear: we have bought their buildings, we have bought their companies, and now we are going to buy their art.' After the *Salvator*'s auction Liu publicly denied that he was the winning bidder, and he may have been only one of the five bidders who competed up to $220 million. However, a senior New York gallerist told me that Liu was the underbidder, and Liu himself posted a giveaway message on the Chinese website WeChat: 'Congratulations to the buyer. Feeling kind of defeated right now.'

The Louvre Abu Dhabi announced that it would unveil the *Salvator Mundi* nearly a year after the auction, in September 2018. The museum displayed an image of the *Salvator* on its website, with a quote from Mohamed Khalifa al Mubarak, chairman of the Abu Dhabi Department of Culture and Tourism: 'Lost and hidden for so long in private hands, Leonardo da Vinci's masterpiece is now our gift to the world.' Its display at the Louvre Abu Dhabi would be 'a milestone for the region, but for the world too,' he continued. 'Unveiling this painting in the context of the museum's own narrative on humanity, and its message of acceptance and openness, is testament to its enduring beauty, message and relevance.'

THERE IS A HOUSE IN NEW ORLEANS

It is common practice among collectors and dealers not to disclose the current or recent previous ownership of works of art. Thus, if you inspect the labels in an art gallery or read the entries in an auction catalogue, they often say only 'Private Collection'. That tradition was upheld by Robert Simon and Alex Parish, who declined to tell anyone from whom they had bought the *Salvator Mundi* in 2005. When Simon and Parish sold the *Salvator* to Yves Bouvier in 2013, Sotheby's made them sign a non-disclosure agreement about their purchase, the previous owner and the sale to Bouvier. The auction house would have wanted, above all, to minimise the chances of the original owner discovering the price differential. In the past, such transactions have led to thrilling headlines and interminable lawsuits, even if auction houses rarely lose these cases. But even before Sotheby's became part of the story, Simon and Parish had been reticent on the subject.

'We're a little opaque as to the date and location of acquisition,' Parish told me. 'We purposefully have never corroborated Louisiana as the place we bought it. And I'm not going to now. Why? Because some grandson of whoever those people are who sold it is going to

decide, "Oh, that's my $450 million picture. Who can I sue?"' Parish waved at me theatrically. 'I'm right over here.'

There was therefore, when I began to research this book, a second blank in the history of the *Salvator Mundi*: the period between the Cook Sale in 1958 and Simon's acquisition of it in 2005. There were two clues about where it had been. One was the name in the buyers' list for the Cook sale: Kuntz. That name had been misspelt in another copy of the catalogue, in which the art historian Ellis Waterhouse had noted down the names of buyers, and written 'Kunz', omitting the 't'. Martin Kemp suggested that this was the name of the seller, while speculating that it was a false name, a pun on *Kunst*, the German word for art.[1] Another clue came from a legal document filed in November 2016 by Sotheby's, which by this time was involved in legal wrangles with Simon and Parish over the sale to Bouvier. It said: 'On information and belief, Defendant Parish acquired the *Salvator Mundi* for under $10,000 at an estate sale in Louisiana in the early 2000s.'[2] Prior to 2017, Simon had scrupulously referred in media interviews only to 'an unnamed private collector in the United States'.[3] After that, he began referring sometimes to an auction or estate sale in New Orleans.[4]

When I pressed Parish for further clues, all he would say was that the seller was not an aficionado. 'A lot of people don't know, don't care, and don't have any aspirations to own art,' he said. 'Their attitude is, "I don't want this painting. I'd much rather have a car." If you've been around it as long as I have, you know that there are some people who don't give a damn about art. My God, most Americans don't. It's not part of their world.' He looked at me and beckoned with his finger: '"OK. Give me the painting."'

* * *

My first internet search turned up one Felix Herwig Kuntz, who was born in 1890 and lived until 1971; a cheerful, if nondescript-looking, bald and bespectacled businessman, the scion of a very wealthy land-owning and oil-mining family in Louisiana. Kuntz collected mostly Americana – historical documents, including many about slavery, which he donated to Tulane University in New Orleans. He also bought furniture and European paintings – *continental paintings*, as they were known in the trade in America. Landing-card records, available through online family history databases, showed that on 24 May 1955 he had flown KLM from New York to London, and later that year had flown back from Paris to New York. He had also flown out of London on a Pan Am flight to New York on 21 June 1959. The dates weren't perfect – a fact I supposed was explained by the incomplete records of US customs – but they were close enough to make him possibly the Kuntz who won the *Salvator* at the Sotheby's auction of 1958, at which Sir Francis Ferdinand Cook was offloading the remains of his family's collection.

Furthermore, Felix Kuntz's heirs had sold pictures from his estate through the New Orleans auction house Neal in 2005. He had been close to Alonzo Lansford, a painter and art critic who was the first director of NOMA, the New Orleans Museum of Art, appointed in 1948 and then unceremoniously fired in 1957 for unknown reasons. Lansford's greatest achievement at that institution was to persuade the Kress Foundation to lend thirty-one Italian Renaissance paintings to the museum. (It is a small world: decades later Dianne Modestini restored many paintings from the same collection.) There seemed to be so many connections, or at least the kind of evidence on which provenance stories are often built. There were classified ads in old newspapers from Biloxi, Mississippi, and Alexandria, Louisiana, in which Kuntz advertised himself as an art dealer. An exhibition of the highlights of his collection was held at the Louisiana State Museum in 1968, with a catalogue essay which related that 'Felix liked to

reminisce about the casual manner in which he began what was to become the main interest of his life – collecting … He found the attics of old houses were veritable treasure troves and that people were willing to sell … He made innumerable trips, going further and further afield … He also had agents who made purchases for him in this country and abroad.'[5]

Then I found a newspaper article from the *El Paso Herald*, dated 27 May 1960. The headline ran: 'Piece of Da Vinci's work in E.P. Doctor's Gallery'. It wasn't about the *Salvator Mundi*, but was nevertheless promising. Dr Ettl, 'a well-known El Paso pathologist', had a 'most prized and priceless possession' which had been 'bought from the heirs of the Lobar family a number of years ago by Felix Kuntz, now a retired executive of the Texas Oil Co.'. It was 'a segment of the last picture painted by Leonardo da Vince [sic] …' The article continued, '"When da Vinci was dying," said Dr Ettl, "he took the last picture he painted and tore it into several pieces. He gave one fragment to each of several close friends."' The artwork belonging to Ettl, titled *Eunuch in a Red Cap*, was not a Leonardo, but it did seem to show that Felix Kuntz bought and sold would-be paintings by the master.

I had another lead to follow up: estate sales at New Orleans auction houses. I hunted through the New Orleans auction catalogues in New York's Frick Collection and in libraries in New Orleans, and found nothing. But there was one New Orleans auction house whose catalogues did not seem to be archived in the city: the St Charles Gallery. The St Charles was the dumping ground of New Orleans' auction houses. As a local told me: 'They got all the junk which the others turned down.' The gallery, however, no longer existed. It had closed down in 2011, when its parent company, New Orleans Auction Galleries, filed for bankruptcy.[6]

There was only one institution in America that held the St Charles Gallery's publications: the Ingalls Library at the Cleveland Museum

of Art in Ohio. I spent several hours there, leafing through fifteen catalogues, scanning over 2,800 pages and more than 17,000 items up for auction, before I found the *Salvator Mundi*. It was Item 664 on page 110 of the 9–10 April 2005 sales catalogue. There was a very low-resolution, low-contrast but unmistakable photograph of the picture. This is what Simon and Parish would have first seen – and it confirms that the painting sold at this small, low-rent auction house is the one they purchased. The text that accompanied it said:

> *After Leonardo da Vinci (Italian, 1452–1519) 'Christ Salvador*
> [sic] *Mundi', oil on cradled panel, 26 inches x 18½ inches.*
> *Presented in a fine antique gilt and gesso exhibition frame.*

The St Charles Gallery sold the *Salvator Mundi* just four months before New Orleans was devastated by Hurricane Katrina. The painting had had yet another narrow escape.

The catalogue entry ended with numbers in brackets, '1200/1800', indicating, as is the custom in auction listings, the high and low price estimate. Inside the catalogue was a loose-leaf, single typed page, a price list of all the sold works, which one usually only finds in the copy of the catalogue owned by the auction house. Item 664 had gone for $1,175, $25 below the low end of the estimate, and thousands of dollars less than the $10,000 Simon and Parish had said they paid for it. They had obviously feared, I reasoned to myself, that if they told the world the real price, no one would ever believe the painting could be a Leonardo. That was the best $9,000 they never spent. Never before had adding an extra zero made such a difference to the value of an item. Unless, of course, someone else had actually bought it at the auction, and they had then bought it from them afterwards for a mark-up …

So now I knew which auction house had sold the painting – but I still didn't know who was the previous owner. However, someone

who had worked at the St Charles at the time might remember who had been the seller. On the first page of the catalogue there was the usual list of employees. I contacted the former president, Jean Vidos, the executive president Tessa Steinkamp, and auctioneer Michael DeGeorge. None of them recalled the *Salvator Mundi*. 'I don't remember it. No recollection of that,' Tessa Steinkamp told me. 'And when that gallery closed, everything was thrown away. No one has those records.' When she started in the business, Vidos told me, people would call her up and say they had an original Degas: 'I'd say, "Oh, my God, I'll run right over!" But after a while you realise it's probably *not* ever going to be an original Degas, so you kind of say, "Yeah, sure, bring it in and we'll have a look." And it also depends on where things are coming from. If it's just some guy's house, you're not going to expect to find a Leonardo da Vinci. If the guy thought he had a da Vinci, he'd be calling Christie's or Sotheby's before he was calling the St Charles Gallery.'

On its cover, the catalogue listed the names of some of the sources of the works on offer at the sale. The Estate of Robert and Joanna Butcher, Shreveport, Louisiana; the New Orleans Garden District Mansion of Trent Reznor; the Estate of Basil C. Hendry Sr, Baton Rouge, Louisiana; Edgewood Plantation, Natchez, Louisiana; Important American Furniture from a Midwest Collector and Numerous Private Collections. Naturally, the first person of interest was the celebrity in that list: Trent Reznor, the frontman of the rock band Nine Inch Nails and now a composer of film scores. It would be a gift to my narrative arc if it turned out that the *Salvator Mundi* had once been owned by a rock star. Reznor had owned a big nineteenth-century whitewood mansion in New Orleans, with a two-tiered double-colonnaded porch running all the way round. It looked like the right place to hang a Leonardo. He had put the house on the market in 2004, and an online article in the entertainment blog Blabbermouth stated promisingly: 'The interior decor was

Gothic/Victorian', and the property 'was visited by over 100 potential buyers, although the realtor began screening them to weed out fans looking for a glimpse inside Reznor's home'. I managed to find one of those visiting fans, who disappointingly informed me that there had been no Christian art inside Reznor's house.

However, real estate was about to become important in my investigation. I began to research the other names on the cover of the catalogue. The Edgewood Plantation was clearly not in the frame. There was no way to find the names behind the anonymous 'Numerous Private Collections' or the 'Midwest Collector'. If the *Salvator* seller had been one of these, I would never have been able to identify him or her. I did trace Robert and Joanna Butcher's son, to whom I sent an email, but he replied that 'none of the items as shown in your email from the catalogue were ever owned by my mother or father – not their type of art'. Basil C. Hendry Sr was my last chance.

I Googled the property Basil C. Hendry had owned in Baton Rouge. There were several photographs of it online, dating from when it was on the market in 2005. It was another big wooden mansion set in beautiful grounds. There was art on the walls, though clearly nothing particularly expensive or exquisite. There were plenty of decorative items on tables and mantelpieces – candleholders, vases and urns. To my eyes they looked like the kind of trinkets that come from gift shops in malls. This was not the home of a collector of Old Master paintings. However, if a damaged and ridiculously overpainted Leonardo could hang anywhere and not be recognised, this looked like the kind of place. I noticed that the house had many staircases, and that is when I remembered that Robert Simon had once told a journalist that the previous owner of the *Salvator Mundi* had it hanging in a stairwell.

Then, a month later, the German news magazine *Stern* published a long article on the *Salvator Mundi*. At the top of the article, above the headline 'The Greatest Art Thriller in the World', was a photo-

graph of a wooden staircase, taken from above, with the *Salvator Mundi* hanging on the wall. Alex Parish had found the photograph on the internet years earlier, when he had been researching the history of the painting. The staircase looked the same colour, and seemed to have the same curving wooden banister, as those in the photographs of Basil C. Hendry's property in Baton Rouge.[7]

Now was the time to apply connoisseurship, the Morellian method, to my search for the painting. I brought up on my computer the images of the staircase in the German magazine along with those from the real-estate website, and examined them carefully side by side. The spindles were exactly the same. The *Salvator Mundi* had been acquired by Felix Kuntz, or so I thought, in 1958, and had subsequently belonged to Basil C. Hendry, whose heirs sold it in 2005. At this point in my research I had not yet spoken to Alex Parish about the auction, as I drew up my own hypothetical provenance for the *Salvator*'s missing years:

1958: Felix Kuntz of Louisiana buys the 'Boltraffio' *Salvator Mundi* at Sotheby's Cook Sale in London.

1959: After a long sojourn in Europe, touring and collecting art, Kuntz returns to America.

1960: Kuntz sells his Italian School pictures, which he has acquired along the way but really has no interest in. *Eunuch in a Red Cap*, supposedly by Leonardo, goes to Dr Ettl, a collector Kuntz had heard of from his art-collecting friends the antiquarian Joe St Cyr, owner of the London Shop, and Alonzo Lansford, former director of the New Orleans Museum of Art. Ettl is not interested in Kuntz's other pictures, so either St Cyr or Lansford buys the *Salvator Mundi*.

Sometime between 1960 and 2005: Either St Cyr or Lansford sells the *Salvator* to the Hendrys in Baton Rouge as 'After Leonardo', because the Boltraffio attribution has been

forgotten at some point. Perhaps the painting had changed
hands more than once.

2005: Hendry's heirs approach the St Charles Gallery with a lot
of inherited art to sell. It is catalogued and appraised.

Catalogues are published and put online in advance of the 30
March–8 April preview at the gallery. As a subscriber, Robert
Simon receives a catalogue in the mail. Alex Parish looks at it
online. They both see Item 664 and are interested; they
contact a middleman ('Mr M') they know in Louisiana and
ask him to bid for the painting on their behalf.

11 a.m., Sunday, 10 April 2005: Bidding for Item 664 starts at
$1,200 … There are no takers, so Mr M offers $25 under the
bidding price, and Michael DeGeorge, the auctioneer, pounds
his gavel, announces that the item is sold for $1,175, and
moves on to the next one.

Monday, 11 April 2005 (or soon thereafter): Mr M packages up the
picture and sends it to Simon; in return Simon (and Parish)
send him $10,000 for his trouble … and the game moves on.

Plausible?

There were a number of Hendrys in online directories in Louisiana,
any of whom might or might not have been related to Basil Hendry,
and might or might not have been responsible for their relative's
estate. I sent letters of enquiry to a few of them, and a week or so later
I received an email from one Basil Hendry. The subject line read
simply '?' and the message said 'Call me,' followed by a Baton Rouge
phone number.

That is how I came to dial the number of the undisclosed 2005
owner of the *Salvator Mundi* at 6.39 p.m. on Thursday, 13 September
2018.

His name was Basil Hendry Jr, and he now resided in Santa Fe, New Mexico. He was in construction, and was known locally as 'Tookie'. He was expecting my call. I told him about the St Charles catalogue and the *Salvator Mundi*. 'I'm trying to trace the provenance of that painting. It appears that it showed up in the St Charles Gallery catalogue of April 2005, and your late father's estate was part of that catalogue. But it's very hard to tell from the catalogue what pieces belonged to whom. So I'm trying to find out if that might have been one of the pieces that at one point belonged to your father.' I wanted to say as little as possible, because I did not know how much Hendry knew himself. Most people do not read the arts pages of newspapers and online blogs.

'I can tell you about that because I was executor of my father's estate,' he replied. 'My father wasn't an art collector, he inherited some artwork from his aunt. Her name was Minnie Kuntz, Mrs Warren Kuntz. She lived in New Orleans. She left him these paintings. Her husband was an antique and art collector. He had a furniture business in New Orleans, but they lived all over the place and they travelled all over the world. I didn't know either of them very well. I'd only seen them once or twice in my entire life.'

Mrs Warren Kuntz. It was a Kuntz named Warren, not Felix, who had purchased the painting at the 1958 Sotheby's Cook auction in London. All this time I had been chasing the wrong Kuntz.

'They bought an old house in ruins on Bourbon Street in New Orleans and fixed it all up. That's where they lived until he died. I spent a night in that house right after he had passed away. I just noticed that there was a lot of artwork and antiques, but that was it. I don't know anything about that kind of stuff. My dad also knew nothing about art, and he had some of the paintings in his house when he passed away, and as executor it was my business to sell those paintings. I couldn't tell you one single thing about the provenance of those paintings, or their names, or who they were painted by, or anything else.'

'Where did your father hang the paintings he inherited?' I asked cautiously.

'Everything that I sold at auction was hanging in his house,' said Tookie. 'I went to live with my father and look after him for the last five years of his life. My father died in June 2004, and I didn't really start selling off stuff until 2005. We were trying to sell the house, so we wanted the house to remain as decorated as possible so it looked its best, so incrementally we brought stuff to St Charles Auction.'

There was a pause in Tookie's monologue.

'Let me tell you the whole story,' he said. 'One of my nieces had graduated from art school in Savannah, Georgia, and she knew how to scan the paintings. We had some very large, three foot by five foot, or bigger, religious paintings. We could tell they were very old, maybe sixteenth-century or something, but we didn't know what to do with them. So we emailed pictures of everything that was old up to Christie's, just to see if there was any interest at all. Christie's flew a lady down to see what we had.'

Tookie remembered the Christie's representative well.

'I picked her up at the airport. I asked where she was from, she said Rome. She said her mother was born in Hong Kong, and her father was from Vienna. She went to art school in France, and came straight to the United States. The only place she'd been besides New York was Chicago, and some place in Texas, and Baton Rouge. She walked through the house. We had small paintings all over the place. If I remember, this Jesus Christ thing was maybe no more than two foot by three foot, or eighteen inches by twenty-four inches, something in that area …'

Those were the correct dimensions of the *Salvator Mundi*, showing that Tookie had a superb memory.

'It wasn't that big, not as big as the other stuff. It didn't look that old. But she saw all of that, I think. She went through the

house, she looked at everything that was hanging in there, she would walk by every single piece, saying, "Not for me, not for me, not for me." When she got to the big religious paintings – I forget how many there were, it might have been seven or eight, no more than that – she said, "For me, for me, for me, for me." I had absolutely no clue about anything. We just trusted Christie's.'

The Christie's specialist returned to New York, and later Tookie received a list of the pictures the auction house wanted. The *Salvator Mundi* was not on it.

'Then Christie's sent down their people and they came in and put the pictures in their truck and took off. Later we flew to New York and watched the auction, and our paintings went very quickly, sold for about $3,000 apiece.'

I widened my eyes. The implication of what Tookie was telling me was that Christie's, the auction house that sold the *Salvator Mundi* to its new Gulf owners in 2017, had viewed all his father's paintings in 2005, but had passed on the *Salvator Mundi*, leaving it hanging on a staircase wall.

'What was the name of the painting?' Tookie asked me.

'*Salvator Mundi*.'

'Who's it by?'

'There's some debate about that, but it may be by Leonardo da Vinci.'

'No kidding?' I could almost hear Tookie's eyebrows rising. 'What does it look like?'

I described its distinguishing features.

'Well, you know, one of my daughters called, and I told her I've got something strange going on, somebody's looking for me and calling all my friends. I said it's something to do with a painting that was hanging in her grandfather's house. Then she said one of the paintings that always impressed her was the picture of Jesus Christ.

She said it was on the wall going up the stairs. I vaguely remember that there *was* a painting of Jesus Christ, but he had a lot of religious stuff in there.'

Tookie was putting two (hundred million) and two (hundred million) together.

'That Jesus painting could have been on the wall when the lady from Christie's said "Not for me"!' he laughed. 'That's what I'm trying to say. But what we're talking about here is thirteen years later. I'm not getting any younger.'

Then his tone changed, and his voice slowed down. 'If that's the case, I will be very disappointed in the St Charles people and Christie's for not recognising it. Because if it's really a Leonardo da Vinci ... Well, if it was Leonardo da Vinci, that would have been a very old painting. I just don't remember it even looking that old. I just don't remember it having that look.'

I thanked Tookie for his time and his story, and asked if we could meet in person. I tried to contact him a few more times after this initial phone call, but he declined to speak to me unless I negotiated a large fee with his lawyer as payment for an interview. I understand he has been taking advice about taking legal action against the auction houses, but nothing has transpired to date.

The phone call had produced another lead for me. *From Rome. Born in Hong Kong. Father from Vienna. Art school in France*. I traced a woman who used to work at Christie's Old Masters department in New York but now lives in Britain, and whose profile matched this description. I contacted her, and she agreed that Tookie's description 'sounds like me', but she could not remember visiting the house in Baton Rouge, even after I mailed her photos of its interior. Another lead gone cold, somewhat mysteriously.

There is a document written by a local appraiser, probably prior to the Christie's visit, which values Hendry's artworks and prices the *Salvator Mundi* at only $750, attributing it to 'Continental School

(19th Century)'. The appraiser wrote: '*Portrait of the Head of Christ, Oil on Panel. Framed 28" x 17.5". Poor Condition*'.

Following its apparent rejection by Christie's,* the painting was consigned to the St Charles sale. Alex Parish told me that he bid for the painting via phone, and recalls that there might have been one other rival bid. There was no middleman, no Mr M. Parish was able to buy the painting for $1,175. Neither he nor Robert Simon ever went to New Orleans to view the picture. The most expensive painting in the world was bought over the internet and the telephone.

Parish recalls: 'They opened the bidding and then I gave my bid and then no answer. "Going, going, gone!" You know, you're bidding at whatever it was, eleven o'clock in the morning, and it's at some sleepy auction. And you're just thinking, "Oh fuck, what did I just do?" I got a call from the auction house two days later. They asked me, did I want to walk away? They had a person who had missed the auction, who'd like to offer me a short profit. I'm not even sure I'd arranged for shipping by then. Since it was so cheap, I said, "Well, you know, in for a penny, in for a pound, so thank you but no thank you."'

The painting was delivered to Parish's home address.

'Around a third of it was obviously covered with over-painting,' he remembers. 'But I could see from other parts which were not covered with over-paint that this was clearly a sixteenth-century panel. Immediately I thought, "It's period, and we're off to the races." I can see the hand, which is untouched, is gorgeous, and the fabric is also

* I asked Christie's to confirm that one of its specialists inspected the Hendry estate, and it replied: 'Christie's performs thousands of appraisals every year. Given that this visit would have been executed nearly fifteen years ago, we do not have any employees who recall this visit or can verify that it took place. In any case, given that the painting was almost entirely over-painted at the time, it is not surprising that it might have been overlooked by any professional appraiser, just as it was by the auction house in Louisiana that eventually sold it in its over-painted state.'

very beautifully done. Parts of the hair are clearly original, and they're beautiful, but please, make no mistake, I am not a Leonardo scholar. My initial thought was maybe, after we clean this thing up, we might see it's by Bernardino Luini. A beautiful Luini would be into six figures, and let me tell you, that's exactly what I want.

'I lived with it for a few days. I had it out. I looked at it. When I get a new picture, I tend to try to stare it down. I know that's a weird phrase. But I would put it out and look at it as frequently as I could, just to get a bead on it. I can tell you that early pictures in particular, they're subtle, and they're not always straightforward. A lot of times it does take a relationship with them before you get their full authority, full power, full character – whatever you want to call it. Oftentimes, when I've had a real good picture, I used to sit down with a bottle of wine and enjoy it. People today think, "What? You'd sit and stare at a painting?" I'm like, "Yes. I'd sit and look at a picture for a long period of time."

'Then Bob [Robert Simon] was like, "Bring it to me, bring it to me, bring it to me."'

The buyer of the *Salvator Mundi* in London in 1958 was Warren Kuntz, not Felix, and they were not related. Warren Kuntz did not sell his painting to anyone, as I had imagined; it was simply inherited by his relatives, and handed down from generation to generation. The problem with provenance stories – like my hypothetical one for the *Salvator Mundi* in the second half of the twentieth century, and the one provided for the painting by Robert Simon, Margaret Dalivalle, London's National Gallery and Christie's – is that the bar for admissible evidence is set very low, so they can often be undermined by the discovery of one new and inconvenient fact.

Warren Kuntz (1899–1968) and his wife Minnie (who would live until 1987) left Southampton on 7 July 1958 on the *Zoella Sykes*, an

old hulk of a cargo ship. There were only two other passengers on board: sixty-seven-year-old cotton merchant Albert Dalrymple and his wife, plus the crew. There is no record of the Kuntzes or the painting in the captain's log. They may well have had several crates of purchases in the hold.

The bread-and-butter trade for Warren Kuntz was furniture, not art. He was vice president and general manager of the New Orleans Furniture Manufacturing Company. It was a profitable business: by the end of the 1930s it was the largest furniture-maker in the city. Warren and Minnie were upstanding members of the community. Minnie was involved in Christian charitable activities, sometimes appearing on the social pages of the local papers. Warren's business, meanwhile, was successful enough for him to indulge his passion for buying art and antiques. Judging by the St Charles Gallery sales catalogue, the Kuntzes bought mostly religious subjects: an 'Italian White Marble Figure of a Robed Franciscan Monk'; a needlepoint panel of 'Christ Blessing the Loaves attributed to the New Orleans Academy'; and carved wooden crucifixes from the late nineteenth century.

On 2–3 June 2005 the Kuntz paintings selected by Christie's were auctioned at its 'House Sale' in New York. There was a Madonna 'After Michelangelo' and a 'Portrait of a Gentleman, standing three-quarter length, in a black vest and cape' attributed to 'North Italian School, 18th Century': 'Both from one Mrs. L. Kuntz, New Orleans, by descent to the present owner.' One assumes the initial is a typo. Christie's is possibly not always as thorough as one might wish.

The Kuntzes are an example of how, over the twentieth century, art collecting spread to an ever broader class, percolating down through the strata of society and across borders and oceans. This expansion was driven, entirely predictably, by the logic of industrialisation and consumerism, by rising wealth and population growth; but it was also powered by the opposites of those forces – depression and destruction. In the good times art was a sound investment, as new

buyers flocked to the market and prices rose; in the bad times prices crashed, and art was a bargain. It was as a result of this that the art dealer's mantra was born: 'There is never a bad time to buy art.' After two world wars, art was cheap and abundant at the time Warren Kuntz began collecting. The market was favourable to people with modest incomes and eclectic tastes. The Kuntzes were not connoisseurs intent on building a museum-quality collection by the greatest names in art history. They were hobbyists who filled their home with images and objects which bore the patina of history and piety. The Kuntzes were apple-pie art collectors – one can hardly imagine a world further removed from the mansions and storage depots of the other owners of the *Salvator Mundi* than American post-war suburbia. They did not use art to project intellectual sophistication and geopolitical power. And yet, despite the vast disparity in status, wealth and epoch, Warren and Minnie Kuntz had something beautiful in common with King Charles I and Queen Henrietta Maria: a love of art, which they hung all over their homes, including in the stairwells.

CHAPTER 21

MIRAGE IN THE DESERT

The Louvre Abu Dhabi is the most opulent museum in the world. It opened in 2017, ten years after the Emirate's ministers signed a $1.3 billion deal with France that allows it to use the Louvre's name until 2037, and also to borrow three hundred works of art (including Leonardo's *La Belle Ferronnière*). Designed by the prestigious French architect Jean Nouvel, its immense, porous dome is a miracle of engineering, 180 metres across, covered with eight layers of geometric lattices which carve up the bright light of the desert sun into thousands of stars. Underneath this canopy stand sixty gleamingly white buildings arranged in clusters, a minimalist village of squares and rectangles within which the entire cultural history of the world is compressed and exhibited. It evokes a biosphere for a pristine colony on a distant planet.

Inside, works of art are displayed according to a new organising principle. They are not divided according to national and regional 'schools' – as exhibits have long been laid out in museums in Europe and America, and as Sir Francis Cook presented his collection. Instead, art from all over the world is organised chronologically, in rooms titled 'The First Villages' or 'The Global Stage'. The message to the visitor is that there is more that unites humanity than divides

it – an idea reinforced by mother-and-child sculptures from three different religions in the front atrium. In other spaces, Bibles are exhibited next to Qur'ans and Buddhist Sutras. Colonialism is filtered through a 'Modern Orientalism' section, where the influence of art from elsewhere on Western artists is celebrated. Invited to speak at the museum's opening ceremony, France's President Emmanuel Macron proclaimed, 'Beauty can fight against hatred.'

It is clear why a museum such as the Louvre Abu Dhabi might wish to display the *Salvator Mundi*. The painting is an icon of everything the institution is promoting – a religious image which, through its celestial orb, transcends its own particular creed to become an emblem of faith itself, executed by the 'universal artist', as Leonardo is described by art historians. The *Mona Lisa* is the world's most famous and most visited artwork. The *Salvator Mundi*, a male and spiritual counterpart to the *Mona Lisa*, has the power to turn the Louvre Abu Dhabi into a cultural landmark.

We should pause to congratulate the painting at this point. Against all odds, it seemed it had finally triumphed over every obstacle in its way – an undocumented genesis, an uncertain provenance, damage, disappearance, the obscurity of regional America, restoration controversy, the scandal of the offshore economy, and numerous lawsuits – to become the greatest trophy in the art market, to be placed on permanent exhibition as a fully-fledged Leonardo da Vinci in the finest museum built in recent times. However, if visitors flock to the Louvre Abu Dhabi to see the *Salvator Mundi*, they will not find it. Leonardo's painting has yet to be installed.

On 3 September 2018, two weeks prior to the painting's scheduled premiere appearance at the museum, the Louvre Abu Dhabi abruptly announced that it was cancelling the event. No reason was given. The press release promised that more news would follow, but at the time of writing, nothing has been heard.

* * *

The original American intelligence reports about the identity of the *Salvator*'s buyer were almost certainly correct. The painting was bought with Saudi money. Prince Badr was the winning bidder. He was acting, insiders claim, as an agent for Crown Prince Mohammed bin Salman. But if the Saudi royal family weren't buying the painting to put in the flagship museum of their closest allies, why were they buying it?

The thirty-three-year-old Mohammed bin Salman effectively came to power in 2017, displacing his cousin bin Nayef. Some say he was appointed by his father, the octogenarian King Salman, who is widely reported to suffer from Alzheimer's and has long retired from active kingship. Others say MBS, as he is widely known, took over in a coup assisted by Donald Trump's White House. 'We've put our man on top!' Trump told friends at the time.[1]

Bin Salman grew up in a large palace in Riyadh, served by a staff of fifty, and was accustomed from an early age to the deference that wealth brings. In his youth he organised parties in the desert for his school friends, who in return are said to have recited paeans and poems in tribute to him. The narrative of his rise to power has a strangely familiar flavour, as if one had read it somewhere once on the back of a paperback found in a flea market. Bin Salman was always at his uncle's side, taking notes as he visited factories and attended meetings with him, while his older cousin bin Nayef had a shorter attention span. Once appointed deputy ruler, bin Salman worked to sideline his relative, apparently signing orders in the king's name. There are darker anecdotes, denied by his spokesmen, about the businessmen he is alleged to have pressured into pouring millions into his development fund, and about the land sold to him by a reluctant official who was said to have received an envelope in the mail with a bullet in it.[2]

His doting father showered him with official positions. He has no military training, yet he was appointed the youngest defence minis-

ter in the world. He never studied abroad, but he became the head
of a new Council for Economic and Development Affairs and chair-
man of a new council overseeing Aramco, the national Saudi oil
company, which produces almost 10 per cent of the oil used on the
planet.

Bin Salman knew that his oil-rich country was in need of drastic
modernisation. Its archaic system of government and its social cohe-
sion were held together by its boundless wealth. The state parcelled
out slices of economic activity among family networks and distrib-
uted subsidies to its fortunate citizens, while a constant stream of
viscous black wealth was pumped from the ground under their feet.
But the price of oil had halved in recent years, and the Saudi govern-
ment was in debt. It was predicted that unless it found other sources
of income and reduced its spending, the country would be bankrupt
in two years. There were political threats at home and abroad. The
Arab Spring uprisings in 2011 called for democratic reforms. Across
the Gulf, Saudi power was threatened by the rise of its regional
arch-rival Iran. America accused the Saudis of funding Islamist organ-
isations, and President Trump was demanding, as his former adviser
Steve Bannon put it, 'action, action' from MBS, who enthusiastically
embarked on a programme of overnight transformation.

The purchase of the *Salvator Mundi* must have played a part in this
reformist agenda. It came, quite suddenly, amidst a blizzard of uncon-
ventional and contradictory modernising policies which the young
and inexperienced MBS was launching in 2017. There were gestures
of liberalisation – women were given the right to drive, and cinemas
allowed to reopen after decades of closure – while opposition activists
and Islamic extremists alike were imprisoned and sentenced to death.
Bin Salman boasted that Aramco would be floated on the stock
exchange in the largest IPO in history, and that he would build the
world's biggest solar-power park in the desert (although neither has
come to pass at the time of writing). Abroad, bin Salman and his Gulf

allies were taking extreme action against Iran. MBS kidnapped the Lebanese prime minister Saad Hariri, who they thought was falling under the influence of their rival, while he was on an official visit to Saudi Arabia in November 2017, and forced him to temporarily resign; and he deepened military engagement in the Yemeni civil war, where human rights groups say the Saudis have been bombing civilian areas with banned cluster bombs. Eleven days before the *Salvator Mundi* went under the hammer, bin Salman arrested two hundred leading members of Saudi society, imprisoning them in a luxury hotel in Riyadh and collecting $100 billion of fines for corruption before releasing them.

Art had its role to play in all this. The combination of cultural liberalisation and political repression had already been trialled by Abu Dhabi and Qatar. Both states have used art to create the illusion of advancing freedoms and to co-opt liberal networks around the world into supporting their regimes. The art world has benefited financially from Abu Dhabi's patronage of art fairs and biennales, and from Qatar's purchases from auctions and in private sales – worth $25 billion in the last ten years by some estimates – and it has responded with flattery. Posing in front of Leonardo's *La Belle Ferronnière*, which is on loan to the Louvre Abu Dhabi, Louvre president Jean-Luc Martinez told *The Art Newspaper* that the museum was 'the most important cultural project of the twenty-first century'. Western artists and curators have proved susceptible to the official line that art would be a precursor to gradual political change in the Gulf, and have defended the censorship that is imposed on art there. 'We are introducing a new language, we don't have to start with the swear words,' said the director of Public Art Programs at the Qatar Museums Authority and Phillips auction house deputy chairman Jean-Paul Engelen. 'In Europe, we didn't go from Michelangelo to Damien Hirst in a decade.'[3] The 2015 Biennale in the Emirati state of Sharjah was titled 'The Past, the Present, the Possible'.

A few months before he bought the *Salvator*, Mohammed bin Salman announced that he would invest $64 billion in his country's 'cultural infrastructure'. The ancient temples, tombs and the oasis city of Al-'Ula, long closed to the outside world, would be opened up to tourism. Gulf newspapers reported that the crown prince had a programme to build 230 new museums, an astronomical number which was surely pulled out of a hat. 'The most significant reform process underway anywhere in the Middle East today is in Saudi Arabia,' wrote the Pulitzer Prize-winning author and journalist Thomas L. Friedman in the *New York Times* a week after the auction of the *Salvator*. 'Yes, you read that right. Though I came here at the start of Saudi winter, I found the country going through its own Arab Spring, Saudi style.'[4] Almost a year later, on 2 October 2018, the Saudi-born *Washington Post* columnist and blogger Jamal Khashoggi was tortured and assassinated by Saudi agents when he visited their consulate in Istanbul to obtain papers for his forthcoming marriage. In the Gulf States art is a projection of power, as it has been for centuries throughout the world, but it also functions in a new way, as camouflage, to disguise what is really going on.

The *Salvator* was, by all accounts, the first major artwork bought by bin Salman. Therefore someone with high-level contacts in the art market must have advised him. One candidate for this role could have been President Donald Trump's son-in-law Jared Kushner, who forged a friendship with the Saudi crown prince in the early days of the Trump campaign in 2016, and is said to have assisted his rise to power. Kushner and his wife, Trump's daughter Ivanka, have their own art collection (which Kushner failed to declare as an asset, as he was legally obliged to do, when he assumed a position in the White House), and are regular attendees at Sotheby's and Christie's auctions. Ivanka Trump counts among her friends the Russian collector Dasha Zhukova, founder of Moscow's Garage Museum and former wife of billionaire oligarch Roman Abramovich. Kushner made a secret visit

to Saudi Arabia in late October 2017, two weeks before the Christie's auction.

The Saudi crown prince may have seen in the *Salvator Mundi* a personal symbol of his growing power. Just as Martin Kemp has suggested that the *Salvator*'s crystal orb was a symbol of the cosmos for Leonardo, so it is possible to imagine that the Saudi crown prince saw in the translucent sphere a symbol of the magnitude of his influence. During President Trump's state visit to Saudi Arabia in May 2017, Trump, MBS, Jared Kushner, Ivanka and a large entourage of international dignitaries attended the opening of a new hi-tech surveillance centre, Etidal, the Global Center for Combating Extremist Ideology. The VIPs flowed into a cavernous futuristic hall, illuminated by blue spotlights, in which two hundred technicians sat at computer terminals arranged in crescent-shaped rows, each wearing a red-and-white *keffiyeh*. At one end of the operations centre, on a slender waist-high stand, a luminous globe of the world glowed. Trump, the ageing Saudi King Salman and the Egyptian president Abdel Fatteh el-Sisi shuffled towards this orb, and laid their hands on it as if it were a crystal ball, and they were taking part in a séance. Photos of this moment went viral. It became the definitive image of bin Salman's power.

It is even theoretically possible that a well-informed art adviser could have drawn Mohammed bin Salman's attention to the most outlandish theory about the life of Leonardo of them all.

In the late nineteenth century a movement swept European art and literature known as Orientalism. Its adherents viewed the Middle East as an arcadia, uncorrupted by industrialisation and uninhibited by Christian morality. Amidst this, the most reserved and reticent of all the Leonardists, Jean Paul Richter, succumbed to one of those flights of fancy which tend to tempt Leonardo scholars at some point in their academic careers. In an essay, 'Leonardo da Vinci in the Orient', which appeared in a German art journal, the *Leipziger Zeitschrift fur Bildender Kunst*, in 1881, the young Richter claimed to

have found evidence in the notebooks that the artist had converted to Islam.

Richter drew attention to pages on which Leonardo composed a report addressed to a high official of the Mamluk Sultan, the Devatdar, who ruled over a region roughly covering modern-day Egypt.[5] He described the landscape of the Taurus Mountains, drew sketches of their forbidding slopes and a map of part of Asia Minor, and offered an eyewitness account of an earthquake and an avalanche which destroyed an unnamed city:

> A ruinous torrent and flood of water, sand, mud, and stones, entangled with roots, and stems and fragments of various trees; and every kind of thing flying through the air fell upon us; finally a great fire broke out, not brought by the wind, but carried as it would seem, by ten thousand devils, which completely burnt up all this neighbourhood and it has not yet ceased. And those few, who remain unhurt, are in such dejection and such terror that they hardly have courage to speak to each other, as if they were stunned. Having abandoned all our business, we stay here together in the ruins of some places of worship, men and women mingled together, small and great … I know that as a friend you will grieve for my misfortunes, as I, in former letters have shown my joy at your prosperity …

Richter thought that the 'The detailed report, accompanied by illustrations, to the Devatdar, which fortunately has been preserved with the letters, leaves no room for doubt that the material for the letter was assembled by Leonardo on extended travels in Asia Minor,' which he dated to the early 1480s. It was significant, he argued, that Leonardo wrote of 'our lands', 'our city' and 'our borders', as it indicated that he was working for the Egyptian sultan. The 'urgent' tone of the artist's requests showed that he knew the Devatdar personally. Other sketches in his notebooks, of the anatomy of apes

and of the land around Suez in Egypt, demonstrated first-hand knowledge which Leonardo could only have obtained if he had been there. The quality of the paper on which Leonardo wrote his report offered further corroborating evidence: it was rougher in texture than that he normally used in Italy. Some support for this thesis came from a Viennese museum director, Moritz Thausing, who found a few more clues for Leonardo's Islamic adventure: his luxurious clothing, the distance he kept from the opposite sex, and his backwards handwriting, since Arabic is also written right to left. So why do neither Leonardo nor his contemporaries ever actually mention this sojourn in the Middle East? Richter suggested that Leonardo kept it a secret because while he was there he became a Muslim.

None of this explains why Prince Badr, bidding on behalf of MBS, made such unprecedented increments in price against his rival at the auction – ten, eighteen, and then thirty million dollars. Beyond the question of who bought the *Salvator Mundi* lies the final piece of the puzzle: why were they prepared to pay so much? Badr's irregular style of bidding is probably the clue. He was behaving as if he had something to prove. In all likelihood, the Saudis thought they were bidding against their regional rivals the Qataris, with whom they have been engaged in a bitter dispute which has included a blockade of their tiny neighbour. The Qatari royal family had built up a stock of one political and financial commodity in which the Saudis didn't have a stake: art. They were known to have bought the two most expensive works of art in history, paying $250 million for a Cézanne and then $300 million for a Gauguin. Badr's bid on the *Salvator* marked a dramatic if belated Saudi entry into the market for trophy works of art. The auction was a stage for the continuation of politics by other means, just as bulk-collecting Renaissance paintings had been polit-

icised by Charles I and Europe's seventeenth-century monarchs. This was, quite probably, a trillionaire's pissing contest.

That does not explain, however, why the Saudis seemingly pretended to give the painting away after they had bought it. Auction houses assiduously protect the right of every bidder to privacy and anonymity. My theory is that neither Badr nor bin Salman expected their identities as the buyers to be revealed, and they were embarrassed by the subsequent disclosure. Bin Salman saw multiple problems with the optics: he, the *de facto* head of an Islamic kingdom, had been revealed to have bought an image of Christ, the most expensive one ever sold, at the same time that he was waging wars abroad and urging moderation at home. So, one might deduce, he swiftly offered the painting as a loan, gift, swap or sale – we don't know which – to the newly opened museum of his closest ally, Abu Dhabi, as a way of offloading his shameful purchase. Abu Dhabi's tweeted claim that it had actually paid for the painting was probably made at the request of bin Salman. But either the Saudis or Abu Dhabi must subsequently have had second thoughts. Abu Dhabi might have expected a contract with the terms of the loan or gift, which was not forthcoming. Bin Salman might have decided to keep his 'male *Mona Lisa*' for himself, to show in one of his museums or to park as an asset in his investment portfolio. Alternatively, it is possible that both Gulf States may be concerned about the authenticity of the picture and the price that was paid for it.

Whatever Crown Prince Mohammed bin Salman's motivations, the *Salvator Mundi* has not yet journeyed to Arabia. It has not left Europe since it was sent there after the Christie's auction.

CHAPTER 22

FRAGILE STATE

At the time of writing, the *Salvator Mundi* has vanished once again into the *sfumato* of art history. There is no official information about where it is or when it will be exhibited again. No one is permitted to see it. 'Nobody outside the immediate Arab hierarchy knows where it is,' Martin Kemp has told journalists. Robert Simon is 'disturbed' by the situation. It is no longer the Last Leonardo, it is the Lost Leonardo.

The last time its location was known was autumn 2018. The painting was sent to Switzerland several months after its auction in New York – an unusually long delay, which raises questions in itself. It is being stored in a high-security vault, probably in the Geneva Freeport. Dianne Modestini was contacted by a Swiss restorer in autumn 2018 asking for advice about the preservation and transportation of the painting to the Louvre in Paris, but it has not been sent there. It has never travelled to Abu Dhabi or Saudi Arabia. In June 2019, one art market insider, Kenny Schachter, said he had been reliably informed it was on the Saudi ruler's yacht, but there is no hard evidence for this.[1]

Amidst the uncertainty, cracks have begun to emerge between the *Salvator*'s proponents. Kemp offered a veiled criticism of Modestini's restoration to the *Guardian*, for which he later apologised. Referring to Leonardo's *pentimento* of the thumb, he told the paper's art critic Jonathan Jones, 'Both thumbs are rather better than the one painted by Dianne.'[2] He also turned on the National Gallery, saying, 'One of the rules of all public museums is that you don't exhibit something that's on the market.' Margaret Dalivalle has distanced herself from the attribution process, which, she points out, was already confirmed by the National Gallery when she began her research. A sudden resignation at Christie's added to the darkening mood: the mastermind of the *Salvator*'s sale, Loïc Gouzer, left the company abruptly in December 2018, saying he wished to devote himself to environmental projects.

Modestini fears for the *Salvator*'s safety. 'In the beginning of September, after they announced that they were not going to be showing it I spoke to the French curator and two officials from Abu Dhabi. I said I'm really worried about the painting. We packed it for travel in a climate-sealed envelope, but it's not a permanent arrangement to protect it from changes in temperature. The panel is very reactive. I said, "If you actually are the owners of the picture, or if you have possession of it – or if you are not, but you know who has it – would you please tell whomsoever that they need to keep it at 45 per cent relative humidity?"' Modestini is worried that the *Salvator* could break up again if exposed for too long to the wrong climate. 'It is a very fragile painting,' she says.

This adjective is appropriate. The entire art historical construction of the *Salvator Mundi* is fragile. Around the majesty of the preserved blessing hand, Simon and his collaborators have built a house of cards of circumstantial and sometimes tendentious evidence that reminds one of the opening caveat of a Hollywood period drama: *Based on actual events*. There are too many art historical hoops this painting has to jump through to stand a real hope of being accepted and attributed

long-term to Leonardo da Vinci. There is no evidence from Leonardo's lifetime that he painted it himself. There is no proof that a French king commissioned it, or that it ended up in his court, or that it travelled from there to the collection of Charles I. There is scant proof that it was in Britain at all before 1900. There is insufficient documentation of the restoration to know what the restorer did to it. None of the great art historians and connoisseurs who saw it before 1958 identified it as a Leonardo. The art historians and connoisseurs of our own time who have seen it are deeply divided. The directors of several of the world's leading museums viewed it, but did not try to buy it. The composition of the painting lacks Leonardo's narrative and anatomical twists. It could too easily be a patchwork of studio drawings. The information about the painting's provenance and restoration has been too partial, too controlled by those with a commercial and professional interest in it, to be fully relied upon. Whatever the painting once was we can never know, because the original has been lost forever under four centuries of multiple restorations. The story told by Robert Simon, Martin Kemp, Margaret Dalivalle, Dianne Modestini, the National Gallery in London and Christie's auction house about the *Salvator Mundi* has too many plot holes to be completely credible. The provenance is speculative, the attribution optimistic, the restoration extensive, the auction unconventional, the price exorbitant, and the new owner a novice.

It is easy to see how a potpourri of interests – financial, political and even psychological – combined to turn a workshop painting into a Leonardo. The National Gallery saw an opportunity to strengthen its argument that its own Leonardo painting was genuine and to make its Leonardo exhibition stand out from all the others. A sensational new discovery was useful to Martin Kemp, whose reputation had suffered from the *Bella Principessa* attribution. The Saudis were looking for a major work of art to compete with the Qataris. The extreme damage suffered by *Salvator* made it possible to *Leonardise* the

restoration. The restorer, heartbroken after the death of her husband, overcame the grief of her bereavement through the chance to bring a Leonardo back to life. The market and museums mostly went along with it all – or at least kept their doubts to themselves – because the financial and political incentives were irresistible.

And yet, one cannot help but feel a wave of admiration and sympathy for Robert Simon, Alex Parish and their team. It is an unparalleled achievement to have found a painting of such quality in such obscurity, and to have worked for almost a decade to bring it back from the dead. When Simon and Parish bought it, the painting was a piece of junk, a thrift-store picture sold at a rock-bottom price. Twelve years later they had persuaded one of the world's most revered museums, the two most powerful auction houses in the world, and two of the world's wealthiest men that this was a masterpiece by the greatest artist who ever lived. Regardless of one's views of the quality of the painting, this was an unprecedented achievement, engineered with great skill, intelligence, patience and diplomacy, and perhaps even a little chutzpah. It is hard to imagine anyone who deserved to find a lost Leonardo more than Alex Parish, after decades of humdrum work at the coalface of art history. It is hard to find a dealer with a more impeccable reputation than the quietly erudite Robert Simon. Martin Kemp and Margaret Dalivalle have researched the painting for almost a decade without taking a penny in payment for their labour, a remarkable commitment. Dianne Modestini's restoration was elegant and necessary: the painting was in such poor condition that the alternative would have been the dustbin. For all of these individuals there was no certainty of success, and time and again victory eluded them. In the end they got their picture over the surprisingly thin line that divides the masterpiece from the mediocre. If the attribution of the painting to Leonardo is at the moment based more on feelings than on facts, then so be it – this is a Leonardo for our age, a post-truth Leonardo.

* * *

For most of 2019, there remained a flicker of hope for the *Salvator Mundi* and its believers. The Louvre had requested the painting for its Leonardo da Vinci exhibition in the year of the five hundredth anniversary of the artist's death, opening in October 2019. The publication of Robert Simon, Martin Kemp and Margaret Dalivalle's long-awaited and much-delayed book about the painting was scheduled for release a week before the Louvre show opened. At the same time, restorer Dianne Modestini launched a website with a detailed documentation of the restoration of the painting. These three events looked timed to coincide for a reason. It was difficult not to imagine that the *Salvator Mundi* would end the year with a triumphant return to grace, with the irrefutable endorsement of the museum that holds the largest collection of Leonardos in the world, supported by a definitive scholarly book on the subject and publication of all the technical information about the painting. If that had happened, the attribution question would have been settled for the foreseeable future.

But it didn't. Simon, Kemp and Dalivalle's book failed to offer significant new evidence, let alone proof that their painting, rather than the Pushkin *Salvator*, had been in the collection of Charles I and II or that it was an autograph Leonardo, rather than a workshop collaboration like the *Madonna of the Yarnwinders*. Modestini's website failed to resolve the anomaly of her beardless Christ, when compared to Hollar's etching, and of the mystery of whether the appearance of Christ's face had more to do with damage and overpainting than with the original artist's technique. If the Louvre had been permitted to borrow the picture and put it under its own independent microscopes, both these questions might have been answered.

More than once the Louvre made requests for the painting from the Gulf owners. After the *Salvator*'s auction, the museum's president, Jean-Luc Martinez, declared, 'We hope to see the *Salvator Mundi* in Paris. The goal is to gather the greatest number of works by Leonardo.'

The French National Assembly passed a special law to insure the painting for transport and display for the vast sum that had been paid for it. The curators produced designs for the layout of the exhibition, leaked to the press at the time of the opening of the show, in which a space was assigned to the *Salvator Mundi*. The curators told the press they expected it to come. Even after their exhibition opened, they suggested it might be a late arrival. But the owner never gave an answer to their approaches.

The reason for this became clear in an interview the Louvre curator Vincent Delieuvin gave to *Le Figaro* newspaper six weeks before the exhibition opened. Asked about the *Salvator*, Delieuvin said 'We have asked for it. If we get it, we will take a look at it, and we will decide if we think it is actually by the hand of Leonardo, or only partly so, or not at all.'[3] In order words, the Louvre had refused to guarantee to the *Salvator*'s owners that they would put a Leonardo da Vinci label on it in the exhibition. The owner did not explicitly demand this guarantee, because a refusal would have damned his painting. But neither did he lend it. The Saudi *Salvator* is illustrated in the Louvre catalogue, but in the caption only the title is listed – no artist whatsoever is named. The *Mundi* limbo continued and continues to this day.

But …

Their picture *could* be a Leonardo. Many people, both great art historians and members of the public, have stood in front of it and felt carried away by the *zing* of a Leonardo, a sublime air of power, mystery and spirituality. The blessing hand and the blue garments hold out the promise that one day a scholar might find incontrovertible proof of Leonardo's execution of this work for the French court. We know for certain that it is not a nineteenth-century copy or a forgery, because the scars of its history run too deep for that. Two of the world's greatest Leonardists, Martin Kemp and David Alan Brown, have attributed the picture to Leonardo, no ifs and no buts. Who can

blame Robert Simon for orchestrating the most persuasive campaign he could, and taking advantage of the loopholes and vested interests of the art world?

There is in fact a broad consensus, though not the one Christie's has suggested. The *Salvator Mundi* is almost certainly everything that everyone says it is. It is a workshop painting which Leonardo supervised and to which he added the finishing touches, in just the way Fra Pietro da Novellara and Antonio de Beatis observed when they visited his studio in his lifetime. The majority of Leonardo specialists agree that Leonardo painted some parts of the picture. Even its harshest critics believe that the master's brush touched it in places. At its most prosaic, the saga of the *Salvator Mundi* is the latest chapter in the long-running art historical debate over whether high-quality Renaissance workshop productions should be categorised as fully autograph by the master, or as master plus workshop.

Regardless, the discovery of the painting is an undeniably significant event. If it is by Leonardo and his workshop, then it was one of the workshop's highest-quality productions. The hand, hair and embroidery tell us that. The picture exhibits none of the typical weaknesses of other studio efforts – no clumsy foreshortening, sickly-sweet and vapid smiles, schematic drapery and fuzzy *sfumato*. Robert Simon's *Salvator* is the finest example of one of Leonardo's most numerous and widely disseminated branded product ranges – not the prototype, but the apogee. It adds new perspectives to an understanding of Leonardo, as both an unusually spiritual and his most conventional and traditional painting: it's Leonardo catering to the mainstream market, perhaps. Leonardo has taken the ancient image of the blessing Christ, combined it with the *Veronica* – the impression of the face of Christ on a shroud – and then given it all a *sfumato* upgrade, producing, shortly after 1500, an image that is poised between the medieval and the modern, an image that opens the door to the new world, just as Leonardo himself did. Secret signs hidden

in the picture – the double helix in the curls of the hair, and the omega (albeit degraded by time) as Christ's chest wound – link this Christian image to mathematics and the classics. The transparent orb is the finishing touch. This intensely realistic object, a secularisation of the traditional orb with cross, tells us that nature is God. The word that unites all of Leonardo's activities is *designer*. For Leonardo, design, *disegno* – which is also the word for drawing in Italian – was the foundation of the arts, and the *Salvator Mundi* is a superbly designed image. If it is a workshop painting then the *Salvator* challenges us, in this age of Andy Warhol, Olafur Eliasson and Ai Weiwei, to rethink what our art historical definition of a Leonardo should be. The old distinction between 'original' and 'studio' may be outdated.

There is a relentless logic to the situation the *Salvator* now finds itself in, as a secret painting. It has become a victim of the secrecy upon which the unregulated art market, and around it the twenty-first-century globalised economy, is built. The art market is plagued by mutual suspicions. Open discussion between professionals, academics and institutions, which must take place for a consensus to emerge, is stifled. Instead of facts, there are factions. Instead of information, there is advocacy. It is a court with only lawyers – no judge, no jury. The independent filters have been marginalised or forgotten, if not abandoned. There is a feedback loop in which the mistrust with which many independent scholars regard the art market is returned by dealers and museums, who claim the right to secrecy and opacity to defend themselves against the prejudices their procedures and processes have themselves inspired. Beyond this dystopian art world lies the global economy of the 0.001 per cent, the offshore network of financial and political power, where the wealth of society is siphoned off by dictators, oligarchs, financiers and tech monopolists, and then funnelled into the world's most expensive paintings.

Leonardo's Christ has been contaminated by both the art historical and the socio-economic contexts.

The *Salvator Mundi* represents a tragedy for the art world. Those on the outside are tempted to see a scam of huge proportions, in which a piece of junk has been passed off as a masterpiece. It is a great misfortune that popular mistrust of the art world now runs this deep. But those on the inside know that there is a second, more profound, tragedy here, which is the inverse of the first: when a potential masterpiece, such as the *Salvator Mundi could* really be, is discovered, the systems for its assessment are now so compromised that a positive verdict may never be credible. Short of a miracle, the *Salvator Mundi* will thus find itself floating forever in a Sisyphean limbo, where efforts to climb the summit of art history and authenticate it permanently as a Leonardo are eventually, ultimately, inevitably, doomed to fail.

AFTERWORD

When I was an art history student at Cambridge in the eighties, I organised an evening of performance art, inspired by Fluxus and Beuys, as one was back then. My friends and I promoted the event with photocopied posters we put up in colleges across town. I remember mine. It had three grainy enlarged photos from a DIY catalogue of hands with a paintbrush in one, a sponge in another and a roller in the third, working on a wall. I emblazoned the images with the slogan 'Clean Art', in a style that owed much to Barbara Kruger and the Appropriation art of the Pictures Generation. I often thought of that image I made over thirty years ago as I wrote this book. It seemed fortuitously prophetic, not only because of the controversy surrounding the restoration of the *Salvator Mundi*, but because of the accusations of deception and fraud swirling around the painting.

I remember when I first noticed that an art boom was under way, decades later. It was 2006, and someone had just bought a Lichtenstein for $15.7 million. I was writing a monthly column as an art critic for the British current affairs magazine *Prospect*, and I had just finished making a television series on contemporary art, *Art Safari* (2003–05), which charted the rise of the phenomenon itself. I admire

Lichtenstein's work, but I remember thinking that $15.7 million was an absurd amount to pay for it. Only $1 million was for the art, I thought – the rest had to be explained by hidden financial benefits. I remember thinking quite clearly, *If some people have this much to spend on art, there is something seriously wrong with the world economy.* Two years later Lehman Brothers collapsed, and the financial crisis followed. However the art market, after an initial brief downturn, continued to grow. In many ways the story of the *Salvator Mundi* was foretold by this trajectory.

On the face of it, we appear to be in a golden age for art. There are more artists, more museums, more collectors and more gallery-goers. The art market has globalised, as the continents of Asia and Africa grow their own art worlds to bolt onto Europe's and America's. Every public museum seems to have a new extension with a polished concrete floor and a posh café. Barely a month goes by without a collector somewhere in Asia or Latin America opening their own personal set of skylit modernist cubes in which to exhibit their trophies. Art fairs proliferate in regional cities. The art is less snooty and the audience is broader than ever as curators have reached out to them with spectacles like Olafur Eliasson's waterfalls in New York harbour and Anish Kapoor's giant mirrored bean in Chicago, and funfair rides like Carsten Höller's enormous slides in the Palazzo Strozzi and Tate Modern. There is even (I have the impression) a more sophisticated attitude to art among the public. I'm sure I hear the phrase 'My kid could do that' less than I did twenty years ago.

The record-breaking attendance figures for Luke Syson's Leonardo exhibition at the National Gallery, and the sought-after tickets (selling on the black market for hundreds of pounds), seem to exemplify this welcome moment of cultural democratisation and inclusiveness. In such a world, the enormous price of the *Salvator Mundi* is almost

logical, as are all the other price tags that cause shock one day and are perfectly acceptable the next. Of course art is getting more expensive. As time passes it becomes increasingly rare and increasingly desired.

And yet, the case of the *Salvator Mundi* tells us that all is not well in the art world. It is impossible to imagine a more vivid symbol, indeed, more glaring proof, of the dysfunctionality within the ecosystem of art than the fact that the most recently discovered work by the most famous artist of all time – never mind its outrageous cost – dares not show its face. The extremity of this situation cannot be over-estimated, and must not be ignored.

The *Salvator Mundi* tells us that art is being taken away from us – literally. The experience of art is being captured at the very moment of its greatest expansion. There is a real-world parallel: what has been happening to art is what has been happening to the global economy, which has been captured by the offshore society of billionaires and banks, operating outside the frameworks of civil society.

Stories of corruption and deception surface from time to time. A Brazilian billionaire smuggles a rolled-up Basquiat through New York customs claiming it is worth a hundred bucks ... New York art dealers resolve disputes with the IRS over unpaid sales tax and other duties worth tens of millions ... Swiss bank staff patrol art fairs with computers containing encrypted PowerPoint presentations showing how new clients can secretly move their money offshore. Those inside the art market, including many supposedly 'independent' commentators, respond defensively that there are of course a few bad apples in the magnificent display of the fruits of human creativity. And yet, whenever the curtain is pulled away forcibly, by lawyers or investigators, it seems that this is what is revealed.

Not only private sales but also public exhibitions are funded by entities whose profits are made, at least in part, offshore. The danger

is that museums become places where the visitor can do nothing more than either applaud or resist the choices of the rich. Art, when its owners deign to show it to the public, becomes a spectacle of extravagance. The museums' new extensions are so opulent that the experience of visiting them is belittling, not empowering. The cost of the works of art is so great that every other meaning in them is obliterated save for their being symbols of excess. Our experience of art is being hollowed out.

The art world says, ''Twas ever thus.' This may be true, but that is the point. The critics of the art world have got it the wrong way round. They complain that art has become a commodity, a tool for reputation and money laundering. They attack the market as unregulated and opaque. It has long been like that. Today these sins are greater in scope and more complex in their nature, of course, but that is mostly a function of inflation and modernisation. The world has changed, but the art world hasn't. Today we have democracy, civil society, freedom of speech, the rule of law, a regulated form of capitalism, best practice, codes of conduct, industry guidelines and so on. Yet the rules that govern the art ecosystem are little different from those of the seventeenth century. Art dealers and collectors have exploited the primitiveness of the art market to turn it into a monster.

The problem with the art world today is not that it has changed, but that it *hasn't* changed.

The dangers are clear. In the social and political arenas we have witnessed a revolution against 'elites', motivated by inequality and enabled by the new technology of social media. Trust in politicians and the media has collapsed. Trump, Brexit, and the rise of neo-fascist, so-called populist dictators around the world are the result. Something analogous may soon happen to the cultural elites.

In fact it is already happening. Behind the utopian façade lies an ambiguous reality. In London, the 2018 visitor figures for the British Museum, the National Gallery and the National Portrait Gallery have seen a drop since 2015 of around 2.4 million − 16 per cent.[1] The Louvre had 7.4 million visitors in 2016 − 1.2 million fewer than the previous year. The signs of resistance are growing. The global patronage of museums by the Sackler family is coming under scrutiny, since their wealth is based on the sale of opioids. Activists led by photographer Nan Goldin have mounted protests and several museums, among them the Guggenheim in New York and the National Portrait Gallery and the Tate in London, have recently announced that they will no longer accept donations from the Sacklers. BP abandoned its sponsorship of Tate Britain amidst growing protests. Even the overall figures for the art market over the last decade don't look good: they have not yet returned to their 2007 peak.[2] Change is already afoot.

The case of the *Salvator Mundi* is unique, in that it has compressed within its history a litany of all the archaic flaws of the art world. There is the possibility that it will show the art world that it is in its own interests to clean up its act.

The ecosystem of art needs both regulation and self-policing. Substantial transactions in the art market should be no more secretive than those in financial and commodity markets. It should be no more acceptable for a museum to accept donations from families and companies whose wealth derives from environmental degradation, the sale of addictive drugs or facilitating tax avoidance offshore, than it is acceptable for governments to sell arms to regimes that bomb civilians or assassinate their political opponents. The art world's stakeholders can no longer pretend that the ethics of those who patronise and finance it are not relevant, or are outweighed by the irresistible commercial pressures to compete internationally, or, worst of all, as some of them claim, are superseded by their higher responsibility to support the cause of art and artists.

But the art world needs more freedom too, and the *Salvator Mundi* speaks to that as well. Where the institutions of art have rules, they are often the wrong ones – out of date, no longer fit for purpose. Museums, for example, are not, by convention, allowed to exhibit a work of art that is on the market or to show a newly discovered one with a doubtful attribution – the source of much of the controversy over the *Salvator Mundi*. But as exhibitions and museums multiply, while the stock of old paintings remains much the same, it is unreasonable to expect curators not to look for pictures with surprises and controversial backstories to put into their shows. Such disputes are part of the reality show of art. What is needed are protocols which prevent the museum from taking sides in a developing story of attribution.

It was and continues to be important that visitors see the *Salvator Mundi* on a wall in a museum, so that they can join a debate about whether it is or isn't a Leonardo. It was actually a good and brave idea of Luke Syson and Nicholas Penny to defy convention and include the *Salvator* in their Leonardo exhibition at the National Gallery. But it should have been done within a framework, which does not yet exist. It should have been catalogued not as a Leonardo, but as something that might be.

The *Salvator Mundi*'s condition is a sign of things to come. We accept that much of the art of great ancient civilisations – Egyptian, Assyrian, Roman and Greek – is today ruins and fragments, the colours faded and the limbs shattered. We must anticipate that, as time goes by, art works that are not as old, but are becoming older, will sooner or later themselves become ruins or collections of fragments. We must learn to be grateful for whatever remnants of genius survive, even if they are only fleeting shadows on fingernails and a few thin strands of hair.

Leonardo would be happy with the fate of his painting. His highest ambition was to be the master painter at a magnificent court, and

to enjoy the wealth and fame that brought. Now he is the artist of the most expensive painting in history. He would be pleased that his picture has established painting as the most valuable of all the arts, as he often argued it was. He would not worry if it was owned by a brutal ruler – he worked for two of them. He would smile at the endless discussions of pedantic scholars over whether and where his brush had touched the panel. He himself said, '*La pintura è cosa mentale*.' Painting is all in the mind.[3]

That is why I hope that the *Salvator Mundi* will be on display in a public museum again soon. But with an honest question mark.

ACKNOWLEDGEMENTS

This book was written by one hand – mine – but, a little like the *Salvator Mundi*, that may possibly be the only purely autograph feature of it. Behind that hand lie the thoughts of scores of the world's leading art historians, who I consulted in the course of writing the book. I feel as if I assembled a cast of hundreds to stage my story about the *Salvator Mundi*.

I had the privilege of being invited to write this book as a Visiting Fellow at the Warburg Institute in London, for which I thank the institute's director Bill Sherman. The Warburg's imaginative approach to academic enquiry, its openness to multi-disciplinary research, its understanding that the history of art does not exist in a bubble, its pioneering recognition of the importance of the itineraries of the works of art, and the value it places on the independence of enquiry, whether by scholars, journalists or the curious, was a daily inspiration to me.

I was equally fortunate that a majority of the key people involved in the discovery, attribution and sale of the *Salvator Mundi* were happy to meet me and permitted me to record interviews with them. My thanks go to art dealers Robert Simon and Alex Parish;

restorer Dianne Modestini; Professors Pietro Marani and Maria Teresa Fiorio; curator Luke Syson and director Sir Nicholas Penny of the National Gallery in London; and the Metropolitan Museum's curator of drawings and prints Carmen Bambach. I would also like to thank provenance researcher Margaret Dalivalle, Britain's leading Leonardo scholar Martin Kemp, and David Alan Brown from the National Gallery of Art in Washington, DC, for answering some of my emails.

This book owes its greatest debt to Frank Zöllner, professor of art history at Leipzig University and author of the *catalogue raisonnée* of Leonardo's paintings and drawings. Over the nine months I wrote this book, Frank and I exchanged emails on a weekly basis, and we became friends. Amidst the often fractious and emotional debate over the nature of the *Salvator Mundi*, Frank showed only calm and collected objectivity and the highest standards of academic independence – qualities for which I have often particularly admired German scholarship. The Swiss-based art historian Dietrich Seybold, who specialises in the history of connoisseurship, played a similarly large role in my book. Seybold's online essays about the various versions of the *Salvator Mundi*, and his pioneering research into their provenance, were a starting point for my own exploration of the history of the family of Leonardesque *Salvator Mundi*s. Dietrich's love of the wild-goose chase of provenance research was infectious and inspiring, as was his equally admirable, unerringly rational interrogation of the principles of connoisseurship. As the months went by, he and I swapped many stories about these different paintings, as well as about the nature of connoisseurship. I road-tested most of the ideas and themes of this book with Frank and Dietrich.

I employed specialist researchers in five different countries to help me uncover and establish the facts in this book. Chris Buchanan in America performed the miracle of tracking down the secret seller of the *Salvator Mundi* in 2005 in New Orleans. Another postgraduate,

Amy Parrish, recommended to me by Jeremy Wood, professor of art history at Nottingham University, and provenance specialist Julia Armstrong-Totten explored the Getty archives in Los Angeles for me. Courtauld Institute postgraduate Andres Rubiano Velandia kindly assembled material for me about Leonardo's studio. Denis Stolyarov, another Courtauld postgraduate, dug deep into Russian archives for me, with the help of producer Masha Kedder in Moscow and art historian Catherine Philips in St Petersburg. In London Eileen Byrne spent weeks assembling and analysing the publicly available legal documents concerning Dmitry Rybolovlev and Yves Bouvier. I am also grateful to researchers Anna-Francesca Leccia in Italy, Maria Linsel in Germany and Frances Vieta in New York.

Among the numerous art historians, museum curators, historians and scholars whom I spoke to in the course of writing this book, none were more friendly or wise than Andrew Barclay, senior research fellow of the history of Parliament, and Erin Griffey, associate professor at the University of Auckland. Marlise Rijks and Ruben Suykerbuyk at the universities of Leiden and Ghent provided me with generous advice about Dutch seventeenth-century art collections. Antiquarian bookseller Robert Harding from Maggs, Canadian scholar Anne Thackray, New Hollstein print scholar Simon Turner and Australian lecturer Andrea Bubenik all shared their expertise about Wenceslaus Hollar with me. Lisbon-based cultural historian Jeremy Roe and Professor Jean Andrews from Nottingham University offered their deep knowledge of early-seventeenth-century Spanish art collecting. Professor Stephen Bowd from Edinburgh discussed Leonardo's funeral with me in the context of contemporary burials. I was fortunate to be able to discuss French royal inventories and Leonardo's French period with Laure Fagnart from the University of Liège, with the British art historian of the French Renaissance Professor Robert Knecht, and also with researcher Lucas de Francesco.

I exchanged emails with Reverend Nigel Cave IC about the Joseph Hirsts, father and son. Lastly, I benefited from conversations regarding Leonardo's religious beliefs and the unreliability of Vasari with Oxford Research Fellow Dr Matthew Landrus and Professor Emerita of the University of Colorado, Claire Farago, whom I met at Frank Zöllner's Leonardo conference in Leipzig in summer 2019.

I spoke to Francesca Borgo from St Andrews and Charles Robertson from Oxford Brookes universities about Leonardo and attributions, and discussed the hair of the *Salvator Mundi* and the shortcomings of connoisseurship with Emanuele Lugli from Stanford. Curator Gerlinde Gruber at the Kunsthistorisches Museum in Vienna advised me on Leopold William's art collection; Andrea Bacciolo from the Max Planck Institute for Art History, advised me on the Barberini gift. Lynn Catterson from Columbia University assisted me as I researched the late-nineteenth-century art market. I had numerous email exchanges with Professor Thomas M. Bayer, one of the first historians of the eighteenth- and nineteenth-century art market. Dr Elisabetta Sambo from the Fondazione Federico Zeri, Professor Hermann Mildenberger from the Klassik Stiftung Weimar and postgraduate scholar Serena Zanaboni shared their knowledge of the world of nineteenth-century copyists and forgers. Ilaria della Monica from I Tatti, the Harvard University Center for Renaissance Studies, went into the Berenson archives and retrieved relevant documents for me. Historian of glass Paul Engle, Stefania Gerevini, art history professor at the Milanese Bocconi University, and Heike Zech, curator of applied arts at the German National Museum all furthered my limited knowledge of the history of crystal and glass orbs. Clare Browne, textile historian at the Victoria and Albert Museum, offered her interpretation of the clothing of Christ in the *Salvator Mundi*. Maria de Peverelli at Holkham Hall in Norfolk advanced my knowledge of the property's version of the *Salvator Mundi*, and even kindly photographed the back of it for me. At the Warburg Institute I had

numerous conversations and email threads with the former director Charles Hope, the curator of the photographic collection Paul Taylor, the deputy director Michelle O'Malley, and former Getty and National Gallery, London, curator David Jaffe. Art historian Elon Danziger, Richard Cook, the descendant of Sir Francis Cook, and John Somerville, the Cook family archivist, all generously shared their knowledge of the Cook Collection. Catherine Casley, collections manager, Department of Western Art at the Ashmolean Museum in Oxford shared the digitised archive of Sir John Charles Robinson's papers. Vincent Delieuvin, the Louvre curator who is organising the five-hundredth-anniversary Leonardo exhibition in 2019, kindly responded to my emailed enquiries. The former director of the Gemäldegalerie in Berlin, Bernd Lindemann; Dr Hans Ost; and the CEO of Lempertz, Henrik Hanstein, gave me their accounts of the time when the *Salvator Mundi* was offered for sale to them. Larry Keith, head of conservation at the National Gallery in London, Elizabeth Ravaud from the Centre de Recherche et de Restauration des Musées de France, and New York restorer Paul Himmelstein all advised me on the restoration issues of the *Salvator Mundi*.

I enjoyed conversations with the fiercest critics of the *Salvator Mundi*, Michael Daley from Artwatch International and French Leonardo specialist Jacques Franck. Yves Bouvier was kind enough to invite me to meet him in Geneva, while Dmitry Rybolovlev's representative, Brian Cattell, obtained a statement for me from the oligarch. Art market reporters Judd Tully and Kelly Crow offered me their recollections of the auction of the *Salvator*. I shared information and ideas on many occasions with Alison Cole at *The Art Newspaper* and her colleagues Georgina Adams, Cristina Ruiz and Martin Bailey. On two occasions *The Art Newspaper* considered my discoveries about the painting to be worth sharing with its readership on the front page.

My editors Arabella Pike from William Collins in London and Andra Miller from Ballantine in New York, and the legendary Robert

Lacey at William Collins, worked tirelessly and against an impossible deadline to turn my disorganised smorgasbord of art history into a sleek mystery story. I thank Sarah Hopper for the photo clearances and Iain Hunt for the plates layouts. The wonderful cover is the work of Julian Humphries. Finally, my deepest gratitude is reserved for my agents at Janklow & Nesbit, Emma Parry in the New York office, and above all Claire Conrad in London. Without Claire I simply would not have become an author. And if she hadn't told me one day in 2017 that the last book I wrote with her, about humour under communism, was one of her favourites, I would never have been inspired to conceive the idea for this book.

Ben Lewis
March 2019

NOTES

CHAPTER 1: FLIGHT TO LONDON

1. Robert B. Simon, 'Bronzino's Portrait of Cosimo I in Armour', *Burlington Magazine*, September 1983

CHAPTER 2: THE WALNUT KNOT

1. The prophecies are dated 1497–1500. See Kenneth Clark, 1954, p.69.
2. 'Although the defect must have been obvious from the beginning, no effort was made to excise the knot and patch the wood, or to apply fabric or stoppa to strengthen the area.' Dianne Modestini, 'The *Salvator Mundi* by Leonardo da Vinci Rediscovered: History, Technique and Condition', in *Leonardo da Vinci's Technical Practice: Paintings, Drawings and Influence*, ed. Michel Menu, Paris, 2014, p.140.

CHAPTER 4: PAPER, CHALK, LAPIS

1. Carmen Bambach, *Leonardo da Vinci, Master Draftsman: Catalogue to an Exhibition at The Metropolitan Museum of Art*, New York, 2003, p.5.
2. 'The type of drapery and even the technique suggest the period of the *Virgin and St Anne*.' Kenneth Clark, *Leonardo da Vinci Drawings at Windsor Castle*, Phaidon, 1969, p.94.

CHAPTER 5: ZING!

1. Martin Kemp, *Living with Leonardo: Fifty Years of Sanity and Insanity in the Art World and Beyond*, Thames & Hudson, 2018, p.10.
2. Martin Kemp, *Leonardo da Vinci: The Marvellous Works of Nature and Man*, OUP, 2007, p.107.
3. Martin Kemp, 'Authentication in Art 2014 & Guidelines', https://authenticationinart.org/aia-past-events/aia-congress-2014/.
4. Kemp, *Living with Leonardo*, p.11.
5. Quoted in David Grann, 'The Mark of a Masterpiece', *New Yorker*, 12 July 2010.
6. Kemp, *Living with Leonardo*, p.9.
7. Kemp, *Marvellous Works*, p.201.
8. Martin Kemp & Pascal Cotte, *Leonardo da Vinci: La Bella Principessa: The Profile Portrait of a Milanese Woman*, Hodder & Stoughton, 2010, p.82.
9. *Sunday Times*, 27 July 2008. See also Richard Dorment, 'La Bella Principessa: A £100m Leonardo, or a Copy?' *Daily Telegraph*, 12 April 2010.
10. Klaus Schröder, the director of the Albertina, stated, 'We are not convinced that it is an authentic drawing by Leonardo. It was examined by our own research centre, our curators, our restoration department, and the Vienna Academy of Fine Arts. No one is convinced it is a Leonardo.' Quoted in Milton Esterow, 'The Real Thing?', Artnews, 1 January 2010. http://www.artnews.com/2010/01/01/the-real-thing/.
11. The *New Yorker* article also pointed to paintings Biro had sold in the eighties which experts dismissed as forgeries. Biro disputed the accuracy and insinuations of these allegations, and sued the magazine for libel. The lawsuit was dismissed without determining whether the allegations were true or not. As is often the case in American libel suits, the court found as a threshold issue that Biro could not maintain his lawsuit because he failed to plausibly argue that the defendants published the allegations with knowledge of falsity or reckless disregard for the truth, the standard that applies when public figures sue for libel.
12. 'Living with Leonardo', *The Art Newspaper* Podcast, Episode 25, hosted by Ben Luke, 29 March 2018.

13. Kemp, *Living with Leonardo*, p.145.

CHAPTER 6: THE BLUE CLUE

1. Kemp, *Marvellous Works*, p.30.
2. Ernst Gombrich, 'The Mystery of Leonardo', *New York Review of Books*, 11 February 1965.
3. Walter Isaacson, *Leonardo da Vinci: The Biography*, Simon & Schuster, 2018, p.301.
4. See Jessica Hoya and Kenneth C. Millett, *A Mathematical Analysis of Knotting and Linking in Leonardo da Vinci's Cartelle of the Accademia Vinciana*, Department of Mathematics, University of California, Santa Barbara, CA 93106, USA, 2014.
5. Kemp, *Living with Leonardo*, pp.187–8.
6. Andrew M. Goldstein, 'The Male *Mona Lisa*?: Art Historian Martin Kemp on Leonardo da Vinci's Mysterious *Salvator Mundi*', *Blouin Artinfo*, 17 November 2011.
7. See Sixten Ringbom, *Icon to Narrative*, Davaco, Doornspijk, 1984; Kathryn M. Rudy, *Rubrics, Images and Indulgences in Late Medieval Netherlandish Manuscripts*, Brill, Leiden, 2017; and Frank Zöllner, unpublished lecture 'Leonardo's *Salvator Mundi* as a Religious Image', Paragone: Leonardo in Context, Leipzig, 18–21 July, and Zöllner and Johannes Nathan, *Leonardo da Vinci: The Complete Paintings and Drawings*, Taschen, 2019, p. 9.
8. These thoughts emerge from exchanges I have had with Frank Zöllner, who writes: 'An aspect of the New York *Salvator Mundi* that has been wholly ignored up till now is the exclusively blue raiment worn by Christ. This uniform drapery colour is unusual in a portrait of Christ painted on panel in this epoch.' Frank Zöllner, *Leonardo da Vinci: The Complete Paintings*, 2019, p.251.

CHAPTER 7: VINCI, VINCIA, VINSETT

1. Bernard de Mandeville, *The Fable of the Bees*, London, 1795, p.206.

CHAPTER 8: THE KING'S PAINTING

1. Bishop Goodman, quoted in Roger Lockyer, *The Life and Political Career of George Villiers, First Duke of Buckingham 1592–1628*, Longman, New York, 1981, p.20.

2. *Historical and Biographical Memoirs of George Villiers I, Duke of Buckingham*, London, 1819, p.16; Sir Henry Wotton, *Reliquiae Wottonianae*, 1651, p.81.

3. Wotton, *Reliquiae Wottonianae*, p.82.

4. Glyn Redworth, *The Prince and the Infanta: The Cultural Politics of the Spanish Match*, Yale, 2003, pp.79–80.

5. Quoted in Jerry Brotton, *The Sale of the Late King's Goods*, Macmillan, 2006, p.91.

6. James Howell, *Epistolae Ho-Elianae*, p.76, quoted in ibid., p.100.

7. Vincent Carducho, *Dialogues About Art and Painting*, Madrid, 1633, Dialogue 1, f.22r.

8. Alonso de Castillo Solorzano, 'A Don Juan de Espina', poem, 1623, quoted in Enrique Garcia Santo-Tomas, *The Refracted Muse: Literature and Optics in Early Modern Spain*, Chicago, 2017, p.124. Anonymous ballad, 'Chronicle of the Party that Don Juan de Espina threw in his house, on a Sunday night, the last day of February 1627', quoted in ibid., pp.121–2.

9. Quoted in ibid., p.122.

10. Carducho, *Dialogues About Art and Painting*, Dialogue 8, f.156v.

11. Ruth Saunders Magurn (ed.), *The Letters of Peter Paul Rubens*, Harvard, 1955, p.322.

12. Edward Chaney, *The Evolution of English Collecting*, Yale, 2003, p.54.

13. Quoted in Dr Godfrey Goodman (ed. John Brewer), *The Court of King James the First*, Vol. I (first published 1839), Read Books, 2011, p.369.

14. *Abraham van der Doort's Catalogue of the Collections of Charles I*, edited with an introduction by Oliver Millar, The Walpole Society, Vol. XXXVII, 1958–1960, p.89; Windsor Mss f.19.

15. Quoted in Bendor Grosvenor, 'Lessons in Collecting from the Court of Charles I', *The Art Newspaper*, 9 March 2018.

16. Hugh Trevor-Roper, *The Plunder of the Arts*, Thames & Hudson, 1970, p.57.

17. George Vertue and Horace Walpole, *Anecdotes of Painting in England*, Vol. II (first Published 1762), Chatto & Windus, 1876, p.13.
18. These remarks are thought to come from one of the king's former art advisers, Balthasar Gerbier, who reinvented himself later as a parliamentarian with the pamphlet 'The None-Such Charles his Character', London, 1651.

CHAPTER 9: LITTLE LEONARDOS

1. Frances Ames Lewis, *Isabella and Leonardo*, Yale, 2012, Appendix, p.223.
2. Bertrand Jestaz, 'François Ier, Salaì et les tableaux de Léonard', in *Revue de l'art*, 4, 1999, pp. 68–72.
3. Bernard Berenson, *The Italian Painters of the Renaissance*, Vols I–II, Phaidon, 1968, pp.89–92.
4. Quoted in David Alan Brown, Marco Carminati, Pietro Marani, Maria Teresa Fiorio, *The Legacy of Leonardo: Painters in Lombardy 1490–1530*, Random House, 1998, p.10.
5. Kemp, *Marvellous Works*.
6. Bambach, *Leonardo da Vinci, Master Draftsman*, p.41.
7. For this information and theory of the Antwerp production of the *Salvator Mundi* copies, I am indebted to Dietrich Seybold. See http://www.seybold.ch/Dietrich/ASalvatorMundiGeography and http://www.seybold.ch/Dietrich/ASalvatorMundiAtlas
8. See Dietrich Seybold, www.seybold.ch/Dietrich/ASalvatorMundiProvenance.

CHAPTER 10: THE *SALVATOR* SWITCH

1. This inventory was discovered and published by the British art historian Jeremy Wood. The entry for the *Salvator Mundi* was spotted by Margaret Dalivalle after his article was published. Jeremy Wood, 'Buying and Selling Art in Venice, London and Antwerp: The Collection of Bartolomeo della Nave and the Dealings of James, Third Marquis of Hamilton, Anthony Van Dyck, and Jan and Jacob Van Veerle, c. 1637–52', *Journal of the Walpole Society*, Vol. LXXX, 2018, pp.70–3.

After the story broke (Alison Cole, 'Leonardo's Salvator Mundi: Expert Uncovers 'Exciting" New Evidence. Did Louvre Abu Dhabi's $450m painting belong to an English nobleman who followed Charles I to the scaffold in 1649?', *The Art Newspaper*, 30 August 2018), Dalivalle commented: 'I immediately recognised the significance of one item hanging in the Lower Gallery: "Christ: with a globe in his hande done by Leonardus Vinsett" – the artist now known uniformly as Leonardo da Vinci. The precision of the description in the Hamilton inventory is itself vanishingly rare in a seventeenth-century English document, as is a painting attributed to Leonardo. [The inventory entry] sounds feasible to me … given the company it kept; it was placed among paintings of prestigious Della Nave and Priuli [both notable Venetian collections] provenance.'

If the pictures can both be identified as the *Salvator Mundi* in Abu Dhabi, Dalivalle has a plausible scenario as to how the painting found its way from Hamilton's collection into the ownership of Charles I: 'The painting was in a collection closely, almost incestuously, related to the Royal Collection; the king, according to a document of 18 October 1638, expressly wished to have the pick of paintings bought by Hamilton in Venice, threatening the imposition of customs duty, and the king and queen's predilection for Leonardo is documented,' Dalivalle says. 'Therefore, I consider there is a strong possibility that this painting was seen at Chelsea House and chosen by the king at some point between 1638 and 1641, finding its way to the queen's apartments at Greenwich.' She adds: 'I have found no evidence that the *Salvator Mundi* was brought by Henrietta Maria from France; it belonged to her by dint of the fact that it was recorded in a property of her jointure in 1649.'

2. This may be the same picture listed in another Hamilton inventory but attributed, incorrectly, to Raphael: '*31. A picture of our Saviour with a globe in his hande of Raphell*'. In those days inventory compilers often got the names of the artists wrong.

3. Quoted in E.K. Waterhouse, 'Paintings from Venice for Seventeenth-Century England: Some Records of a Forgotten Transaction', *Italian Studies*, 7:1, 1952, p.6.

4. Quoted in Katherine S. Van Eerde, *Wenceslaus Hollar: Delineator of his Time*, Folger Shakespeare Library, University Press of Virginia, 1970, p.9.

5. Joanne Snow-Smith, *The Salvator Mundi of Leonardo da Vinci*, Henry Art Gallery, University of Washington, 1982.

6. Ibid., p.27.

7. 'Leonardo: *Salvator Mundi*', Christie's Auction House, New York, 2017, p18.

8. Pierre Dan, Sebastian Cramoisy, 'Un crist a demi-corps' – *Le Tresor des Merveilles de la Maison Royale de Fontainebleau*, Paris, 1642, p.135.

9. This inventory of paintings was written by the painter Charles le Brun: 'No. 15 A painting taken from the Cabinet of Fontainebleau in the manner of "Leonnard d'Avincy" representing Our Lord half figure holding a globe [*monde*], height 43.2cm, length 35.1cm painting on wood with a gilt border. [In the margin:] Seen in Paris 8 August 1690.' The painting is mentioned again in inventories of Versailles in 1695 and 1709. See Laura Fagnart, *Léonard de Vinci a la cour de France*, Rennes, 2019.

10. Pierre Guilbert, *Description historique de château, bourg et forêt de Fontainebleau*, Paris, 1731. Just to complicate matters, Guilbert says the picture he saw is a French seventeenth-century copy of a Leonardo original by Jean Dubois. The original was hanging elsewhere. The expert on Leonardo and France, Laure Fagnart at the University of Liège, told me that she thought the Nancy d'Oggiono is the one the French kings owned. She wrote to me: 'I do not believe that the painting at Christie's was entirely executed by the hand of Leonardo, nor that it was commissioned by Francis I or Louis XII, as has been suggested.'

11. See Dietrich Seybold http://www.seybold.ch/Dietrich/ASalvatorMundiGeography

12. Dietrich Seybold published the first pioneering study of the provenances of the various known versions of Leonardesque *Salvator Mundis*, and drew attention to the Charles I provenance claimed by the Pushkin Museum in Moscow for their *Salvator Mundi*, writing, 'Can it be excluded that the picture mentioned in the inventories of English Royal collections is the painting of the Pushkin State Museum of Fine Arts?'; http://www.seybold.ch/Dietrich/ASalvatorMundiProvenance

CHAPTER 11: THE RESURRECTION

1. Dianne Modestini, 'The *Salvator Mundi* by Leonardo da Vinci Rediscovered: History, Technique and Condition', in *Leonardo da Vinci's Technical Practice: Paintings, Drawings and Influence*, ed. Michel Menu, Paris, 2014, p.140. This article was originally presented as a paper at the CHARISMA conference 'Leonardo da Vinci's Technical Practice: Paintings, Drawings and Influence', organised jointly by the National Gallery (London), Centre de Recherche et de Restauration des Musées de France (C2RMF) and the British Museum, London, 13–14 January 2012.

2. Dianne Dwyer Modestini, *Masterpieces*, based on a manuscript by Mario Modestini, Cadmo, Fiesole, 2018, p.411.

3. Ibid., p.416.

4. Modestini, 'The *Salvator Mundi* Rediscovered', p.142.

5. Modestini, *Masterpieces*, pp.414, 418, 419.

6. My interview with Dianne Modestini.

7. Modestini, *Masterpieces*, p.417.

8. Ibid.

9. Milton Esterow, 'Rediscovering a Leonardo: How experts around the world concluded that *Salvator Mundi* was a lost work by the master', *Artnews*, September 2011, p.101.

10. Modestini, 'The *Salvator Mundi* Rediscovered', p.150.

11. This report is referred to in a Sotheby's document about the *Salvator Mundi* of 25 January 2015. The document states: 'Other technical observations, including the discussion of incisions in the paint surface and the presence of fingerprints are treated in the Technical Examination Report by Nica Gutman Rieppi.' Robert Simon mentioned to me that the report was only taken to the draft stage, and was never finalised.

12. Sotheby's document, 28 January 2015, submitted as Exhibit F in legal documents, PETITIONERS' MEMORANDUM OF LAW IN SUPPORT OF THEIR APPLICATION FOR AN ORDER UNDER 28 U.S.C. § 1782 TO CONDUCT DISCOVERY FOR USE IN FOREIGN PROCEEDINGS, filed 25 March 2016 by Dmitry Rybolovlev's lawyers. Robert Simon told me: 'I think that idea of the blessing hand not being there originally was just an idea.

It may just be that the shoulder was laid in first and the raised hand added soon after – impossible to say.'

13. British picture restorers, 1600–1950, An online resource, launched in 2009, Jacob Simon ed., https://www.npg.org.uk/research/ programmes/directory-of-british-picture-restorers/ british-picture-restorers-1600-1950-a.

14. Giovanni Morelli, *Italian Masters in German Galleries*, George Bell & Sons, London, 1883, p.2.

15. John Pye, *Patronage of British Art*, London, 1845.

16. Mary Berenson's diary, 1899, quoted in Mary Berenson, *Strachey and Samuels*, Norton, 1983, p84.

17. Thomas Winstanley, *Observations on the Arts*, Liverpool, 1828, p.32.

18. See Dietrich Seybold, 'The Mysterious "Donna Laura Minghetti Leonardo": Re-opening the Case'. The online essay is based on the paper Seybold delivered at the 2010 'A Market for Merchant Princes: Collecting Italian Renaissance Paintings in America' conference, presented at the Frick Collection by the Center for the History of Collecting in America, Frick Art Reference Library, New York. http://www.seybold.ch/Dietrich/TheMysteriousDonnaLaura Minghetti-Leonardo.

19. Ibid. Seybold cites his source: 'published with kind permission of the Bibliotheca Hertziana from the Archiv der Bibliotheca Hertziana – Max-Planck-Institut für Kunstgeschichte, Rome, Nachlass Jean Paul Richter, box 8, folder 3'.

CHAPTER 12: LOST IN A CROWD

1. See N.D. Marchi, 'Auctioning Paintings in Late-Seventeenth-Century London: Rules, Segmentation and Prices in an Emerging Market', in *Economics of Art and Culture*, V.A. Ginsburgh ed., Elsevier, Amsterdam, 2004.

2. André Rouquet, *The Present State of the Arts in England*, London, 1755, p.200.

3. Quoted in Thomas M. Bayer and John R. Page, *The Development of the Art Market in England: Money as Muse 1730–1900*, Routledge, 2011, p.96.

4. See Dietrich Seybold's studies of the provenances of versions: http:// www.seybold.ch/Dietrich/ASalvatorMundiProvenance, http://

www.seybold.ch/Dietrich/SomeSalvatorMundiMicrostories and
http://www.seybold.ch/Dietrich/LeonardeschiGoldRush.

5. These are all listed in the digital bible of provenance research, the Getty Sales Index.

6. Thomas M. Bayer and John R. Page, 'The Development of the Art Market in England', in Taylor and Francis (eds), *Money as Muse 1730–1900*, Routledge, 2015, p.225 n5.

7. P. Pipaud, '*Salvator Mundi*, l'histoire nantaise d'un tableau de Léonard de Vinci', *Bulletin SAHNLA*, 2012, pp.235–76.

8. The Behague Collection, Catalogue, Berkeley, University Art Museum, 1981–82), New York, p.17, quoted in ibid., p.242.

9. 'La Raccolata Leonardsca della contessa de Behague', Exhibition Catalogue, Vinci April–June 1980, quoted in ibid., pp.242–3.

10. Carlo Pederetti, 'Se Leonardo è una chimera: *È errata l'attribuzione del "Salvator mundi"'*, *L'Osservatore Romano* 2 July 2011.

11. 'The Memoirs of Sofya Vladimirovna Engelgard (Novosiltseva) (1828–94)', in 'From the Memoirs (Continued)', *Russkiy Vesnk*, Vol. 193, November 1887, pp.59–80, 180.

12. According to Alexander Andreev's *Collections of European Art in Russia* (3 vols, 1862–64).

13. Sidney C. Hutchison, 'The Royal Academy Schools, 1768–1830', *Journal of the Walpole Society*, Vol. XXXVIII (1960–62), pp.123–9, 147.

14. Inventory 4, 1818, folder 33, Hermitage Archive. Quoted in B. Levinson-Lessing, *Istoriya kartinnoj galerei Jermitazha (1764–1917)/ The History of the Hermitage Art Gallery (1764–1917)*, 1971, p.277 n141.

15. Alan Wintermute, 'Leonardo's *Salvator Mundi*', *Salvator Mundi* catalogue, Christie's New York, 2017, pp.18, 38.

CHAPTER 13: THE HIGH COUNCIL

1. David Alan Brown, *The Young Correggio and his Leonardesque Sources*, Garland, 1981, p.126.

2. 'Leonardo 1452–1519', Palazzo Reale, 15 April–19 July 2015.

3. Ben Hoyle, 'Saviour of the World's Lost Leonardo Treasure', *The Times*, 16 November 2011.

4. Milton Esterow, 'UPDATED: A Long Lost Leonardo', *Artnews*, 15 August 2011.

5. Vincent Delieuvin, *Léonard en France: le maître et ses élèves 500 ans après la traverse des Alpes*, Skira, Paris 2016, p.286.

CHAPTER 14: ENTERTAINER AND ENGINEER

1. Quoted in Kemp, *Marvellous Works*, p.153.
2. Quoted in Charles Nicholl, *Leonardo da Vinci: The Flights of the Mind*, Penguin, 2005, p.46.
3. V.P. Zubov, *Leonardo da Vinci*, Harvard/De Gruyter, Eng. trans. 1968, p.111.

CHAPTER 15: THE GREATEST SHOW ON EARTH

1. Martin Bailey, 'Your First Chance to See the "New" Leonardo', *The Art Newspaper*, No. 227, September 2011.
2. National Gallery, London, *Leonardo da Vinci, Painter at the Court of Milan*, Yale, 2011, p.300.
3. Modestini, *Masterpieces*, p.424.
4. Bendor Grosvenor, '"Leonardo" Exhibition – An In-Depth Review', *Art History News*, 8 November 2011; *Sunday Times*, 14 November 2011; *Guardian*, 13 November 2011; *Burlington Magazine*, Vol. 154, No. 1307, February 2012, pp.132–3.
5. *Daily Telegraph*, 10 November 2011; Paul Joannides, 'Review of Leonardo da Vinci; Painter at the Court of Milan', in *Paragone*, July 2011, pp.57–8; *New York Review of Books*, 9 February 2012; Frank Zöllner, 'A Double Leonardo. On Two Exhibitions (and their Catalogues) in London and Paris', *Zeitschrift für Kunstgeschichte*, Vol. III, 2013.
6. Modestini, 'The *Salvator Mundi* Rediscovered', p.146.
7. This observation comes from an essay by Elizabeth Ravaud in Mohen, Menu and Mottin, *Mona Lisa: Inside the Painting*, Harry N. Abrams, Inc., 2006, p.86.
8. Modestini, 'The *Salvator Mundi* Rediscovered', p.146.

CHAPTER 16: LOOK, COOK FORSOOK

1. 'The Life and Works of Sir John Charles Robinson, 1824–1913', PhD. dissertation, University of Oxford, 1992, for this and following quotations.

2. John Charles Robinson papers, Ashmolean Museum, University of Oxford.

3. The first English edition is *Italian Masters in German Galleries*, George Bell & Sons, London, 1883.

4. Cited in Barbara Pezzini's *Burlington* blog, https://burlingtonindex. wordpress.com/2013/12/02/a-christmas-attribution/. See also Barbara Pezzini, '*The Burlington Magazine, The Burlington Gazette* and *The Connoisseur*: The Art Periodical and the Market for Old Masters Paintings in Edwardian London', *Visual Resources: An International Journal of Documentation*, 29:3, pp.154–83.

5. See Dietrich Seybold, 'Leonardeschi Gold Rush' (2016), http:// www.seybold.ch/Dietrich/LeonardeschiGoldRush.

6. Much of this research was published in Robert Simon, Martin Kemp and Margaret Dalivalle's book *Leonardo's Salvator Mundi* in 2019. The dealer Michael Franses has told me that he was the first to discover the Christie's auction and prior owner from where the Cook's *Salvator* came. I am indebted to Dietrich Seybold for his further research on the Hirsts' Catholicism and intellectual pursuits, George Gribble and other details. I am also grateful to Reverend Nigel Cave from Ratcliffe College, where Joseph Hirst's son was briefly a rector and where his papers are now kept.

7. 'Cook's of St Paul's, 150 years (1807–1957)', official company history, Guildhall Archives, FO Pam 1194.

8. *The Autobiography of Maude Gonne: A Servant of the Queen*, Chicago, 1995 (first published 1938), pp.23–4.

9. 'A Catalogue of the Paintings at Doughty House Richmond and Elsewhere in the Collection of Sir Frederick Cook, BT', ed. Herbert Cook, Vol. I, p.vii.

10. The account book is kept at the Ashmolean Museum, Oxford; see Davies and H. Cook, 'The Gallery at Richmond Belonging to Sir Frederick Cook', *Les Arts*, 44, August 1905, p.iv.

11. 'A Catalogue of the Paintings at Doughty House …', Vol. I, p.vi.

12. Letter from C.F. Walker to Bardini, 2 December 1890.

13. V. Ryder, *The Little Victims Play: An Edwardian Childhood*, London, 1974, p.57.

14. 'Editorial Article', probably written by Roger Fry, *Burlington Magazine*, inaugural issue, 1903.

15. Herbert Cook, 'The Portrait of Ginevra de Benci by Leonardo da Vinci', *Burlington Magazine*, 1912, reprinted in *Reviews and Appreciations of Italian Old Masters*, Heinemann, 1912, p.93.

16. Preface by Herbert Cook, *Catalogue of Pictures by Masters of the Milanese and Allied Schools of Lombardy*, Burlington Fine Arts Club, 1898.

17. Ibid., p.60.

18. Herbert Cook, 'Leonardo da Vinci and Some Copies', *Burlington Magazine*, December 1911, reprinted in *Reviews and Appreciations of Italian Old Masters*, p.22.

19. Dietrich Seybold kindly supplied me with the relevant page from Richter's diaries.

20. Sir Robert Witt of the National Arts Collections Fund. Also: 'They are shits,' wrote Lord Crawford to Clark about the Cook Collection trustees in October 1939. Quoted in James Stourton, *Kenneth Clark: Life, Art and Civilisation*, William Collins, 2016, p.171.

CHAPTER 17: OFFSHORE ICON

1. 'Relative income measures the amount of income or wealth relative to per capita GDP. When compared to other incomes or wealth, it shows the economic status or relative prestige value of the owners of this income or wealth because of their rank in the income distribution ... Relative output measures the amount of income or wealth relative to the total output of the economy.' https://www.measuringworth.com/calculators/uscompare/relativevalue.php.

2. https://www.artsjournal.com/realcleararts/2012/12/bid-rejected-leonardo-is-not-going-to-dallas.html.

3. Yuri Slezkine, *The House of Government: A Saga of the Russian Revolution*, Princeton, 2017, pp.413–14.

4. 'A Russian Billionaire's Monaco Fiefdom', *Der Spiegel*, 16 November 2018.

5. Andrew E. Kramer, 'A Russian City Always on the Watch Against Being Sucked Into the Earth', *New York Times*, 10 April 2012.

6. Renaud Revel, *Le Mystérieux Monsieur Rybolovlev: Enquête sur l'oligarque le plus puissant du monde*, Paris, 2017, p.56.

7. 'Sy B.', 'Dmitri Rybolovlev, l'oligarque au masque de glace', *Le Temps*, 5 March 2015.

8. Quoted in Arnaud Ramsay, *Dmitry Rybolovlev: The Man Behind Monaco's Football Renaissance*, Biteback, 2017, Kindle edn, location 856.

9. Revel, *Le Mystérieux Monsieur Rybolovlev*, pp.75–6.

10. Ramsay, *Dmitry Rybolovlev*, location 1058.

11. Quoted in Vicky Ward, 'Did this Billionaire Get Swindled Out of Millions in an Elaborate Art World Scheme?', *Town & Country Magazine*, 17 November 2015.

12. Quoted in Will Fitzgibbon, 'The Panama Papers: How the One Percenters Divorce: Offshore Intrigue Plays Hide And Seek With Millions', *ICIJ*, 3 April 2016. https://www.icij.org/investigations/panama-papers/20160403-divorce-offshore-intrigue/.

13. Rybolovleva vs. Rybolovlev, Claim No. BVIHCV2008/0403, Judgment (ECSC HC, 18 February 2009).

14. Sam Knight, 'The Bouvier Affair: How an Art-World Insider Made a Fortune by Being Discreet', *New Yorker*, 8–15 February 2016.

15. Quoted in Hugo Miller, 'Art's $1 Billion Question: Was Russian a Victim or Savant?', *Bloomberg*, 31 May 2016.

16. Criminal charge for forgery of documents (art. 90 of the Penal Code) and fraud (art. 330 of the Penal Code) vs. Mr. Yves Bouvier and any participant, letter from Rybolovlev's lawyers to General Prosecutor's Office, Monaco, 9 January 2015, PACER Case 1:16-mc-00125-JMF Document 3-9 Filed 03/25/16.

17. 'Declaration of Daniel W. Levy in Opposition to Petitioners' Motion to Amend the Protective Order to Allow Use of Discovery in Geneva, in Opposition to Petition for Further Discovery, and in Support of Continued Sealing, dated March 13, 2018', PACER Case 1:18-mc-00050-JMF Document 20-1 Filed 03/13/18 p.19.

18. According to Tania Rappo herself, in Ward, 'Did this Billionaire Get Swindled Out of Millions …'

19. Email from Mr Bouvier to Mr Sazonov of 28 December 2012, cited in PACER Case 1:16-mc-00125-JMF Document 3-9 Filed 03/25/16.

20. Email from Mr Bouvier to Mr Sazonov of 23 December 2011, ibid.

21. Revel, *Le Mystérieux Monsieur Rybolovlev*.

22. Amended Complaint Accent Delight/Xitrans Finance vs. Sotheby's, PACER Case 1:18-cv-09011-JMF Document 29 Filed 11/21/18.

23. Christopher D. Shea, 'Private Pinacothèque de Paris Museum to Close', *New York Times* blog, 12 February 2016.

24. PETITIONERS' MEMORANDUM OF LAW IN SUPPORT OF THEIR APPLICATION FOR AN ORDER UNDER 28 U.S.C. § 1782 TO CONDUCT DISCOVERY FOR USE IN FOREIGN PROCEEDINGS, Case 1:16-mc-00125-JMF Document 2 Filed 03/25/16.

25. Rybolovlev paid Bouvier $118 million for the painting. Bouvier paid Heller's client Steve Cohen $93.5 million. PACER Case 1:16-mc-00125-JMF Document 31-5.

26. Ramsay, *Dmitry Rybolovlev*, location 2465.

27. PETITIONERS' MEMORANDUM OF LAW IN SUPPORT OF THEIR APPLICATION UNDER 28 U.S.C. § 1782 Case 1:18-mc-00050-JMF Document 7 Filed 02/13/1.

28. Ibid.

29. In a written response, Sotheby's stated to the author: 'Mr Valette never made this statement and had no knowledge as to whether Mr Bouvier intended to resell the piece or, if so, to whom. Neither Sotheby's nor Mr Valette have seen any document containing or purporting to memorialize this alleged statement.'

30. Declaration of Daniel W. Levy in Opposition to Petitioners' Motion to Amend the Protective Order to Permit Use of Discovery in the United Kingdom, dated November 20, 2017, Case 1:16-mc-00125-JMF Document 115-12.

31. Sotheby's written statement to me runs: 'That the insurance valuations did not include the amounts that Mr Bouvier paid is consistent with Sotheby's internal practices and procedures. Furthermore, Mr Valette understood Mr Bouvier to be the owner, and so it can hardly be said that he "concealed" the fact of Mr. Bouvier's purchase.'

32. Ian Hamel, 'Le Suisse Yves Bouvier serait tombé dans un piège à Monaco', *Le Bilan*, 23 August 2017.

33. Chantal Mathez se Senger, 'Les Ports francs veulent devenir plus transparents', *Le Bilan*, 12 November 2015.

34. Knight, 'The Bouvier Affair: A Question of Trust', *Tatler*, August 2018.

CHAPTER 18: LDV RIP

1. See Martin Kemp, 'Leonardo and the Ineffable', annual lecture, Leonardo da Vinci Society, 17 May 2019. Claire Farago also shared her unpublished research on Leonardo and Augustinianism with me.

2. See Pascal Brioist, 'Louise de Savoie et le projet de Léonard de Vinci a Romorantin', in Brioist, Fagnard and Michon, *Louise de Savoie, 1476–1531*, Rennes, 2015.

3. Marco Carminati, *Cesare da Sesto, 1477–1523*, Jandi, Milan, 1994, pp.6–7.

4. See the technical analysis of Cesare da Sesto's *Madonna with Child, St Joseph, St Giovannino and another Saint,* held in a private collection in 'Dating and Technological Features of Wooden Panel Painting Attributed to Cesare da Sesto', Mauro Bernabei, Gianluca Quarta, Lucio Calcagnile and Nicola Macchioni, *Journal of Cultural Heritage* 8 (2007), pp. 202–8.

CHAPTER 19: NINETEEN MINUTES

1. Jerry Saltz, 'Christie's is Selling this Painting for $100 Million. They Say it's by Leonardo. I Have Doubts. Big Doubts', Vulture.com, 14 November, 2017; Scott Reyburn, 'Contemporary Art Sales: Do I Hear $100 Million?', *New York Times*, 11 November 2017; Frank Zöllner, *Monopol* magazine, 14 November 2017.

2. 'Leonardo da Vinci's *Salvator Mundi* Discussed by Alastair Sooke & Christie's Specialists', Hong Kong, 17 October 2017. https://www.youtube.com/watch?v=9NeLMJfQpK8.

3. Ibid.

4. https://www.artprice.com/artprice-reports/the-contemporary-art-market-report-2018/general-synopsis-contemporary-arts-market-performance.

5. Dr Clare McAndrew, 'The Art Market 2018', report by Art Basel and UBS.

6. 'Leonardo da Vinci's *Salvator Mundi* Discussed by Alastair Sooke & Christie's Specialists'.

7. My thanks to Scott Reyburn at the *New York Times* for discussing these figures with me.

8. Modestini, *Masterpieces*, p.423.

CHAPTER 20: THERE IS A HOUSE IN NEW ORLEANS

1. Kemp, *Living with Leonardo*, p.190.
2. SOTHEBY'S, INC. against: R.W. CHANDLER, LLC, ROBERT SIMON FINE ART, INC., SIX HAMILTON, LLC, SALVATOR MUNDI, LLC, RITTENHOUSE ASSOCIATES, LLC, ADELSON GALLERIES, INC., WARREN ADELSON, ALEXANDER PARISH, ROBERT SIMON, COMPLAINT filed 21st November 2016, UNITED STATES DISTRICT COURT SOUTHERN DISTRICT OF NEW YORK, Case 1:16-cv-09043, p.8.
3. Robert Simon press release, 7 July 2011: 'Cook's descendants sold the painting at auction in 1958 for £45, when it was catalogued as a copy after a work by Boltraffio, one of Leonardo's most gifted students. For the remainder of the twentieth century, the painting was part of an American collection until it was sold following the death of a family member.' Carla Raffinetti, 'Unravelling the Provenance Behind Leonardo da Vinci's *Salvator Mundi*', *Artlyst*, November 2012: '1958: Cook's descendants sold the painting to an unnamed private collector in the United States'; Esterow, 'UPDATED: A Long Lost Leonardo': 'The work is owned by a consortium of dealers, including Robert Simon, a specialist in Old Masters in New York and Tuxedo Park, N.Y. It was bought at an auction in the United States in 2005.'
4. Keri Geiger, 'Sotheby's, a Prized Art Client and His $47.5 Million da Vinci Markup', Bloomberg.com, 30 November 2016: 'Everyone in the art world knew the story. "Salvator Mundi," purchased at an estate sale in Louisiana, had turned out to be the work of Leonardo da Vinci.' Simon and Parish were bound not to disclose any details of the provenance of the *Salvator Mundi* in 2005, nor details of the sale to Bouvier, by an NDA they signed with Sotheby's at Sotheby's request, Simon told me. But, he added, the Sotheby's complaint published previously confidential details of the sale, which he then considered to be in the public domain.
5. Connie C. Griffith, 'Felix Kuntz – a Personal Reminiscence', Foreword to *250 Years of Life in New Orleans: The Rosemonde E. and Emile Kuntz Collection and The Felix H. Kuntz Collection*, Louisiana State Museum, 1968.

6. The New Orleans Auction Galleries filed for Chapter 11 bankruptcy in April 2011. It had been accused of auctioning fake paintings for hundreds of thousands of dollars, and it owed over fifty clients sums totalling $500,000.

7. Silke Müller, 'Der Grösste Kunstkrimi der Welt', *Stern*, 23 August 2018, pp.40–9.

CHAPTER 21: MIRAGE IN THE DESERT

1. Quoted in Michael Wolff, *Fire and Fury: Inside the Trump White House*, New York, 2018.

2. Dexter Filkins, 'Saudi Prince's Quest to Remake the Middle East', *New Yorker*, 2 April 2018.

3. Quoted in David Batty, 'The Rise of the Gulf Art Scene', Gulfography blog, 24 July 2012.

4. 'Opinion: Saudi Arabia's Spring, at Last', *New York Times*, 23 November 2017.

5. Dietrich Seybold, *Leonardo da Vinci im Orient: Geschichte eines Europäischen Mythos*, Böhlau Verlag, 2011.

CHAPTER 22: FRAGILE STATE

1. https://www.news.artnet.com/opinion/kenny-schachter-on-the-missing-salvator-mundi-1565674

2. https://www.theguardian.com/artanddesign/2018/oct/14/leonardo-da-vinci-mystery-why-is-his-450m-masterpiece-really-being-kept-under-wraps-salvator-mundi

3. https://www.lefigaro.fr/arts-expositions/l-exposition-vinci-c-est-dix-ans-de-travail-20190909

AFTERWORD

1. Javier Pes, 'Why Are Attendance Rates Nose-Diving at London's Art Museums? Directors Frantically Search for Answers', Artnet, August 2018.

2. Dr Clare McAndrew, 'The Art Market 2018 – An/Art Basel and UBS Report'.

3. Thanks to Professor Francesca Borgo, St Andrews, for this thought.

BIBLIOGRAPHY

Peter Ackroyd, *Civil War*, London, Pan, 2015

Georgina Adam, *Dark Side of the Boom: The Excesses of the Art Market in the Twenty-First Century*, London, Lund Humphries, 2014

G. Agosti, R. Sacchi and J. Stoppa (eds), *Bernardino Luini e i suoi figli*, Milan, Officina Libraria, 2014

Francis Ames-Lewis, *Isabella and Leonardo: The Relationship Between Isabella d'Este and Leonardo da Vinci*, New Haven, Yale University Press, 2012

Carmen C. Bambach, *Leonardo da Vinci, Master Draftsman*, New York, Metropolitan Museum of Art, 2003

Carmen C. Bambach, 'Seeking the Universal Painter' (review of National Gallery Leonardo exhibition), *Apollo*, Vol. LXXXIII, February 2012

Nicola Barbatelli and Margherita Melani (eds), *Leonardo a Donnaregina: Il Salvator Mundi Per Napoli*, Naples, CB Edizioni, 2017

Andrew Barclay, 'Recovering Charles I's Art Collection: Some Implications of the 1660 Act of Indemnity and Oblivion', *Historical Research*, Vol. LXXXVIII, Issue 242, November 2015

Andrea Bayer (ed.) et al., *Painters of Reality: The Legacy of Leonardo and Caravaggio in Lombardy*, New Haven and London, Yale University Press, 2004

Thomas M. Bayer and John R. Page, *The Development of the Art Market in England*, London, Routledge, 2016

James Beck and Michael Daley, *Art Restoration: The Culture, the Business and the Scandal*, London, John Murray, 1994

Sylvie Béguin, *Andrea Solario en France* (exhibition catalogue), Paris, Ministère de la culture, Editions de la Réunion des Musées Nationaux, 1985

Bernard Berenson, *North Italian Painters of the Renaissance*, New York and London, G.P. Putnam's Sons, 1907

Ambrogio Bergognone, *Acquisizioni, scoperte e restauri … Pinacoteca di Brera, Milano*, Florence, Cantini, 1989

Lita-Rose Betcherman, *Buckingham's Man: Balthazar Gerbier*, Bev Editions, 2011

Giulio Bora, David Alan Brown, Marco Carminati, Maria Teresa Fiorio and Pietro Marani, *The Legacy of Leonardo: Painters in Lombardy 1490–1530*, Milan, Skira, 1998

Tancred Borenius (ed. Herbert Cook), *A Catalogue of the Paintings at Doughty House, Richmond, & elsewhere in the Collection of Sir Frederick Cook, Bt., Visconde de Monserrate*, 1913

John Brewer, *The American Leonardo: A Twentieth-Century Tale of Obsession, Art and Money*, London, Constable, 2009

Pascal Brioist, Laure Fagnart and Cédric Michon, *Louise de Savoie (1476–1531)*, Tours, Presses Universitaires François-Rabelais, 2018

Jerry Brotton, *The Sale of the Late King's Goods: Charles I and his Art Collection*, London, Pan Books, 2018

Jerry Brotton and David McGrath, 'The Spanish Acquisition of King Charles I's Art Collection: The Letters of Alonso de Cardenas, 1649–51', *Journal of the History of Collections*, Vol. XX (1), May 2008

Dan Brown, *The Da Vinci Code*, Bantam Press, London, 2003

David Alan Brown, *The Young Correggio and his Leonardesque Sources*, New York, Garland, 1981

David Alan Brown, *Andrea Solario*, Milan, Electa, 1987

David Alan Brown, *Leonardo da Vinci: Origins of a Genius*, New Haven, Yale University Press, 1998

Jonathan Brown and John Elliott (eds), *The Sale of the Century: Artistic Relations Between Spain and Great Britain, 1604–1655*, New Haven and London, Yale University Press in association with Museo Nacional del Prado, 2002

Andrea Bubenik and Anne Thackray (eds), *Perspectives on Wenceslaus Hollar*, London, Harvey Miller Publishers, 2018

William Buchanan, *Memoirs of Painting; with a chronological history of the importation of pictures by the great masters into England since the French Revolution*, London, R. Ackermann, 1824

Marco Carminati, *Cesare da Sesto, 1477–1523*, Milan, Jandi, 1994

Lynn Catterson, *Dealing Art on Both Sides of the Atlantic, 1860–1940*, Leiden and Boston, Brill, 2017

David Chambers and Jane Martineau (eds), *Splendours of the Gonzaga* (exhibition catalogue), London, Victoria & Albert Museum, 1981

Marco Ciatti and Cecilia Frosinini (eds), *Il Restauro dell'Adorazione dei Magi di Leonardo: La riscoperta di un capolavore*, Florence, Edifir, 2017

Marco Ciatti and Antonio Natali (eds), *Raffaello: La Madonna del Cardellino restaurata*, Florence, Mandragora, 2008

Kenneth Clark, *Leonardo da Vinci*, London, Phaidon, 1954

Kenneth Clark, *A Catalogue of the Drawings of Leonardo da Vinci in the Collection of His Majesty the King at Windsor Castle*, Cambridge University Press, 1935; London, Phaidon, 1968

Martin Clayton and Rufus Bird, *Charles II: Art and Power*, Royal Collection Trust, 2017

Rachel Cohen, *Bernard Berenson: A Life in the Picture Trade*, Yale University Press, 2013

Wilkie Collins, *A Rogue's Life: From his Birth to his Marriage*, London: R. Bentley & Son, 1879

Jonathan Conlin, 'Collecting and Connoisseurship in England, 1840–1900: The Case of J.C. Robinson', in Inge Reist (ed.), *British Models of Art Collecting and the American Response*, London, Routledge, 2014

Herbert Cook, *Catalogue of pictures by masters of the Milanese* and allied schools of Lombardy, London, Burlington Fine Arts Club, 1898

Sir Herbert Cook, *Reviews and Appreciations of Italian Old Masters*, London, Heinemann, 1912

Obituary of Sir Herbert Cook, *Burlington Magazine*, Vol. LXXIV, No. 435, June 1939

Philippe Costamagna, *An Insider's Memoir of Masterpieces, Money, and the Magnetism of Art*, New York, New Vessel Press, 2018

Michael Daley, 'Problems With the New York Leonardo *Salvator Mundi*, Part I: Provenance and Presentation' (14 November 2017), http://artwatch.org.uk/problems-with-the-new-york-leonardo-salvator-mundi-part-i-provenance-and-presentation/

Michael Daley, 'The $450m New York Leonardo *Salvator Mundi*, Part II: It Restores, It Sells, Therefore It Is' (1 January 2018), http://artwatch.org.uk/the-450m-new-york-leonardo-salvator-mundi-part-ii-it-restores-it-sells-therefore-it-is/

Michael Daley, 'A Day in the Life of the New Louvre Abu Dhabi Annexe's Pricey New Leonardo *Salvator Mundi*' (20 February 2018), http://artwatch.org.uk/a-day-in-the-life-of-the-new-louvre-abu-dhabi-annexes-pricey-new-leonardo-salvator-mundi/

Michael Daley, 'Nouveau Riche? Welcome to the Club!' (27 February 2018), http://artwatch.org.uk/nouveau-riche-welcome-to-the-club/

Michael Daley, 'In Their Own Words: No. 3 – The Reception of the First Version of the Leonardo *Salvator Mundi*' (11 March 2018), http://artwatch.org.uk/in-their-own-words-no-3-11-march-2018-the-reception-of-the-first-version-of-the-leonardo-salvator-mundi/

Michael Daley, 'Startling Disclosures on the Re-re-restored Leonardo Salvator Mundi' (29 March 2018), http://artwatch.org.uk/startling-disclosures-on-the-re-re-restored-leonardo-salvator-mundi/

Michael Daley, 'The Leonardo *Salvator Mundi* Saga: Three Developments' (10 April 2018), http://artwatch.org.uk/the-leonardo-salvator-mundi-saga-three-developments/

Michael Daley, 'Leonardo Scholar Challenges Attribution of \$450m Painting' (9 August 2018), https://www.theguardian.com/artanddesign/2018/aug/06/leonardo-da-vinci-scholar-challenges-attribution-salvator-mundi-bernardino-luini

Michael Daley, 'How the Louvre Abu Dhabi *Salvator Mundi* became a Leonardo-from-Nowhere' (18 September 2018), http//artwatch.org.uk/how-the-louvre-abu-dhabi-salvator-mundi-became-a-leonardo-from-nowhere/

Michael Daley, 'Two Developments in the No-Show Louvre Abu Dhabi Leonardo *Salvator Mundi* Saga' (11 October 2018), http://artwatch.org.uk/two-developments-in-the-no-show-louvre-abu-dhabi-leonardo-salvator-mundi-saga/

Michael Daley, 'The Pear-Shaped *Salvator Mundi*' (12 November 2018), http://artwatch.org.uk/tag/michael-daley-and-salvator-mundi/

Michael Daley, 'Two Troubled Leonardos' (17 November 2018), http://artwatch.org.uk/two-troubled-leonardos/

Michael Daley, 'The Leonardo *Salvator Mundi* Part I: Not "Pear-Shaped" – Dead in the Water' (6 February 2019), http://artwatch.org.uk/the-leonardo-salvator-mundi-part-i-not-pear-shaped-dead-in-the-water/

Michael Daley, 'The Louvre Museum's Bizarre Charge of 'Fake information' on the $450 million *Salvator Mundi*' (22 February 2019),http://artwatch.org.uk/the-louvre-museums-bizarre-charge-of-fake-information-on-the-450-million-salvator-mundi/

Pierre Dan, *Le Trésor des merveilles de la maison royale de Fontainebleau*, 1642

Elon Danziger, 'The Cook Collection, its Founder and its Inheritors', *Burlington Magazine*,Vol. CXLVI, No. 1216, July 2004

Kathleen Dardes and Andrea Rothe (eds), 'The Structural Conservation of Panel Paintings', Proceedings of a symposium at the J. Paul Getty Museum, 24–28 April 1995

H.E. Davies, *Sir John Charles Robinson (1824–1913): His Role as a Connoisseur and Creator of Public and Private Collections*, PhD thesis, University of Oxford

Julia A. DeLancey, 'Dragon's Blood and Ultramarine: The Apothecary and Artists' Pigments in Renaissance Florence', in Marco Fantani et al. (eds), *The Art Market in Italy, Fifteenth–Seventeenth Centuries, Modena*, 2003

Vincent Delieuvin, *Saint Anne: Leonardo da Vinci's Ultimate Masterpiece* (exhibition catalogue), Paris, Louvre, 2012

A.G. Dickens (ed.), *The Courts of Europe: Politics, Patronage and Royalty*, London, Thames & Hudson, 1977

Helen S. Ettlinger, 'A Postscript to Inigo Jones – "Puritanissimo Fiero"', *Burlington Magazine*,Vol. CXXXIII, No. 1064, November 1991

Laure Fagnart, 'L'appartement des bains et le cabinet des peintures du château de Fontainebleau sous le règne d'Henri IV', in Colette Nativel (ed.), *Henri IV: Art et pouvoir*,Tours, Presses Universitaires François-Rabelais, 2016

Laure Fagnart, *Léonard de Vinci à la cour de France*, Rennes, 2019

Valeria Farinati, *Interni e Architettura nel Primo Settecento Veneziano: Palazzo Priuli Manfrin a Cannaregio*,Venezia Arti, 1992

Maria Teresa Fiorio, *Giovanni Antonio Boltraffio: Un pittore Milanese nel lume di Leonardo*, 2000

Pamela Fletcher and Anne Helmreich (eds), *The Rise of the Modern Art Market in London: 1850–1939*, Manchester, 2013

William Powell Frith, *My Autobiography and Reminiscences*, 7th edn, London, R. Bentley & Son, 1889

John Gage, *Colour and Culture: Practice and Meaning from Antiquity to Abstraction*, London, Thames & Hudson, 1993

Klara Garas, 'Das Schicksal der Sammlung des Erzherzogs Leopold William', *Jahrbuch der kunsthistorischen Sammlungen in Wien*, Vol. LXIV, 1968

Carlo Ginzburg and Anna Davin, 'Morelli, Freud and Sherlock Holmes: Clues and Scientific Method', *History Workshop*, No. 9, spring 1980

Richard T. Godfrey, *Wenceslaus Hollar: A Bohemian Artist in England*, New Haven and London, Yale University Press, 1994

Elizabeth Goldring, 'Art Collecting and Patronage in Shakespeare's England', in Malcolm Smuts (ed.), *The Oxford Handbook of the Age of Shakespeare*, Oxford University Press, 2016

Maude Gonne, *The Autobiography of Maude Gonne: A Servant of the Queen*, London, 1938

Erin Griffey (ed.), *Henrietta Maria: Piety, Politics and Patronage*, London, Routledge, 2008

Erin Griffey, *On Display: Henrietta Maria and the Materials of Magnificence at the Stuart Court*, London, The Paul Mellon Centre for Studies in British Art, 2016

Pierre Guilbert, *Description historique des château, bourg et forêt de Fontainebleau, etc.*, Paris, 1731

James Hamilton, *A Strange Business: Making Art and Money in Nineteenth-Century Britain*, London, Atlantic, 2014

Francis Haskell, *The Ephemeral Museum: Old Master Paintings and the Rise of the Art Exhibition*, New Haven, Yale University Press, 2000

Francis Haskell (ed. Karen Serres), *The King's Pictures: The Formation and Dispersal of the Collections of Charles I and his Courtiers*, New Haven, Yale University Press, 2013

Mary Frederica Sophia Hervey (completed by Catherine M. Phillimore and ed. G.C. Williamson), *The Life, Correspondence and Collections of Thomas Howard, Earl of Arundel, etc.*, Cambridge University Press, 1921

Ludwig Heydenreich, 'Leonardo's *Salvator Mundi*', *Raccolta Vinciana*, Vol. XX, 1964

David Howarth, *Lord Arundel and his Circle*, New Haven and London, Yale University Press, 1985

Walter Isaacson, *Leonardo da Vinci*, London, Simon & Schuster, 2017

Franciscus Junius, *Painting of the Ancients*, London, 1638

Laurence Kantner, *Leonardo: Discoveries from Verrocchio's Studio*, Yale University Press, 2018

Larry Keith and Ashok Roy, *Giampietrino, Boltraffio, and the Influence of Leonardo*, London, National Gallery Technical Bulletin, Vol. XVII, 1996

Martin Kemp, *Leonardo da Vinci: The Marvellous Works of Nature and Man*, London, Dent, 1981

Martin Kemp (ed.), *Leonardo da Vinci: The Mystery of the Madonna of the Yarnwinder*, Edinburgh, National Gallery of Scotland, 1992

Martin Kemp, *Leonardo*, Oxford University Press, 2011

Martin Kemp, *Living with Leonardo: Fifty Years of Sanity and Insanity in the Art World and Beyond*, London, Thames & Hudson, 2018

R.J. Knecht, *Renaissance Warrior and Patron: The Reign of Francis I*, Cambridge University Press, 1994

Annick Lemoine, *Nicolas Regnier: Peintre, collectionneur et marchand d'art*, Paris, Athena, 2007

The Literary Works of Leonardo da Vinci (ed. Jean Paul Richter), 3rd edn, London, Phaidon, 1970

Leonardo on Painting: An Anthology of Writings by Leonardo da Vinci with a Selection of Documents Relating to his Career as an Artist (selected and trans. Martin Kemp and Margaret Walker), New Haven and London, Yale University Press, 1989

The Notebooks of Leonardo da Vinci, arranged and trans. Edward MacCurdy, with additional translations by Ladislao Reti, London, Folio Society, 2009

Roger Lockyer, *Buckingham: The Life and Political Career of George Villiers, First Duke of Buckingham, 1592–1628*, London, Longman, 1981

Emanuele Lugli, 'Leonardo and the Hair Makers', in Francesca Borgo, Rodolfo Maffeis and Alessandro Nova (eds), *Leonardo in Dialogue*, Marsilio, 2018

Pietro C. Marani, *Leonardo da Vinci: The Complete Paintings*, New York, H.N. Abrams, 2000

Pietro Marani and Maria Teresa Fiorio (eds), *Leonardo da Vinci: The Design of the World* (exhibiton catalogue), Milan, Palazzo Reale, Skira, 2015

V.E. Markova, *Sobranie Zhivopisi. Tom 1. Italia VIII–XVI veka*, Moscow, Gosudarstvennyĭ Muzeĭ Izobrazitel'nykh Iskusstv Imeni A.S. Pushkina and 'Galart', 2002

Louisa C. Matthew, '"Vendecolori a Venezia": The Reconstruction of a Profession', *Burlington Magazine*, Vol. CXLIV, No. 1196, November 2002

Stanley Mazaroff, *Henry Walters and Bernard Berenson: Collector and Connoisseur*, Baltimore, Johns Hopkins University Press, 2010

Michel Menu (ed.), *Leonardo da Vinci's Technical Practice: Paintings, Drawings and Influence*, Paris, Hermann, 2014

Dmitry Merezhkovsky (trans. Bernard Guilbert Guerney), *The Romance of Leonardo da Vinci*, London, Nonesuch Press, 1938

Oliver Millar, *The Tudor, Stuart and Early Georgian Pictures in the Collection of Her Majesty the Queen*, London, Phaidon, 1963

Oliver Millar, *The Queen's Pictures*, London, Chancellor, 1984

Dianne Dwyer Modestini, *Masterpieces* (based on a manuscript by Mario Modestini), Fiesole, Cadmo, 2018

Giovanni Morelli ('Ivan Lermolieff'), *Die Werke Italienischer Meister in den Galerien von München, Dresden und Berlin. Ein Kritischer Versuch*, Leipzig, 1880

Andrea Mozzato, *The Pigment Trade in Venice and the Mediterranean in the Second Half of the Fifteenth Century*, online pdf

Maria João Neto, *Monserrate: The Romantic Country House of an English Family*, Casal de Cambra, Caleidescópio, 2015

Maria João Neto, *Monserrate Revisited: The Cook Collection in Portugal*, Casal de Cambra, Caleidoscópio, 2017

Charles Nicholl, *Leonardo da Vinci: The Flights of the Mind*, London, Penguin, 2005

Steven N. Orso, *Philip IV and the Decoration of the Alcazar of Madrid*, Princeton, NJ, Princeton University Press, 1986

Henry Peacham, *Peacham's Compleat Gentleman*, 1634. With an introduction by G.S. Gordon, 1906

Iain Pears, *The Discovery of Painting: The Growth of Interest in the Arts in England 1680–1768*, New Haven and London, Yale University Press, 1988

Linda Levy Peck, *Consuming Splendour: Society and Culture in Seventeenth-Century England*, Cambridge University Press, 2005

Carlo Pedretti, *Leonardo: A Study in Chronology and Style*, London, Thames & Hudson, 1973

Carlo Pedretti, *Leonardo: The Machines*, Giunti, 1999

Elizabeth A. Pergam, 'John Charles Robinson in 1868: A Victorian Curator's Collection on the Block', *Journal of Art Historiography*, No. 18, June 2018

P. Pipaud, '*Salvator Mundi*, l'histoire nantaise d'un tableau de Léonard de Vinci', *Bulletin SAHNLA*, 2012

Andrea Geddes Poole, *Stewards of the Nation's Art: Contested Cultural Authority 1890–1939*, Toronto, 2010

John Pye, *Patronage of British Art, an historical sketch*, London, 1845

La Raccolata Leonardesca della contessa de Behague (exhibition catalogue), Vinci, 1980

Arnaud Ramsay, *Dmitry Rybolovlev: The Man Behind Monaco's Football Renaissance*, London, Biteback Publishing, 2017

Gerald Reitlinger, *The Economics of Taste: The Rise and Fall of Picture Prices 1760–1960*, London, Barrie & Rockliff, 1961

Renaud Revel, *Le Mystérieux Monsieur Rybolovlev*, First Document, 2017

Charles Robertson, 'Leonardo da Vinci: London. Exhibition Review', *Burlington Magazine*, Vol. CLIV, No. 1307, February 2012

Sir John Charles Robinson, *Memoranda on fifty pictures selected from a collection of works of the ancient masters*, London, privately printed by Whittingham & Wilkins, 1868

Sir John Charles Robinson, 'An Alleged Michael Angelo', *The Art Amateur*, Vol. V, No. 6, November 1881

Sir John Charles Robinson, 'The Gallery of Pictures by the Old Masters, Formed by Francis Cook, Esq., of Richmond', *Art Journal*, May 1885

Sir John Charles Robinson, 'On Spurious Works of Art', *The Nineteenth Century*, Vol. XXX, No. 177, November 1891

Sir John Charles Robinson, 'English Art Collecting and Connoisseurship', *The Nineteenth Century*, Vol XXXVI, No. 212, October 1894

Jean André Rouquet, *The Present State of the Arts in England*, London, J. Nourse, 1755

Royal Academy of Arts, *Charles I: King and Collector* (exhibition catalogue), London, 2018

Charles Sebag-Montefiore and Julia Armstrong-Totten, *A Dynasty of Dealers: John Smith and Successors 1801–1924 – A Study of the*

Art Market in Nineteenth-Century London, Arundel, Roxburghe Club, 2013

Meryle Secrest, *Duveen: A Life in Art*, Chicago, 2005

Domenico Sedini, *Marco d'Oggiono: Tradizione e Rinnovamento in Lombardia tra Quattrocento e Cinquecento*, 1989

Dietrich Seybold, *Das Schlaraffenleben der Kunst: Eine Biografie des Kunstkenners und Leonardo da Vinci-Forschers Jean Paul Richter (1847–1937)*, Paderborn, Wilhelm Fink, 2014

Dietrich Seybold, *Leonardo da Vinci im Orient: Geschichte eines europäischen Mythos*, Cologne, Böhlau Verlag, 2011

Dietrich Seybold, 'Giovanni Morelli and Leonardo da Vinci', http://www.seybold.ch/Dietrich/TheVirtualResearch Institute

Dietrich Seybold, 'The Leonardeschi Gold Rush', http://www.seybold.ch/Dietrich/LeonardeschiGoldRush

Dietrich Seybold, 'Leonardo da Vinci's Travels to the East', http://www.seybold.ch/Dietrich/BacklistLeonardoDaVinciSTravels ToTheEast

Dietrich Seybold, 'The Mysterious Donna Laura Minghetti Leonardo', http://www.seybold.ch/Dietrich/TheMysterious DonnaLauraMinghetti-Leonardo

Dietrich Seybold, 'A *Salvator Mundi* Provenance', http://www.seybold.ch/Dietrich/ASalvatorMundiProvenance

Dietrich Seybold, 'Some *Salvator Mundi* Microstories', http://www.seybold.ch/Dietrich/SomeSalvatorMundiMicrostories

Fern Rusk Shapley, *Complete Catalogue of the Samuel H. Kress Collection, Italian Paintings XV–XVI Century*, London, Phaidon, 1968

Janice Shell, *Pittori in bottega: Milano nel Rinascimento*, U. Allemandi, 1995

Marie-Laure Sibert, *Les Rencontres d'Amboise*, Tours, Éditions Barcla, 1969

Joanne Snow-Smith, 'The *Salvator Mundi* of Leonardo da Vinci', *Arte Lombarda Nuova Serie*, No. 50, 1978

Joanne Snow-Smith, *The Salvator Mundi of Leonardo da Vinci*, Seattle, Henry Art Gallery, University of Washington, 1982

Julie Spraggon, *Puritan Iconoclasm During the English Civil War: The Attack on Religious Imagery by Parliament and its Soldiers*, Boydell Press, 2004

Marika Spring, Antonio Mazzotta, Ashok Roy, Rachel Billinge and David Peggie, 'Painting Practice in Milan in the 1490s: The Influence of Leonardo', National Gallery Technical Bulletin Vol. XXXII, *Leonardo da Vinci: Pupil, Painter and Master*

Paolo Squatriti, *Landscape and Change in Early Medieval Italy: Chestnuts, Economy and Culture*, Cambridge University Press, 2017

James Stourton, *Kenneth Clark: Life, Art and Civilisation*, London, William Collins, 2017

Wilhelm Emil Suida, *Leonardo und sein Kreis*, Munich, 1929

Paul Taylor, *Condition: The Ageing of Art*, London, Paul Hoberton, 2015

Simon Thurley, *Whitehall Palace*, New Haven, Yale University Press, 1999

Gillian Tindall, *The Man Who Drew London: Wenceslaus Hollar in Reality and Imagination*, London, Vintage, 2013

Annalea Tunesi, *Stefano Bardini's Photographic Archive: A Visual Historical Document*, Phd thesis, Leeds, 2014

Simon Turner, *The New Hollstein German Engravings, Etchings and Woodcuts, 1400–1700: Wenceslaus Hollar*, Part V, Sound and Vision Publishers 2011

Francesco Malaguzzi Valeri, *La corte di Ludovico il Moro: La vita privata e l'arte a Milano nella seconda metà del Quattrocento*, Milano, Ulrico Hoepli, 1913

Katherine S. van Eerde, *Wenceslaus Hollar: Delineator of his Time*, Charlottesville, University Press of Virginia, 1970

Giorgio Vasari, *The Lives of the Painters, Sculptors and Architects*

Filip Vermeylen, 'The Colour of Money: Dealing in Pigments in Sixteenth-Century Antwerp', in Jo Kirby Arkinson (ed.), *The European Trade in Painter's Materials to 1700*, London, National Gallery of Art

George Vertue, *Anecdotes of painting in England with some account of the principal artists; and incidental notes on other arts; collected by the late Mr. George Vertue; and now digested and published from his original MSS. by Mr. Horace Walpole*, London, 1759

Edoardo Villata, Vanna Arrighi and Anna Bellinazzi (eds), *Leonardo da Vinci, La Vera Immagine: Documenti e Testimonianze sulla vita e sull'opera*, Milan, Giunti, 2005

Gustav Friedrich Waagen, *Treasures of Art in Great Britain* (3 vols, first published 1854), London, Cornmarket Press, 1970

Giles Waterfield, *The People's Galleries: Art Museums and Exhibitions in Britain 1800–1914*, Yale University Press, 2015

E.K. Waterhouse, 'Paintings from Venice for Seventeenth-Century England: Some Records of a Forgotten Transaction', *Italian Studies*, Vol. VII, 1952

Evelyn S. Welch, *Shopping in the Renaissance: Consumer Cultures in Italy, 1400–1600*, Yale, 2009

Timothy Wilks, 'Plundered Art for the Collections of Charles I?: The Capture of Munich in May, 1632', in Hildegard Wiegel and Michael Vickers (eds), *Excalibur: Essays on Antiquity and the History of Collecting in Honour of Arthur MacGregor*, Oxford, Archaeopress, 2013

Timothy Wilks, 'Art Collecting at the English Court from the Death of Henry Prince of Wales to the Death of Anne of Denmark', *Journal of the History of Art Collections*, Vol. IX, No. 1, 1997

George Charles Williamson, *Bernardino Luini*, London, 1899

James Anderson Winn, *Queen Anne: Patroness of the Arts*, New York, Oxford University Press, 2014

Thomas Winstanley, *Observations on the Arts*, Liverpool, W. Wales & Co., 1828

Alan Wintermute, David Ekserdijan et al., *Salvator Mundi* catalogue, Christie's New York, 2017

Jeremy Wood, 'Connoisseurship of the Arts', in *Nicholas Lanier, 1588–1666: A Portrait Revealed*, London, The Weiss Gallery, 2010

Jeremy Wood, 'Buying and Selling Art in Venice, London and Antwerp: The Collection of Bartolomeo della Nave and the Dealings of James, Third Marquis of Hamilton, Anthony Van Dyck, and Jan and Jacob Van Veerle, c.1637–52', *Journal of the Walpole Society*, 2018

Frank Zöllner, *Leonardo da Vinci, 1452–1519: The Complete Paintings and Drawings*, Cologne, Taschen, 2007, 2017, 2019

Vasily Zubov (trans. David H. Kraus), *Leonardo da Vinci*, Cambridge, Mass, Harvard University Press, 1968

INDEX